Interrogative Design

Interrogative Design

edited by Ian Wojtowicz

The MIT Press

Cambridge, Massachusetts

London, England

ART
CULTURE
TECHNOLOGY

POLISH CULTURAL
INSTITUTE
NEW YORK

M
I
T

The MIT Press would like to thank the Art, Culture, and Technology program at MIT and the Polish Cultural Institute of New York for their generous production support, as well as the anonymous peer reviewers who provided comments on drafts of this book. The generous work of academic experts is essential for establishing the authority and quality of our publications. We acknowledge with gratitude the contributions of these otherwise uncredited readers.

This book was set in Gerstner Programm and New Century Schoolbook by Graphite Design Labs Inc. Printed and bound in the United States of America.

Library of Congress Cataloging-in-Publication Data

Names: Wojtowicz, Ian, editor.
Title: Interrogative design / edited by Ian Wojtowicz.
Description: Cambridge, Massachusetts : The MIT Press, [2024] | Includes bibliographical references and index.
Identifiers: LCCN 2023054771 | ISBN 9780262048651 (hardcover)
Subjects: LCSH: Social justice. | Violence--Social aspects.
Classification: LCC HM671 .I58 2024 | DDC 303.3/72--dc23/eng/20240214
LC record available at https://lccn.loc.gov/2023054771

10 9 8 7 6 5 4 3 2 1

The parrhesiastes is someone who says everything he has in mind: he does not hide anything but opens his heart and mind completely to other people through his discourse.

— Michel Foucault

Contents

Essays

Projects

Commentary •

Preface

Interrogative design is an idea that has withstood the test of time. Well-respected and oft-cited in media art and critical design circles, many have adapted its techniques in their own work. Originally framed in the 1990s in the book *Critical Vehicles*, Krzysztof Wodiczko's approach to industrial design for critical social discourse still resonates today. When *Wired* ran a public call for new forms of technology-based art and cultural critique, the article cited interrogative design as a key inspiration.[1] Surprisingly, despite broad interest and growing application, interrogative design as a concept and practice remains underdocumented. This book introduces the idea, in depth, to support a new generation of critical designers and artists.

Wodiczko has described parts of his methodology in essays and studio courses at MIT, Harvard, and throughout the world. Prior to this volume, however, there has been no exhaustive description of the topic. To date, only two pages have been published specifically on the concept.

Guides to socially responsive work such as IDEO's *Human Centered Design Toolkit* help artists and designers focus their work, yet few approaches are as deeply researched, enduring, and influential as interrogative design. As technological advances continue to spread into more spheres of human activity, the design of our tools—from buildings to artificial intelligence—is increasingly at the center of complex social, environmental, and political problems. We need better approaches to reshaping culture and communication for the benefit of those who need the most help. Interrogative design is one such approach.

This volume covers artistic works and projects influenced by the concept and includes reprints of source material and new essays by Wodiczko and others who elaborate and extrapolate the idea. The goal of this book is to consolidate and explain interrogative design in an accessible volume that will delight art historians with new material and serve students as a practical handbook.

I was a student of Wodiczko's at MIT and Harvard and I learned his approach firsthand. Many of his former students and colleagues featured in this book have generously contributed their images, writing, advice, and enthusiasm to bring this book together. I hope you will find Wodiczko's design philosophy as interesting and inspiring as we have.

Ian Wojtowicz

Warsaw and Vancouver

human activity seems to be progressing toward a strange horizon once the province of science fiction. At the time of this writing, news reports of advances in robotics, artificial intelligence, bioengineering, and space travel are a daily occurrence, reinforcing William Gibson's observation that "the future is already here, it's just not evenly distributed."[1]

The present and the future seem to be colliding in unknown ways, bringing with them social, political, and biological realities difficult to predict. Where are these trends going? What are their unseen costs? Is society equipped for these new situations? Is there good diversity of thought on these topics?

Some of the consequences of new technologies are obvious: speed, comfort, convenience, control, wonder. However, myriad problems are emerging. The COVID pandemic showed the human toll of *l'avenir* that has "a way of arriving unannounced."[2] It exposed structural gaps in healthcare that caused many unnecessary fatalities, spurred the construction of further technologies of social control, and highlighted widespread interpersonal isolation and the fragility of the social fabric.

Beyond the pandemic, data shows that wealth inequality is increasing within countries even though it is narrowing between them.[3] This inequality is driving a host of social problems, from health to crime.[4] Climate change threatens the dramatic loss of ecosystems and the forced migration of massive numbers of people around the world.[5] These migrations will be drivers of regional conflicts for years to come,[6] while nuclear weapons continue to threaten massive regions of the planet.[7] Small-scale wars and petty conflicts continue to erupt around the world, with the regular targeting of civilian populations by both state and non-state actors, using continuously evolving techniques within conflict zones whose boundaries are unclear.[8] Technological and economic change have precipitated a regression toward nationalist politics via rapid growth in public misinformation and disinformation and the weaponizing of the Internet—a technology which had previously been considered a pathway to international peace and prosperity.[9] And the codevelopment of biotechnology and artificial intelligence is leading to what Yuval Harari calls "the hacking of the human being," which could endanger individual free will and the future of democracy and liberty across the world.[10] Society seems unable to generate effective public

discourse about the problems that face us. Thomas Homer-Dixon calls this problem "the ingenuity gap"—the increasing inability of populations to talk about, let alone solve, the complex issues of the twenty-first century.[11]

Despite the nature of these concerns, societies seem to be doubling down on existing techniques to reason their way out of them. Western cultures try to understand various common dilemmas through television talk shows, web-based articles designed around mimetic potential, and specialized academic journal articles locked away behind expensive paywalls. Crowdsourcing through social media seems to have made things worse.[12] Today, books are responsible for transmitting complex conversations over long expanses of time, sometimes centuries,[13] yet the efficacy of long-form reading is in decline.[14] Screen-based media have reduced societies' ability to sustain the prolonged attention necessary to delve deeply into complex topics.[15] New technological problems call for innovative approaches to empathy and ingenuity.

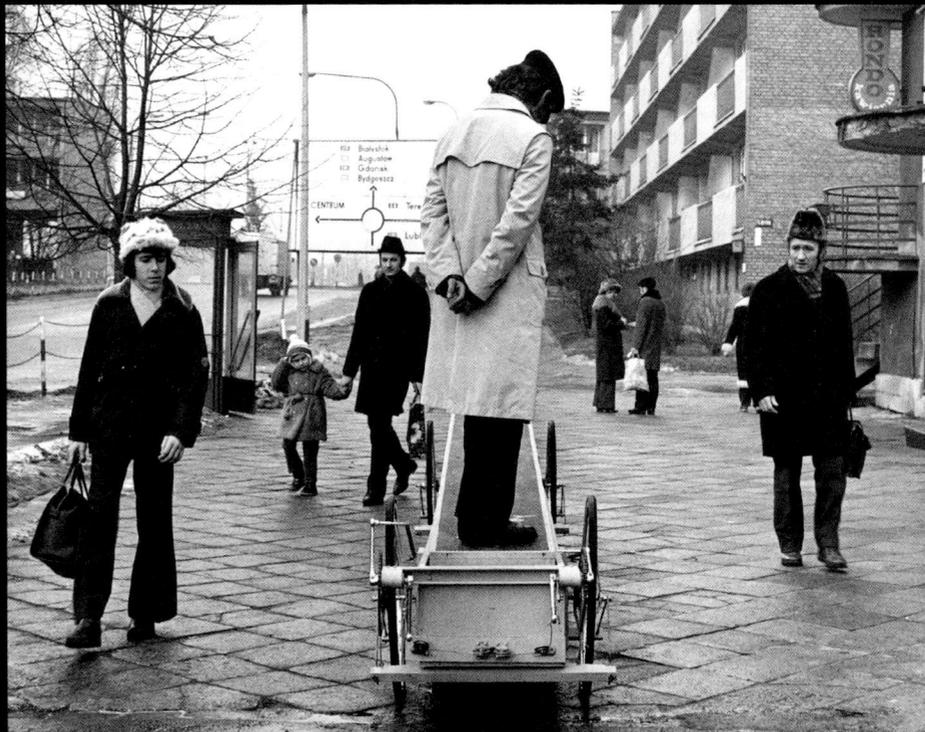

1.1 Krzysztof Wodiczko's *Pojazd 1* (1971) in use by the artist on the streets of Warsaw.

Interrogative design is one such approach.

What Is Interrogative Design?

Interrogative design is a way of stimulating public discourse on topics that receive little attention through normal market forces. It spurs people to think through complex topics where traditional media and mainstream public education fail. Design projects influenced by this technique are formally unsettling, uncanny even, leaving their audiences in an unresolved state, provoking participation in further stages of meaning-making.

Interrogative design doesn't solve problems, it *produces questions*.

The originator of interrogative design, Krzysztof Wodiczko, trained as an industrial designer in communist Poland in the 1960s before his migration to Canada and then the

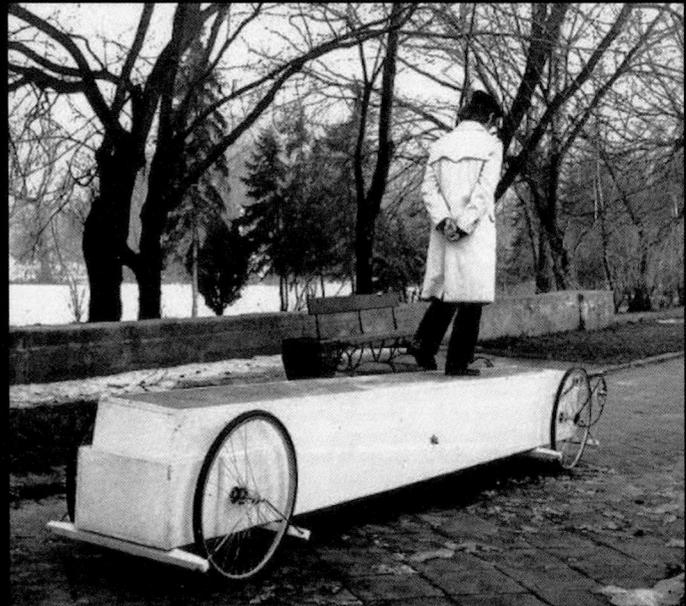

1.2 Krzysztof Wodiczko's *Pojazd 1* (1971), side view.

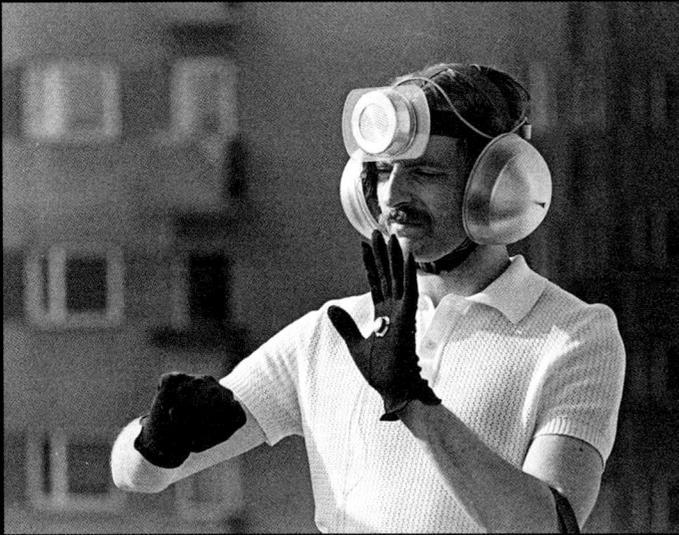

1.3 Krzysztof Wodiczko's *Personal Instrument* (1969) in use by the artist.

United States. His progression from commercial practitioner to artist and social commentator was shaped by a political environment that was highly averse to dissent, yet much in need of it. As a professional industrial designer at UNITRA in Warsaw, Wodiczko designed electronic products including, among other things, public address systems for use in offices and factories. One of his earliest works of interrogative design was the inclusion of a prominent off-switch for these systems, providing an uncommon freedom in totalitarian times.[16]

Outside of this professional context, his early artistic works included rhetorical vehicles such as *Pojazd 1* in which a single driver would pace back and forth on a platform, in contemplation, causing a tilting mechanism to transform the shifting weight into driving momentum. Only by pacing back and forth could the operator move forward. Such a non-statement was safe from censorship and yet sent a clear message about the potentially subversive act of free thought in a police state.

Wodiczko's political projects continued after his emigration, including one of his best-known works, *Homeless Vehicle*. On the surface, this project is an attempt to solve homelessness with a custom lightweight mobile home. In effect, however, it was an artwork that questioned the very conditions that give rise to homelessness. Its absurdity provoked inquisitiveness and focused protest, directing deeper attention to the topic.

As his approach to design evolved through further work, Wodiczko put his ideas to paper in a 1994 essay, "Interrogative Design." His thinking was also influenced by numerous artists and philosophers, notably Michel Foucault and Bertolt Brecht. The former explored the importance of *courageous* free speech to democratic life. The latter described a new form of theater that sought to jar its audiences out of hypnotic romantic storytelling through the techniques of *interruption* and *alienation*. Art, according to Brecht, should produce thought, not comfort. Wodiczko would later be influenced by Chantal Mouffe's writing about *agonism*. She asserts that thriving democracies require ongoing contention and oppositional encounters more than public deliberation and consensus-building (as Habermas and Rawls advocated). For Mouffe, disagreement is more important than harmony.

But interrogative design is also a material art. In Wodiczko's own words, interrogative design

> includes ... the performative use of specially designed communicative equipment. These projects' purpose is to inspire and assist the people who choose to take part in them to become present day parrhesiastes (free, fearless speakers) and social agents. By extension, the aim of these projects is to contribute to the process of animating the city as a site of agonistic public discourse and dynamic democratic process.[17]

The topics of fearless speech, the role of the city, agonistic discourse, performativity, and equipment design are all discussed in greater detail later in this book.

Interrogative design interrupts the public and provides them with new symbolic-cognitive tools. It focuses attention without resorting to PR tactics, exposing issues to vivid public debate. It also hopes for its own obsolescence.

> Interrogative design questions the very worlds of needs of which it is born. It responds interrogatively to the needs that should not, but unfortunately do, exist in the present "civilized" world. In the unacceptable world, interrogative design should present itself and be perceived as unacceptable.[18]

Various other design methodologies such as speculative design, design fiction, and design thinking also take an in-

3

The aim of interrogative design is to animate the city as a site of public discourse.

terest in similar issues. Much has been published on these topics in the last few years and many projects have been produced in these modes. Like interrogative design, these approaches operate at the interface of art and technology.

Interrogative design is a specific way of working. It operates within public space and makes use of participatory processes and performance techniques. It is interested in the production of questions and in creating conditions and spaces for questioning. Interrogative design promotes extended cooperative research. It opens spaces for new questions before the familiar rush to solution-making that designers are well known for.

A notable difference between interrogative design and speculative design is that it does not seek to imagine some potential future, but rather to reveal hard truths about the present. Reality and truth, although elusive, are nonetheless a central focus. Interrogative design also takes an approach to design that more actively inhabits public space and is more rooted in embodied performativity in the present moment than in imagining a future. These differences are further articulated in the sections of this book on "Public Space," "Theater," and "Realism."

Wodiczko explains,

> The word "interrogative" suggests seeking the truth and, by the virtue of appearing and functioning in public space, articulating and exposing truth such as the truth of the conditions of the existence and survival needs of the homeless and immigrants or war veterans. I am a bit disappointed by the proliferation of the use of the term "speculative." It is too liberal and shallow a word in time of deep issues that need to be addressed. ... Questioning means interrogating. Learning, looking with a magnifying glass, detecting, examining the hidden true facts.[19]

This leads to

> confronting, recognizing, and acknowledging the truth even if such truth is a composite of contradictions. A convergence of hate and love, freedom and confinement, desire and resentment or unneeded needs.[20]

Interrogative design offers a cultural instrument that brings to light uncomfortable truths and offers conditions for deeper reflection when so many problems of the present seem intractable.

It is a way of designing that takes a more collaborative approach to design than either speculative design or design fiction. The section on "Participation" goes into these ideas in detail. From Scandinavian cooperative design of the 1960s to IDEO's "design thinking" to more contemporary social justice research of Sasha Costanza-Chock, participatory design processes of all kinds are available to designers today. Interrogative design, too, has a particular way of looking at participation that is beneficial to designers and the communities they work with.

The question of what and how to design for social good is not simple. Interrogative design provides a specific set of design techniques at a time when options and possibilities proliferate. In this book you will find interrogative design's philosophical underpinnings and a synthesis of its source materials into a methodology for working critically on urgent topics. The book also contains select texts and projects of Wodiczko's along with the work of some of his students and colleagues. By using interrogative design's array of techniques (question-centered design, participation, public space, performance, realism, memory, prosthetics, ethical alertness), your own projects may benefit from this distinctive approach.

However, this is not a definitive work. Treat it as a starting point for your own conversation with these ideas. Make notes in the margin. Explore the book's "composite of contradictions." Make note of its disagreements with itself (such as Jaekyung Jung's comment that interrogative design serves established power structures, or Mark Jarzombek's criticism of the cultural discourse around trauma, or Sara Hendren's warnings on the use of prosthetics as a metaphor). Dog-ear the book. Redact it. Argue with it. Question it. Tear out sections you disagree with or tear out pages that are so important they deserve to live in another context. Glue in drawings or new pages. Interrogate interrogative design. Use this book to construct new potential. Use it to look optimistically toward a material world that is essentially unfinished.[21]

Interrogative design is an ongoing discourse, and, like Ernst Bloch's *concrete utopia*, is "a realm of real possibility."[22]

Interrogative Design

Krzysztof Wodiczko

Essay reprinted from *Critical Vehicles: Writings, Projects, Interviews* (Cambridge, MA: MIT Press, 1999)

- **Editor:** Ex-students, colleagues, and other commentators have provided marginal notes reflecting on material throughout this volume. This dialectical way of reading is easier when you focus on either the commentary or main text first.

- **Sung Ho Kim:** Interrogative design is not a dogmatic manifesto for contemporary design strategies, but a vehicle to generate voices for the people who have been silenced by our political and social regimes. The formation of this design practice emerges from collaboration with various talents in multiple disciplines that grant public awareness to marginalized individuals and cultures around the world.

 Interrogative design searches for opportunities to instigate a critical discourse within the social fabric of the everyday. This investigation becomes a generative tool for the design process and the motivating conceptual framework of projects.

 These projects also become valuable pedagogical mechanisms to demonstrate to the public that design is not all driven by commodity, but can be seen through the lens of social, cultural, technological, environmental, and political codes of human desires.

- **Ani Liu:** The essay brings to mind the e.e. cummings quote: "Always the beautiful answer who asks a more beautiful question." One of the effective things that interrogative design does is create discussion amongst a broad audience. In posing these questions through design, a multiplicity of voices and points of view can be represented, far vaster than if the designer had tried to originally "solve" the problem.

- **Warren Sack:** Adding notes in the margin initiates us into a relationship of *chavrusa*, of friendship, discussion, and debate around a shared text. The text itself becomes what Krzysztof calls a "critical mirror," even as he calls for us to design such mirrors. This text interrogates how we are to reflect on our own design work in conversation with others. We are asked to engage in a process of questioning the user's preconceptions and assumptions about others and the self—a Socratic line of questioning that inevitably circles back to interrogate the questioner. Interrogative design does not offer definitive solutions but rather the means to continue our discussions and to open our circles of conversation to others.

- **Sohin Hwang:** More than 25 years after this essay was written, interrogative design has significance in two ways. One is the role of the question in art, which makes sure the artistic process should promise and come with a form of discovery, whether it is a discovery of solutions and alternatives or of better questions. This not only walks away from the representational regime in art-making; it also questions any forms of teleological approach in art-making. The second way interrogative design has significance is that it reconciles the realm of the aesthetic and the realm of the sociopolitical without submitting the aesthetic to the sociopolitical. Rather it reclaims and rediscovers the territory of the ancient value of beauty where the good and the right and the beautiful used to be one, which has been missing under modernization and exploitative capitalism.

- **Mark Jarzombek:** Krzysztof Wodiczko's interrogative design is not just a theory that governs much of his work, but the title of a workshop that Wodiczko hosted for several years in the early 2000s at MIT. The focus of the workshop was for participants to learn to "break their silence in order to interrupt the world around them in an empowered critical voice."[1] In other words, interrogative design was not about artists speaking "about" the world, but artists overcoming the structures of silence that operate on all of us, both at the normative and political levels. The task of the student as future artist was to learn to "speak" in ways that the rest of us cannot, and translated that effort into a world view that understands the difficulty of speech for those who are even less empowered. Wodiczko emphasized the long lineage of such resistance movements in the modern age, but he wanted in particular to focus on the social construction, artifice, and downright difficulty and infirmity of speech in relationship to governing hegemonies. "Speech" could, of course, come out in different ways. But it was for him a type of bottleneck that was both theoretical and powerfully ontological.

Interrogative Design (1994)

Interrogative: 1. Of, pertaining to, or of the nature of questioning; having the form or force of a question. 2. Of a word or form employed in asking questions.

Design as a research proposal and implementation can be called interrogative when it takes a risk, explores, articulates, and responds to the questionable conditions of life in today's world, and does so in a questioning manner. Interrogative design questions the very world of needs of which it is born. It must respond with a double urgency to such a world. First, it should function as an emergency aid in the process of survival, resistance, and the healing of social, psychological, and physical wounds. Second, it needs to increase and sustain the high level of ethical alertness that creates, in the words of Benjamin, a state of emergency understood not as an exception but as an everyday ethical condition, an ongoing motivation for critical judgment toward the present and past to secure a vision for a better future.

Instead of deconstructing itself, design should deconstruct life. Design should unmask and uncover our singular and plural lives, our lived experience, and a history of this experience from the panopticon of our subjectivity and ideological theater of our culture, no matter how unacceptable and repressed or neglected such experiences may be.

Design must articulate and inspire communication of real, often difficult lived-through experience, rather than operate as a substitute for it (i.e., the kitsch of Sharper Image design). The experience and its history are the often invisible and seemingly unimaginable complexes of problems, internal and external, that have been quickly covered up by the naive facades of all design "solutions" to these problems, and more recently by melancholic "deconstruction" of the design heritage of such cover-ups.

Design must put in doubt its search for all such often well-intended design solutions or self-deconstructions, to open the way to explore, discover, uncover, and expose the hidden dimensions of lived experience. Doing so, design as a practice must acknowledge this experience as a history of resistance to the conditions of life and a history of one's destabilized identity in the process of often enforced reconfiguration.

A history, being a critical structure of experience, is a recollection of the lived events of the past infused with the criticism of the present.

Interrogative design must create the points and spaces of convergence for a multitude of internal and external enquiries to such experience and its history.

Design of any object, space, place, network, or system must become a tech-

17 nology and a technique of constructing an artifice that would function as an opening through which a complexity of the lived experience can be recalled, memorized, translated, transmitted, perceived, and exchanged in a discursive and performative manner. Design must not hesitate to respond to the needs that should not, but unfortunately do, exist.

Designers must work *in* the world rather than "about" or "upon" it. In an unacceptable and contradictory world, responsive and responsible design must appear as an unacceptable and contradictory "solution." It must critically explore and reveal often painful life experience rather than camouflage such experience by administering the painkillers of optimistic design fantasies. The appearance of interrogative design may "attract while scandalizing"—it must attract attention in order to scandalize the conditions of which it is born. Implicit in this design's temporary character is a demand and hope that its function will become obsolete.

The oldest and most common reference to this kind of design is the bandage. A bandage covers and treats a wound while at the same time exposing its presence, signifying both the experience of pain and the hope of recovery. Is it possible to further develop such a bandage as equipment that will communicate, interrogate, and articulate the circumstances and the experience of the injury, provoking so as to prevent its recurrence?

The proposed design should not be conceived as a symbolic representation but as a performative articulation. It should not "represent" (frame iconically) the survivor or the vanquished, nor should it "stand in" or "speak for" them. It should be developed *with* them and it should be based on a critical inquiry into the conditions that produced the crisis. Interrogative design can also function as a critical mirror questioning the user's preconceptions and assumptions about others and about the self. The equipment can reinterpret various existing materials and components, like protective clothing, portable tools, electronic gear, defensive armor or weaponry, prosthetic components, wearable digital equipment, alert devices, shields, or a combination of these. One of the objectives of the design is to extend the use of the media of communication to those who have no access to them but who need them the most, and to those who have full access to them but who fail to take critical advantage of them.

Originally published in a slightly different version as "Projektowanie i doświadczenie," in *Krzysztof Wodiczko, Sztuka Publiczna* (Warsaw: Centrum Sztuki Wspoczesnej, 1995), p. 29.

- **Ben Wood:** For most artists their head is their studio, where ideas incubate and get assembled. A city is a very energetic and engaging place in which to assemble work. The interrogative approach, rather than being centered within the traditional venue of the "monastic" art studio, is situated mostly in the city. It looks at the very edifices, symbols, monuments, and components of the urban core, using the power of critical design to propose new design forms and methods. It revives static histories, passionate discursive processes, inclusive works of public memory, and unforeseen futures.

- **Garnet Hertz:** This essay tramples all distinctions between art and design, jumping straight into the idea that artists are designers. It leaps into the task at hand—which seems more important anyhow—that studio work needs to work against the "painkillers of optimistic design fantasies." Still, over a quarter century after it was published, this is one of the best two-page summaries of how critical design practice works.

- **Sampson Wong:** To me, the most intriguing phrase in the piece is "attract while scandalizing." It feels like words I wanted to utter but have never been able to do so.

- **Orkan Telhan:** This essay's importance lies in its capacity to transform the idea of utility and function in design.

 The "bandage," as KW brings up, certainly originates to cover a wound. But through interrogative design now we can use the bandage as a critical tool that can also make us think about who the wounded is, who the oppressor is, and who benefits from a "cover-up."

 It gives the designer the responsibility to propose a solution to "bleeding" out blood, but also the chance to socially, culturally, or politically empower the wounded so that they can act or react against the causes of their suffering.

- **Dana Gordon:** This bandage metaphor is presented as the most common reference, yet I find it extremely valuable. In its clear image are tightly folded both the deep personal understanding of pain as well as the external indication of it, which is read and interpreted by culture—this side is the fascinating one, the public mirror of the subject. As architects and designers, we are trained to search for these points of empathy. The bandage is a familiar mark that we perceive and interpret. In a way, it points out the existence of a diagnosed pain. How can we create bandages that may facilitate an additional exposure? How can we discuss the wound and protect it at the same time? What type of a designed entity can simultaneously nurture and expose?

- **Ani Liu:** I think this is also another unique strength that differentiates interrogative design from traditional design; it is a platform through which ideas can flow, transcending the nature of "static" representation.

- **James Shen:** The concept of working "in the world" through interrogative design has been particularly influential to me. In order to reveal truth, design must be embedded in everyday life. However, in order to achieve a critical function, it is necessary for the work to be distinguishable from the banal in a way that invites public participation. The design may seem foreign, but its use and its relationship to the public must come naturally. The intervention can in this way engender a generosity from the participant, a willingness to exposing vulnerabilities to the public in an open conversation that can truly heal. The significance of the design is the result of public participation in the context of everyday life.

- **Robert Ochshorn:** While Krzysztof's projects can be emotional to produce or observe, the emotions are not the subject of the work. Rather, project participants often show emotions precisely as they grasp and articulate structural understanding. The projects are proposed as relations of part to whole, of individual to society. They validate and support the ability of those most adversely affected to address their city from an extended first-person perspective.

- **Jaekyung Jung:** I think that creating a situation that challenges and interrogates the firm beliefs rooted in the old city that we no longer question because we are so familiar with it is in line with the core notion of the interrogative design. However, we must remember that it is very dangerous to question the history and order of the victors that are built on victimized peoples and that reject all questions and doubts. Then, how is it possible to maintain the critical imagination and spirit that can gaze at the reality of life without settling for the familiar senses buried in the memory of the city? Thinking about the answer to this question may help us understand what interrogative design is about; of course, the answer to this question will be different for everyone.

 My answer is that interrogative design does not serve to maintain order that solidifies the interests of a specific group by linking the spirit constituting the sense of order or design matter to superficial aesthetics or decorative rhetoric. Unlike this approach, it connects design thinking to the question of ethics, a borderless exploration of the nature and condition of human life. The situation that interrogative design serves solidifies the given order of social, economic, political, and cultural memory and inevitably produces the lives of strangers who must be located on the imagined periphery of the order. Indeed, the produced strangers include the designer himself or herself who served to strengthen the order.

Homeless Vehicle

Krzysztof Wodiczko

1988

- **Editor:** *Homeless Vehicle* is a prototypical work of interrogative design and a remarkable event in art and design history—both an earnest response to New York's homelessness problem and a provocation for more just solutions.

 The project involved a participatory design process with the itinerant inhabitants of New York. Working together with Wodiczko, they invented a vehicle that addressed their key concerns: mobility, privacy, security, and hygiene. With a nod to the typology of shopping carts, the Vehicle is both familiar and uncanny. Futuristic, yet rooted in the present.

 It became a practical tool, a public injunction, and a discursive vehicle. It interrupted public space and called attention to the normally visibly invisible problem of homelessness, while giving its inhabitants a medium for speaking with the public about their lives and needs. The vehicle prompted the question "What is this?" much as novel consumer products elicit interest and conversations among random people. The unwritten rules of consumer culture allow for the breaking of unwritten social engagement taboos. This strange vehicle enabled encounters between homeless people and the public that would not have happened otherwise.

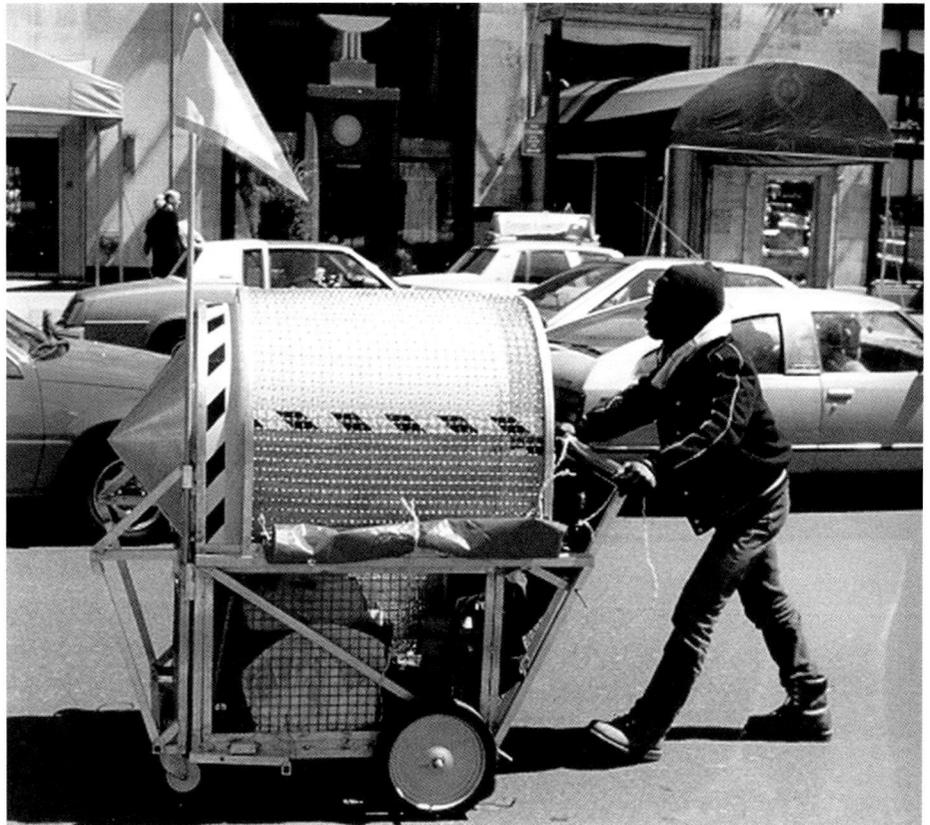

1.4 Krzysztof Wodiczko's *Homeless Vehicle* (1988).

- **Sofia Ponte:** One of the main activities that occupied a segment of the homeless community in New York was related to the New York State Returnable Container Law, implemented in 1982, which required US supermarkets to refund five cents to consumers for returning a can or bottle. The *Homeless Vehicle* is a military-looking artwork consisting of an articulated vehicle made of metal, aluminum, steel mesh, and Plexiglas to be driven by a homeless person who collects, groups, and returns bottles and cans to commercial establishments in exchange for their deposit value.

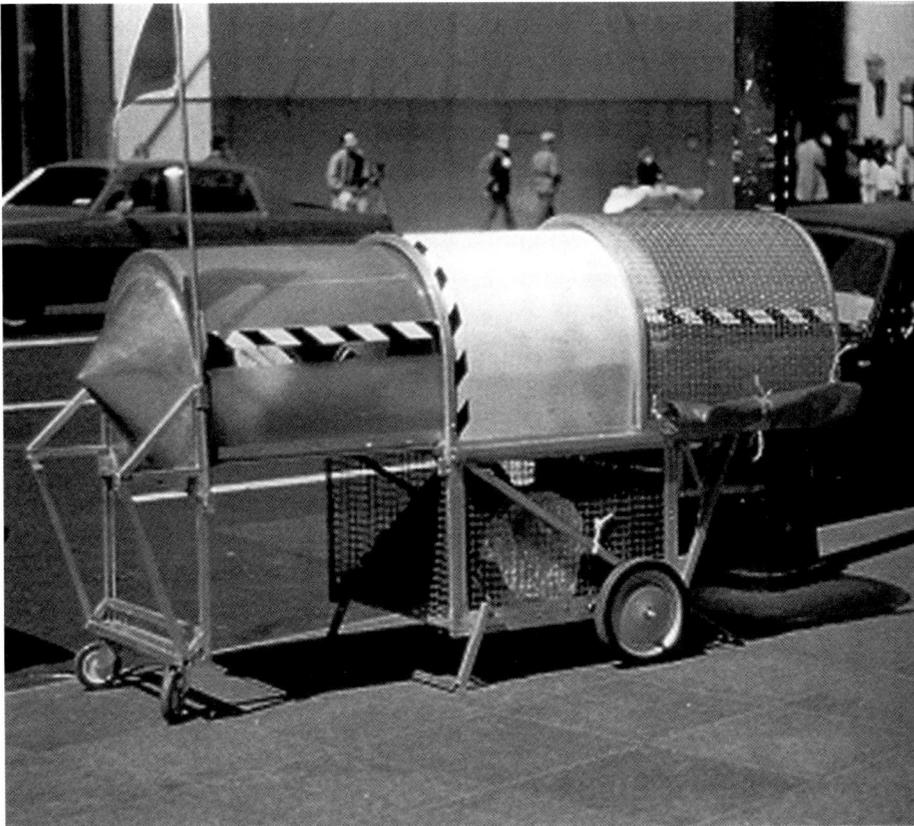

1.5 *Homeless Vehicle* (1988), expanded view.

• **Natalia Romik**: Star architects, even if they pretend to look for other tactics (fields or breakthroughs), have their hands tied too tightly by real estate capital to be able to sustainably mediate between different modes of action. They adopt the bird's-eye view of financial flows as a natural one, hovering too high above a metropolis to speak with its citizens. In contrast, nomadic architecture, like the *Homeless Vehicle*, approaches the issue of homelessness from below (beneath), utilizing the participatory tools of art to engage contemporary nomads at every stage of the process. The dedication to progressive transformation is a historical constant of nomadic projects, in both architecture and art. Lightness, transience, practicality are modalities of many nomadic projects today (see my project *Nomadic Shtetl Archive*). They are purposefully antimonumental, despising capitalist ossifications of FIRE industries [finance, insurance, and real estate] that entomb social space as real estate. They are animated by the nomadic flows in a dialectic manner—reclaiming people's freedom of movement while challenging the mobility of capital.

• **Sofia Ponte**: Krzysztof Wodiczko's interrogative design concept offers an anti-aesthetic dimension by transforming a familiar situation into an uncanny one. It is as important for *Homeless Vehicle* to be used as a means of storage and transportation of belongings, cans, and bottles as it is to serve as a personal shelter.

According to Wodiczko, four prototypes slightly different from each other were put into circulation in New York, more precisely in the areas of City Hall Park and the areas adjacent to the Criminal Court building, City Hall, Wall Street, Battery Park, Tompkins Square Park, Central Park, Grand Army Plaza, Fifth Avenue, Trump Tower, Greenpoint Park, Washington Square Park, and Broadway-Lafayette.[3]

• **James Shen**: The *Homeless Vehicle* was designed to stimulate conversation around homelessness. But it was also designed to address practical concerns such as providing a safe place, a place to rest and to wash up. Because of this, some observers interpreted the design as a proposed solution. I think this led Krzysztof's later projects to focus more on communication and public discussion rather than addressing more mundane concerns.

1.6 *Drawing for Homeless Vehicle* (1988), ink and white correction fluid on paper 19 x 24.1 inches.

- **James Shen**: I believe the *Homeless Vehicle* may have been the first project of Krzysztof's that was not operated by himself and involved a collaborative process with a specific community. He used sketches as conversation starters with homeless people he met in different cities. Their contribution can be seen in his shift from dealing with privacy issues in early sketches to concerns for safety in the final version.

- **Sofia Ponte**: Since 1987, the US government has defined homelessness as people who sleep in collective public shelters or in places that are not meant to be inhabited, such as cars, abandoned buildings, open air places, and transport stations.[4]

- **Editor**: The *Philadelphia Inquirer*, in grouping *Homeless Vehicle* with John Malpede's *Los Angeles Poverty Department*, reveals a misunderstanding of how both projects operate. Neither project is a "depiction" of homelessness. These are not representational projects, but operational ones. They are media for homeless people to communicate their experiences to the public who would otherwise not see or hear them. Conventional wisdom suggests that artists may only provide "statements" or "solutions." In the less conventional option artists provide discursive space—a cognitive context—while viewers and "operators" supply the thinking.

1.7 Press coverage in the *Philadelphia Inquirer* (November 2, 1989).

1.8 Press coverage in the *Wall Street Journal* (April 4, 1989).

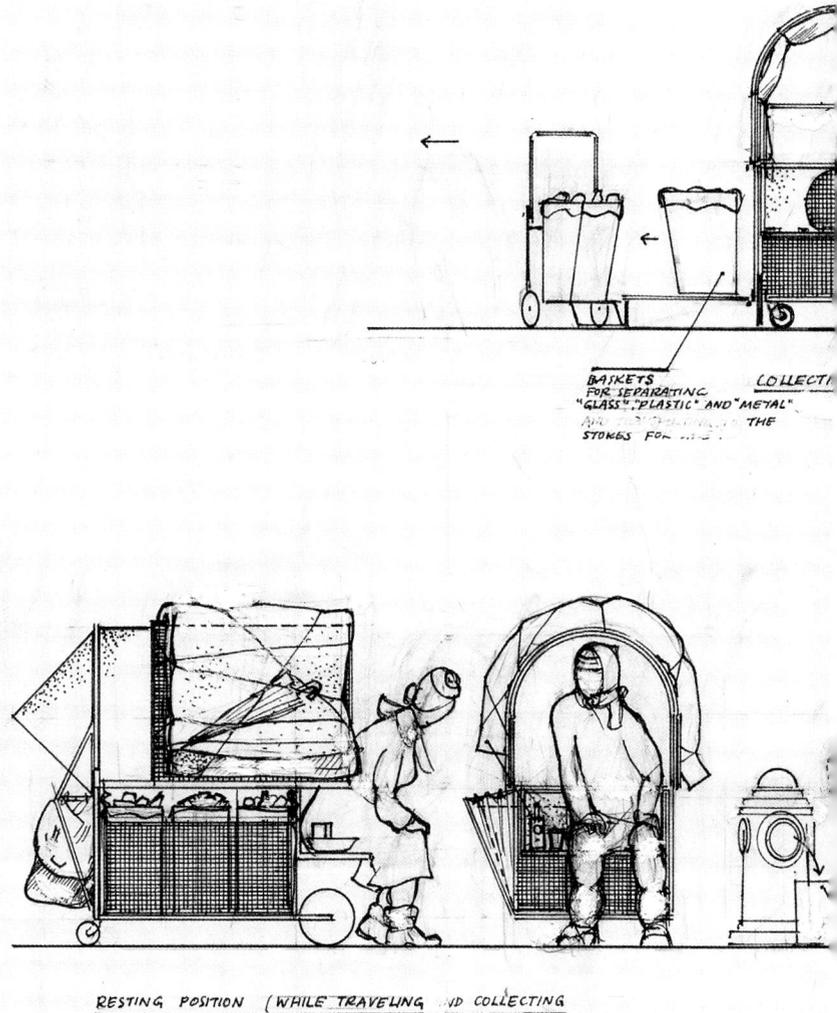

BASKETS FOR SEPARATING "GLASS" "PLASTIC" AND "METAL" ... THE STOKES FOR ...

RESTING POSITION (WHILE TRAVELING AND COLLECTING

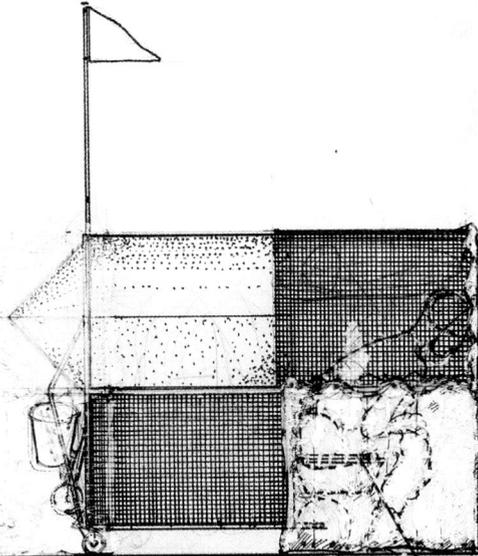

TOILET POSITION

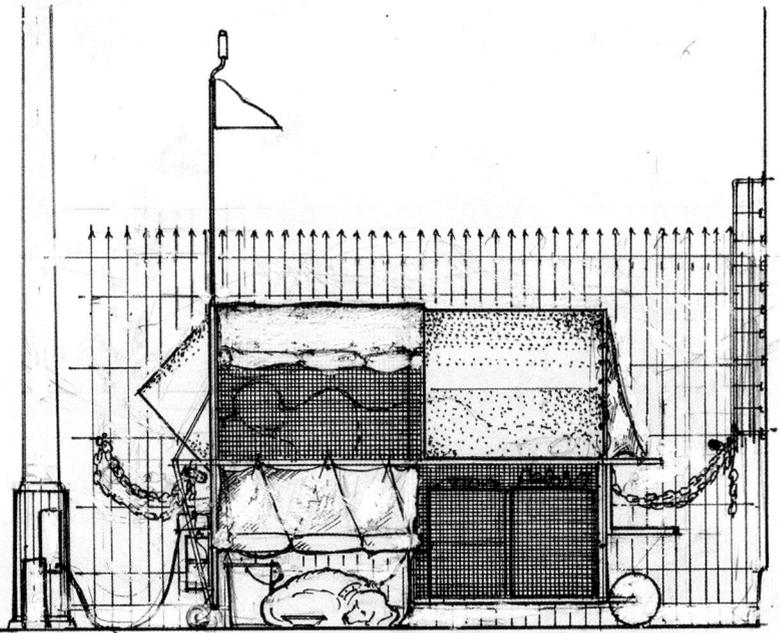

TOILET UP

HANDLE / SEAT / STEP
IN TOILET POSITION
(TOILED DESK DOWN)
PLASTIC CURTAIN DOWN

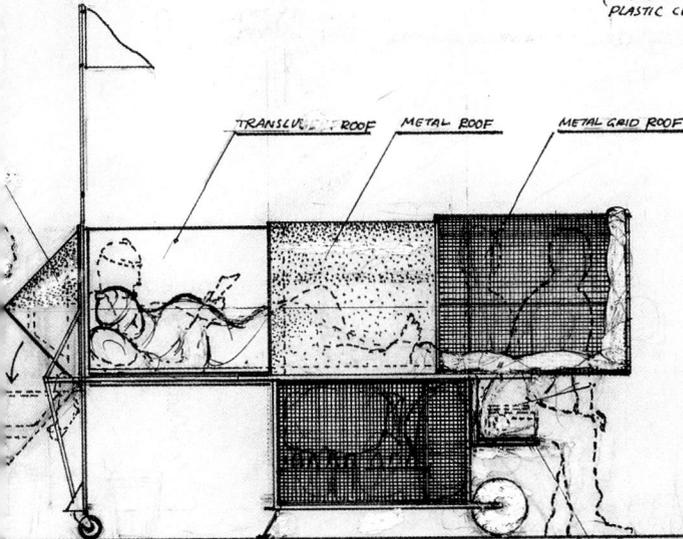

SLEEPING POSITION (NIGHT)
METAL GRID OVER TRANSLU___,
SECURITY FLUSHING LIGHT INSTALLED, VEHICLE CHAINED

TRANSLU___ ROOF METAL ROOF METAL GRID ROOF

WASHING SLEEPING _____ POSITION (DAY)
METAL NOSE OPERATES AS EMERGENCY EXIT,
STORAGE FOR BASIN AND OTHER OBJECTS AND TOOLS, WHEN OPEN AS
BASE FOR BASIN WHILE WASHING, AND BARBECUE KITCHEN.

HANDLE / SEAT / STEP
IN SEATING POSITION

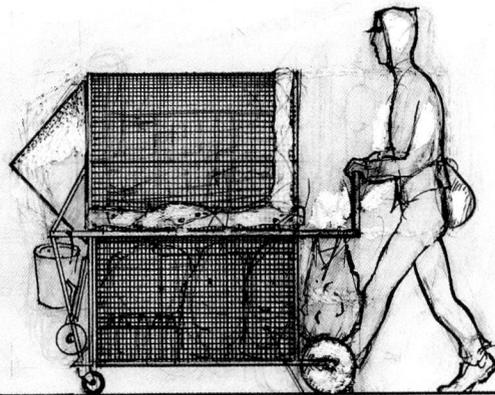

TRAVELING POSITION

CONTAINER FOR COLLECTED BOTTLES
AND OTHER RE-SALABLE OBJECTS

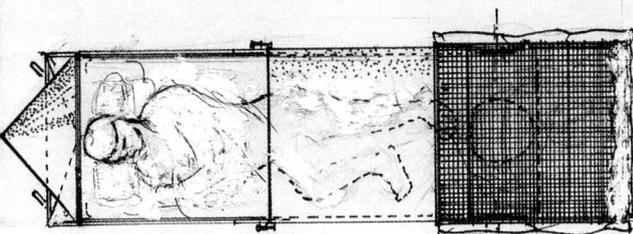

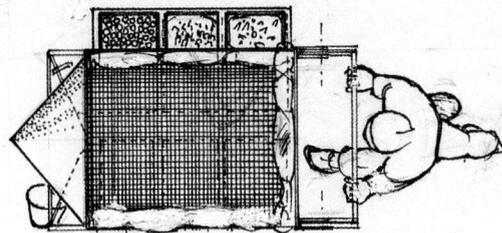

Depicting the destitute

For these actors, homelessness is no role — it's dark reality.

By Stephan Salisbury
Inquirer Staff Writer

The Biggest Chump in America, fresh from Los Angeles, serenely surveys the scene. A mugging is being re-enacted in front of him. It turns increasingly violent.

Mychael Lee-Starr, sporting black fur coat; red, pink and purple bandannas; buckskin boots; red nylon sweat pants; blue sweater, and red tie, fights off Henry "T" Williams and Keith Crawley.

Several people standing near the action scramble away as Lee-Starr goes down in a wild flurry of arms and legs. He lands with a *wham.*

"You're going to get hurt somebody mug you," says Crawley, shaking his head and turning Lee-Starr and his tousled fur coat loose. "You fight too hard, they going to bust you up and let you know. We playing, Mychael, but the real deal, they bust you up."

The *real deal,* that's what interests the Chump, who actually is John Malpede, founder and artistic director of the award-winning Los Angeles Poverty Department, or LAPD, one of the most unusual performance groups in the country. Formed in 1985, it is composed of people straight from the bottom of L.A.'s Skid Row, straight from what Malpede calls "the biggest, baddest" skid row in the country.

They have been in Philadelphia for a little

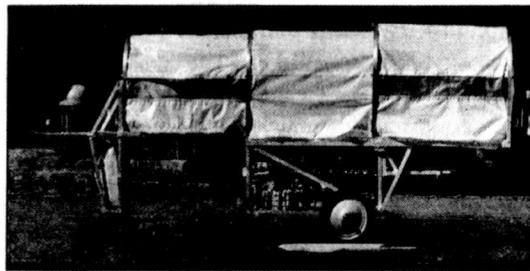

(See LAPD on 4-C)

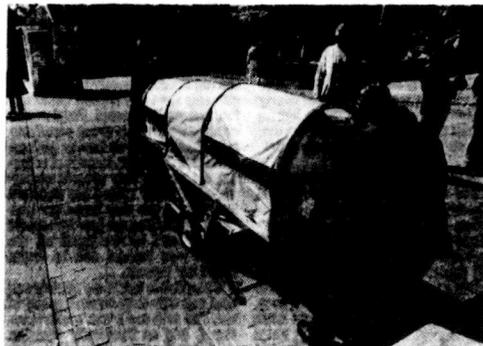

The Philadelphia Inquirer / GREG LANIER

"Homeless Vehicle" will be on view at the conference "Voices of Dissent: The Arts of Social Change."

Artist Krzysztof Wodiczko, creator of the cart, says it is a tool that makes the homeless visible figures on the urban landscape.

Call it cart art: Here's a vehicle that's symbolic — and useful.

By Stephan Salisbury
Inquirer Staff Writer

Public monuments lend public space the illusion of permanence and stability.

Even when the identity of some great bronze horseman in a park has faded into anonymity, the generic form of horse and rider speaks of triumph and service and social continuity. Even when the form of a monument rising in the midst of a building plaza is abstract, its large scale is testimony to public or corporate power and stability.

Such are the monuments of the stout burghers and the governing classes — solid, big, secure, even in whimsy.

What, then, to make of a mobile, expandable missile, an aluminum gazebo designed as a "monument" to the dispossessed, as architecture for the evicted, as a warning and a threat?

It depends on who you are and what circumstances you find yourself in.

For Krzysztof Wodiczko's *Homeless Vehicle,* a glorified shopping cart in more ways than one, rolls right to the heart of contemporary urban experience, raising large and disturbing questions about the nature of the city and the people in it.

An exhibition including a prototype of the vehicle, plus photographs of it in action by Joseph Sorrentino and Harvey Finkel, opens tomorrow with a reception for Wodiczko from 5 to 7:30 p.m. at the Painted Bride Art Center, 230 Vine St.; the show runs through Nov. 26. (The exhibition was curated by Julie Courtney and is part of a three-day conference, "Voices of Dissent: The Arts of Social Change.")

The *Homeless Vehicle* is a large cart on wheels, with a receptacle for collecting recyclable bottles and cans and a small, covered platform that can be extended for sleeping. The bow consists of a nose cone that drops down and can be used for storing personal items. And the whole is perched on a sturdy set of wheels so that it can be pushed over long distances

(See "VEHICLE" on 4-C)

A cart for the homeless is symbolic — and useful

"VEHICLE," from 1-C

on rough city streets in the never-ending search for saleable debris.

Its utilitarian functions are simple enough — the vehicle facilitates scavenging and also can be used as emergency shelter. Symbolic functions are more complex.

Covered in bright orange fabric and pushed by a collector, the vehicle makes a striking impact on the monochromatic cityscape. It seems almost a jerry-rigged projectile, a weapon for the homeless. The shape is no accident.

"It is a weapon because it is a tool of resistance," said Wodiczko, 46, a Polish-born artist with a detached and ironic presence. "Between a tool and a weapon, the borderline is not very clear. Tool becomes weapon no matter what kind of shape it has. ... It is a weapon when it's mobile, when it moves, because it acts against the separation of homeless individuals from processes that take place in the city."

The vehicle is a tool that makes the homeless visible figures on the urban landscape, Wodiczko said. When cart and collector turn up in sedate city squares or outside corporate towers, they symbolically comment upon those "citadels of gentrification," creating "a dialogue."

For a couple of days last month, the artist set up a dialogue here, testing the vehicle, which he developed in New York. He had been concerned because, unlike in New York City, there is no law in Philadelphia mandating recycling of bottles and cans.

A visit to a few of the city's recycling centers, however, convinced him that scavenging is very much a part of the local shadow economy. At the National Temple Recycling Center in North Philadelphia, he ran into Vanessa Brown, who proved an invaluable guide to the city's streets. Not

homeless herself, Brown was more than familiar with the chronic problems of homelessness, eviction, joblessness and housing dilapidation. She instantly knew what the vehicle was for, immediately began advising Wodiczko on design improvements and helped demonstrate it for him in her own neighborhood and downtown.

Out on the city streets, a difficult question became crystal clear: Is the vehicle intended as a symbolic, political statement on the homeless, or is it a genuine attempt to find a useful way to alleviate their plight?

The answer, Wodiczko said, is both.

On the one hand, his elaborate cart is an ironic comment on the destructive and ruined state of the city. It certainly isn't intended as a "solution" to homelessness.

On the other hand, in two days on the streets here, he met many destitute people who asked how to get one. *They* saw it as a solution.

"I think that for many of them who talked to us, it would be better than what they have now," Wodiczko said. "But I don't think they would say this is a solution to the homeless."

There are two broad purposes for the vehicle, he said: "One is to make the situation a little better and make this useful in some way, so they can exist in the city, and to make some trouble for non-homeless," he said.

(For the moment, there are only two versions of the vehicle, and the New York-based artist says there is no funding for any more. He is, however, considering the possibility of setting up workshops where homeless people could build more of them cheaply.)

Near 10th Street and Indiana Avenue, a deteriorated area that Vanessa Brown called "New York City," several people gathered around.

"What's that?" one man asked.

"It's for the homeless," Brown replied. "You can sleep in it. You can put your stuff down here. You can break it down." She showed how the vehicle could be expanded and stabilized.

"You homeless?" she asked the man.

"Yeah," he said, walking away. "With all those abandoned houses, who needs it?"

"Fleas in those houses," Brown shouted.

"You need a lot more of them," another man said, peering inside the vehicle. "Like a commune or something."

"That's what I told the man," said Brown, pointing at Wodiczko.

"Otherwise, someone will just come along and punch a hole in it for no reason," the man said, jabbing at the orange fabric. "I'm serious."

At City Hall, the vehicle attracted considerable attention parked above Dilworth Plaza. One man came along, tears in his eyes. "Thank you, thank you," he said to Wodiczko, who seemed a little uncomfortable. "Me and my brother live in a box over there. We need something like this real bad."

Many people came up and dropped coins in the nose cone, which Brown had conveniently left open. "Now we know what that's for," Wodiczko said. "I am still learning about this vehicle."

At Rittenhouse Square the next day, Brown attracted quite a lunchtime crowd. Three businessmen in dark suits watched her from a distance and talked among themselves.

"What is it?" said one. "It's gotta be for bums. This is the '89 model, isn't it? The '90 model is due in a month."

"No choice of colors," said his friend.

"That was the one thing a lot of people complained about this year," said the first man. "I want to know, does it take bottles?"

"Only cans," said a third man.

"Now I know what it is," said the first. "It's a magic trick. It's to convert those cans into crack."

"No," said the second. "There's a bum inside and they're gonna cut him in half."

"He goes inside the can," said the first.

"You put him in the top," said the second, "cut him in half and he comes out in a can. It converts bums into cans."

"Then you take him over to Camden," said the third man.

They all laughed and walked away. Meanwhile, Brown was intent on proselytizing for the vehicle.

"It's easy to handle," she told an inquisitive woman. "It holds a lot. And at night they can sleep on it. It's a very good idea. You get a lot of negative attitudes from people when they see it and a lot of positive. The negative comes from people who are not homeless. To the homeless, this is not junk. You might have someone out there who needs one of these."

The vehicle would not be appropriate for all homeless people, Wodiczko said. It's designed for those who live by scavenging, a population much larger in New York than in Philadelphia, where so much ruined housing stock often makes squatting a useful alternative to street living.

"I don't even know the scope of the problem here because it's hidden much more than in New York," he said.

If the homeless are more "hidden" in Philadelphia than in New York, as Wodiczko believes, why is it that they have prompted such an increasingly thunderous response from civic-minded groups? Wodiczko does not claim to have an answer, but he has some provocative theories. He argues,

for instance, that the contemporary homeless are a class of urban nomads, eliciting the same primal fears that nomadic peoples always do within settled societies.

"To some degree those people are nomads in historic ways," he said. "But the context is completely different. They are born of transformation of the city. They are coming from the city itself, not from the outside."

"The city is now carved in such way that it creates citadels within itself — the real-estate citadels," he continued. "So people are being expelled from those citadels and they create nomadic habitats or communities. And that becomes a threat to gentrified areas. It means that the contemporary nomad ... will always be on the edge of everything and will be in conflict with everyone."

"No matter how vehicle is designed, by the fact that there is a vehicle already poses a threat because of mobility and ability to penetrate different areas. Appear. Disappear. Reappear. A certain frightening overwhelming presence that only nomads can create."

In Wodiczko's view, however, there is actually no "solution" to the plight of the homeless. Rather, "they are products of the city under transformation."

"It's not something that is a side-effect," he said. "In fact, the homeless are a necessary part of this process. It's like unemployment is a part of the economy. The homeless are an important part of ... middle-class housing."

Gentrification inevitably leads to a certain level of dislocation, even homelessness, Wodiczko said. "Unfortunately that's the case and unfortunately no one wants to see it this way."

Where does the vehicle fit into this?

"This is a non-solution project," he said.

The Philadelphia Inquirer / GREG LANIER

Wodiczko showing "Homeless Vehicle" in Rittenhouse Square.

Art as Advocacy: A 'Mobile Home' for the Homeless

By Julie Salamon

New York

Life in the half-gentrified Lower East Side oasis known as Tompkins Square seems like a surreal social experiment. About 150 people sleep in the park here day and night, all year round. They mingle uneasily with other locals, drug dealers and artists, and people who model themselves after Hell's Angels (who could fall into either of the two previous categories). Stockbrokers and lawyers also live in the neighborhood, apparently finding the daily experience of slum chic worth the $450,000 they've been known to pay for a refurbished tenement apartment.

Soup lines form at the edge of the park on Saturdays, just a block away from burned out buildings and the same distance, physically, from Bernard's, where an organic French meal for two, featuring smoked pheasant and monkfish, can easily run $70. When the restaurant first opened, the owner frosted the windows to insulate customers from the desolation outside.

As if all this weren't enough, a crew of Canadian film makers decided to throw something else into the mix one recent Saturday: Krzysztof Wodiczko and his Homeless Vehicle.

Mr. Wodiczko is an artist and a philosopher, a Polish refugee with a Canadian passport who lives in New York. He has acquired his measure of fame in the art world by taking high-powered slide projectors and flashing giant images onto public monuments. You could say that much of his art isn't a thing so much as a happening.

For example, in 1985, he beamed a giant swastika onto the facade of the South African embassy in London's Trafalgar Square. In 1987 he projected the image of a praying figure wearing an oxygen mask onto the Martin Luther Church in Kassel, West Germany, an art center threatened by air pollution from the factories of Leipzig and Frankfurt.

Mr. Wodiczko's method is to provoke, to impose his work on the general public, on passers-by. But Mr. Wodiczko is a considerate provoker; after a few hours he removes his creations simply by unplugging his projector.

It wasn't always so. Back in Poland he built art that was designed to last. Specifically, he built vehicles. He was no Lee Iacocca. His vehicles weren't meant to take people from here to there. They were conceptual protests against totalitarianism. A "worker vehicle," for example, resembled a speaker's podium on wheels; this motorized contraption could move in only one direction, leaving the driver helpless to set his own course.

After emigrating to Canada in 1977, Mr. Wodiczko confronted his new, more benign environment with the projections. But now he has found something suited to vehicular protest: the economic conditions and political conditions that have propagated New York's vast population of homeless people.

So he built a heavy rectangular cage of Plexiglas and steel mesh, with a sheet-metal and aluminum base, sitting on four sturdy wheels. In this form, the Homeless Vehicle is a useful and easily portable container for bottles and cans or personal belongings. However, it can be extended until it resembles a missile and can serve as a kind of mobile home, complete with wash basin tucked into the nose cone.

Mr. Wodiczko doesn't really expect or want the city's parks to turn into giant parking lots, filled with homeless people stretched out in mass-produced versions of his Plexi cylinders. He built his prototype last year as commentary on the city's inability to house its dispossessed. The city responded not by building low-income housing but by putting Mr. Wodiczko's work on display last year at the Clocktower, a municipally owned art gallery.

And that's more or less where the Canadian film crew came in. Derek May works for the officially funded Canadian Film Board as, as he puts it, "a salaried cineaste." He specializes in documentaries on the arts; his most recent work was a piece on Eskimo art.

Mr. May became interested in Mr. Wodiczko, he says, because of the artist's view of "public art as a social catalyst, not necessarily something that promotes the artist as a desirable social object." The Film Board gave him $250,000 to complete the hourlong documentary, which is being shot on location in New York and Montreal.

Mr. May wanted to see how real homeless people might react to Mr. Wodiczko's creation. So he invited Mr. Wodiczko to bring his Homeless Vehicle to Tompkins Square one recent Saturday afternoon. Luckily, Mr. Wodiczko arrived late, after police had cleared the park following a bomb scare and then declared it safe.

As the artist unloaded the vehicle from the back of a green pickup truck, Norman Sizer, one of the park's people, came over to watch. Waving a bottle of Thunderbird wine, Mr. Sizer asked the film makers to take his picture. Somebody asked him what he thought of the vehicle. He looked at it and wrinkled his nose. "That ain't

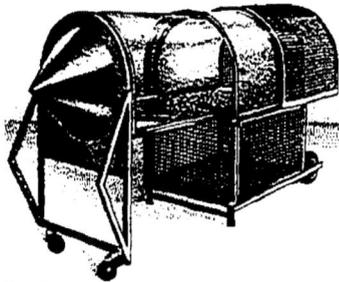

The Homeless Vehicle

nothin'," he said. "What am I going to do with that in the park?"

No one else paid much attention as Mr. Wodiczko wheeled his vehicle into the middle of the park, without creating a stir. It takes something a great deal more bizarre than a conceptual artist and a film crew to attract a crowd in Tompkins Square Park, particularly on a cold and windy day.

Mr. Wodiczko was competing, after all, with the continuous drama being played out on the park's bandshell, about 25 feet away from where he parked his vehicle. Two men and two women seemed permanently encamped on the outdoor stage, which they'd outfitted with a couch and the trash barrel equivalent of a fireplace. "Get out of here," they shouted when the film crew came too close.

Mr. Wodiczko is a small man of 45, who was wearing a large parka, cuffed jeans, a ratty fur hat and a ponytail coming loose from its moorings. He is very approachable, with his bushy mustache and twin-

kling eyes, a friendly existentialist.

But there weren't many approa even though the film makers were of a $25 stipend to homeless people who talk to Mr. Wodiczko on film. From tance, a youngish man called Julius disdainfully of the whole enter "What's he doin'? Pretending he's less? The way Lucille Ball did?"

After being informed of Mr. Wodi purpose, Julius had this to say abou vehicle: "A homeless person wo want that. A homeless person who lost his mind wants to travel as lig possible. You gotta be like a tra Would he like to be in the film? "No he said. "I'm not permanently hom I'm just stuck a bit."

The film makers did find a subj man in a black-and-red jacket who ingly crawled into the vehicle on-ca for $25. The film makers almost lost man, however, when Nathanial Hunt came by.

Mr. Hunter, a senior park residen a salt-and-pepper beard and blazing eyes and an air of authority. "Dor them exploit you," he said to the m the black-and-red jacket. The man ig him. Disgusted, Mr. Hunter walked feet away and remarked to anyone cared to listen. "I know these guys ar ing to make an artistic little film b exploitation." He interrupted hir "Hey," he called over to the film ma "You guys got a permit?" (They d

Meanwhile, Mr. Wodiczko explaine philosophy to the camera. "I think are two forms of spleen among non-l less. One is to look at them as refu garbage, someone who belongs to the world. The second group, who I hate i identifies with the homeless. These n choly men who see the world as a hor place."

Two days later the film crew too Wodiczko and his vehicle down to the Financial District. There he attracte tention when he pushed the vehicle the plaza in front of the Marine Mi Bank skyscraper and parked in front other work of art, a giant red cub first, most of the attention came fro vendors selling pretzels, falafel sandw and soup out of carts parked by the ed the plaza. "I like that contraption," the pretzel lady. "It looks great," sai companion, the soup seller.

Soon they were joined by a cro teen-agers who screamed: "Michael son should try that out!" (Apparen has been reported that Michael Ja sleeps in a youth-preservation capsul resembles Mr. Wodiczko's Homeless cle.)

Then a man wearing a suit an laughed and asked if the artist had a keting plan yet.

Another businessman, wearing a coat, muttered to no one in partic "*You* want to buy a bed for the home Eh? Eh? I've seen everything."

The solution is not... cardboard shacks on wheels. The solution is real housing.

1.9 Eric Roth, executive director of the Bowery Mission homelessness response organization in New York City.

His reaction is also part of my project.... Of course the vehicle must be rejected.

1.10 Krzysztof Wodiczko responds.

• **Editor:** In a 1991 documentary by the National Film Board of Canada, homelessness prevention advocate Eric Roth responds to the project:

I find the concept offensive ... that such substandard housing should be institutionalized in some way and that we should consider housing people at that level as even a partial solution to homelessness. The solution is not cardboard shacks or cardboard shacks on wheels. The solution is real housing ... there are a lot of productive ways to do it that are not as attention-getting as designing a homeless vehicle for people to live in, but they are much more pragmatic and could very much impact the functionality of programs like this one in serving the homeless.[1]

Wodiczko:

All those things he is saying are true. In fact, I would be saying the same things. The problem is what he is not saying. My project is submerged in many doubts and uncertainties that I have. I think that his reaction is also part of my project. It is exactly the impossibility of this project and [the] horrifying absurdity that perhaps this kind of project is needed—not as a solution or temporary solution. The project itself, the design, articulates the situation further than the existing habitat that the evictees developed. [The project] exaggerates, pushes even further exactly to the point of very dark and frightening absurdity.

Of course, the vehicle must be rejected, and that is one of its purposes. In the process of being rejected it brings more information and confronts the non-homeless, provides the possibility for direct dialogue, discussion about the program of this vehicle. This vehicle is inconvenient, disturbing, for everyone, because it looks as if it is well-designed, and it looks as if this is the way it should be. And yet, at the same time, it is obvious that this is exactly what this should not be.

That's the contradiction that this vehicle proposes. That's the most disturbing aspect of it.[2]

• **Editor:** Homelessness is often considered a moral failing rather than a public health or urban planning issue, let alone as an individual's free choice to live outside nomadically. The current best practice in "solving" homelessness is a concept known as "housing first," which insists on the provision of secure housing before any support services.[5] Such approaches have been proved beneficial, but the forced housing of nomadic people can also be a form of cultural genocide. How can public health systems be deployed nondestructively?

Designs like *Homeless Vehicle* are not direct solutions, but second-degree gestures that set the stage for further discussions. Wodiczko created a platform that enabled Roth and others to speak about their approaches publicly.

Origins of *Homeless Vehicle*

Dan Borelli and Krzysztof Wodiczko

Excerpt of a conversation at the Harvard Graduate School of Design, March 1, 2022

Dan Borelli

How did you come to start to think of homelessness in the context of New York City as a designer?

Krzysztof Wodiczko

Well, when I arrived from Canada to the United States—actually from Toronto to New York City—to be shocked by what I was seeing. I quickly learned there were 100,000 homeless people in New York City. That's a result, in some ways, of the politics of Ronald Reagan, who basically supported all the privatization and gentrification as was going on at the time.

That also connected with the destruction of single-room-occupancy hotels, which were an important resource for very poor people. Homeless people as well, who could at least during the colder time in winter, for a very small amount of money, rent a small room. But halfway houses were also destroyed, practically by the lack of funding from the federal government.

So rapid transformation of the city connected with destruction of lots of housing. And they were replaced by more expensive ones, so people ended up on the street. People tried also to seek shelter in city-run shelter facilities, but they proved to be very dangerous for them because of diseases, violence, robbery. Most of those people who could not afford to rent chose to live in subways or on the streets. Because, well, safer for them.

My upbringing, professional upbringing, was industrial design. So naturally, instinctively almost, because that's the way I was taught to think, I decided I should try to design something for that situation. I quickly realized that this is not, of course, going to be a solution to the homeless crisis. There will be a different purpose for this design. It will need to respond to emergency needs, sure, provide

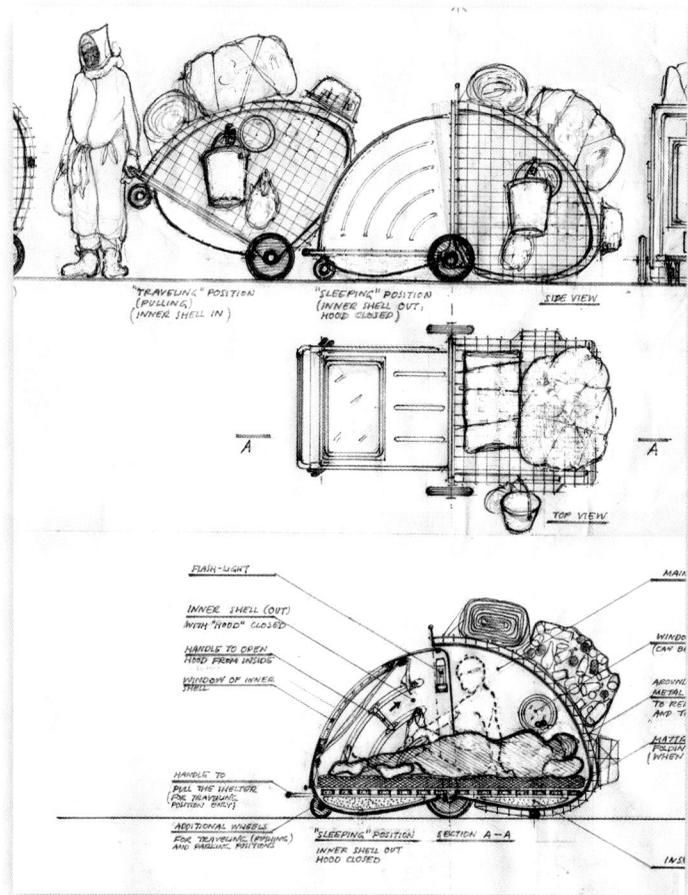

1.11 *Study for Homeless Vehicle* (1987), detail. Ink, graphite, and correction fluid on tracing paper 23 x 19.1 inches.

some better equipment. But at the same time, manifest those needs, articulate those needs, make those needs publicly clear as needs that should not exist in the civilized world. There should be no need for this kind of vehicle or this kind of design. But even if the policy were to change and suddenly large projects, housing projects, were waiting there for homeless people, there would still be a long time of transition.

I decided to make a brief sketch. Whatever I thought would be good. I got to know some of these homeless people already. They were curious to see what it is I could offer. So those sketches are the ones that I presented to them. As you could see, they could respond to classic industrial design thinking. Minimum shell. Something to do with pro-

viding privacy, intimacy for people who are surrounded by an extremely loud and very busy environment.

So that's what I presented. It was on wheels with a shell that opened and closed and could be transported and attached to different places or take advantage of some architecture or set-up or maybe electricity in a lamppost and so forth. The homeless people looked at this. They understood my genuine attempt to respond to their needs. But they immediately told me that this is pretty much all wrong. They did say very clearly, our priority is not privacy but security. If we are hidden in this kind of cell, nobody will know whether we are inside or not. And the garbage truck backing up would crush us.

Also, things that we have here might be taken away from us, somebody else will appropriate what we found, what we collect in order to resell for meager income, such as bottles, cans, glass, metal, and plastic, for which there is a redemption value. So I went back to the drawing board. And I realized that the vehicle should also respond to an avalanche of needs, such as sleeping, movement, walking and collecting things. Sleeping. Maybe washing. Maybe cooking. Resting. Also providing a toilet. Possibility of bathroom, but also maybe some accepting the presence of a dog. Very important companion of many homeless people. Creating the social situations. So there would be more than one vehicle forming a habitat.

As you can see here, one model of this vehicle was demonstrated. So immediately the people would start thinking, as they always do when there is something new, maybe I can buy it. Maybe it's for me. I could take advantage of a new consumer product. It was very clear that the person who was operating it started to work as a performer, as an explainer. Someone who would respond to many questions.

And in this way, all of the complexity of the survival technique of homeless people would become more clear. It would be articulated through this discussion about the object. The vehicle was tested by very experienced homeless operators, users, some of whom were actually connected to a recycling center.

It's clear that the amount of life around this vehicle was surprisingly rich. I did not expect that the vehicle would trigger, inspire, or provoke so many discussions. But in this process from this video, once in a while, you will see a crowd of people discussing things. Some people are against it, saying that it cannot be the solution. Doesn't make sense. Somebody else was curious and thinking, maybe it will really help. Also the person who was operating it was saying things that were not necessarily answers to questions, would talk about how he or she became a homeless person.

And already with these real critical situations, we encounter misunderstandings vis-à-vis police or park rangers or drunk, young inhabitants in the same area. And also, what would be the best thing to do for people like the homeless. There is lots of personal information. I realized that the vehicle created or contributed to the situation very richly. So in that sense, it was successful.

But also, [the vehicle] could not respond as a design machine to many of those needs that its own appearance created. So in other words, it's clear its deficiency was a result of its efficiency. And that deficiency was lack of media, lack of memory, lack of a recording system. Most of those who are pushing those shopping carts, people are thinking they are just faceless shadows, people who are using stolen shopping carts. This vehicle created a very different perception: that they are workers who are operating equipment specifically designed for their labor. So that created a different sense of identity and also a different relationship between them and the public. Because through this vehicle, it was much easier to start speaking, discussing. You discuss the vehicle. But eventually the question is, what is your name? How it is that you became homeless? Do you have friends? Why would you do this?

So all of this happened. But the vehicle was not ready to take advantage of it as media equipment. That created a kind of condition for me to develop different kinds of projects. Of course, not necessarily for homeless people, but also for homeless people. So this actually demanded a media vehicle. Many of those homeless people are skillful. Skillful, but also educated in media.

There's many people among the homeless population with skills and education. What I'm saying also was somehow transmitted by those homeless people, because they're talking about themselves or their colleagues. So I was sad: why is it that it's not on video? Why is it not being transmitted to mainstream media, you know? So those people could actually sell, so to speak, their vision, their image of the city and their image of life in the city from the bottom position of homelessness.

This creates the concept of a kind of new polity, of this homeless person as a person who could be a fearless speaker, who could say things. The *Polis Car* project is exactly an attempt to come up with different functional programs and different mechanical and media equipment. And to imagine contingents of homeless people who are educated enough or with learned media skills and could provide a different image of the city as a counterpoint to the kind of image that is produced by real estate developers or managers of the city.

Dan Borelli

I do want to make the argument that it is intentionally not solution-based, it's proposition-based. And even without the media overlay, in its analog form, by bringing this form forward out into public space, and also that you were doing this in the context of an exhibition with the curator Tom Finkelpearl. And that it generated discourse around it. And that discourse is extremely important.

Krzysztof Wodiczko

The success of this project opened up the need for media. It was efficient and deficient. The vehicle became hungry for more.

Dan Borelli

Right. By making visible the user, you're rehumanizing them back to their own communities. It's a sort of generation of empathy.

Krzysztof Wodiczko

The vehicle was not produced, but it was mass-reproduced. In fact, it showed up in newspapers, in magazines, on television as a kind of difficult topic that caused controversy. So it basically was a kind of scandal that was a good scandal because it exposed a scandalous situation to which the vehicle responded. In fact, I coined this term ["scandalous"] for this method of interrogative design—I call it interrogative design because it's asking so many questions and investigating the situation, exploring it, bringing all of its aspects to the surface. So that's one interrogative aspect. But also, there's the subcategory, or different in terms of method, that I call scandalizing functionality.

> Through its design, a 'scandalizing functionalism,'[1] the *Homeless Vehicle* communicated a great deal of the conditions and techniques of homeless survival.

1. The vehicle design was born of the homeless scandal and it aims at further scandalizing it. In response to the unacceptable world a responsible design should propose and present itself as unacceptable solution. While pragmatically responding to the homeless' needs the appearance and function of the Homeless Vehicle aims at provoking public attention on the unacceptability of such needs and in this way further scandalize the scandal of the homelessness. The vehicle's design is responding to the needs that should not exist in a civilized world but which unfortunately do exist. The scandalous needs (such as the need for a homeless vehicle) must be articulated and answered through scandalous forms and functions. The "utopia" of the vehicle is based on the assumption that its articulating function and scandalizing presence will contribute to better public consciousness (regarding the unacceptable homeless situation), toward the political and social change and the new situation in which the homeless will no longer exist and there would be no longer a need for the homeless vehicle and its design.

1.12 In his essay "Art, Trauma and Parrhesia," Wodiczko describes "scandalizing functionalism" as a synonym for interrogative design.

The Interrogative Design Group

Sung Ho Kim

> All crises begin with the blurring of a paradigm and the consequent loosening of the rules for normal research. … Or finally, the case that will most concern us here, a crisis may end with the emergence of a new candidate for a paradigm and with the ensuing battle over its acceptance.
>
> —Thomas S. Kuhn, *The Structure of Scientific Revolutions*, 1962

Thomas Kuhn opens an intellectual discourse that defines the restrictions underscoring academic pedagogy, which surrounds the young generation with a simplified understanding of the institutional knowledge in a scientific field (which Kuhn calls a paradigm). The paradigm is a customary faith in a speculation and its principles that defines a theory. Kuhn believed that the principles of reality cannot be perceived, and this imperfect awareness always leaves perplexed acknowledgments, creating multiple readings under constant struggle for acceptance in the aesthetics of the everyday. For an emerging paradigm, this confrontational engagement of acknowledgment is the process of defining and accepting the new conceptual framework. John Dewey's *Art as Experience*, published in 1934, anticipates the way for everyday aesthetics to investigate various aspects of the public's aesthetic lives without a preassumed territory. This approach was the basis of research that the Interrogative Design Group explored through the transformational production of creative and artistic endeavors. Exploring the crossing of the territories of science, technology, and social justice is the means of speculating about the paradigm shift within the design discipline in contemporary society. To this end, the Interrogative Design Group was founded by Krzysztof Wodiczko at the Center for Advanced Visual Studies at Massachusetts Institute of Technology, working with researchers Adam Whiton and Sung Ho Kim.

As the American social psychologist and feminist Carol Tavris once said, "History is written by the victors, but it's victims who write the memoirs."[1] It is to embrace the victims and their stories that the Interrogative Design Group formed its objectives during 1996 through 2002: a series of design proposals merging art and technology into a design intent that provoked a critical attention to social and cultural issues of contemporary cultures. The basis for the research was an investigation into artistic and creative practice as a mode of social engagement, with a focus on bodily equipment for healing everyday trauma. The practice acted as a creative generator for conversations between various

• **Krzysztof Wodiczko**: The core members of the Interrogative Design Group (those engaged in research developed and implementation of all IDG projects) were Adam Whiton, Sung Ho Kim, and me as its director. At the same time we were always open to others who wished to join the teamwork as colleagues-contributors to our projects. These included:

Edith Ackerman, who contributed as a research consultant in the areas of education, participatory technology, and cultural anthropology,

Jerzy Stypulkowski, who assisted in the design of software and hardware, especially in the *Aegis* project,

Kelly Dobson, who first tested and advanced the interactive performance with the *Aegis* in public spaces in New York and Berlin,

Robert Ochshorn, who designed the original interface system for participatory projection projects, especially in *War Veteran Vehicle*,

as well as Joshua Smith, who designed an electric sensing system for the gesture-responsive version of the *Alien Staff*.

IDW
INTERROGATIVE DESIGN WORKSHOP

Course Home Page
Contact Info
News
Calendar
Course Materials
 Syllabus
 Handouts
 Resources
 Assignments

Students
Links
Comments
Projects
Bulletin Board

INTERROGATIVE DESIGN: ART, PUBLIC SPACE AND FEARLESS SPEECH:
TECHNOLOGIES OF PROTEST AND DISAGREEMENT

Instructors:
Krzysztof Wodiczko
Room: N51-315H
Telephone: (617) 253-5862
Send e-mail

Fall 2002
Units: 3-3-6
Level: H
Prerequisites: class limit 15

PROTEST - from Latin pro-testari, 'affirm, bear witness to' (testis = witness, as in 'testify'), a pro-active testifying to a wrong in order to bring about a change for the better.

The focus of this workshop will be on those who are striving to break their silence in order to interrupt the world around them in an empowered critical voice. Workshop participants will learn how to conceive and develop communicative equipment, programs and environments to inspire and assist those who are asserting their communcative rights in physical and digital public space. Considering that among these potential "speakers" are those survivors of present-day injustice whose ability to communicate must first be recovered or developed, the design concepts may need to respond not only to ethico-political demands, but also to psychological conditions.

1.13 Interrogative Design Workshop website.

communities and for awareness of other cultural and personal narratives that were once hidden and silenced. This endeavor allowed valuable discourse by expanding the spectrum of the audience. The projects themselves transformed the narratives they embraced and assembled by becoming a symbiotic partner with, and a protagonist of, the invisible voices. The principal aspiration of the Interrogative Design Group was to initiate a comprehensive dialogue of expanding knowledge that disseminates a vision of the world where every living being is respected and embraced because of its invisible relationships balancing the fragile social, political, racial, and economic ecology of a culture. The projects developed during 1996 through 2002 in the Interrogative Design Group are collections of memoirs of the victims who are invisible and forgotten but are given opportunity to reemerge as new actors who are valuable prophets to the world in constant transition.

In Dewey's writing there are two concepts of aesthetics that engage bodily sensations: the first from sensory stimulation and the second from bodily activities. These notions of aesthetics were the motivational mechanisms on which the Interrogative Design Group was founded. The equipment (*Prototypes*, *Aegis*, *Disarmor*, *Tijuana*, and

Handmachine) that was developed during the seven years of research at MIT constituted relationships represented by the users' struggles. The performative features of the equipment simulated tonalities of voice, facial expressions, and bodily gestures and postures. The equipment assisted with morale and comfort, and supported the users' self-confidence in engaging society through aesthetic dimensions. The deployment of the equipment allowed for the promotion and cultivation of virtues through everyday practice. In the field of operation, the equipment generated public awareness, compassion, kindness, and respect for the users' expressions accompanied by aesthetic sensibility. The public forums unfolded collaborative interactions by proliferating appropriate cultural knowledge and aesthetic insights to translate group dynamics for influence to create a defined atmospheric aesthetics.

The Interrogative Design Group's research explored the mechanisms in which moral virtues of thoughtfulness and humility can be expressed not only by human users and participants but also by the aesthetic features of the objects. The designed equipment constituted social stage props that expanded the conversation around cultivating aesthetic empathy and the practice of aesthetic abilities to facilitate respectful, thoughtful, and humane social interactions. The legacy of the Interrogative Design Group demonstrates that design is an important discipline that inspires emerging social aesthetics and embraces interdisciplinary processes to engaging everyday human struggles. This design research practice is imbued with acknowledgments of paradigm shifts that define the evolving cultural ecologies of transitional contemporary society.

Ethical Media Art: A Seminar

Warren Sack

What Is Design?

Design is a glue that binds sociocultural groupings, like cities, with a set of technologies and practices—for example, automobiles and driving—through the planning and implementation of an artifact or system, such as streets and highways.

Designs can materialize cultural formations, as when the highway designers extended the suburban sprawl of Los Angeles.

Culture can influence design, as when the suburban commuters desired cars to travel into and out of Los Angeles, resulting in multi-lane freeways.

Technology can reify design solutions. For example, the ubiquity of cars makes them seem like the obvious means to travel in LA.

Cultural and economic actors can influence technology and design—like when the LA public streetcar system was bought up and then dismantled by the makers of oil and tires in the 1950s, thus encouraging the development of highways and the demand for automobiles. In other words, design, technology, and culture all mutually influence each other.

Any good understanding of design demands an understanding of culture and technology. Any sophisticated notion of an ethics of design requires even more: one must have an understanding of technology, culture, and a clear idea of how design decisions may work for or against a specific community. With an ethics of design one can begin to address questions like this one: Are the freeway system and the automobile traffic a good design for the needs of LA?

Within the art world, considering design's larger political, economic, social, and cultural implications is a legacy of the avant-garde and its refusal of the boundaries of art as distinguished from science, engineering, and the production of the artifacts and situations of everyday life. The avant-garde, including the Constructivists, Productivists, the Bauhaus, Dadaists, Surrealists, Situationists, as well as many contemporary conceptual and activist artists, have often refused to label their work "art" and have preferred, instead, to show how their work functions as design and labor for and/or against specific communities.

• Warren Sack: In the fall of 1995, when I was a graduate student, Professor Krzysztof Wodiczko and I offered a seminar for first-year undergraduates on the topic of interrogative design with the title "Ethical Media Art." I had previously assisted Wodiczko's graduate seminars, but this was the first time we had jointly taught interrogative design to undergraduates. Typically, for the graduate seminars, we might read texts like Donna Haraway's *A Cyborg Manifesto*, Julia Kristeva's *Strangers to Ourselves*, or Chantal Mouffe's writings on agonistic democracy. And, although we designed the syllabus to get there—to that level of difficulty in the assigned texts—we did not start there. Instead, we started with older texts—flawed but clear.

The seminar was open to all incoming students and so we had a class with diverse interests, although most ultimately majored in engineering. My experience with MIT undergraduates has been that they do not just end up as engineers after years of training: they begin their training as already-engineers or at least with the mindset of an engineer. The engineering design they were accustomed to starts with a well-defined problem. Our intention was to introduce them to a different form of design that starts by defining the problem to be addressed and raises critical questions along the way. The following discussion draws on materials from the original course description.

ETHICAL MEDIA ART

Professor Krzysztof Wodiczko

Center for Advanced Visual Studies

N52-157

Warren Sack

Media Laboratory

E15-320F

wsack@media.mit.edu

Wednesdays 4:00pm - 6:00pm, N52-157 or E15-468

(at the Center for Advanced Visual Studies or the Media Laboratory)

Seminar Description

The focus of this seminar will be on ethics and design. "Design" is not a new word (it has its roots in the Latin word *designare*, to designate). However, the contemporary conception of the praxis of design is interwoven with new technologies, means of production and distribution, and divisions and coalitions of (inter)national and local social organizations. The process of design is implicated in the conceptualization and often (material) articulation of artifacts and systems for communities. Thus, one could see design as a 'glue' which binds particular social groupings (e.g., cities) together with a set of technologies (e.g., automobiles) via the planning and implementation of an artifact or system (e.g., the kind of street and highway systems planned by urban designers). Designs can influence communities (e.g., as the highway designers have extended the sub-urban sprawl of Los Angeles). Communities can influence designs (e.g., as the sub-urban commuters have demanded the means to travel into and out of Los Angeles resulting in eight-lane freeways as well as rail transport). Technology can influence design solutions (e.g., the ubiquity of cars make them seem like the "obvious" means to travel in LA county). Communities can influence technology and designs (e.g., as when the LA public street car system was bought up and then dismantled by the makers of oil and tires in the 1950s thus encouraging the development of highways and the demand for automobiles). In other words, design, technology and communities are all mutually influential of each other. Any good understanding of design demands an understanding of community and technology. Any sophisticated notion of an ethics of design requires even more: one must have an understanding of technology, community, and a worked out idea of how design decisions can work for or against a community. With an ethics of design one can begin to address questions like this one: Is the LA freeway system and concomitant automobile traffic a good design for the needs of the LA community?

Within the art world, explicitly including a theory of community into a theory of design is a legacy of the avant-garde and its refusal of the boundaries of 'art' as distinguished from 'science,'

1.14 Archived screen capture of Ethical Media Art course website.

Within and beyond the art world, theorizing design as various processes mediating culture and technologies has been predominantly done by radicals and those of the political left. Contemporary work, especially in digital design, shows that this theorization of design is no longer exclusively the domain of the left. Bottom-up management and ubiquitous computing, for example, have become design strategies for reactionary and right-leaning corporations and public officials.

The appropriation, by the right, of the left's design tactics may be partially influenced by the political migration, from left to right, of various high-profile individuals. For example, Stewart Brand began his publishing career producing the left-wing *Whole Earth Catalog* that was organized around the slogan "access to tools" and written, largely, for the needs of the hippy communes of the 1960s. By the 1990s Brand was advising the Speaker of the US House of Representatives, Republican Newt Gingrich, and so Brand was in the position to explain to political reactionaries radical left design tactics.

The design tactics and concepts discussed in this seminar have their roots in left politics even if they have, now, moved into the repertoire of the right. We chose several early, left-inflected texts for inclusion in the syllabus, not out of a nostalgia for the 1960s (and earlier) left-wing politics, but rather because we found the earliest articulations of these tactics the simplest and the clearest. Although containing many of the main components of a theory and practice of design, the early texts have gaping holes in them, painfully obvious to the contemporary reader; e.g., the expressed sexism in some of them. By interleaving a discussion of the earlier texts with one focused on more recent writings, we could address the problems of the earlier writings.

What Is Interrogative Design?

The year of our seminar, Wodiczko published his essay "Interrogative Design." He defined it like this:

> Design as a research proposal and implementation can be called interrogative when it takes a risk, explores, articulates, and responds to the questionable conditions of life in today's world, and does so in a questioning manner.

And he provided this pithy example.

> The oldest and most common reference to this kind of design is the bandage. A bandage covers and treats a wound while at the same time exposing its presence, signifying both the experience of pain and the hope of recovery.

Early in the term we also provided an example of interrogative design from Wodiczko's own work: the *Homeless Vehicle*. However, it is difficult to demonstrate interrogative design by example because of the way it differs from conventional design, design that defines itself according to the object of design. Automotive design, interface design, medical instrument design, garden design, etc. are all defined by the object of design.

In contrast, interrogative design is defined according to the subject of design, the user, the person who will operate the technology or instrument or object designed. At the time, Wodiczko was best known for his work with the homeless. The *Homeless Vehicle* was essentially a form of mobile shelter and a cart for collecting and hauling cans, bottles, and other useful materials gleaned from the street. Later, in the 1990s, Wodiczko began to work with other neglected groups and individuals: immigrants, victims of domestic abuse, and war veterans. Interrogative designers do not just design for someone or some group, but also design with them, collaborate with them to conceptualize and implement the design and choreograph its performance.

Interrogative design addresses needs that should not exist and gives those who are silenced and neglected a means to have a voice.

Cultural Prosthetics and Cyborgs

A design can be conceived of as an extension or prosthesis for an individual or a community. For example, clothing extends one's abilities to survive severe weather conditions. Various theorists and technologists have termed the aggregate of an individual and a technology a "cyborg." When a technology becomes integrated into the everyday

life of a community the community becomes a new entity; consider LA before and after the advent of the automobile. The logic of prosthetics and cyborgs is not a logic of identity, but one of extension, connection, and empathy.

A design often extends an individual or community to change it, to introduce differences with its past constitution and to introduce similarities to others which, previously, were dissimilar. For example, if I break my leg I become at least temporarily handicapped and my crutches or wheelchair signal to me and those around me that I share an augmentation, a prosthesis, an empathetic stance with others around me who are handicapped, temporarily or permanently. We are all cyborgs when we use crutches, wear contact lenses, take medicine or receive a vaccination, wear clothes, carry an umbrella, ride a bike or drive a car. We are also all cyborgs to the extent that the social, political, economic, and cultural institutions we inhabit incorporate extensions or augmentations like an electric grid, sewage and water systems, a postal service, cellphones, public transport, etc.

When a prosthetic has been designed for cultural augmentation or enhancement, Wodiczko calls it a "cultural prosthetic."

> [C]ultural-prosthetic equipment can aid in the process of re-coding the "self" beyond mere substitution and improvement, to empower the impaired with new abilities, including the virtuosity to regain and acquire an invigorated sense of personal and social worth. The design and technology of cultural prostheses must offer their users both inspiration and assistance in the process of developing new forms and skills of communication and expression, which will aid users in resuscitating lost social ties and connections or to create new ones.[1]

Situated Epistemology and Design Tactics

Who can, who should be allowed to decide whether or what kind of an extension is to be made to an individual or a community? Epistemology, as a special area of philosophy, covers such questions as these: What can be known and who can know what? What kinds of tests must beliefs pass in order to be legitimated as knowledge? In other words, epistemologists often, if implicitly, ask: Who can know what under which circumstances? In the special case of design this question boils down to asking whether the designer knows what sort of extension or change will be best for an individual or community. Many posit that the designer can only know best if the designer knows the affected individual or community well. Such a knowledge entails an education for the designer and, perhaps, for the community or individual as well to learn about the proposed designs and their reception. One might assume that the epistemological and educational questions are easiest when the designer is the individual or a part of the community affected by the design. However, since, an implemented design will necessarily provoke the formation of a new cyborg, the questions are not necessarily simpler since, in such a case, the designer will be a different entity after the implementation. To repeat: interrogative design does not follow a logic of identity.

Beyond the theoretical epistemological concerns is a practical question of design tactics: How does the designer learn what needs to be known? Interviewing members of a community, ethnographic work with a community, sharing prototypes and drawings with community members, giving and receiving critiques from the community—all of these are design tactics useful for the praxis of interrogative design.

Seminar Requirements

Students of the seminar were expected to do weekly readings and activities, attend and participate in discussions, and conduct design and artistic research which would culminate in an end-of-term, final presentation. Each meeting of the seminar included both a discussion of the week's readings and a review of preliminary design proposals and work-in-progress.

Seminar Readings (in chronological order)

Brand, Stewart, *Whole Earth Catalog* (first issued 1968)

Lurie, David, and Krzysztof Wodiczko, "Homeless Vehicle Project," *October* 47

Bos, Saskia, *Krzysztof Wodiczko* (Amsterdam: De Appel Gallery, 1996)

Papanek, Victor, "Chapter 4, Do-It-Yourself Murder: Social and Moral Responsibilities of Design," in *Design for the Real World*, second edition (New York: Van Nostrand Reinhold, 1984)

Papanek, Victor, "Chapter 6, Snake Oil and Thalidomide: Mass Leisure and Phony Fads," in *Design for the Real World*, second edition (New York: Van Nostrand Reinhold, 1984)

Papanek, Victor, "Chapter 9, Design Responsibility: Five Myths and Six Directions," in *Design for the Real World*, second edition (New York: Van Nostrand Reinhold, 1984)

Sparke, Penny, "Avant-Garde Design in Russia," in *Design in Context* (London: Bloomsbury, 1987)

Gabo, Naum, and Antoine Pevsner, "The Realistic Manifesto," in *The Tradition of Constructivism*, ed. S. Bann (New York: Da Capo Press, 1974)

Brik, Osip, "Program of the Productivist Group," in *The Tradition of Constructivism*, ed. S. Bann (New York: Da Capo Press, 1974)

Gan, Alexei, "Constructivism," in *The Tradition of Constructivism*, ed. S. Bann (New York: Da Capo Press, 1974)

Toporkov, A., "Technological and Artistic Form," in *The Tradition of Constructivism*, ed. S. Bann (New York: Da Capo Press, 1974)

Tatlin, Vladimir, "Art Out into Technology," in *The Tradition of Constructivism*, ed. S. Bann (New York: Da Capo Press, 1974)

Marinetti, Filippo, "The Foundation and Manifesto of Futurism," in *Art in Theory 1900–1990: An Anthology of Changing Ideas*, ed. C. Harrison and P. Wood (Cambridge, MA: Blackwell, 1992)

Boccioni, Umberto, "Futurist Painting: Technical Manifesto," in *Art in Theory 1900–1990: An Anthology of Changing Ideas*, ed. C. Harrison and P. Wood (Cambridge, MA: Blackwell, 1992)

Frampton, Peter, "The Bauhaus: The Evolution of an Idea 1919–32," in *Modern Architecture: A Critical History* (New York: Oxford University Press, 1980)

Gropius, Walter, "Programme of the Staatliches Bauhaus in Weimar," in *Programs and Manifestoes on 20th-Century Architecture*, ed. U. Conrads (Cambridge, MA: MIT Press, 1970)

Schlemmer, Oskar, "Manifesto for the First Bauhaus Exhibition," in *Programs and Manifestoes on 20th-Century Architecture*, ed. U. Conrads (Cambridge, MA: MIT Press, 1970)

Jorn, Asger, "Notes on the Formation of an Imaginist Bauhaus," in *Situationist International Anthology*, ed. and trans. K. Knabb (Berkeley, CA: Bureau of Public Secrets, 1989)

Debord, Guy, "Report on the Construction of Situations and on the International Situationist Tendency's Conditions of Organization and Action," in *Situationist International Anthology*, ed. and trans. K. Knabb (Berkeley, CA: Bureau of Public Secrets, 1989)

Debord, Guy, "Theory of the Dérive," in *Situationist International Anthology*, ed. and trans. K. Knabb (Berkeley, CA: Bureau of Public Secrets, 1989)

Debord, Guy, "Détournement as Negation and Prelude," in *Situationist International Anthology*, ed. and trans. K. Knabb (Berkeley, CA: Bureau of Public Secrets, 1989)

Wiener, Norbert, "A Scientist Rebels," in *Collected Works of Norbert Wiener*, vol. IV (Cambridge, MA: MIT Press, 1986)

Wiener, Norbert, "A Rebellious Scientist after Two Years," in *Collected Works of Norbert Wiener*, vol. IV (Cambridge, MA: MIT Press, 1986)

Wiener, Norbert, "Sound Communication with the Deaf," in *Collected Works of Norbert Wiener*, vol. IV (Cambridge, MA: MIT Press, 1986)

Wiesner, J., and N. Wiener, "Some Problems in Sensory Prosynthesis," in *Collected Works of Norbert Wiener*, vol. IV (Cambridge, MA: MIT Press, 1986)

Wiener, Norbert, "Prostheses with Sensory Elements," in *Collected Works of Norbert Wiener*, vol. IV (Cambridge, MA: MIT Press, 1986)

McLuhan, Marshall, "Cybernation and Culture," in *The Social Impact of Cybernetics*, ed. Charles Dechert (New York: Simon and Schuster, 1966)

Haraway, Donna, "A Cyborg Manifesto," in *Simians, Cyborgs and Women: The Reinvention of Nature* (New York: Routledge, 1991)

Harding, Sandra, "Feminist Epistemology," in *Whose Science? Whose Knowledge?* (Ithaca, NY: Cornell University Press, 1991)

Review of V2 organization and Unstable Media projects realized in Rotterdam

De Landa, Manuel, *War in the Age of Intelligent Machines* (Cambridge, MA: MIT Press, 1992)

Lippard, Lucy, "Trojan Horses: Activist Art and Power," in *Art after Modernism: Rethinking Representation*, ed. Brian Wallis (New York: New Museum of Contemporary Art, 1984)

Bhabha, Homi, "Race, Time and the Revision of Modernity," in *The Location of Culture* (New York: Routledge, 1994)

What Is Being Interrogated?

Rosalyn Deutsche and Krzysztof Wodiczko

Excerpt of a conversation at the Harvard Graduate School of Design, November 12, 2021

Rosalyn Deutsche

The GSD exhibition applies the term "interrogative design" to the entirety of your work, although I think you originally used it for a very specific part of your practice: the design of equipment for homeless people and then of instruments for immigrants. Perhaps you can talk about what you mean by "interrogative design," and particularly by "interrogative." What is being interrogated? Who's invited to interrogate? Let's start with those questions.

Krzysztof Wodiczko

I am, by my professional upbringing, and some kind of utopian commitment, an industrial designer. So I was educated in this field. And, of course, we were very much into making and resolving issues or responding to problems in order to find a solution. "Solution" seemed to be the most frequent word used in the industrial design community. But it's clear there are problems that need a much more complex approach and that design cannot find a solution.

... [The *Homeless Vehicle* project] reinforced my doubts about the possibility of resolving everything through design. Actually, questions became more important than answers. Recognizing the situation as such was more important for me than finding a quick facade of a solution behind which you will camouflage the problem.

The design also poses the first question, something to interrogate: "How can design respond to needs that should not exist in the civilized world?" Yet they do exist, no matter how much we don't want to see them. They do exist and people are dealing with those needs, their needless needs, and they have to respond to those needs the way they can with their bare hands, like homeless people, by using those vehicles, carts, appropriated equipment, seen as scavengers, as people who are stealing something,

rather than as legitimate workers, people who contribute, in fact, to some degree to the economy or well-being of the city and environment by collecting bottles, cans, and plastic, metal, and glass.

My response was to create emergency equipment, but overloaded with a functional program to the point that the equipment will carry on all of those needs, those functions that should not exist in the world. So those two elements together maybe deserve, like a hope, the term "interrogative." It is more intervention and questioning. In fact, it suggests that we're dealing with a criminal situation, with something that needs to be investigated.

The criminal situation was described by many people, including you, Rosalyn, but also Neil Smith, and other people in our circle at that time. These fields described what was called "uneven development," which was clear: the process of very rapid and asymmetrical development. Something was developed quickly, somebody else was evicted, almost automatically, in the same process. So the production of homelessness was connected with real estate development and gentrification. You know, "the fine arts of gentrification," as you pointed out, Rosalyn.

Rosalyn Deutsche

I'm glad you characterized the interrogations prompted by interrogative design as criminal investigations. In that regard, do you think that your equipment for homeless people and for immigrants has similarities with Forensic Architecture, the group based at Goldsmiths in London that uses innovative technologies to investigate buildings and spaces in order to provide evidence of crimes, especially war crimes, that can be used in international tribunals and courts?

Krzysztof Wodiczko

Definitely, there is a connection here. Of course, the method is different. This is more of an investigation. Forensic Architecture focuses on investigation by trying to reconstruct, I understand, the crime that was committed by focusing on the sites and all of the logistics, by focusing on the site of damage or destruction, going back to all of the history and other conditions. I think there are very clear similarities. Of course, here I'm introducing a kind of probing vehicle. Something that is dispatched to open, to visualize, to somehow articulate, also to create a converging point of debate and discussion. So, this intervention here is not simply presenting a sculptural object that contains all of those elements of truth, of people's survival technique with all of the details. But also it creates conditions for the operator to become a presenter. Someone who explains, someone who illuminates people about the history of his or her own life that led to this situation of being homeless, and also explaining with details why this or that particular thing is designed this way. What is this for and how much will it cost? How many of them might be produced? There are so many questions being asked.

So the vehicle is actually provoking questions, inspiring questions, and also inviting a kind of very confrontational exchange. Exchanging of points of view. It's very discursive, if not agonistic, in its effect. The social and discursive effects of this vehicle were a surprise to me. It was a surprise to the point that I realized that the vehicle cannot fulfill, cannot respond to the avalanche of various situations that it provokes, because it doesn't have certain capacities that it should have. So in a way, the criticism of this vehicle for its insufficiency also led to other interrogative projects, especially in the area of media.

This vehicle didn't have communication media, didn't have a memory or electronic memory. It was just a functional object that helped the person operating and everybody around to argue around it and discuss it and reveal the so-called reasons why this vehicle was designed this way. But what this person would say about their own life could be reinforced by some technology. … But [their speech] was reproduced by the media with all kinds of stories,

discussions, interpretations. So in fact it extended its life through media.

Rosalyn Deutsche

As you're talking, I'm thinking that the insufficiency of the vehicle was part of what you were trying to show, that this is not a solution. You dramatized not only the problem but the fact that real solutions were not being offered, plans that would actually house people or help homeless people in other ways. Also, you made me think of another similarity between the *Homeless Vehicle* and Forensic Architecture. It allowed homeless people to testify about the conditions of their lives. Likewise, Forensic Architecture collects evidence, so that it can testify at trials. Of course, that evidence has to be spoken through because it doesn't speak itself.

Krzysztof Wodiczko

Yes, I agree. I learned from you also how to understand this *Vehicle*. One of the things you said was its utopia is based on the hope that its function will render it obsolete, am I right?

Rosalyn Deutsche

Yes, that sounds familiar.

Krzysztof Wodiczko

That's another aspect of interrogative design that somehow leads to its own extinction. It wants to stop functioning and be replaced by something really effective.

Rosalyn Deutsche

Because it shouldn't have to exist in the first place.

Krzysztof Wodiczko

Yes. I added another term to this, because I grew up as a kind of person who was into form follows function: functionalism. I have mentioned this before, not so much Bauhaus, but Ulm School of Design. They invented this "systematic design methodology." Functionalism reached in a very more precise and pseudo-scientific form. I decided to also use the term "scandalizing functionalism."

Rosalyn Deutsche

One of your brilliant terms that I've learned so much from.

Beyond Interrogative Design?

Krzysztof Wodiczko

The word *interrogative* sounds disturbing and provocative. It may make someone's teeth hurt, or turn their stomach inside out. The police interrogate criminal suspects. Interrogation can unfold the hidden truth about the ways the crime was committed and reveal its motives. No one wishes to be interrogated. Things, events, and people do not wish it and are afraid of becoming a subject of interrogation. Philosophical interrogation can disclose the complexity of a problem and disclose an inconvenient truth behind it. One may design something, while someone else may interrogate such a design. Design and interrogation do not easily and peacefully go hand in hand.

Of course, one may (and should) take the risk of interrogating a complex, unexplored situation as a part of design research, and this may lead to the formulation of intelligent and responsible design projects. But such projects have little chance, if any, to publicly articulate and disseminate the harsh truth of such interrogations *through* their design—through the projects' provocative symbolism, functional programs, and performative operation.

My industrial design experience in 1970s Poland informed me too well about such limitations. Indeed, most mainstream designs are not expected to be manifestations, articulations, and elaborations of the social, cultural, or environmental problems but the successful "solutions" to these problems.

Taking an interrogative approach to design was a rudimentary requirement in my industrial design education and professional practice. In 1960s and 1970s communist Poland, it was an ethical obligation, for myself and for my design colleagues, to closely question the regime's political "guidelines" and industry's priorities and assumptions and interrogate the real conditions of life and work of potential users of our design projects.

The purpose of such questioning and research interrogations was to challenge the social ignorance and numbness on the part of the state industry apparatus, and to convince it to adopt our findings and hopefully implement our designs.

If our social interrogations were lucky enough to be occasionally accepted, under no circumstances were the symbolic and functional aspects of the products and equipment to be allowed to be designed with the purpose of exposing and confronting social problems and provoking critical discourse.

Of course any mass production industry—capitalist or communist—tends to exclude the needs of socially and culturally marginalized users. In communist Poland, however, it was the vast majority of the population (all but the communist elite) that was marginalized by abstract ideological guidelines, a remote centralized perspective, and poor social knowledge on the part of the Politburo and industrial bureaucracy.

In such a centralized autocratic and ignorant system, we were trained by our industrial design schools to function as a "fifth column," to infiltrate industries with our interrogative design research focused on people's unacknowledged critical conditions and needs. Against their corrupted passivity and indifference, we were trying to make the industrial and political authorities become socially accountable—demanding that with the help of our unsolicited research and design they would finally live up to their lofty socialist slogans.

The agenda of infiltrating industry with challenging research was to some degree successful, but the conceptualization and implementation of designs that could have generated wider discourse through their appearance,

functional program, performative operation proved to be impossible.

Acting desperately against such impossibilities, I attempted on a few occasions to introduce into industry the "interrogativity" in my designs proposals. In one example, in 1968, when working in the Central Industrial Design Bureau of Polish Electronic Industry (UNITRA), I proposed to visually overexpose—by its location, scale, texture, and color—the off switch in TV sets designed by our team. Such a design's objective was to visually point out to the users the option to stop listening to and watching the poisonous propaganda programs transmitted by state communist media (the communist channel was the only one available).

As expected, the head of the design office immediately opposed the proposal. To justify his opposition, he brought up the example of a spoon, a tool that, he said, should not be designed in consideration of its potential use for poisoning someone. The danger of poisoning, he argued, should not be the designer's area of concern, but that of the health and public safety authorities.

In my riposte, I reminded him that the function of a TV set could not be compared to that of a spoon because, unlike our generic household spoon, a TV set is solely and exclusively used for poisoning. Also, such a TV set, a sort of "media spoon," was used by only one user who owns it—the Politburo's propaganda department called Radio and Television Broadcast Committee (Komitet do spraw radia i telewizji). In this way we are not even TV set users but rather the recipients of its poison, having only one operational option left for us: to switch the TV set off and in this way refuse to accept its delivery of poison.

The proposal was rejected, but it triggered a heated (and risky) politico-ethical discussion about industrial design's role in an authoritarian reality, even though all office conversations were under secret service surveillance. Applying the 1980s interrogative design concept to my 1960s TV off switch design proposal, I could say that it was my first attempt at interrogative design practice.

This and other similar project proposal rejections forced me to realize that the public implementation of my interrogative designs was only possible outside of mass production industry and only when conducted under the name of "media art experiments" and media art performances. The censorship and ideological state guidelines also demanded that such "experiments" should be "personal" (rather than social), address not specific but "universal" human conditions, and advance "the artist's search for new means of expression" (rather than communication). These "experimental" works of course must not be designed for industrial production or larger dissemination. Such a situation and such a conclusion gave birth to my first "artistic" designs and media performances such as the *Personal Instrument* (1968–1969) and *The Vehicle 1* (1971–1972).

The very first use of the term *interrogative* in reference to my work appeared in 1992, during a conversation with Dick Hebdige in which we discussed the social operation of the *Homeless Vehicle* (1988–1989), the project to be displayed that year as a part my retrospective exhibition at the Walker Art Center in Minneapolis. In his exhibition catalogue essay "The Machine Is Unheimlich," Hebdige elaborated on the interrogative character of the *Homeless Vehicle Project*, especially referring to the socially investigative process of its making, as well as to its ques-

tion-provoking appearance, functional program, performative use, and public performance. In his words:

> We are forced by the interrogative mode in which Wodiczko frames the *Homeless Vehicle Project* to ask the question, "What exactly are the homeless vehicles for?" ... In the awkward process of interrogation that they initiate, the vehicles make everybody–except their intended users–feel uncomfortable. ... Wodiczko's machine-offensive on the streets of United States cities demands that we acknowledge the existence of a specific crisis, reflect upon its causes, and respond to the question it provokes: "If not this, then what do you suggest?"[1]

My earlier 1980s conversations with Rosalyn Deutsche, exchanging thoughts and theoretical references, as well as her essay elaborating on *Homeless Vehicle* published in *Evictions* in 1998 were also pivotal for my later thinking on interrogative aspects of my art and design. Her pointed comment that "implicit in [the vehicle's] impermanence is a demand that its functions become obsolete"[2] confirmed a "concrete utopia" behind the vehicle interrogative operation.

The interrogative aspects of the *Homeless Vehicle* project were also implied in initial discussions with David Lurie and in the essay we coauthored, "A Vehicle for the Urban Nomads" (*Public* [York University], 1989). Conversations with sociologist Neil Smith and his essay "Contours of a Spatialized Politics: Homeless Vehicles and the Production of Geographical Scale" (*Social Text*, 1992) focused on the *Poliscar* project, informed my further thinking about the "interrogativity" (and "interrogability") of my work.

Such conversations and writings and above all my experience with public implementations of the *Homeless Vehicle*, and street testing of the *Poliscar* project, encouraged the interrogative direction of many of my later works such as the *Alien Staff*, the *Mouthpiece*, the *Aegis*, the *War Veteran Vehicle*, the interactive participatory monument projections in Tijuana, in St. Louis, and in Weimar, and more recently the drone technology-based projects in Milan, Kraków, Poznań, and New York.

The word "interrogative" challenges the word "design" by the fact of uncovering and manifesting the problems while not seeking design solutions to these problems. Such design's provocative, public truth-telling agenda and operation resemble public interventions of the ancient Cynics. Beginning with the *Homeless Vehicle*, interrogative designs are intended to inspire and assist their user-performer-operator—the homeless person, the war veteran, the refugee—to act as a present-day *parrhesiastes*: a critical and honest truth-teller.

As such, interrogative design may be negatively perceived and condemned as "cynical" because of its parrhesiastic method—examining, exposing, and scandalizing the criminality of inhuman conditions of life and provoking public discourse on them. Interrogative design may also be feared and resented, especially with the "truth-telling" role played by its survivors-users. Among "solution-driven designers," interrogative designs may even invoke a sense of guilt for being potential suspects and accomplices to social and design crimes. For example, they may fear and resent the *Homeless Vehicle* project for implicitly criticizing their design contributions to the "uneven urban development" that builds housing for the rich while evicting the poor. One may see the *Homeless Vehicle*'s design as being born of the ruined lives caused by urban revitalization—a living testament to its criminality.

In other words, interrogative design may be resented for its indirect criticism of the mainstream designers' crime of passivity, blindness, indifference, and neglect regarding the needs of alienated, impoverished, and marginalized people (i.e., not engaging in noncommissioned, pro bono social emergency projects addressing such critical human conditions).

The 1980s term and concept of "interrogative design" may feel outdated or even irrelevant in the face of today's less interventionist, less contestational, and more proactive approaches, such as artistic and design projects for alternative ways of living (as in Nato Thompson's *Living as Form: Socially Engaged Art 1991–2011*, MIT Press, 2017). In the contemporary "engaged art" context, interrogative design may appear to some critics as a fruitless effort in investigative trouble-making.

Pragmatically, considering the politics of creative, visionary, and critical (risk-taking) research and practice (especially in seeking support from granting organizations and agencies and applying for professional and teaching jobs in the design and academic world), the use of more "open," less "harsh" terms such as "speculative design" seems tactically wise as an effective and inoffensive way to introduce and disseminate their criticality and interrogativity.

A decade ago, Anthony Dunne and Fiona Raby moved beyond their critical design approach toward the more open and complex field of speculative design (see *Speculative Everything: Design Fiction and Social Dreaming*, MIT Press, 2013). In a parallel shift, albeit with a different motivation, I suggested a need to move beyond my interrogative design toward a more transformative and proactive framework and practice (see my essay on "Cultural Prosthetics," later in this book).

Of course, moving *beyond* something does not necessarily mean acting against it or rejecting it. In shifting toward the new position, one may well recognize the value of the preceding one as a base from which to move on. Speculative design—according to Dunne and Raby—would not stop carrying on a critical design dimension while moving *beyond*, into a new field.

In the essay "The Transformative Avant-Garde: A Manifest of the Present" (*Third Text*, 2014), I have pointed out the need to move, in an art and design practice, beyond contestation and toward *transformation*, and beyond a deconstruction toward the *new construction*. I thought, then, that the scandalizing, provocative and forensic program of the interrogative design agenda demanded to be expanded and stretched toward more *proactive* and *transformative* projects.

Indeed, beginning with the *Arc de Triomphe: World Institute for the Abolition of War* project (2010) my works have already taken the transformative route without abandoning their interrogative agenda. The Arc de Triomphe project interrogates the cult and culture of war while aimed at transforming it into new knowledge and new culture of Un-War. A more recent project, *A House Divided ...*, interrogates the American political divide between opposing social groups and constituencies, while proactively testing the new aesthetics and media methods toward respectful conversations and listening—to transform a culture of malignant conflict into one of civilized dialogue.

This questionable world demands and deserves to be closely questioned.

Interrogative design should probe, closely examine, and expose in detail such a questionable and unacceptable world while turning it to the point of absurdity by its designs' *questionable and unacceptable usefulness*. It may also provide an emergency functional assistance to the survivors of the dysfunctional world, so they could testify as witnesses to such a world's wrongs and become critical agents for change. The unacceptable world must be challenged and transformed by our new design projects and visions: critical, proactive, provocative, alternative, investigative and assertive.

It is my belief that any designs that ethically and aesthetically focus on today's world and its future—to explore, expose, articulate, address, closely question, and in a critical, transformative, visionary, polemical, or absurdist way challenge the troubling and emergency conditions, situations, and needs of which they are born, while set to inspire or trigger a new perception, imagination, and discourse—are inherently interrogative in nature.

—

I am most grateful to all my colleagues and friends, including former and present collaborators, students, and assistants—some of whom share their projects and thoughts on the generous pages of this book—for their design, art, research, and academic work in which the interrogative spirit remains integral to their practice and intellectual agenda.

Krzysztof Wodiczko

New York City, 2023

2 When Is Design a Question?

After years of working with many different designers and design processes, I have noticed one attribute that makes interrogative design completely unique. Conventional design and engineering processes begin with *problem statements* followed by iterative periods of research, prototyping, and testing toward a viable *solution*. Design is such a pragmatic enterprise and the idea of "designing solutions" so deeply baked into the discipline that a designer who works without trying to "solve a problem" may soon be unemployed.

Interrogative design presents an alternative organized around the production of *questions* rather than solutions, akin to works of philosophy or scientific research. Wodiczko's 1994 titular essay opens with some definitions of the word *interrogative* that serve as useful waypoints.

> **Interrogative: 1. Of, pertaining to, or of the nature of questioning; having the form or force of a question. 2. Of a word or form employed in asking questions.**[1]

Let us look at each of these definitions in turn.

Pertaining to the Nature of Questioning

The description, "pertaining to the nature of questioning," is a kind of meta-description of all that surrounds questions. The phrase suggests that the *interrogative* encompasses a much broader sphere of things than merely the utterance of fully formed questions. First, the idea of *questioning* suggests an action, a force, an interaction. One might consider puzzlement, incongruity, curiosity, boredom, silence, abundance of information, and various other conditions as precursors to questioning.

The *nature* of questioning suggests some relationship to the common environment surrounding questions and the act of questioning. What naturally precedes and what naturally follows questions? What is pertinent, relevant, or applicable to the environment of questioning?

Facial and bodily gestures certainly pertain to the nature of questioning. The intention of the speaker is relevant, as is the expectation of an answer. The beginning of any research project usually contains a set of questions, and the

outcome often produces more questions than the researcher had started with. The accumulation of information archived for future use certainly pertains to the nature of questioning. Finding answers, as well as not finding answers, and the art and science of prediction: these all pertain to the *nature of questioning*.

Now that all recordable data can potentially train artificial intelligence systems to produce predictive models of reality, almost everything pertains to the nature of questioning. The future itself is inherently interrogative.

The Form or Force of a Question

The second definition of "interrogative" as "the form or force of a question" suggests that something can be a question without being a literal question. This is a topic that Lani Watson goes into in more detail in her essay in this section.

Consider all the ways that one can ask a question without asking a question. A preamble or presentation of incomplete information can conjure questions in the minds of an audience. A dialogue between two people almost always involves questions. Any paradoxical or contradictory situation will also elicit questions. Adding a question mark near an object or situation produces an invitation to curiosity.

Objects are questions too. Contemporary sculpture makes use of this phenomenon through ambiguity, abstraction, and incompleteness—remarkable techniques that bring viewers into a quizzical dialogue with art. Designers of commercial products also make objects that have the form or force of a question: "What is this?" or "How does this work?" or simply "I love this. Where did you get it?" are all questions that designers aim to provoke through their work. Any object that looks unfinished also will have the form or force of a question: a prototype, a proposal, or something under construction or in need of some repair.

Moments and situations can also have the force of a question. News events, gathering crowds, coincidences, and juxtapositions. "Why is this happening?" or "What does this mean?" are common responses. A pause in conversation or some directional momentum in a monologue can also produce implied questions. Gaps create vacuums that people feel impelled to fill.

In George Loewenstein's famous meta-study of psychology research, he proposed an "information gap theory" with five example techniques for generating curiosity:[2] posing questions, presenting incomplete sequences, creating unexpected events, the possession of information by others. The fifth technique, which is quite remarkable, is simply too valuable to share here. I know it, and you don't so you'll have to look it up yourself. It's amazing.

Any technique that creates curiosity in others has the force of a question.

A Form Employed in Asking Questions

The suggestion in this third definition involves conventions and objects connected to the literal utterance of questions. Consider the props and environments where questions are asked. A light shining in one's face during an interrogation. Or for that matter, anything that produces anxiety or pressure during a solicitation for information.

Less confrontational environments also have forms employed in asking questions. An online forum that encourages questions for a presenter. An open microphone at the foot of a stage. The raising of a hand. A chance encounter. A freeform conversation. A round table. A raised eyebrow. The typology of meeting rooms is itself a form for questions. Various bodily postures can be employed to ask different styles of questions.

Classrooms too, are forms employed in asking questions, although they should be designed to be more employable in the service of questions rather than simply receiving information.

Some reflection can produce an endless list of forms that are employed in the asking of questions.

When Is Design a Question?

David Graeber describes communities in Nigeria where paying back debts exactly is considered offensive. Gift-giving and over/under value bartering keep a process of debt exchange moving to form continuously deeper community relationships.[3] The difference in the debt pressure between people is similar to interrogative design's ability to elicit questions from operators and from the public. Questions embedded in works of interrogative design and their *irresolution* form a kind of vacuum that must be filled by participants and viewers—a sort of mystery-solv-

ing back-and-forth absent from conventional works of design where problems are answered and resolved, like a neatly repaid debt. Interrogative design keeps the exchange open and continuous between the artist, the object, its users, and the public surrounding it all.

When is design a question? Sara Hendren posed the question in one of this book's editorial meetings, and I borrow it here as the title of this section. It is a singularly brilliant litmus test for any design project: "Is this design an answer to a problem, or is it a question?" When design is a question, it is interrogative design.

For many people, the act of asking a question is negatively associated with humiliation in religious or secular classroom settings or family environments, where a question can be interpreted as a challenge to authority. Posing a question often requires the gathering of courage. Foucault's call to *parrhesia* (fearless speech) suggests that public testimony and truth-telling can be risky activities. For many, the simple act of asking a question in a formal setting can be unsettling. Even science education, which should be the home of curiosity in the academy, can be improved to be more focused on the production of questions instead of retracing existing knowledge. The Buddhist and Socratic traditions of dialogue and questioning have much to teach,[4] and so too does the Talmudic approach.

Questions need not be threatening. Interrogative design aims to ease the anxiety around question-asking through the design of unusual prototypes and playful forms that help people communicate.

What Is a Question

Lani Watson

Questions are common to all of us, regardless of the languages we speak, the places we live, or the identities we inhabit in the many different aspects of our lives. We all ask questions. Much like design, questions play a ubiquitous role in our everyday lives, though we rarely pay conscious attention to the questions that we ask or the impact that they have. And yet, again much like design, questions are constantly shaping and guiding our perceptions, thoughts, and interactions. They are a central feature of our inner lives and structure much of our communication with others and our relationships with everyone from strangers to loved ones, and with the environment around us.

I am a philosopher fascinated by questions. I have spent the past ten years learning, writing, and speaking about questions, from many different angles, and I am still as fascinated as ever. The opening question of this section of the book asks "when is design a question." This question itself prompts a series of further questions: when is design asking questions of us; when is design provoking us to ask new questions, or forcing us to ask questions of ourselves; how can design itself be a question, and what does it mean to say that it is.

Before we can dive into these questions, there is a more fundamental question to ask, the one in the title above—What is a question. I call this the "Question Question" and have offered an answer to it elsewhere.[1] By articulating that answer here, I aim to open up the Question Question for those interested in the concept and practice of interrogative design and to provide a basis for considering the question on its own terms, as well as a route to addressing those further questions that emanate from thinking about design in terms of questions. If we are seeking to better understand when or how design can be a question, it will be constructive to first consider the nature of questions themselves.

My answer to the Question Question is based on a combination of philosophical analysis, everyday observation, and the results of a large online survey. In the survey, participants are asked to read through ten short, everyday scenarios and to judge, in each case, whether or not the scenario contains a question. The survey has had over 6,500 responses to date and takes, on average, 12 minutes to complete. Before I offer my answer to the Question Question (and reveal some key findings from the survey), you may want to take the survey yourself. It can be accessed at philosophyofquestions.com/questionnaire.

My answer to the Question Question can be helpfully broken down into two central claims. The first is that a question is an act. This tells us not only what type of thing a question is, but also what type of thing it is not. Most significantly, it tells us that a question does not need to be expressed in spoken or written language. Perhaps this doesn't seem like an especially significant insight. It is not hard, after all, to come up with examples of questions that we ask without using spoken or written language: looking at one's watch to tell the time or gesturing to a waiter for the bill across a crowded restaurant are two familiar illustrations.

It is, nonetheless, curious that most dictionaries and reference sources define a question exclusively in terms of language. The *Oxford English Dictionary*, for example, defines a question as "a sentence worded or expressed so as to elicit information."[2] The same definition is found when typing "what is a question" into Google.[3] Dictionary.com defines a question as "A sentence in an interrogative form, addressed to someone in order to get information in reply."[4] Wikipedia defines a question as "an utterance which typically functions as a request for information."[5] The *Collins Concise English Dictionary* (8th edition, 2012) defines a question as "a form of words addressed to a person in order to elicit information or evoke a response; interrogative sentence."[6]

Despite the authority of these sources, it seems clear (at least to me and many of the survey participants) that a question is not merely a "sentence," "utterance," or "form of words." Rather, it is, first and foremost, an act. The survey provides support for this. For example, most of the survey participants agreed that the unspoken act of looking both ways before crossing the road is a question (66% of participants at time of writing). Similarly, most of the survey participants agreed that the act of looking a word up in the dictionary to find out what it means is a question (81% at time of writing). In both cases, the majority judge there to be a question despite the fact that no language is used. This indicates that, for the majority, a question does not need to be expressed in spoken or written language in order to be a question.

You may have noticed the absence of question marks in this piece. Likewise, there are no question marks in the survey. This too does not appear to affect people's judgments about what counts as a question. Think of a typical online search. According to the survey, the majority consider the search phrase "local

Edinburgh butchers" to be a question (72% at time of writing), despite the fact that it is not an interrogative sentence and does not contain a question mark. I am yet to meet anyone who considers the use of a question mark to be a deal-breaker for determining whether or not something is a question. I take this as further evidence that, despite what the reference sources say, questions are not best defined exclusively in terms of linguistic markers.

Rather, a question is an act. One that we perform regularly from our earliest years and throughout our lives. Of course, that act may be spoken (a speech act) or written. But questions are not merely something that we say or write; they are fundamentally something that we do. Recognizing that questions are performative in this way moves us beyond dictionary definitions and into the realm of philosophical analysis. It is, I think, a crucial step toward better understanding the nature of questions. This recognition, moreover, broadens our appreciation of the role that questions play in our lives. Questions go beyond words and form. They are part of how we act in the world.

Of course, questions are not the only acts that we perform. They are one type of act among many. This brings us to the second central claim that comprises my answer to the Question Question: A question is an information-seeking act. With this second claim, we move further beyond the domain of dictionary definitions. Rather than defining a question in terms of a particular form of language, I define questions in terms of what they do. Technically speaking, we have moved from a formal to a functional analysis of questions; an analysis derived from function rather than form.

To elucidate, it is useful to think of a question as a tool. Tools are typically analyzed in terms of function rather than form. A wrench, for example, has the function of tightening and untightening screws. A hammer, on the other hand, has the function of hammering in nails. These different functions are what make one object a wrench and another a hammer. This, however, does not mean that wrenches and hammers are only ever used to (un)tighten screws and hammer in nails. They can be and are used for numerous other purposes: to prop open doors, to smash through glass panes, to display in sculptural art. These alternative uses do not change what it is to be a hammer or a wrench. To define a thing in terms of its function is not to determine every instance of its use. It is to identify the thing that makes it what it is, as opposed to something else.

A question is a tool for seeking information; a cognitive tool. It is, therefore, defined by its information-seeking function. This is what makes a question a question, as opposed to something else, and yet it allows that we use questions for many other purposes. We use questions to show that we care about someone, to engage in polite conversation, to express ourselves, to embarrass someone or to exert power over them, and so on. Nonetheless, in all these cases and more, the tool itself remains the same because it has the same essential

function. A question is a question in virtue of its information-seeking function. Thus, a question is an information-seeking act.

We can appreciate the force of this functional analysis by looking at rhetorical questions. Rhetorical questions are typically expressed as interrogative sentences, and so have the form of a question, but they do not have its function. In fact, rhetorical questions are defined by the negation of this function: they are explicitly not used to seek information. As such, rhetorical questions help to draw a conceptual boundary around the functional analysis of questions. Even when an utterance has the form of a question, it does not count as a question unless it has the function of seeking information.

Again, the survey provides support for this. For example, most of the survey participants judged that an uninterested "How are you" directed at a disliked colleague does not count as a question (54% at time of writing). Similarly, most of the survey participants judged that the despondent utterance "Will it ever stop raining" directed at the weather, does not count as a question (58% at time of writing). In both cases, the majority judge there to be no question despite the fact that both contain interrogative sentences. In other words, the utterances have the form of a question, but not its function. This indicates that, for the majority, a question is identified by its information-seeking function, rather than its linguistic form.

Notably, the consensus in these cases is much lower than in those cited earlier. This reflects something that is probably clear to anyone who takes the survey, or reflects on the Question Question for any length of time. It is a deceptively simple question with a surprisingly complex range of possible answers. Only one scenario in the survey reaches a consensus above 90%, indicating that in all but the most paradigmatic cases, there is nontrivial divergence in our judgments about what is and is not a question. Given that questions are so familiar and ubiquitous, this is itself a surprising and thought-provoking result.

I have argued that a question is an information-seeking act. This is the most intuitive and compelling answer to the Question Question that I have found to date. I invite anyone intrigued by questions or interested in the ways that they manifest in the world around us to consider this answer and, more importantly, to consider the question for themselves. Again, if we are seeking to better understand when or how design can be a question, when design is asking questions of us, or forcing us to ask questions of ourselves, it will be constructive to first consider the nature of questions.

Reflect

Jaekyung Jung

2008

2.1 *Reflect*, on public transit.

Reflect is a performance piece in which a performer wearing a reflective instrument walks from Bunker Hill to the Boston Common along the Freedom Trail in Boston. The walk of the unidentifiable performer begins at the Bunker Hill Monument, where a battle between the colonial and British troops took place, via the site of the Boston Massacre a conflict between Bostonians and redcoats in 1770, to the Old South Meeting House, where people's gatherings were held to fight against their enemy, the British army, and to commemorate the Massacre. His or her journey ends when she or he arrives at the Boston Common—a former military training area, public execution

ground, gathering place for protests, and an entertainment park for citizens—passing through the Granary Burying Ground, where many of those who died during the American Revolution were buried, and the State House, where Boston's political power is concentrated today.

This journey evokes memories of the historical trajectory of blood, struggle, conflict, and victory of the United States, which controls the axis of the current global political, economic, and cultural order; however, the goal of this trip is not to relive in our memory the priceless victory of the contemporary Empire, which was won through countless sacrifices, as the Freedom Trail tour programs usually tell. The walking mirror body adds the reality of people who live and work in the solid urban order, where memories of victors have been accumulated. The mirror body that suddenly appears on the route of collective memory or hypnosis creates an ephemeral and unstable moment in which people face themselves as if they were strangers to themselves in their everyday life. In the foreign body, the images of researchers walking toward the biotech companies where huge capital and brainpower are concentrated, international students of various nationalities heading to privileged university campuses, homeless people lying on outdoor benches without a place of their own in the city, and tourists visiting the Freedom Trail are illuminated for a moment and disappear like phantasmagoria. The phantasmagoric image of these strangers, summoned for a while causing a rupture in the stable collective memory, interrogates them like a kind of questionnaire in itself.

"Who is the stranger reflected in that unknown foreign body on the Trail?"

2.2 *Reflect*, at Sailors and Soldiers Monument on the Boston Common.

2.3 Map of *Reflect* performance route.

43

Sound Interventions

Andrew Todd Marcus and Richard Streitmatter-Tran

2001

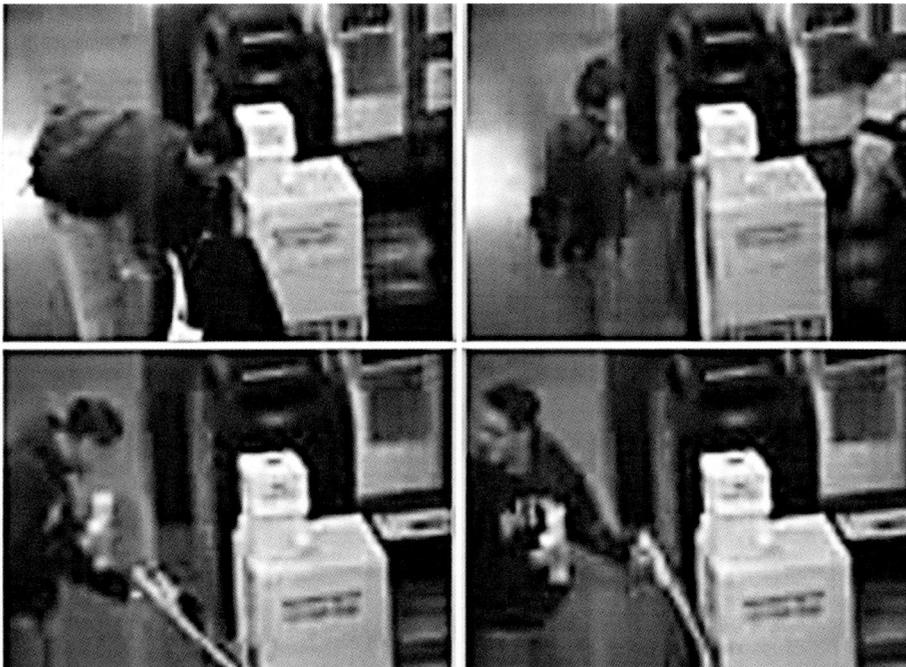

2.4 Video stills from installation.

We were both enrolled in the class Interrogative Design Workshop at MIT shortly after the attacks on the World Trade Center in 2001. We were tasked to come up with a device that would respond to the unreliable information in the media on the events of those days. We designed a device that would hack the ubiquitous newspaper vending machines found throughout the city. When the door was opened, it would break a magnetic switch that (a) would broadcast a message that would contest/question that day's front-page news with a message that we prerecorded or (b) through a built-in audio recording device would allow the last user to record up to 30 seconds of their own message that would in turn be broadcast to the next customer. Normally, this would have been a straightforward exercise, but given the climate following the attacks, hacking public machines was extremely dangerous, particularly with homemade wired electronic devices installed that might resemble bombs. We were very careful to monitor the hacked newspaper vending machine at all times and were prepared to intervene and explain our experiment to authorities should there be any misunderstanding of what the device actually was.

The work was co-conceived, developed, prototyped, and refined by the two of us over the course of the semester as a demonstration for the potential of tactical art interventions. Inspired by several of Professor Wodiczko's projects and artworks and his selection of focused readings, Richard continues to look at the relations between technology and power, as an artist and university lecturer, in his work and with his students in Vietnam.

2.5 Support letter.

Department
of
Architecture

Massachusetts Visual 77 Massachusetts Cambridge Phone 617-253-5229
Institute Arts Avenue Massachusetts FAX 617-253-3977
of Technology Program Room N51-315 02139-4307

FAX

Fax # 617.482.3507

Attention: John Palmer

Mr. Palmer,

Andrew Todd Marcus is part of a seminar here at the Massachusetts Institute of Technology called the Interrogative Design Workshop, for which I am the Graduate Teaching Assistant. His desire to examine and test the mechanism, ergonomic potential, and other aspects of newspaper boxes are of a research nature only. His research will involve no commercial activity or fiscal endeavors. Please contact me if you have further questions.

Sincerely,

Sanjit Sethi
Teaching Assistant for The Interrogative Design Workshop.

sanjit@mit.edu
617.504.6001

• **Sanjit Sethi:** Seeing documentation of Andrew and Richard's *Sound Interventions* project brings back powerful memories of TA-ing Krzysztof's Interrogative Design Workshop in the fall of 2001. 9/11 occurred on the second meeting of the class, and the experience was a surreal one. The seminar was taught in the evening, in a very run-down building on the MIT campus called N51. By the time the seminar met that day, we had all seen the nonstop media coverage of the planes crashing into the Twin Towers and the ensuing convulsion of violence and destruction. Everyone was emotionally numb from the day's events, and we were all struggling to focus and make sense of what had happened.

Engaging in a three-hour seminar was the last thing on many students' minds.

Krzysztof and I spoke before class started and we talked about how, if we were going to have class, it was going to be a class like no other. In many ways, the core ethos of the Interrogative Design Workshop was present at this moment. Krzysztof felt that the only way to move forward was through purposeful dialogue and creative action.

The goal for that class was to create a space of asymmetrical dialogue where it was okay if there were digressions or the conversation meandered, and that it was our job to simultaneously make room for dialogue, emotions, and community care. I think everyone who left the class that evening went home exhausted, feeling heard, and with a sense of resolve that whatever the world would look like the next day, creativity and critical inquiry were essential. The class meeting on 9/11 created a spark that fueled the work we did throughout the rest of the semester, and very likely informed many of the students' approaches to this day.

Student projects and class dialogues throughout the semester looked critically at systems of power and ways to provide agency and voice to those who were marginalized. There was deep concern over rampant xenophobia, overreaching by government entities, and a jingoistic media that was suppressing the truth. These concerns were addressed critically in projects like Andrew and Richard's and created opportunities for additional dialogues and investigations in future workshops. The fall 2001 Interrogative Design Workshop had a profound impact on so many of us who participated in it and it remains a powerful educational moment felt to this day.

45

Slope : Intercept

Sara Hendren

2013

2.6 *Slope : Intercept*, expanded.

Slope : Intercept is a networked architecture project organized around the inclined plane. It's a material and digital set of works, documenting the material ramps I designed, installed, and used with others; it also gathers ramps of all kinds in an online collection: industrial or useless, formal or informal, ancient or new.

The project is a deep genealogy of the inclined plane or ramp, one of Galileo's "simple machines." I have designed a set of ramps that are about 3 feet square and perform as a modular set of objects: a low-profile bit of geometry designed to nest and stack, to attach side by side, to maneuver about with wheels. They form a suite of objects for installation in public space, both as a mode of critical play and critical access.

These ramps are designed for use by two sets of unlikely bedfellows seeking elevation in cities: skateboarders, whose radical leisure tends to be unwelcome in urban centers, and wheelchair users in search of ramps for single-step entrances, a common access challenge in cities like Boston and New York, but also in global cities like Toronto and Seoul.

I'm interested in the ramp as an extended architectural form at the urban scale, but also as a social technology—a nimble and portable tool for both scripted and unscripted uses, one that creates productive uncertainty about which users make use of ramped physics, and for which ends.[1]

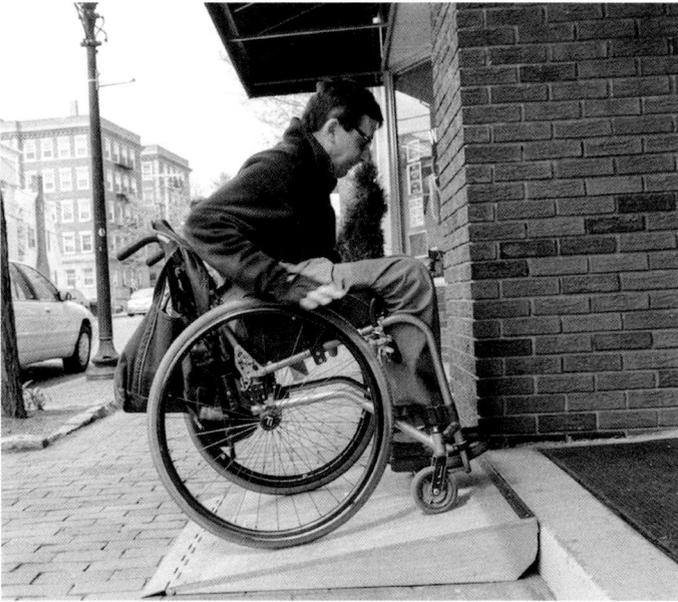

2.7 *Slope : Intercept*, in use.

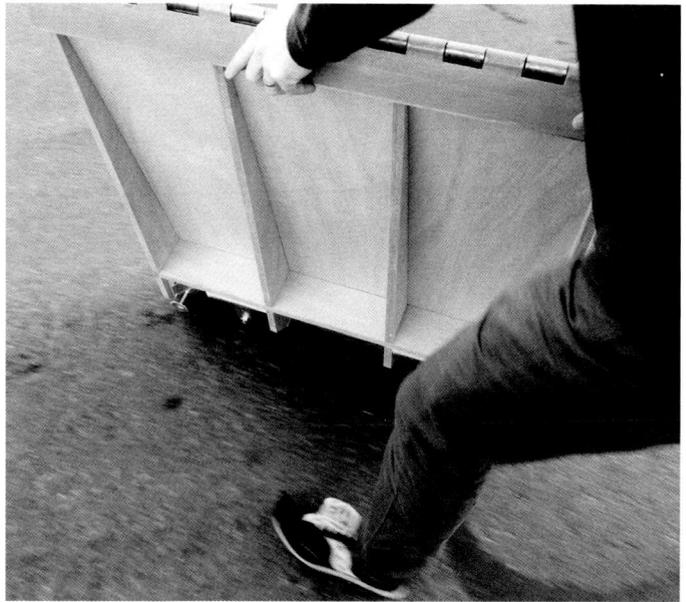

2.8 *Slope : Intercept*, being installed.

2.9 *Slope : Intercept*, in use.

2.10 *Slope : Intercept*, in use.

47

The Emancipati Ensemble

Orkan Telhan

2012

2.11 Orkan Telhan's *Emancipati Ensemble* (2013), an ensemble of readers working together.

- **Editor:** This emphasis on social reading, questioning, and multiple interpretations relates to Canadian author Irshad Manji's similar proposal to reintroduce the old concept of ijtihad to madrasas.[2] Telhan's work of interrogative design encapsulates the process of question-based research and study in the bias of the medium itself.

The *Emancipati Ensemble* (2013) is an installation that features readers who address the needs of a more discursive religious pedagogy. These readers connect with each other and form "reading ensembles" among two to four children. The screens of the tablets make a shared reading surface and let children read, watch, and learn together. The dual-tablet interface presents information with alternative points of view by using custom content analysis software. Children get exposed to perspectives from multiple points of view that span across different religions and belief systems—orthodox, secular, scientific, or agnostic opinions at the same time. Thus, children not only can introduce their own preferences and styles of learning by picking from a multitude of sources but also can share with each other what they individually encounter during their studies.[1]

When Is a Museum?

Pete Ho Ching Fung and Samein Shamsher

2019

2.12 *When Is a Museum?* installation in active use.

Curated by Gillian Russell, *When Is a Museum?* was commissioned by the *"Museum and the Web"* conference to explore how a museum could be collectively reimagined. Over the four-day conference, we collected objects from the attendees and re-presented them as artifacts and souvenirs. Replicas of a used bar of complimentary hotel soap sit alongside screen-printed tote bags and DIY paper models of a beloved children's toy car. A stolen Whitney Museum journal, a Splenda package from the 1970s, a friendship ring, coffee cakes from Hong Kong—each object is documented with its personal story. In the considered repetition of these actions within a compressed time frame and architectural space, the complex intertextual nature of a museum is laid bare and made mutable.

Making these often-hidden acts visible, the work earnestly searches for both its current cultural necessity and the very actions which give it legitimacy. A dialogue begins to form around this itinerant museum and the conference-goers: of the contradictions within a museum's systems, of the tensions hidden behind drawers and careful caretakers of other people's cultures, of our desire for knowledge and to know of the world through the possession and reproduction of artifacts. Through the participatory making of this

shadow museum, the premises and promises connected to the institution are made visible, allowing for a collective reflection of both its current cultural necessity and the very actions which give it legitimacy.

When Is a Museum? exemplifies a series of works produced by Discordant Projects. Between 2015 and 2019, the design collective has employed the process of the "pseudo-institution" as a design methodology to interrogate alternative futures through creating experimental presents. Through the rescripting of the banal functions of the institutions that frame so much of everyday life, whether of a school, a laboratory, a political entity, a religious denomination, or in this case a museum, pseudo-institutions adopt a cloak of respectability, of expected power through which the act of designing itself can become subversive. The design of this pseudo-museum never set out to recreate the fraught histories of ethnographic museums it imitated. Rather its goal was to position the museum itself as a site that must perpetually reconstitute itself through its multitude of artifacts, actions, and, perhaps more crucially, the relationships the museum spaces condition. This making and ultimately unmaking of a museum, from inception to death, allows for a closer appraisal of a museum's often immutable structure.

Much in the same way that interrogative design uses newly designed artifacts which disrupt expected social and cultural norms, the pseudo-institution seeks to generate dialogue through subversive acts as opposed to a functional alternative of the institution itself. This subversion is primarily achieved in two ways. The first is through collective acts of making: crafting nonsense artifacts, weirding and disrupting their expected notations, uses, and display. Within the work of *When Is a Museum?*, souvenirs were the typology subjected to this process. By utilizing designs' various processes and scripts, the act of making is at once familiar and yet becomes foreign, engendering a sense of curiosity and openness, allowing for a more open conversation among all participants.

The second way in which this subversion and ultimately this dialogue are achieved is through the now common promises of participatory design; of the radical inclusion of all individuals in the process of a design's becoming.

In the case of *When Is a Museum?*, however, the participatory promises of design were used to refigure the institution itself as it was in the process of being made. By opening all parts of the pseudo-institution to participatory processes of negotiation, crafting, delegation, and questioning, a space was created for a specific public to generate conversations about elements of museums, about themselves as caretakers of these institutions, and about the museums' possible futures, which are often out of reach or cut off from the very staff which maintain their function.

This mode of working considers design as a means to interrogate alternatives through the process of a design's becoming, rather than through reflection on a designed outcome. For designers and practitioners, our aim is to become facilitators of personal inquiries, what anthropologist Arjun Appadurai would call "the right to research." All human beings are, in a sense, researchers, since all human beings make decisions that require them to make systematic forays beyond their current knowledge horizons.[1]

By shifting research from a professional activity to a right, Appadurai argues that individual exploration and discovery, whether they have relevance to others, are no less important than knowledge that is directly taught and imposed upon said individual through or by an institution. The significance of these kinds of designs, then, is that they allow for a greater public participation in the contexts that make up our everyday lives. Spaces such as museums, while professing to advance ideas of inclusion and openness, continue to be siloed and opaque systems, even within themselves.[2]

The pseudo-institution functions as a space where the personal and the political overlap, and where a public can probe and question as part of the interrogative right to inquiry. The process of designing then becomes a liminal space that allows for a collective discussion and potential reimagining of often intractable systems, or at the very least a retelling of the possibilities of the systems that exist within the institution. If not within the experimental qualities of the here and now, where do we search for differences and imagine alternatives?

Museum Dissensus Instrument

Ian Wojtowicz

2019

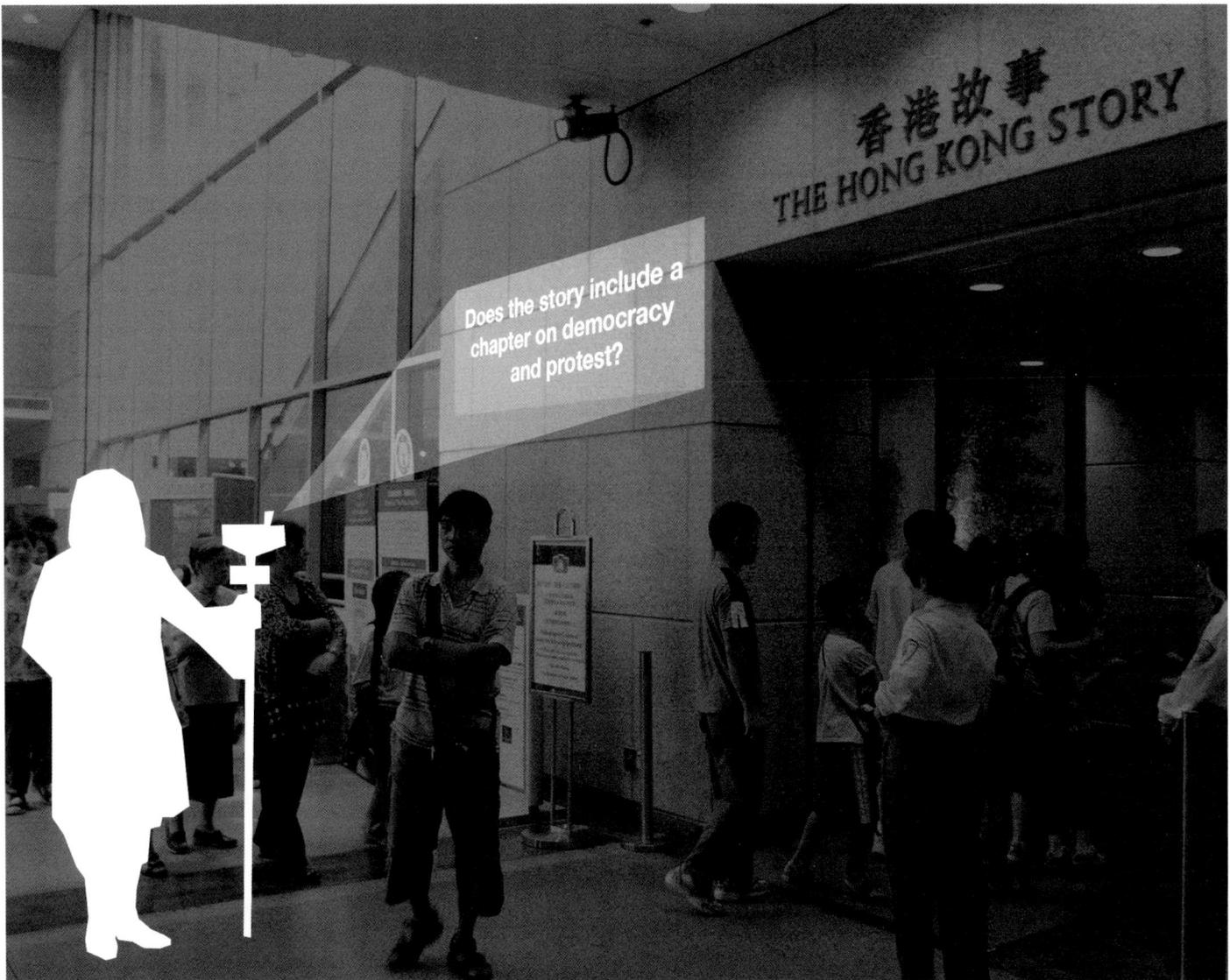

2.13 Illustration of the *Museum Dissensus Instrument* at the Hong Kong Museum of History.

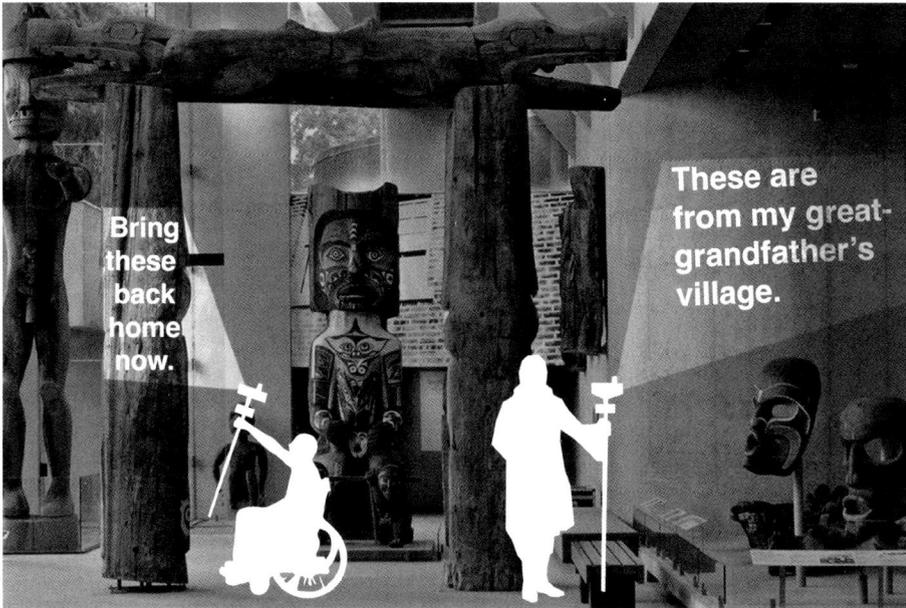

2.14 Illustration of the *Museum Dissensus Instrument* at the Museum of Anthropology in Vancouver.

Museums are sites of political soft power that create immersive multisensory experiences around singular authoritative narratives. People visiting these grand halls are granted permission from the institution to receive this sanctified knowledge in meticulously designed environments. Even the most progressive museums have latent biases and, unlike libraries, have little patience for visitors who rearrange objects[1] or who leave any trace of their disagreements with the content. Museums are broadcast media.

The *Museum Dissensus Instrument* is a portable voice-and-image projection system that enables visitors to push back symbolically at museum exhibits. The use of this instrument produces agonistic moments within the seemingly unalterable environment of museum interiors. The instrument is equipped with cameras that enable the online sharing of interventions and a system for others in the vicinity to contribute their own material.

Layers of momentary (UV-free) light graffiti animate museums with questions, commentary, and conversation, changing these rarefied halls of central authority into places of vibrant democratic multiplicities and shared debate.

2.15 Prototype of the *Museum Dissensus Instrument*.

The Paradox of Contradiction

Dora Apel

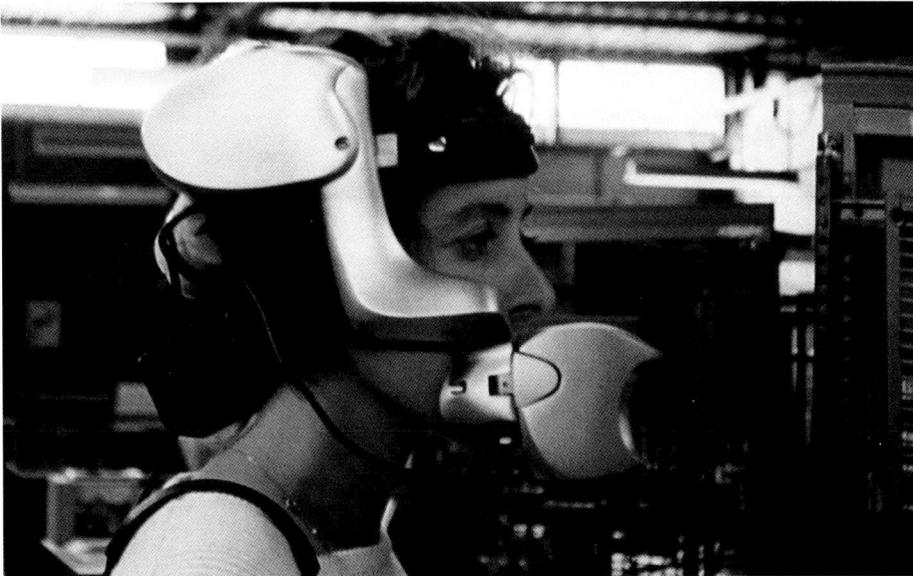

2.16 Krzysztof Wodiczko's *Porte-Parole Mouthpiece* (1993).

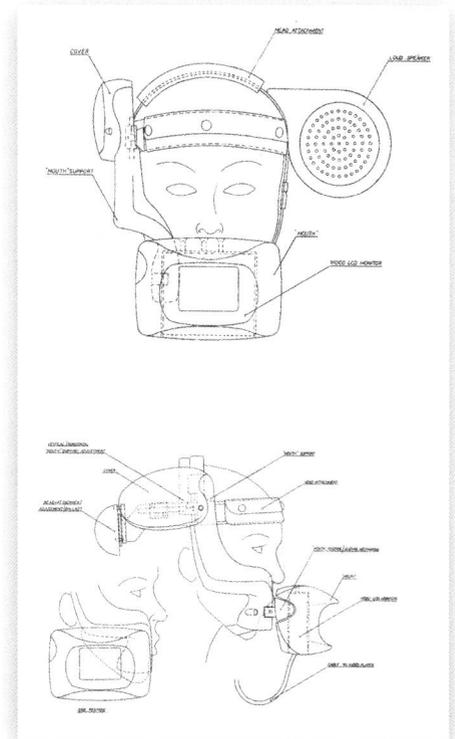

2.17 Krzysztof Wodiczko's *Porte-Parole Mouthpiece* (1993), diagram.

We might say that interrogative design is best understood as premised on contradiction, on the critical and fundamental paradox of contradiction, which, we might also say, is central to life itself and its productive, dialectical development.

Take, for example, Krzysztof Wodiczko's work *Porte-Parole Mouthpiece*, the second in his series *Xenological Instruments*. In order to bring "natives" closer to "strangers," the mysterious-looking prosthesis worn on the head of Wodiczko's subjects is meant to help the wearer overcome his or her sense of alienation. Yet this is accomplished by making the wearer look even more "alien." In this manner, however, the wearer is more likely to elicit the curiosity and, it is hoped, the empathy of people who might otherwise be indifferent, afraid, unaware, or suspicious. By suggesting that the alienated foreigner might better communicate in this strange, self-conscious, and cumbersome way, through a small built-in video monitor that displays their lips and tells their story through small loudspeakers, Wodiczko's technological device turns its wearers into oddly curious cyborgs rather than ordinary immigrants. The contradiction of

alien versus domestic, native versus stranger, citizen versus other is made so extreme and, in a way, so heartbreaking that communication, or the idea of communication, or the willingness to communicate, in fact becomes more possible, more potent, more urgent.

Works such *Porte-Parole Mouthpiece* or *Homeless Vehicle* (1988–1989)—another kind of "emergency aid"—are part of an ethical artistic practice that is meant to offer its subjects a greater sense of agency. Yet these works point to another kind of contradiction: in order to promote agency, the projects necessarily highlight, and are premised on, their subjects' lack of it. In other words, in order to interrogate the nature of the social and cultural conditions in which Wodiczko's interrogative design is produced, the artist offers solutions that are impossible as authentic solutions. By proffering a device or vehicle of temporary empowerment, those same objects illustrate the discriminatory and deprived nature of their subjects' existence on the margins of society.

In the more recent work *MONUMENT* (2020)—one of his many projections that attempt to empower immigrants, refugees, war veterans, survivors—Wodiczko projects the likenesses, voices, and stories of twelve refugees onto the 1881 statue of David Glasgow Farragut, celebrated as a naval hero of the Civil War with a monument designed by Augustus Saint-Gaudens in Madison Square Park in New York City. Wodiczko's subjects are also from countries riven by civil war, including Syria, Guatemala, Afghanistan, and Mozambique, but, like most migrants and refugees, they are unlikely to be publicly acknowledged or have the public opportunity to give testimony on the life-changing events they have suffered and endured. In Wodiczko's twenty-five minute projection, they recount some of their harrowing experiences, in the process conveying something of the horror and trauma of what it means to be stateless and rightless.

On the one hand, *MONUMENT* provides the public with a rare opportunity to hear these stories and creates an outlet for the subjects to share their stories; on the other hand, the work demonstrates in limited measure the massive, ongoing oppression and persecution of peoples in a world of perpetual war and violence leading to forcible displacement, statelessness, and rightlessness.

As migration has become a global emergency, with more than eighty million people forcibly displaced (either within their home countries or outside of them, according to the UN Refugee Agency), another contradiction is highlighted. In 1948, the United Nations General Assembly adopted a Universal Declaration of Human Rights that asserted, "Everyone has the right to leave any country, including his own." But most countries today, including the United States, attempt to limit the influx of immigrants and asylum seekers, building border walls and detention centers. What good is the right to emigrate if it cannot be fruitfully exercised?

Perhaps, then, the biggest contradiction raised by Wodiczko's work is the contradiction of democracy itself, which is central to the ideological framework of his practice. What kind of democracy will provide social justice for all? Can equality and freedom be brought about within capitalist bourgeois democracy? Or does democracy under capitalism always privilege the few over the many in a hierarchy of class, race, and gender that will always keep the subjects of Wodiczko's projects somewhere near the bottom?

Democracy is not democracy, argues philosopher Michael Huemer, if it is exclusionary. Bourgeois democracy, however, has always been exclusionary.[1] The United States was founded on the notion that "all men are created equal" but excluded Black people, women, and Indigenous peoples from this equality. Indeed, it was founded on and coexisted with a system that enslaved millions of Black people and that continues to subordinate their rights to this day. Rather than criminalize migrants and refugees and militarize national borders, free movement and open borders would construct people not as "illegal aliens" or enemy invaders but as global citizens and neighbors with human rights. But that would require the construction of a different kind of democracy.

The paradox of contradiction thus offers an opportunity for radical critique and critical dialogue on the politics of social struggle and the route to a better future. We might see this as a central function of interrogative design. Wodiczko's works rupture a sense of public complacency, focus on the marginalized, and point to the growing catastrophe of forced displacement in its various forms while offering a means, a platform, however temporary, for the other to speak, to become visible, to exist in the public sphere and to assert their humanity and their right to have rights.

2.18 Krzysztof Wodiczko's *MONUMENT* (2020) projected in Madison Square Park in New York, on the statue of Admiral Farragut.

3 Participation

Another distinguishing feature of interrogative design, one that I have used in my own projects, is its participatory processes. Interrogative design invites outsiders to co-develop projects. Interested parties activate social processes, animating the work with a growing circle of participants who are at once both audience and authors, simultaneously performers and designers. Participatory interrogative design enables projects to live longer, developing various collective memories in and around the projects, furthering the social transformations activated and inspired by the projects.

Community involvement in interrogative design takes a variety of forms, from institutional collaboration to social work, from legal consultation to public promotion. These sessions involve collaborative design charrettes where the project is co-created with external participant-designers. Other sessions involve participants on a more documentary level through interviews, storytelling, and testimonies.

Involving communities in creative processes may be familiar to professional designers under other terms such as ethnographic research, project reviews, public feedback meetings, and user testing. In commercial parlance, "stakeholders" provide creative input. However, the term "participatory design" takes these arm's-length approaches a step further by bringing users into projects as designers. These participants have substantial input into the finished product, taking ownership of its outcome. They bring detailed firsthand subject matter expertise to the table and are invited into design meetings where they work with the core designers to build and test prototypes, shaping the project. Users, in participatory design, become co-designers.

Working with an external community to affect the form of a project is also a feature of *crowdsourcing* and of training machine learning models on public data. A common technique in commercial software, crowdsourcing allows networked systems to offer services, forms, and experiences through the aggregation of large amounts of public user data. Designers generate public participation, gleaning information and repackaging it for other users. Media companies such as Google and Facebook use crowdsourcing to provide the bulk of the content for their media services, as does the online encyclopedia Wikipedia. Artists also use this technique.

• **Nitin Sawhney**: Participatory design often implies common purpose, motivations, stakes, and equitable dispositions among participants engaging in a consensual process toward amenable design outcomes. When participatory design emerged as a practice in Scandinavia in the 1970s and 1980s (originally referred to as cooperative design), it was motivated by Marxist ideals to empower workers in labor unions by fostering greater inclusion and democratic decision-making for the introduction of new technologies in the workplace. Yet for people to feel more empowered in the process, participatory design must spur an action agenda and an explicit political-ethical orientation that may allow them to better engage their civic rights, challenge power relations and constraints imposed, and negotiate potential conflicts emerging.[14]

Much of how participatory design is practiced today, particularly in industry and design consulting firms (but not necessarily in community-based contexts), may unintentionally support neoliberal ideals of individualization and depoliticization, while implicitly ignoring or responding poorly to the complex cultural and collective social contexts that may embed many forms of antagonism and agonistic pluralism, as Chantal Mouffe has suggested.[15]

While participatory design practices often engage individual stakeholders, they offer less recognition of the political capacity and processes of engaging institutions as inherent to the participatory process; this notion of institutioning expands participation in the public realm, offering macro-level frames for policy and action.[16] The turn toward focusing

depoliticizes participatory design by inhibiting participants and designers from seeing the wider societal implications of their work.

As participatory design methods have moved from the workplace to public spaces, designers have started to question how these types of engagements create more heterogeneous terrains of stakeholders and contexts, and how they reflect local democracy in relation to these challenges.[17]

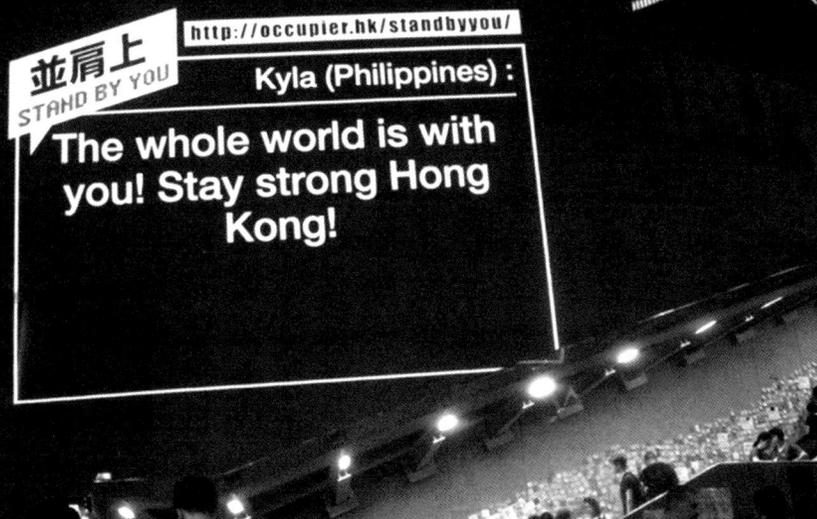

3.1 Add Oil Team, *Stand By You* (2014).

Orkan Telhan's 2013 project *United Colors of Dissent* enabled pedestrians in Istanbul and other cities to vote on topics relating to personal and political freedom using their cellphones. Their aggregated responses were shown on the facade of a public digital advertising board. The project created an alternate communication channel in civic spaces within political environments hostile to free speech. Telhan uses crowdsourcing to advance the aims of civic participation in public space.

A similar project took place in Hong Kong during the 2014 Umbrella Movement protests. *Stand By You* was a public projection project by the Add Oil Team which broadcast a live Twitter stream of messages in support of the protests onto the Hong Kong legislature building. Over 30,000 messages were projected onto the building.[1]

Despite these notable uses of crowdsourcing in artistic contexts, crowdsourcing in the commercial world is not always as empowering as it may seem. Nicolas Bourriaud writes:

> Today ... the individual has shifted from a passive and purely repetitive status to the minimum activity dictated to him by market forces. ... Here we are summoned to turn into extras of the spectacle.[2]

The "minimum activity" of civic engagement offered by crowdsourced platforms such as Facebook and Twitter pales in comparison to more active forms of civic participation offered by face-to-face assembly. Both physical and virtual space are important spheres of influence for any cultural project, but in-person communication helps people build reciprocally trusted connections. In a public protest, people see and meet one another, building "mutual knowledge." (I know that you know that I know, and you know that I know that you know.)

Harrell Fletcher: I would add art and social practice, which is the term used for the kind of art that I teach and that I have been doing for over twenty-five years (though the term emerged less than twenty years ago). Art and social practice, unlike studio/gallery art, prioritizes collaboration, participation, coauthorship, interdisciplinary approaches, and working in both art and non-art contexts.

3.2 Orkan Telhan, *United Colors of Dissent* (2013).

3.3 Orkan Telhan, *United Colors of Dissent* (2013).

It is no surprise that totalitarian societies make great efforts to restrict public assembly while encouraging online communication though carefully managed online media.[3]

While crowdsourcing gleans shallow amounts of user input and sensor data through a project, and participatory design involves users within the design process itself, interrogative design goes further, connecting these two techniques. It uses participatory processes to design communication objects.

Other participatory techniques include portraiture, documentary interviews, ethnographies, oral histories, storytelling, workshops, street theater, and participatory performance. While portraiture traditionally involves a direct depiction of a human subject as the work itself, interrogative design is interested in tools and systems that mediate the person's subjectivity. The means through which a subject is depicted is as important as the images themselves. Interrogative design is the apparatus for a portrait-like experience rather than for portraiture itself.

Unlike documentaries, interrogative design does not assemble participants' stories in service of another narrative. It seeks to empower participants' speech as speech. Participants' testimonies are the final narrative of the work. Works of interrogative design are media for speaking through and speaking with. They focus and amplify the speaker's voice.

If interrogative design is only tangentially related to portraiture, it does hold some connections to participatory art—a practice Claire Bishop defines as one where "people constitute the central artistic medium and material, in the manner of theatre and performance."[4] While interrogative design may focus on the

• **Harrell Fletcher**: I disagree with the idea that people are the medium or material in socially engaged art; instead I see people as collaborators and participants who have various levels of agency as part of socially engaged art projects. A medium or material does not have agency.

• **Ben Wood**: The nature of projection, ... particularly in a society with so many different stories and cultural experiences, becomes an exercise that is too large and too difficult to tackle from a single viewpoint. If these issues and stories are to reach individuals on the street and public level then voices need to be heard from more than one source or person. Because of this there is a need to collaborate with individuals and interested groups, via projection as a means to explore and present constructed animated realities that allow viewers to receive and access alternative viewpoints and histories.

Video projection lends itself to presenting these forms, old and new, together into a structure that is conducive

to talking about time and place. ... Projections are an ideal electronic cinematic form that enlivens architecture and public space with multiple layers of physical, social, historical, cultural, and civic engagement.

• **Harrell Fletcher**: In Portland State University's Art and Social Practice MFA we promote the idea of there being three "audiences": the first is the artist and any collaborators and participants, the second are people who experience the project directly but were not a part of its creation, and the third are people who experience the work in mediated form, which could be word of mouth or on the web or in a publication or lecture, etc.

construction of a physical object, people are always central. Their participation is co-crafted, and their participation enacts the work.

The interface between people and the designed object is important. Interrogative design produces communication *instruments*. These objects serve as ruptures in everyday life and as prosthetics through which participants speak. They also serve as visually memorable markers of larger social concerns. Bishop calls artifacts like these a "necessary link between the artist and a secondary audience (... everyone else who didn't participate)."[5] Interrogative design objects are links to larger social movements.

Everyday commercial objects are meant to be "consumed by a passive bystander."[6] Interrogative design subverts the nonstop shopping environment of public space with a technique Wodiczko calls "scandalizing functionalism." Objects are finely crafted and suggest the satiation of some consumer desire yet interrupt daily life with uncomfortable truths: the voices of marginalized people, unresolved historical injustices, present-day crimes, fractures in unwritten rules.

Participatory art projects tend to insist that "there must be an art of action, interfacing with reality, taking steps—however small—to repair the social bond."[7] Interrogative design objects redirect consumerism, precipitating new questions in search of better conditions of life.

Interrogative design addresses the question of "social impact" by involving community groups. This separation of responsibility enables artists to make better art and the organization to reinforce positive social outcomes. Rather than an artist trying to do both by entering "a realm of useful, ameliorative and ultimately modest gestures," interrogative design takes a collaborative approach.[8]

The participatory art technique of "authorial renunciation"[9] (a practice similar to crowdsourcing where "individual authorship is suppressed in favor of facilitating the creativity of others")[10] is less common in interrogative design, where the focus is on producing artworks whose "potency derives from [their] singularity, rather than from [their] exemplarity as replicable models."[11] And herein lies one of the tensions of this book: how to adopt a methodology which itself resists replication?

Interrogative designers design their own group participation processes. Matthew Mazzotta calls his the "outdoor living room." Wodiczko calls his the "Inner Public." In the latter, a set of external participants join the project and straddle the roles of co-creator and audience member. They are an early-stage public that interacts with the project and helps respond, critique, build up, and speak through the project before it is shared with the public at large (the "Outer Public"). Wodiczko's process follows approximately eight stages, which are described in detail in the essay "The Inner Public" in this section.

By contrast, design researcher Sasha Costanza-Chock takes a less artist-centered approach and instead builds around a decentered network of collabora-

tors. The Design Justice Network she co-founded formed a set of ten guiding principles for community-based design projects that respond to the needs of marginalized people.

Design justice rethinks design processes, centers people who are normally marginalized by design, and uses collaborative, creative practices to address the deepest challenges our communities face.

1) We use design to sustain, heal, and empower our communities, as well as to seek liberation from exploitative and oppressive systems.

2) We center the voices of those who are directly impacted by the outcomes of the design process.

3) We prioritize design's impact on the community over the intentions of the designer.

4) We view change as emergent from an accountable, accessible, and collaborative process, rather than as a point at the end of a process.

5) We see the role of the designer as a facilitator rather than an expert.

6) We believe that everyone is an expert based on their own lived experience, and that we all have unique and brilliant contributions to bring to a design process.

7) We share design knowledge and tools with our communities.

8) We work towards sustainable, community-led and controlled outcomes.

9) We work towards non-exploitative solutions that reconnect us to the earth and to each other.

10) Before seeking new design solutions, we look for what is already working at the community level. We honor and uplift traditional, indigenous, and local knowledge and practices.[12]

This approach to participatory design is highly process-oriented. While traditional projects may require a primary design authority or artist to guide and complete a work, projects that follow Costanza-Chock's process are less particular about the outcome than about the politics and values that form the making of a work.

Your own process may be substantially different from interrogative design, design justice, speculative design, or any other methodology. Any project that uses public or semi-public participation with social organizations can produce strong results. To make a project that is really a work of art, however, may require what Claire Bishop calls "the creation of singular acts that leave behind them a troubling wake."[13]

The Inner Public

Krzysztof Wodiczko

Excerpted from Field: A Journal of Socially-Engaged Art Criticism, Spring 2015

FIELD

A JOURNAL OF SOCIALLY-ENGAGED ART CRITICISM

The Inner Public

Krzysztof Wodiczko

In this essay I would like to elaborate on the specific kind of public that emerges in my projects and that is generated from within the process of social and technical production of these projects. I call this public the Inner Public. The Inner Public is critical to project participants' testimonial role and to the social integrity and complexity of the projects. For the participants, and for the development of the projects, the group and network of people who constitute the Inner Public function as the projects' first audience and informed interlocutor. The Inner Public also plays a role as secondary witness and as an emotionally involved "fearless listener," without which the participants' stories and testimonies – my projects' foundation – cannot be developed and shared. Participants receive moral support and tactical advice from the Inner Public, and, considering the risks attached to their acts of public truth-telling, a sense of protection. Participants are the nucleus and the core of the Inner Public. Through its involvement, the Inner Public generates the development and transformation of the projects. In sum, the integrity of any project, in all the stages of its production, including its public reception and its social afterlife, depends on the testimonial role of the project participants and the audience function of the Inner Public.

Project Participants as Collaborators

My works in public space include participatory projections-animations of urban monuments as well as the performative use of specially designed communicative equipment. These projects'

• **Editor:** Wodiczko mentions here his projection projects; however, in this book I have focused on interrogative design's relationship to industrial design, object-making, and Wodiczko's "specially designed communicative equipment."

FIELD 1 | Spring 2015

purpose is to inspire and assist the people who choose to take part in them to become present day *parrhesiastes* (free, fearless speakers) and social agents.[1] By extension, the aim of these projects is to contribute to the process of animating the city as a site of agonistic public discourse and dynamic democratic process.[2] The most critical aspect of my projects is the process of involving, inspiring and assisting participant-collaborators in the development of their capacity for sharing and critically communicating their experience in a frank, fearless and emotionally articulate way. Through these projects they performatively tell the truth of their lived experience, not only on behalf of themselves, but also, as emergent social agents, on behalf of others who have lived through and continue to suffer unjust conditions of life, but do not have the advantage of such communicative media.

In most discussions about my work the focus is on the spectators rather than on the participants who are the key contributors to my projects. This is due to the fact that my projects are treated as spectacles or public events–something that is developed solely for the perception and reception of the so-called "public." Consequently, those conversations that refer to my projects tend to focus on questions and matters concerned with the "reaction of the public," the "audience's response," and further, of the "public impact" of the works. These issues are important, but in my view, divert attention from most of my projects' social and artistic objectives. When people examine my projects from an external perspective (that of the spectator), they risk missing the point of view of its inner workings and the projects' focus on the participants as project collaborators, performers, truth-tellers and testifiers. The external perspective also misses the psychologically developmental and aesthetic aspects of the formulation of public witness testimony.

To be fair, the limited focus on public reception is in part understandable, given that those who comment on a work are often not aware of the process that goes into the project's development. Since many participants desire to remain anonymous, and, due to the psychologically sensitive process of recording testimony,

28

• **Nitin Sawhney:** In a deliberative democracy participation is governed by the norms of rational discourse, equality, and symmetry. This assumes that all participants have the capacity and right to initiate and engage in "speech acts" that question, interrogate, and argue their own positions freely and without coercion. Seyla Benhabib[1] invokes a sound critique that these idealized social conditions rarely exist in most public spheres. Even when they do, it presumes that participants must engage within the norms and procedures prescribed for such discourse, which in itself sets a condition for a power imbalance and biases the space of possible outcomes.

Chantal Mouffe proposed agonistic pluralism as an alternative to deliberative democracy, explicitly acknowledging power and antagonism as inherent "political" characteristics of the public sphere. In a pluralistic democracy there needs to be room for dissent and for "conflictual consensus" to manifest as real alternatives to imposed dispositions, forced choices, and tokenistic participation. An agonistic democratic approach allows us to confront the multiplicity of voices and complexity of power structures embedded in a pluralistic society; the challenge is how to transform "antagonism" into an "agonism." Mouffe believes that for democracy "agonistic confrontation is in fact its very condition of existence."[2]

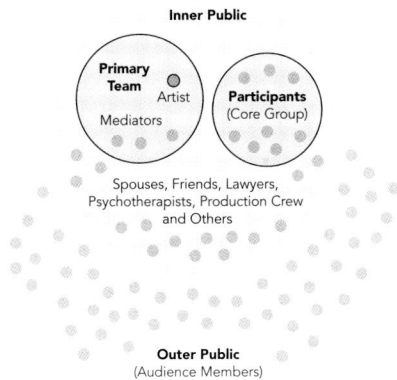

3.4 Schematic diagram of the Inner Public process.

• **Sara Hendren:** Lygia Clark is another artist whose interests also emphasized the useful and poetic registers of the things she made. Part artist and part art therapist, her work was also an unresolved dialogue between the artifacts' inner and outer meanings, for both their "users" and spectators.

the inner perspective of a project's development often cannot be shared. Thus, the work is perceived externally, on the basis of its final public presentation and in terms of video documentation. The focus on the final appearance of the projects misses what I consider to be the main point of the work: everything that is human and social and that contributes to the making of the project *before* the final moment of its public presentation and reception. This includes, among many other aspects, the initial meetings with the people who may take part in a project, the long process of their self-selection, the elaborate process of recording and re-recording testimonies, related conversations and discussions, as well as other developmental stages of the project–usually referred to as "preparatory" material.

In most theoretical and critical discussions of public art, there is rarely any emphasis placed on the value and meaning of projects for those who invest lived experience in them. However, a grasp of the psychologically developmental, therapeutic, educational and performative procedures of these works is crucial for understanding the social objective of such projects. In this essay I would like to recount the basic developmental stages of the process involved in making any one of my projects. This, I believe, is important for understanding not only the method of my work, but also the method of other artists' whose projects involve working with people. It's impossible to develop a more sophisticated account of methodology until we move beyond the narrow focus on audience reaction that is typical in much art criticism. Such a limited, external focus, seemingly insightful and no matter how well meaning, reduces the scope and understanding of the project. Considering the kind of work I do, I would much prefer if a more appropriate question was asked, such as: "What was the meaning and the value of the project to those who choose to speak, perform and address the public through it?"

To save one soul in a city by inspiring and assisting someone to break their silence and publicly share, address and denounce unacceptable conditions of life is to save the entire city. By salvaging

29

64

FIELD 1 | Spring 2015

and expanding the inclusiveness of the city's democratic process and its public space as a site of critical discourse, the people who choose to be part of a project are not merely 'participants,' since such word would suggests too passive a role, but are active agents who take the project to heart and contribute to it by putting themselves on the line. For this, they must also develop an artistry—sometimes to the point of performative virtuosity—in making use of these projects in public space. A self-selected group of such collaborators and performative users always plays a fundamental role in each project. If they succeed in making sense of the project for their own lives and the lives of others, it is their success. If they do not succeed, I consider it my failure.

Krzysztof Wodiczko, *The Tijuana Projection* (2001). Organized and commissioned by INSITE 2000, part of the project in the Border Art Festival of San Diego and Tijuana. Photo courtesy of Krzysztof Wodiczko.

30

• **Nitin Sawhney:** An artist who is external to a community, as is often the case with Wodiczko, takes a great deal of risk in undertaking a participatory and site-specific artistic work, both in terms of its aesthetic trajectory which cannot be fully planned in advance and its impact on the potential inner and outer publics. Building the trust of the initial core participants, facilitating an open discursive space with sensitivity, and allowing a plurality of agonistic "truths" to emerge is key to generating authentic participation and the kind of "fearless witnessing" and "fearless listening" that Wodiczko seeks in his work.

A crucial factor is the nature of self-selected participants or collaborators who are drawn to such projects in their early stages and the agency they have in shaping the work and engaging others along the way. They have the potential capacity to legitimize the project by leveraging their own "subcultural capital" to draw in other participants in their own communities, in essence mediating the inevitable distance the artist must bridge in expanding the inner and outer publics involved and transformed by the work.

This expanding network of core members who take ownership and believe deeply in the values of the project also shields the artist from public media critique to some extent and supports newly engaged participants in navigating traumatic memories or difficult experiences they may encounter. Hence, the creative, emotional and subcultural capital invested by the core group of members can have a deeply transformative effect on the success of such public artworks that operate on large-scale and place-based social contexts in the city.

- **Harrell Fletcher:** [The Tijuana Projection] was extremely inspiring for me when I first heard about it and saw some limited documentation. Though I had been a fan of Wodiczko's earlier monument projections, the participatory nature of [this] project took the work to another level. It showed how powerful it could be to combine visually stunning forms with social engagement.

- **Ben Wood:** Particularly accessing monuments and memorials of historic significance, this approach offers an opportunity to reflect upon multiple layers of history, memory, and meaning.

 What does the monument remember? What would happen if the monument had the chance to speak about the horrors to which it has been eyewitness? What would be its testimony?

 In my own work, each project begins with deep, sustained, and immersive research related to all aspects of the site, its history and context. This naturally includes a consideration of both the site's past and its future—and the communities served.

 How are we to excavate this history within the monument? How may we reveal the untold or unknown story of the monument?

- **Dana Gordon:** The process became the message. The whole view of a design project could be totally inverted—the aesthetics in its physical final form evidently became secondary to the process of creation and its participatory nature. Change was actually happening while creating—performing a healing session with the people as we build together, not only a tool as a "thing" but also an event, a performance, with its direct confrontation and immediate personal implications.

Two Publics

Two kinds of publics are constituted by each project. The first public is internal. It comes from within the project and is formed through the discourse generated by and accompanying all the social and technical stages of a project's development, research, production and postproduction. I call this the *Inner Public*. The second public is external as it comes from outside the project and encounters the project in its final or near final form, through its public tests, final presentation and through the unfolding public discourse around it. It becomes a witness and an audience to what is presented as a final work, a result of the workings of the *Inner Public* itself. I call this second public the *Outer Public*.

In the development of each project, my primary focus is always on the formation of the *Inner Public*. The measure of a project's success is its capacity to inspire, assist, and protect the development and transmission of the public voice and expression of those who choose to take part in it. As they gradually begin creating and perfecting the project's narrative and master their communicative performance they become its formative force—its primary contributors. The formation of an *Inner Public* begins with a small group of potential contributors. This Core Group serves as an "avant-garde" in the formation of the *Inner Public*. These few people, three or four of them, encourage others to join the project. Even if later in the process of producing a project one of two of its members drop out for some reason (as it happened in the case of one of the projects I'll discuss below, produced in Tijuana), their formational function is crucial. The Core Group is not only a nucleus, it also serves as a reservoir from which the "participants" are recruited and the *Inner Public* further developed.

The Core Group benefits from the support of a team that develops a strong trust towards the project and, in this case, consisted mainly of the head of Factor-X, a Tijuana-based worker's rights organization, and her co-workers, as well as a group of family members and friends who provided hidden, behind the scene

31

66

FIELD 1 | Spring 2015

informal support. Lawyers, curators, production and postproduction teams and of course myself are a part of the Core Group's support system. The process of decision-making regarding each step in the development of a project is shared by all parties. The project's discursive dynamic is an important aspect of the project because it brings to it both the inside and the outside perspective. Considering this dynamic, the Core Group, thanks to the formal support team as well as the informal support network that operates behind the scene, becomes the nucleus of the first public of the project, its *Inner Public*. The *Inner Public* is born of the project and acts as its foundation and vital force. Its role as social agent may go beyond the support that is offered to project participants because its members are connected with other social support groups and networks through which they may add critical support and an informed perception of the project.

The Inner Public

The project and the formation of the *Inner Public* begins as soon as those who keep coming to a project's initial meetings begin to discuss it and consider their potential involvement in it. This is usually a small number of people to whom the idea of the project has been presented. Often, they are initially suspicious of the project, for fear of being manipulated by it. At the same time, for some, their curiosity and intuitive interest contradicts and challenges this suspicion. Taking a leap of faith they may eventually choose to endorse the project's overall cultural aim and consider the possibility of joining it. Without fully knowing why, they are gradually drawn to the idea of contributing. Overcoming or at least temporarily putting aside their initial suspicion, they open up to the project and consider the possibility that in some ways it will be useful to them. At this stage, their role shifts beyond being mere participants. Rather, they become co-creators as they gradually become involved and invested in developing the project. Initial discussions become increasingly sharp and articulate and exchanged stories gain in honesty, fearlessness and emotional charge. What is said, and how

32

3.5 Krzysztof Wodiczko's *Tijuana Projection* helmet camera apparatus (altered for clarity).

3.6 Krzysztof Wodiczko's *Tijuana Projection* facade projection mapping (altered for clarity).

• **Sara Hendren:** Artist Tania Bruguera has famously said that she wants her work not to be "an art that points at the thing, but an art that is the thing." This is a central tension in much social practice and worth considering for all cultural producers who are interested in "use value" as part of a cultural exchange. How much of the work is a signpost? And how much does it deliver in and of itself?

it is said, connects the participants' existential experience with a critical and political perspective.

As meetings proceed and are attended by new potential participants, who are often accompanied by their friends and families, the Core Group of those who are now fully committed to the project emerges. This group becomes the core of subsequent meetings. Every participant deliberates over the possibility of their direct or indirect, "behind the scene," involvement in the project by gauging what they might gain from it, emotionally, socially, and culturally. They take into consideration not only their own gain but also the project's social impact on others and on society at large. In this way, regular meetings are extended by other contacts and gatherings, behind the scene, which trigger the focus of the *Inner Public* on matters that are often kept private, hidden, or suppressed, and which then become issues of political and public significance. Despite the fact that the project's working meetings unfold within places that are not "public" and are that are invisible to the "outside world," these discussions are nonetheless part of the larger public discourse. This is because of the "publicness" of the project and the fact that issues that are normally hidden but that are then shared, exchanged and passionately deliberated are the very heart of these meetings.

Engaged in this discourse, members of the initial group finally confirm their "participation" in the project. They have come to perceive the social need for revealing in public the hidden truth of their lives, and they do so on behalf of themselves and others. They see the value of the project as a vehicle for such testimony. They also feel that through the project they can connect or re-connect with the larger society and in addition gain communicative skills. In this way, the Core Group of the project's *Inner Public* is formed. In further stages of the development of the project, and as a result of its social inclusiveness, this Core Group of the *Inner Public* will greatly expand. When expanded, the *Inner Public* will engage others who are not directly involved but who are supporting those who attend the meetings. Through its connections with the

Presentation to Institution

↓

Intra-institutional Connections

↓

Presentation to Mediators

↓

Initial Presentation to Participants

↓

Surviving Destruction

↓

Truth-Telling Workshops

↓

Inner Public Expansion

↓

Presentation to the Outer Public

3.7 Sequential diagram of the Inner Public process.

FIELD 1 | Spring 2015

broader city population, the *Inner Public* becomes an informative and supportive force affecting the reception of the project on the part the *Outer Public*.

Stages in the Formation of the Inner Public

The *Inner Public* is formed through the following successive stages. The idea of the project is presented to an art institution that is experienced in the production of media-based projects in public space, such as a media art center, public art festival, museum, etc. The institution then establishes an initial connection with those social support organizations that are most relevant to the project, be it a war veterans' association, a homeless center, a *maquiladora* workers association, an immigrant support center, or a transitional social housing service. These organizations in turn involve their cadre of social service workers as potential collaborators. The proposed project is then presented to other members of the organization. As the first objective of these workers is to protect and help the people they serve, they will likely raise many questions and concerns regarding the participants' safety and the project's concrete cultural, social and psychological benefits for the participants. These issues must be further discussed with both the social workers' superiors and with the art institution.

In the case of the Tijuana-based project, staged at El Centro Cultural, the process of determining the subject matter for the work, as well as identifying a potential urban site and learning about and discussing possible options and issues, included, among other contacts, the head of a team of social workers at Factor X, an urban sociologist from the University of Tijuana who's work focuses on the situation of Maquiladora workers in Tijuana (specifically addressing violence against women and their social and legal supporters by factory managers, the police, and unemployed men, and against police by drug cartel's etc.), and some very initial but important contacts with female maquiladora employees. The idea of creating

• **Editor:** The development of an Inner Public follows approximately eight developmental stages. Not all works of interrogative design adhere to this process; however, you may find this useful.

1) **Presentation to Institution**

The first step in an interrogative design project's public life is the introduction of the project to an art institution experienced in public projects, such as a media art center, festival, or museum. Having a host organization enables the artist to have a center of operations and to make use of an existing network of support systems to facilitate the building-out of the project.

2) **Intra-institutional Connections**

Next, the art institution is encouraged to work on behalf of the artist to create connections to social support organizations aligned to the interests of the project. In Wodiczko's case this included "a war veterans' association, a homeless center, a maquiladora workers' association, an immigrant support center, or a transitional social housing service." These connections are crucial in providing intermediaries who can represent the project to a wider community.

34

3) Presentation to Mediators

At this point, the project is presented to a small group of professionals connected to the institutions involved. Some back and forth is to be expected between the various participants gathered. This exchange can help form important ethical questions that frame the project and set the stage for its further development. A willingness to change the proposed project can help the project survive scrutiny by this group, transforming them from outsiders to part of the inner circle of collaborators.

4) Initial Presentation to Participants

Once the project has passed muster with the inner group of mediators, it is time for the project to be introduced for the first time to an external community of participants. In design parlance these people are both "stakeholders" and "end users." They form the bulk of the Inner Public and will participate in the formation of the project and its content.

a projection-animation at El Centro Cultural, an iconic building in Tijuana which residents call La Bola, and of inscribing speaking faces onto it, developed in response to what I learned from these people. I thought that the idea of projecting, in the most familiar and accessible public space in the city, the magnified faces and voices of these who refuse to hide and be silent, who bravely tell the truth of their lives and share their critical position on the current situation in Tijuana, and who do so through the façade (face) of the most prominent structure in the city, made democratic and "parrhesiastic" sense. My initial sketches presenting this idea were than presented to the above mentioned people and to the curators, to whom I also conveyed my willingness to change the proposed projection idea, should they feel it was for some reason wrong or inappropriate. I was a bit surprised that it met with their approval without much question or worry. During the subsequent preproduction and production meetings the aesthetic direction of the projection itself was seldom discussed or questioned.

If the project "survives" this initial stage of consideration, examination and discussion, and if it promises both benefits and safety, it is now ready to move on and be presented to potential participants by a social worker, by myself and by the project's social production coordinator. Potential participants are initially skeptical and suspicious of being invaded and manipulated by the project. My responsibility is to make clear to them that my aim as an artist is to animate public space with the ideas, experiences, and voices of those who are marginalized from it, for their own benefit and for that of the larger public. It also has to made clear that the specific direction of the project is subject to changes occasioned by the participants' feedback and that the substance of the testimonial, critical and propositional input must come from them and not from anyone else. The participants are made to understand that they will be both the authors and actor-performers of what they say and how they say it through the project.

Despite the above explanations, the integrity of the project is put to the test once again by both the social workers and the

FIELD 1 | Spring 2015

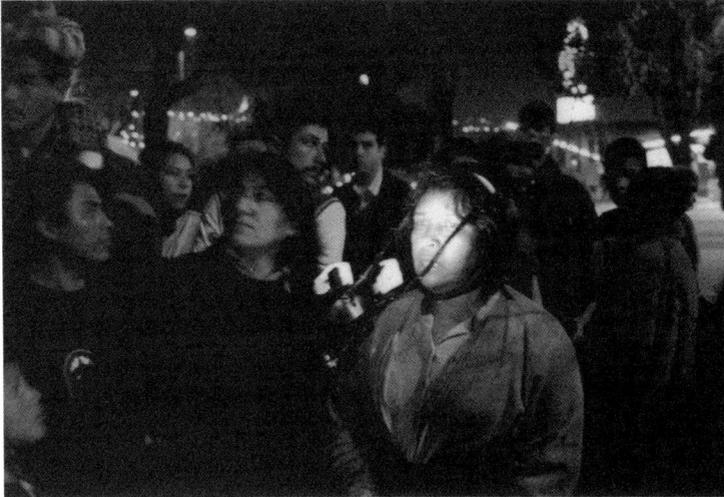

Krzysztof Wodiczko, *The Tijuana Projection* (2001). The headset, equipped with a video camera, LED lights and a microphone allows the wearer to project her face and voice in real time onto the facade of El Centro Cultural in Tijuana. Organized and commissioned by INSITE 2000, part of the project in the Border Art Festival of San Diego and Tijuana. Photo courtesy of Krzysztof Wodiczko.

potential participants who feel curious but still skeptical about the undertaking. While discussions take place some among the potential participants express a guarded interest in joining the project; others no longer show up to the meetings. On the other hand, those who initially claim to have "nothing to say," but keep returning time to time to observe the proceedings, may come to be the most motivated, articulate and frank performers and animators of the projects. Still, the project is in danger of being psychologically compromised and even destroyed by potential participants, who doubt, mistrust, and scrutinize it for having been proposed to them from an external, unknown, and uninformed agent. It is now in serious danger of being rejected entirely. Despite such a self-defensive reaction, the social production team and I continue to

- **Sung Ho Kim:** The *Tijuana Projection* equipment was designed as a protective headgear that counterbalanced the weight of the video camera, LED lights with diffuser lens, and a vocal microphone built into the headgear for the user's comfort. The back support belt was designed to assist better posture and support by allowing the women to use the full capacity of the mobile studio for long durations with flexible movements. The belt held the input and output devices for all audio and video switch boxes. The user's face and voice are projected onto and amplified through the Centro Cultural de Tijuana (IMAX theater). The women who wore the equipment recall their traumatic experiences caused by various abuses. The intention for this projection and the equipment was to give the Mexican women a public voice, to engender self-confidence and alleviate their pains. The *Tijuana Projection* encourages the user to survive and heal through the empowering experience of amplification, the reassociation with society, and the denunciation of gender injustice.

36

• Editor:

5) Surviving Destruction

The primary administrative team of the project must show its resilience. Any project that deals with contentious or emotionally charged subject matter is likely to run into opposition as it develops. The project will be tested by both participants and the mediators. Participants will self-select as the meetings continue. Some will drop out and others may stay and become ardent supporters of the project. A willingness to change to adapt to the needs of the participants is crucial, as is commitment to earning the trust of participants.

organize the meetings, determined that the project will somehow take place.

The obligation of the primary team is to survive this potential destruction and present itself as strong again and again. We may have to present the project to new potential participants as a way to spark the interest and confidence of those in doubt. It is now clear to the latter that they are the ones who must choose the project rather than be chosen by it: no one is going to be rejected but neither is anyone going to be a privileged participant. Upon such realization, the project seems to have survived the danger of destruction. Consequently, its use value has increased as it has begun to be perceived as self-confident, open, inclusive, and durable. As participants understand that the project is in their hands, they become both its users and collaborators. As discussions continue, the participants feel that they are ready to confront difficult matters and take on brave tasks, such as publicly sharing the harsh and often painful truth of their lived experience.

As the proposed project gradually loses its "outsider" status, it is progressively adopted and shaped by the inner world of the Core Group of potential participants. While it still belongs to the outside world from which it originated, it has now become part of the inner world of those who infuse it with their shared stories, testimonies and critical ideas. The project becomes a sort of "transitional object" for the participants who in this way become its collaborators.[3] To secure the project's developmental character, the issue as to whether it is "Wodiczko's artistic project" or the "art of participants testimonial performance," is formulated and brought into discussion by the organizers. It is not raised again, and—in the course of the increasingly emotional exchange and sharing of stories by the Core Group and later by the participants in prerecording and recording sessions—it is perhaps intuitively understood as an inappropriate and potentially disturbing question. The project absorbs the ideas, imagination, and hopes of those who now intuitively feel that they can somehow use it for the betterment of their own traumatized lives, and even further the lives of others like themselves. Some

FIELD 1 | Spring 2015

sense a potential new role and even a mission for themselves as spokespeople and social agents.[4]

The meetings gradually take the form of an experience-sharing and truth-telling workshop, during which some participants write notes in preparation for the video recording. In some instances the project becomes a truth-writing workshop. Because writing is governed by a different part of the brain than the one responsible for speaking, writing helps some people recover suppressed and difficult memories. They may try to read them aloud before recording them for projection or before sharing them with the use of the performative equipment that I design for use in public space. At the same time, outside of the meetings, potential participants discuss the project with their friends, trusted members of their family, lawyers, psychotherapists, social workers, investigative journalists and so forth. They may be in a contact with lawyers (in the case of the Tijuana Projection through the Factor X social support organization) or psychotherapists, art therapists and cultural workers (in the case of Derry-Londonderry project discussed below through the Verbal Arts Center). They debate the meaning of the project and the risk and benefits that further and deeper involvement may entail.

An increasing number of people are now involved as indirect contributors to the project. The *Inner Public* expands in scale and scope beyond the initial Core Group, becomes more confident and committed to the project, and is more open and inclusive to newcomers. As others join the working meetings, the traumatic memories and difficult experiences are now shared and confronted. The project is now ready for further development. Supported by a network of informed and engaged members, the initial Core Group of potential participants has now become an integral part of the growing inner circle of the project–its *Inner Public*. This could include not only family and friends, but also social, legal, and therapeutic support networks, as well as a technical production and postproduction crew, including a film crew, video editing and special interface equipment crew, and a projection, sound and

- **Sara Hendren:** When theater critics evaluate actors, they might speak of a player's level of "commitment" in the work—the measure of alignment between the inner world of the written character and the inner life of the actor herself. In Wodiczko's work, the theatrical frame, even for truth-telling, seems to aid individuals in committing to perform the story they have to tell. The artifice of the designed spectacle and its audiences paradoxically makes that commitment possible.

- **Editor:**

 6) Truth-Telling Workshops
 The bulk of interrogative design projects' development happens through workshops, group discussions, and interviews. This is where one can see substantial transformations in participants through their speaking, and in the public through their listening. The project evolves as its people evolve.
 This group of people represent an "initial Core Group" or people who are now invested in the realization of the work.
 Projects with difficult subject matter use workshops with an "Inner Public" to help build trust and confidence among the participants, between the participants and the artist, and psychologically within participants themselves.

38

The act of opening up and publicly recounting traumatic memories is an important step in the healing process.

> [Pierre Janet distinguished] between two kinds of memory—"traumatic memory," which merely and unconsciously repeats the past, and "narrative memory," which narrates the past as past—[Janet validated] the idea that the goal of therapy is to convert "traumatic memory" into "narrative memory" by getting the patient to recount his or her history.[3]

Further, Judith Herman, professor of clinical psychiatry at Harvard University, writes:

> In the second stage of recovery, the survivor tells the story of the trauma. She tells it completely, in depth and in detail. This work of reconstruction actually transforms the traumatic memory, so that it can be integrated into the survivor's life story. Janet described normal memory as "the action of telling a story." Traumatic memory, by contrast, is wordless and static. ... The ultimate goal ... is to put the story ... into words.[4]

Transforming one's lived experiences into the form of a story to be recounted for others to hear can be an important step toward recovering from a difficult past. Interrogative design offers communications tools that, when appropriately applied, can have ameliorative effects on its Inner Public.

lighting team, among others. At this stage, the formation of the *Inner Public* is complete.

The Inner and the Outer Public

The public media, especially their local branches, as well as socially minded journalists and reporters, tend to focus their attention on project collaborators and other members of the team, giving them voice through interviews. This offers an additional opportunity for the members of the *Inner Public* to share further with the *Outer Public* what they have to say, that is, beyond what has been already said through the projections-monument animations or public performances with instruments. Prepared by their own testimonial work in the project, the project's participants-collaborators-performers may now wish to say more, through radio, television, and the press. In this way the witnesses, listeners and readers multiply the points of conversation throughout the city. This increased mediation injects a pointed content to the exchange of information and views among the members of the *Outer Public*. The project takes place not only during the public presentation but also, and often, during the earlier projection and performances tests, when media people and passers-by stop and speak to the project's performative users, to the crew members, to project coordinators and to other members of the *Inner Public*. Ad hoc discussions about the project's technical aspects switch to questions related to the project's social aspects.

People in the city begin to hear rumors while driving by (stopping without turning off their car's engine). Because "someone was wearing strange equipment" or because there is "something involving the monument," the next day at work, or in some other situation, someone will ask someone else what was happening and may receive a quite informed and passionate answer. The public media, especially the press, use the secondary or ripple response to the project to acknowledge and address the issues that are still

FIELD 1 | Spring 2015

too controversial to expose directly. Rather than "tackle the problem head on," the press takes the opportunity of the projection event or media performance itself and of the availability of direct statements and stories from people who collaborated in it, interviewing each of them (and myself) separately to raise issues with apparent objectivity. Typically TV crews interview the larger, diversified "audience," with the same question: "What do you think about this?" When present at that moment, the members of *Inner Public* often relay the question to others in order to trigger further public discourse and to reach toward the *Outer Public*.

Speaking of the impact of the *Inner Public* on the *Outer Public*, one must acknowledge the importance of "unintentional" contributors, collaborators and users of my projects. In one example, the projection on *El Centro Cultural* in Tijuana, such an unexpected collaborator was a professional interpreter who was commissioned from Mexico City to provide live translation of the unfolding of a real time projection narrative. At one point the interpreter burst into tears, unintentionally interrupting the flow of translation and of public reception. The emotionally disturbing narrative of the projection became emotionally disturbed itself. A large number of people, who had come from San Diego and knew little if any Spanish, and who had been wearing headphones to hear the translation, suddenly took them off. The translator told me later that this was the first time in her long career that she had experienced such an emotional and unprofessional reaction. This was a reaction that came from her heart or stomach, perhaps triggered by some of her own lived experience, a "Brechtian" interruption producing the "alienation effect."[5] She joined the project only at its final production stage but unexpectedly and unintentionally became its crucial collaborator. Her "unprofessional," emotionally charged behavior greatly contributed to the strength of the *Inner Public* and to the project's perception by the *Outer Public*.

• Editor:

7) Inner Public Expansion

Part of the maturation process of interrogative design projects is a kind of symbolic "handing over" of the project from the artist to the community—a process that is part of what Bishop calls "authorial renunciation." The Inner Public becomes attached to the project and claims some kind of ownership over its outcome. This is an important measure of the project's success. Much like Rancière's "ignorant schoolmaster" who advances students' intellectual growth by teaching them that he has nothing to teach them,[5] Wodiczko says in the adjacent text, "If they succeed in making sense of the project for their own lives and the lives of others, it is their success. If they do not succeed, I consider it my failure."

For participants whose testimonies carry great psychological weight and social risk, the project can become what Derek Winnicott calls a "transitional object"—a psychological comfort device that provides a sense of security and helps a subject move to a state of greater independence. Once the project is in the right form and is ready to be handed over, the initial Core Group carries it forward to a growing circle of participants.

The Outer Public as Witness

Even when viewers come to a project as mere spectators, they often stay there not "without interest" and listen to—and hear—painful stories and testimonies. They may stay through repeated cycles in the projection loop for ethical reasons. Despite even the rain, they perhaps feel obliged to listen and watch out of solidarity with those who bravely opened their mouth and spoke out. What is projected is not only the truth of what is said, but also the truth of the very refusal to remain silent about that truth—the truth about the possibility of doing so with emotional intensity, honesty, and with a sense of social mission. Testimony in public space is an assault on the silence about matters that are vital to the city and to its people. Viewers are reluctant to walk away from such a blast of truth. Perhaps they feel obliged to stay because what is said is difficult to hear and because it is painfully true.

It is possible that some spectators regret they were not part of the performance, because they realize its critical and proactive (transformative) dimension. Realizing this loss, they are ready to take on the role of relay, to speak up, to break the silence, and to design a more meaningful way of living with their own trauma. Were they spectators? Were they an audience? Although many may come with the expectation and intention to simply "enjoy" the projection as a "spectacle," they may find themselves drawn into it as unintentional witnesses, co-witnesses or secondary witnesses. They recognize through their own experience the truthfulness of the testimonial narrative of the projection. Staying with the projection, these viewers both reveal and publicly confirm the accuracy that is transmitted by the project's stories, testimonies and statements. Through their emotional focus on the projection, they build an empathetic bridge between themselves, as members of the *Outer Public*, the participants and the *Inner Public* of the project. Through their "fearless listening" they add to the credibility and the truthfulness of the project. Despite emotional difficulty, and even sometimes the rain, these committed and well-informed

41

• Editor:

8) Presentation to the Outer Public
Now the project is ready for public presentation and the work will become a live vehicle through which the Inner Public speaks to the Outer Public. The long period of preparation of the Inner Public helps when the media attention turns these participants into spokespeople for the project. Their rehearsal of testimonies and interpretations for other members of the Inner Public helps give them the confidence to speak to the city and beyond once the project opens up to the wider (Outer) public.

FIELD 1 | Spring 2015

people give an example to others to stay and bear witness. They become true contributors to the project and help build the civic consciousness of the *Outer Public*.

"Fearless Speaking" Requires "Fearless Listening" and Vice Versa

The projection at El Centro Cultural gained momentum when the project participants spoke through special wearable equipment to project their faces and voices "in real time" onto the gigantic façade of El Centro Cultural in front of the assembled crowd. They were encouraged when sensing the supportive focus and fearless listening commitment of this special and large contingent of the *Outer Public* and this added to their confidence and the emotional force of their fearless speech. This added to the external "moral support" received by participants by trusted and emotionally supportive social workers, friends, family members, lawyers, and others from the project team and larger network of the *Inner Public* who came to encourage and protect them. My own participation was temporary of course, but continuity was created through Factor X, a Mexican government sponsored organization that teaches the maquiladora workers about their human, legal and political rights, especially these relate to labor relations, which supported the project. They continued to use the original footage of the projection's testimonial videos as well as the video documenting the actual event of projection long after the projection event to solicit new members, to educate them and trigger their engagement. It was also used by Factor X social workers as part of their case studies presentations at national and international conferences on Maquiladora labor and border economy. This is another example of the influence of the *Inner Public* on the *Outer Public*, this time in terms of the "afterlife' of the project.[6]

- **Ani Liu:** The first project that I ever saw of Krzysztof's was the interviews with maquiladora workers in Mexico, and I wondered, could this also be a little bit exploitative, because what happens to these people who share their intimate truths for this artwork? I imagine the process to be so cathartic, but then the artist leaves and the art exhibition is finished. But then what happens to the worker, who has a possibly therapeutic experience, but then where does it leave her? Can she be employed again in that town? That was actually something that I talked to Krzysztof about. Through him I started to learn the art of this type of empathetic, nuanced, and delicate collaboration. The art of having difficult conversations that transcend an interview. To try to figure out what the other party needs, and to be respectful in the capture of it. He goes there for a long time, to be a part of the fabric of a community, so that it's not so in-and-out.

• **Editor:** This section provides an example of how interrogative design projects can contribute to peace-building efforts.

Case Study: Public Projections in Derry-Londonderry, 2013

As was the case in Derry-Londonderry some participants may need to seek the approval and endorsement of larger groups of people before the can make a final commitment. They may need the approval of the segregated and embattled parts of the city where they themselves live and work. Participants, especially those involved in social work, have done this so as to protect their families, the people with whom and for whom they work, themselves and the project from violent repercussions. They present to others the larger benefits of the public dialogue that the project is hoping to encourage, and defend it against sectarian mistrust and opposition. Again, in the case of the Derry projection, dialogue was especially difficult and critically important, since it was based on and relied upon the participation of people of all ages from both the Republican and Loyalists communities, many of whom, in the not too distant past, were fighting and killing each other in a protracted civil war. Radical groups and militants from each side of the conflict were ready to threaten the project by posing the risk of violent attacks against participants and the larger public.

According to the account of a cultural worker from the Verbal Art Center, a cultural center responsible for co-organizing the project, and thanks to the engagement of the participants, community workers and activists, at least five hundred people from Protestant and Catholic parts of the city were involved behind the scene as part of the project's social and political support. These five hundred people greatly multiplied the *Inner Public* well beyond the twenty-two core participants (from both Catholic and Protestant communities). This was in addition to the similar number of people on the social, cultural and technical production team plus their friends and families as well as these who could not participate but were "around." The Derry City Council did not expect that the project would receive such broad social support. Its members were not aware or were not confident about the potential benefits of the

43

FIELD 1 | Spring 2015

Krzysztof Wodiczko, *Public Projection for Derry Londonderry*, Lumiere Festival, Derry-Londonderry, Ireland. Produced by Artichoke, Commissioned by City of Culture 2013, photograph by Maria Niro. Photograph courtesy of Krzysztof Wodiczko.

project, secured by the very process of its production via an *Inner Public*, and expressed fear that the project would cause violence rather than encourage an open and inclusive dialogue in public space. The fears increased when the City Council was informed by Sinn Féin, the political wing of the Irish Republican Army, that it "cannot protect the project" against threats of attacks from militant paramilitary groups in the city.

Despite such a tense situation, the risk of violence diminished because of the support that was gained by the participants from their inner circles and because of the positive impact of informal community meetings that engaged influential groups from Catholic and Protestant sections of the city. Generated in this way by an *Inner Public* of nearly six hundred people that represented two

very different religious and political views, the project's method acted as a security blanket and buffer zone for the development of it's final presentation, when members dissolved potential violence by invisibly but effectively mixing with the *Outer Public* at various sites of projection. They did this by merging into the "audience," (*Outer Public*) during the projection without being recognized as members of the *Inner Public*. They would engage in conversations with spectators, "infiltrating" them with a more refined or informed perception of the project based on an understanding of the projection as a cultural contribution to the necessary work of an open and inclusive engagement with the memory of the civil war. People endorsed and protected the project as a cultural vehicle for the creation of an inclusive public space and for the transformation of a dangerously segregated city into a common place. They supported the use of public space for symbolic, nonviolent exchange, open to opposing views and beliefs, including the traumatic memories of The Troubles (the civil war in Northern Ireland).

With the support of its *Inner Public*, the project was ready to become a transitional zone in conflict transformation that could contribute to a positive peace process, based on open, "agonistic" memory discourse and not on the idea that this violent history should be segregated to public silence and private sectarian talk.[7] As a result of the presence and influence of the *Inner Public*, the violent members of sectarian groups from the *Outer Public* lost their social support and could not attack the project. Projections were staged at the Derry Corner, a site charged with the memory of Bloody Sunday and of the beginning of The Troubles. The project demanded an emotional focus on the voices of the participants who expressed opposing points of views, critical interpretations of the past and the present, and ideas about the future. By listening to disturbing memories and testimonies, the *Outer Public* actively engaged in agonistic memory and no violent reactions against the project took place. And so, the fears of the City Council and the warnings from Sinn Féin proved to be unfounded

45

FIELD 1 | Spring 2015

Case Study: El Centro Cultural Tijuana, Baja California Norte, Mexico, 2001

For the El Centro Cultural projection in Tijuana, there were eight core members who finally chose to join the project. The work focused on women who had suffered domestic and labor-related violence. Through the larger-than-life projections of their faces the participants testified about their own experiences and those of hundreds of young maquiladora workers who had survived police assaults, drug violence, gender abuse and life threatening industrial working conditions. The project was organized by the InSite 2000 border art festival. Key to the project was the involvement of Factor X, which I've described above. Factor X, as I've noted already, is an organization that functions primarily to teach Maquiladora workers about their rights. Since the overwhelming majority of these workers are very young women Factor X also operates as a post-traumatic self-help support group for them, and thus indirectly supports their families. In their discussions with workers and their families Factor X helps them cope with, and reduce, the many forms of violence that they regularly encounter, including violence related to either the workplace or the police, domestic and sexual violence and violence they encounter in crossing the border into the U.S..[8] It is the first space in Tijuana in which these workers can share experiences that had been, due to shame, previously kept private, such as physical abuse, rape, incest, sexual abuse, their merciless exploitation at work, and medical and family problems in Tijuana, and in the countries and villages from which they came in southern Mexico further in Central and South America. Factor X meetings fostered arguments, discussions, confessions, grievances and new demands, and helped in the development of stories, testimonies and statements for the project.

My arrival at the Factor X center initiated a process of self-selection by potential participants. Because people seemed reluctant to participate, I was repeatedly questioned by a social worker, who insisted that I call her regularly but who was nearly

46

impossible to reach by telephone. I had to keep proving myself committed, qualified, and resilient, despite the fact that the odds seemed stacked against the project. I faced initial doubt and skepticism on the part of this social worker. Other members of Factor X as well as the militant lawyers' group that supported and protected its operation were understandably wary of foreign filmmakers and journalists who notoriously exploit local misery for their careers abroad, and who, doing so, simplify, romanticize and sensationalize the life of people and compromise their safety. However, in the end, a new perception of me emerged and I began to be called "artista polaco" (Polish artist), which gave me some credibility–though one could just as easily have called me American or Canadian. The name "Polish artist" was probably invoking the myth of the Pole as imaginary fellow-revolutionary from the time of Mexicans' nineteenth-century independence struggles and definitely as someone to be trusted more than a "Gringo" (a derogatory name for Americans in Mexico).

At each meeting, there was a different configuration of potential self-selecting participants. A discussion about collaboration led us to include the feedback and tangential involvement of even those who ultimately decided to not participate. Each of the potential participants began consulting with their families and friends before considering taking a calculated risk in agreeing to join the project. As it has been the case with many other projects, the eight people who eventually decided to embrace the project were each part of larger networks that were not directly involved but acted as witnesses, disputants or supporters. This multiplying effect also expanded to an outer circle of social workers, lawyers, and professionals. Some maquiladora women workers who came to the meetings to discuss their involvement in the project brought their babies and children. Others brought their husbands, brothers and sisters, and even their dogs. All of these became contributing members of the *Inner Public*, even the dogs.[9]

Because it was a public project, the contributing performers had to think carefully about what they would say and how to say it.

47

FIELD 1 | Spring 2015

One striking example of the calculated risk involved in participating in the projection came from a woman whose husband had been imprisoned as a result of her report to the police and a lawsuit for incest. He had made it clear that upon his release he planned to kill her, but she chose nevertheless to speak through the projection with the hope of protecting herself. She hoped that the visibility and public knowledge of her situation granted by the project would lead to a degree of protection on the part of the media and the public sphere. The process of developing the project created a protective buffer zone of witnesses between the protagonists and those who might wish to act against them. Thus, from the initial core, the circle of the *Inner Public* began expanding into concentric networks of people who came to provide social protection and moral support to participants during the projection tests and later during the final presentations.

The following is an account of the people who contributed to the development and formation of the *Inner Public*. There were eight project participants and three social workers—members of the Factor X organization. The three social workers engaged a few others, plus some other volunteer rights workers who were working for Factor X. About six people engaged others in discussing and elaborating the project and so there were about eighteen people total. The initial group of users-contributors expanded through their closest friends and family members, who provided consultation, consolation, and opinions (eight contributors x three or four close contacts = 24-36 people). The friends and family members of the Factor X professional help network became implicated in decisions related to the project (about eight professionals involving five friends and family members in discussions = 40 people). There were also the social researchers and academics from outside of Factor X, like urban geographers from the University of Tijuana, a documentary filmmaker-activist, and the colleagues of artists from a border art collective (about ten people).

All of these people were highly engaged in discussions about the project and without them it would have been difficult for me to

learn about Tijuana's labor and cultural context. Also involved was the social production coordinator of the project and her assistant, two InSite 2000 festival co-curators, the director from El Centro Cultural, a translator, and a videographer documenting the project, as well as volunteer student helpers (six to seven people). Last but nor least there was an emotionally and politically committed technical production crew made up of around 25 people: a technical coordinator, a video and sound recording team (three to four people), a video editing team (two people), a video projection team (three people), a sound projection team (three people), people to light the building (one or two people), the videographers (three operators plus one technician), the real time projection interface, sound and video mixing team (two people), a professional interpreter, some university students and a few others who assisted.

All of the aforementioned people were the members of the *Inner Public*. They amounted to a sizable group of about 150-200 people. This *Inner Public* was always there, as Brecht would say, "not without interest," that is, with a willingness to become motivated, responsive, unnerved, at times shocked or radicalized by what they saw. Being a passive or active part of the tests and of the final projection event, some of the members of the *Inner Public* chose to act as the project's informal advocates as well as a protective buffer zone for the safety of those participants performing in public. Most of the 150-200 members of the *Inner Public* had been socially connected with a large number of people from various social strata in the main cities of Tijuana and San Diego. Through such links the *Inner Public*—a strong, well informed, and emotionally supportive context-specific nucleus—helped to generate some 450 to 600 members of the *Outer Public*. This developmental and interventionist *Inner Public* formed a temporary context-specific nucleus around which the project generated its *Outer Public*, which now includes the reader of this text.

Deliberations on the "role of the public" in public art must take into account the fact that in some cases such art, through the social and technical process of its making, may generate its own

FIELD 1 | Spring 2015

public, a "public-within," the *Inner Public*, and that such a public may indirectly and directly effect the larger reception of work by a "public-without," the *Outer Public*. This may be especially evident in the case of artistic and cultural projects that are based on the development of communicative performance by the participants (collaborating contributors) and on the support received by them from their families, friends, and the projects' social and technical production team, as well as from other social groups, organizations and networks.

Krzysztof Wodiczko is renowned for his large-scale slide and video projections on architectural facades and monuments. He has realized more than ninety of such public projections in Australia, Austria, Belgium, Canada, England, Germany, Holland, Northern Ireland, Israel, Italy, Japan, Mexico, Poland, Spain, Switzerland, and the United States. Since the late 1980s, his projections have involved the active participation of marginalized and estranged city residents. Simultaneously, and also internationally, he has been designing and implementing a series of nomadic instruments and vehicles with homeless, immigrant, and war veteran operators for their survival and communication. He received the Hiroshima Art Price "for his contribution as an international artist to the world peace", and represented Poland and Canada in Venice Biennale. The comprehensive monograph of his work has been published by Black Dog, London (2012) and his collected writing will be published in fall of 2015 by the same publisher. Krzysztof Wodiczko is a Professor of Art, Design and the Public Domain at the Graduate School of Design at Harvard University.

Notes

This text, updated in Vinalhaven during the summer of 2013 and 2014, is based on lecture notes for the symposium *The Public in Question: The Politics of Artistic Practices*, held at the Academy of Fine Arts, Vienna, May 4-5, 2007. Fragments are drawn from an unpublished interview I did with Dorris Somer at Harvard University in 2009.

1. Michel Foucault, *Fearless Speech*, edited by Joseph Pearson (Los Angeles, CA: Semiotext(e), 2001).

50

2. Chantal Mouffe, "For an Agonistic Model of Democracy," in *The Democratic Paradox* (London: Verso, 2000), pp. 80-107.

3. D.W. Winnicott, "Transitional Objects and Transitional Phenomena," in *Playing and Reality* (London: Routledge, [1971] 1982), pp.1-25.

4. Judith Herman, *Trauma and Recovery: The Aftermath of Violence-From Domestic Abuse to Political Terror* (New York: Basic Books, 1992).

5. See Bertolt Brecht, *Brecht on Theatre: The Development of an Aesthetic*, edited by John Willet (Frankfurt: Suhrkamp Verlag, 1964).

6. One year after the projection, a Ph.D. candidate from Dublin visited the Tijuana projection site and the Factor X organization. Her dissertation addressed Dublin issues through the encouragement of Factor X to think seriously about developing new educational and cultural methods on domestic and workplace violence as they relate to human rights and politics. Examining the Dublin and Tijuana situation, she referred to Foucault's concept of fearless speech. She later wrote me a note about her experience in that Tijuana bore out my own observations that the courage to speak depends on reciprocal fearless listening and that public truth-telling (testimony) and public truth-seeking (witnessing) are interdependent.

7. On the subject of conflict transformation and positive peace, see Hugh Miall, *Conflict Transformation: A Multi-Dimensional Task*, Berghof Research Center for Constructive Conflict Management, 2004, available online at http://www.berghof-handbook.net/documents/publications/miall_handbook.pdf, accessed September 15, 2013.

8. Maquiladoras are Mexican factories run by foreign companies that export their products to the country of origin. More than 90% of all the murder victims in Tijuana are teenage women. The factories where they work broadcast their labor preferences on big banners that say "Girls Only." Murder is the most visible crime committed against these young women-and therefore against their families and children-but the private and common crimes of rape and incest are a significant feature of their exploitation. A large part of the population of Tijuana is supported by these women as cheap and dependable labor in the many hundreds of maquiladora factories along the border. Tijuana is a large metropolis and the great numbers of unemployed and frustrated men are sources of violence against women.

9. If the initial objective of Factor X was to teach younger maquiladora workers their rights, the projection also eventually became a forum for

the trainers themselves, regarding their social, political and cultural activity. Benefits could be perceived to come from public media art, including its art education and art therapy aspects, especially since the activists of Factor X raised issues linked to their own lives that would otherwise not have seemed primary. In many ways they began to work as a post-traumatic stress therapy self-help group.

Before Commodity There Was Care

Pia Lindman

3.8 Pia Lindman's *Public Sauna* (2000).

Before there was commodity, there was care—care for that which formed existence in its entirety: the air, water, soil, minerals, microbes, insects, plants, animals. In Finnish mythology, everything has its place, and if there is a disease, something is no longer in its place. To heal, one must sing the origin and return.

As I was trying to see what I needed to do to negotiate my displacement from my home to an alien existence—from the warmth and familiarity of the saunas in Finland to the irksome coolness of a windowed steam room at a gym in Cambridge, MA—I explained to Krzysztof what I felt in a public sauna in Finland: there might be a bucket washed and turned upside down, ready and clean to be used by the next bather—to fill with water and to pour the water with the ladle on the hot rocks to get steam. The ladle was equally intentionally placed next to the bucket for the next bather. The soap would be set in a soap dish, to keep it dry. There were all these actions, the signs of which I could find around in the sauna, that spoke of a care of a stranger to a stranger. Indeed, the sauna had been heated by some stranger—with love and care. If it was not heated with love and care, the steam would burn and hurt. Krzysztof made me realize these are the elements to which I should pay attention: these were crucial elements, not only of cultural practice, that informed interrogative design and the use of public space. These were elements through which I could find my methods of interrogative design.

Later I realized these were also elements for democratic space, for care, love, and life itself.

The asking of questions, most importantly by the creation of a space of hope and safety: interviewing survivors of the Hiroshima bombing, women immigrant workers in Tijuana, or victims of gang violence in Boston. I learned that if you do not get an answer to your question, you need to listen to the silence, and find a way to ask questions that reverberate with the world in which this silence first responded.

The empowering and cathartic experience of speaking up, becoming a public figure, can set in motion a process of healing. Once entering the realm of public speech, of speech acts, a being (a person, mind and body, living organism) becomes a subject, and an identity is beginning to be ascribed to it. This identity comes with a baggage—of history, cultural frameworks, prejudices, and other social value systems. Without one's own volition (yes, I believe there is such a thing) one might become a pawn in games beyond one's own grasp. I am thinking of the migrants now pushed into an ever narrower border zone between Belarus and Poland (at the time of writing, November 18, 2021). These migrants are now becoming speaking subjects, they are called by a Western political interpellation to participate in this

3.9 Pia Lindman's *New York Times Performance* (2005).

public performance—an immense tragedy on one hand of failed European Union immigration politics and on the other of opportunist and narcissist heads of states. Is there room to refuse this imposed subjectivity—to consent to not be a single being, as Glissant would propose?[1] What if one could look for other ways of becoming a being?

Another moment where I watched a screeching violence occurring between internal processes of beings and public space was in New York City in the months following 9/11 (where I lived at the time). The need to come together, to mourn together and to be in shock together manifested itself in the amazing flowering of parks and coloring of monuments. Strangers sat on benches crying and holding hands. Photos of missing loved ones hung on fences, lampposts, trees, pleading for connection. I could neither work nor sleep, so I wandered around from park to park. Then came the images in the newspapers—of us, mourning!—and the warmongering words from President Bush. Our mourning was used to license more killing, more war. Mourning is usually thought to be an internal process al-

lowed its time and peace, a private matter, just as one's own sexuality might have been thought to be in the heyday of a naive sense of justice and equality in our world (there might still exist some pockets of naïveté). This is when I decided to research mourning as something snatched from personal experience and made a public performance for political purposes. This research engendered the works *Lakonikon* (2003), *Black Square Book* (2003), and the *New York Times Performances* (2002–2007).

For these works, my data set was images from the pages of the *New York Times* culled from issues in the newspaper from one year (2002–2003). I culled only images I interpreted as depicting human gestures of mourning. These gestures I then reenacted in front of a camera, and from the video stills of these reenacted gestures I made simple line drawings in pencil. I compiled these drawings into four Black Square Books, which are the register of a public language of mourning. This is a language that inscribes us all as subjects into this particular society, through the accepted codes of public speech (gesture, obviously, here as a form of speech—Agamben).[2] Later, I

tested this code in public performances of the gestures always in relation to a monument. Juxtaposing gestures of mourning—performed by a living body—with immobile monuments, I hoped to be able to set the monuments in a reverberation of sorts, somehow to reveal the violence that is always encapsulated in the monumental mass. Like two manifestations on the extreme ends of a spectrum of our public languages inscribed in our democratic and civic societies taking stock of each other.

In the four Black Square Books, the simple line drawings no longer convey any particular contexts nor personalized situations resulting in mourning. These gestures and drawings are based on images that had already been published, and thus the possible infringement on the privacy of that moment of mourning had already occurred. Further, in order not to further infringe on this moment, my technique of alienation (Brecht) lifts this burden of public presentation off the shoulders of the actual person in mourning.[3]

Recently, I have delved deeper into the qualities of personal, private, intimate, and finally subsensorial lives of humans (and others). Instead of public space and civic action I have learned to journey in organic realms where sentiments are not necessarily anyone's property, but neither can they be extracted and alienated to serve a verbal language of Western cultures. My delving has generated a new art practice based on ancient bone-setting healing techniques that I learned from practitioners in my country of origin, Finland. These practitioners, in turn, learned from a line of intergenerational transfer, both from oral traditions (singing and spells) and traditions of physical praxis (Siikala, Tarkka, Honkasalo, Kansanlääkintäseura).[4] This tradition is a technology of the cosmos, healing, and life.

While practicing this ancient healing technique, images emerge in my mind that are generated by the healing process itself. My mind does not create these images—they emerge from the mutual exchange of energy that is the healing process. My own person with its specific history and skill sets then transforms these images into something communicable to the outer world—or the outer public, to use Wodiczko's term, in distinction to the inner (mini-) public which comprises the two or three entities

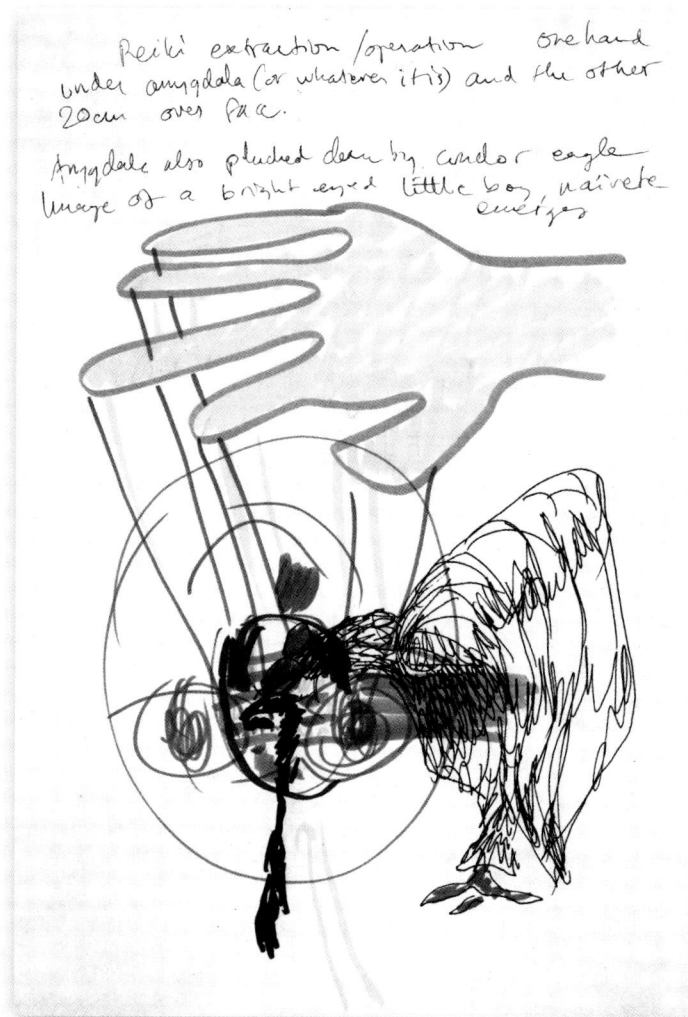

3.10 Pia Lindman's *Nose Eyes Ears* (2016).

participating in the healing session. Quite like in working with the *New York Times* project, where the exchange from one person (the person-in-mourning) to another (myself) went through a process where the inner life of the person-in-mourning is not revealed as such by context, words, or gestures, but as here, in the case of healing, by a transformation through my own (sub)sensorial equipment into an interpretation of the energetic events inside the organism-in-healing. And equally, quite as Wodiczko discusses the processes of inner and outer public, this process does not execute sense or sentiment extraction, but rather enters into a mutual process of transformation by consented collaboration.

The Practice of Interrogative Design

James Shen

Interrogative Design beyond Art

Krzysztof Wodiczko's practice and interrogative design are discussed primarily in the realm of art. This essay is concerned with interrogative design in the context of design and architectural practice. The word "design" in interrogative design emphasizes the role of function. With design and architecture, more than with art, mundane and pragmatic issues are primary concerns. The approach relies on design methodologies developed to address functional issues. It is on this foundation that interrogative design achieves results that stimulate public discourse. The practice of interrogative design is presented here in three scales: it involves users in a collaborative design process; beyond the user, there is an interaction with the public that is built on the history of a place; and finally, there is a nimble interplay with regulation and policy.

Interrogative Dialogue with Users

Addressing user needs and the process of user testing with prototypes are core concepts in product design, a background that I share with Krzysztof. Participation in this context is focused on an individual and not the public. The user's participation starts at the beginning of the design process and informs its development. This is distinct from the participation that takes place as public performance as a resolution of a project.

User testing places the designer in the position of the user in order to better understand their needs. It involves a process of trial and error that forces the designer into an empathetic disposition that erases any preconceived ideas. This process is illustrated by a guitar attachment I designed for a quadriplegic patient while a product design student. Working with the Long Beach Veterans Affairs Hospital, the project entailed creating a working proto-

3.11 James Shen's *Guitar for Quadraplegics* (1999).

type with my partner who was paralyzed from his shoulders downward, and had movement in his arms but not his hands. The final functioning prototype was evaluated through a demonstration by the user and not the student.

After learning that my partner used to be a musician, we agreed to devise a way for him to play the guitar, an activity he was forced to give up after his injury. The result of our collaboration, entailing the testing of numerous prototypes, would have been impossible to achieve on my own. As an able-bodied person, my level of empathy was always limited. We discovered that having the guitar faced up on his lap was the ideal position. The final mechanism held pegs that were rearranged through simple arm movements. The pegs formed a series of preset chords and slid along the neck of the guitar above the strings. Pressing down on the mechanism allowed him to form different chords without the use of his fingers.

Design concerns went beyond physical tasks. It was equally important that use of the device in public did not

produce feelings of shame. The intimacy of our collaboration allowed us to connect on many levels. In the process, my partner shared stories of his experience in the military, his traumas, and his love of music.

Curious Commute, a project I completed as an architecture student in Krzysztof's Interrogative Design class, takes a different approach to participation. Once on

3.12 James Shen's *Curious Commute* project (2005).

the subway I observed a woman, an apparent stranger, reading a newspaper over the shoulder of a man whose daughter napped across his nap. Was the man aware of the woman's eyes on his newspaper? Could he sense her encroaching head? I wondered what would happen if such connections across overlapping personal space were made more explicit.

My device invited others to read the same paper without their gaze intruding into the space of the reader. The contraption was attached to a post in a subway car and consisted of a camcorder with a small screen and a surface that held a newspaper. The camcorder was aimed at the newspaper that was being read by the user of the device, while the screen displayed the contents of the newspaper outward toward those positioned nearby. *Curious Commute* brought about new relationships between strangers through the sharing of reading material. Its function was to remove any stigma associated with this activity by bring-

ing it out into the open. One passenger even suggested to the user to choose a more interesting newspaper to read.

The participation of an individual user in the development of a design, as shown in the VA guitar project, and the performative participation of strangers in public space are quite different. The former is oriented toward pragmatic needs that are personal, while the later addresses public relationships. Krzysztof's *Homeless Vehicle* is an integration of both forms of participation. In the ideation phase of the project his interactions with unhoused individuals led to drastic alterations to the design. This can be seen in the shift from concerns for privacy in his early concepts to safety in his later designs. By collaborating on an iterative design process, he gained the trust of unhoused individuals by properly attending to their everyday concerns. These include the need for secure storage, a place to rest, and a place to wash up. Through this collaboration in the development of the design Krzysztof built relationships that led to public demonstrations of the *Homeless Vehicle* by the users themselves. These performances allowed Krzysztof to address larger social concerns related to homelessness that spoke to a public audience.

Interrogative Dialogue with Places

The *Memorial to the Abolition of Slavery* in Nantes, by Krzysztof and architect Julian Bonder, is an example of interrogative design as architecture. I was fortunate to have worked on the project as an intern. Addressing the tragic history of the slave trade in Nantes, the memorial is a series of interventions on what was previously a banal parking lot along the river. Massive glass panels, etched with articles on the abolition of slavery, slice into the site to expose the underground structure of the eighteenth-century embankment. Visitors are invited into this space beneath the waterline that evokes the hold of a slave ship. Above ground, the site is embedded with thousands of plaques engraved with the names of the ships that sailed from this location and the slaves they carried as a permanent record in public. The project questions what troubled histories lie behind commonplace sites.

The *Plugin House* projects by my practice People's Architecture Office also confront complex histories through architectural interventions. In this case, however, the in-

tervention is inserted into a preexisting context without any disruption. Our approach was to build a new house inside an old house as an alternative way to upgrade conditions that did not involve urban demolition and the dislocation of residents. Our first *Plugin* projects were situated in Dashilar, a historic district in the center of Beijing. By building a house in a house we were able to retain layers of complex history that characterize the community. Embedded in the traditional courtyard houses are traces of a tumultuous past, many aspects of which are not openly discussed. Buildings in Beijing exist as a changing patchwork of construction that reaches back to imperial rule. *Plugin Houses* are inserted as another layer of history, coexisting with what came before like geological strata. The ability to avoid demolition ensures locals are able to remain to preserve the rich oral histories linked to these places. Giving new life to these properties, the project uncovers the value in what already exists. It presents the possibility of renewal without starting anew.

Similar to the *Memorial to the Abolition of Slavery*, the *Plugins* are interventions on existing sites. The memorial exposes through a slice, while the *Plugin House* reveals through insertion. In both instances, these interrogative interventions create a jarring interplay of incongruous elements. The contrasts resulting from these actions are essential in focusing public attention on the issues at hand.

Interrogative Dialogue with Urban Policy

The house-in-house approach is really a formalized version of informal building tactics common in Dashilar, where premodern infrastructure and overcrowding have resulted in slumlike living conditions. Residents, mostly low-income, rely on shared public bathrooms and struggle with Beijing's extreme temperatures. Due to lack of public investment, residents have for generations resorted to informal means of improving their homes. The construction of rooftop additions, the encroaching on shared public space, and the building of new structures within old ones have created an incongruous environment littered with incremental upgrades that question what can and cannot done.

The *Plugin House* bridged a gap between time-tested informal strategies and official planning policy. I consid-

3.13 Krzysztof Wodiczko and Julian Bonder's *Memorial to the Abolition of Slavery* in Nantes (2011).

er these strategies as "found interrogative design," a collective dialogue between neighbors engaged in creative ways of upgrading while taking advantage of regulatory loopholes. We studied these strategies, which in turn inspired the *Plugin House* interventions. As designers we repackaged an approach that may seem like an obvious one for local residents but typically would not be considered by authorities.

Our *Plugin House* projects also functioned as significantly improved housing for residents. We developed a prefabricated building system that incorporates highly efficient insulation, heating and cooling, as well as private bathrooms. Because the *Plugin* system is mass-produced, designs can be customized while remaining low-cost. Each *Plugin House* was designed in close collaboration with residents. And over time this led to considerable trust between our work and the community.

The house-in-house concept was welcomed by residents and caught the attention of Dashilar officials. This led to a multiyear pilot supported by local government, with dozens of completed *Plugin House*s. Through this work, some of the homegrown informal building strategies in Dashilar were legitimized and incorporated into official policy. The

3.14 People's Architecture Office (PAO), *Huang Family Plugin House* in Shangwei, Shenzhen (2018).

3.15 PAO, *Plugin House Demonstration* at Boston City Hall (2019).

Plugin House approach has since been exported to other cities including Shenzhen and Jingdezhen.

The *Plugin Houses* are of the quality of permanent buildings but are also installation-like in nature. This flexibility made the *Plugins* more palatable to authorities. The unique prefab building system allowed people without any skill to erect a house within a day, while the house was just as easy to disassemble. This left the possibility of the intervention being temporary, lowering the risk for officials trying out such a radical approach. If it didn't work out, the *Plugin House* could be removed without disrupting what already existed.

Furthermore, the *Plugin*'s flexibility allowed it to be used as a temporary installation to engage communities and spark conversation on housing issues. In 2018 we partnered with the Mayor's Housing Innovation Lab in Boston to build a *Plugin House* demonstration at City Hall. The purpose was to promote new policies encouraging the building of small houses in private backyards as a way of easing the city's housing crisis. Interestingly, these accessory dwelling units (ADUs) are a common type of informal construction in Boston.

A series of public events was planned around the demonstration. The interior held an exhibit with information on ADU policy. Comments and ideas from visitors were collected and presented as part of the exhibit. A series of events was organized involving public roundtable discussions with community leaders and policymakers. Visitors found that seeing an ADU in person made the concept tangible and easier to conceive of in their own community. It was a very different form of public discourse. Housing policy discussions often remain at the level of abstract powerpoint presentations. The feedback from the event helped inform the drafting of new ADU policy for Boston and that was approved later that year.

After the City Hall event, the Plugin House Company was established as a spinoff of People's Architecture Office, with the purpose of providing low-cost, accessible housing as a product. Our first client is The Other Ones Foundation, a nonprofit in Austin, Texas that manages a transitional housing community for the homeless that is entirely informal. *Plugins* were built by residents and used for housing and community services. The project is a unique example of the use of noncongregate shelter as an alternative way of addressing homelessness.

3.16 PAO, *Plugin House Installation* built by student volunteers at Harvard Yard, Cambridge (2019).

3.17 *Home Economics: Refuge in Refuse*, installation built by students at the Harvard Graduate School of Design, Cambridge (2019).

Interrogative Design Education

Education has been very much part of Krzysztof's practice in his art. His teaching has been hosted by schools of architecture, with many if not most of his students pursuing professional degrees in fields of design. Interrogative design is perhaps as influential in the practice of design and architecture as it is in art, if not more so.

I have integrated interrogative design approaches in my own teaching by having students build architectural-scale interventions in public space. The *Plugin House* has been used as an educational tool for installations at both Harvard Yard and Rural Studio. These demonstrations were built by students, many of whom had little or no experience in construction. With Krzysztof, I also taught a workshop for the Art and Design in the Public Domain program at Harvard. The workshop concluded with a student-built installation in the public space in front of the Graduate School of Design with found objects from the Harvard Recycling and Surplus Center. The course, titled Refuge in Refuse, required students to interview those who frequent the recycling center. This process revealed economies based on the foraging for collectibles, regular shipments of home goods to Jamaica, and the drastic decline of the China-based metal recycling industry. The final installation at the GSD was built with objects identified with these narratives. The course concluded with the presentation of these stories in an open public conversation within the space of the installation. The installation was disassembled two weeks later and the objects were returned to the recycling center.

• **Editor**: "Rural Studio is ... a design-build program [in Alabama] ... working to develop a scalable, sustainable, agile, and resilient delivery process for beautiful, well-designed, high performance affordable homes ... in underserved rural communities."[1]

How Can an Idea Be Woven into the Social Fabric?

Matthew Mazzotta

3.18 Matthew Mazzotta's *Outdoor Living Room*, Saudi Arabia (2015).

I first learned about the *Homeless Vehicle* project as a student in my small-town high school. It was only a few images in a book, but this was the first time I clearly saw the connection between art and activism: a simple way of weaving a provocative idea directly into everyday life.

Until that moment, I had thought art had to be static. The *Homeless Vehicle* was alive in the world, and people had to deal with it without a script. Not because it was dominating the space, but because it drew them in through their curiosity. They wanted to know more. "Is the City providing these? Did you make it? How does it work?" It opened a fragile space for the person inhabiting the cart to communicate about their life and situation.

Years later, when Wodiczko was my professor in grad school, he said something to the effect of "that which is permanent in public becomes invisible, and what is temporary can exist forever in people's memory"—I took this to mean if an object is in our view every day, we become numb to its pull and it falls into the periphery. However, if

something meaningful only exists for a short time, it will be continually recalled and described through stories.

Inspired by his approach to provoking conversations in public, I wondered how deep an idea can be woven into the social fabric, and whether I could make an artwork that did not lose its relevance over time. I wanted to come up with a strategy of making something permanent that retains its everyday potency. From this starting point, I developed a research methodology called the Outdoor Living Room.

I start each public art project by making spaces for listening. I do this by setting up Outdoor Living Rooms, as a way of taking the meeting right to the community and hearing directly from them. By putting domestic objects (living room furniture and refreshments) composed as a living room in public spaces (in the middle of the street, in front of grocery stores, in a park, etc.), I create a familiar space that is easily inhabitable in an unfamiliar setting. This forum encourages discussion and allows for stories and ideas to be recorded. During the discussions, community members reveal specific memories, desires, and secrets of the places they live. The power of the Outdoor Living Room lies in its ability to capture voices of people who may not have time to attend more formal meetings, and its free-form conversational structure allows people to speak about issues that rarely are discussed as a community.

For me, public space is political, and I firmly believe that inherent in every moment is the potential to ignite profound change. As a catalyst, art affords us a compelling perspective to act on this possibility. We need artists who take the principles of interrogative design and integrate new forms of civic participation and social engagement into the built environment to create art that reveals how

3.19 Matthew Mazzotta's *Outdoor Living Room*, York, Alabama (2013).

or their meanings are transformed by current events, designs and aesthetics trend, development occurs, demographics shift, etc.). So how can artists create permanent work that stays relevant to its community, given these changes over time?

"System" is a term I developed for work that functions as a permanent artwork which stays current over time. I see it as similar to how a university functions: it is a permanent presence of buildings and funding structures, but it always refreshes itself to live up to the current moment with its course offerings, teachers, mission statement, and its outreach and network, according to what contemporary culture and the student body demand of it. What was taught a decade ago might now be outdated, yet what the university teaches today will always aim to provide the most compelling ideas, research, and dialogues of our day.

the spaces we travel through and spend our time living within have the potential to become distinct sites for intimate, radical, and meaningful exchanges. I believe that public space is the most potent place to discuss pressing social issues because it contains the richest diversity of perspectives.

Temporary—Permanent—System

When I first started making work, I would separate public artworks into three categories—temporary, permanent, and system. Temporary artworks can push contemporary issues, be mobile, contentious, highly provocative and respond to the present because they exist only in that moment and are then gone.

Permanent artworks are distinctly different and consider the land they are located on and the audience that will live with them in the future. Permanent pieces pass through a layer of critical eyes from the community and local government, which are often nipping at the pieces' aesthetic, physical form and meaning through rules, regulations, and input. Permanent pieces are also susceptible to losing their potency as everything around the artwork changes over time (ideas fall out of favor

3.20 Matthew Mazzotta's *Outdoor Living Room*, Lyons, Nebraska (2016).

Open House

Matthew Mazzotta

2013

3.21 *Open House*, site before renovation.

3.22 Matthew Mazzotta's *Open House* (2013).

My first project that employed my system concept was *Open House*—a blighted home turned into a physically transforming 100-seat theater that provides space for plays, movies, events, or whatever the community would like to see or be part of. Inherent to its design, *Open House* is able to stay current with what is demanded of it through direct participation of the community requesting events. Since its opening there have been movie screenings, comedy events, theater performances, and town hall meetings, all initiated by people in the community wanting to see their neighbors share an experience shoulder to shoulder, something that was not available in York, Alabama—a town of 3,000 people.

3.23 *Open House*, unfolded.

3.24 *Open House*, in use.

5 ft × 6 ft (with Circulation Space)

Gauri Nagpal

2021

3.25 Chandigargh Palace of Assembly. Architect: Le Corbusier. Built in 1962.

3.26 Chandigargh street vendor.

3.27 Chandigargh street vendor.

The story of the city of Chandigarh has been told numerous times since its conception. One of these stories is about a grand vision—to reshape cities into technical machines whose purity would be detached from humanistic concerns. Another is about a radical symbol of creativity and independence, desperately needed by the national leadership of a postcolonial state. Yet another is part of the syllabus of most urban studies programs across the world—a high modernist master plan developed in Europe in the 1950s is transferred to India; this one is a classic. It makes for a convenient scapegoat for all urban life's ills.

The lesser-known story of Chandigarh, however, can be read through numbers. Sector 17 is where the bazaar is, 16 has the loveliest chai, and in sector 23 you will find the best *golgappas*. In a city ruled by numbers, it is easy to

3.28 Chandigargh street vendor.

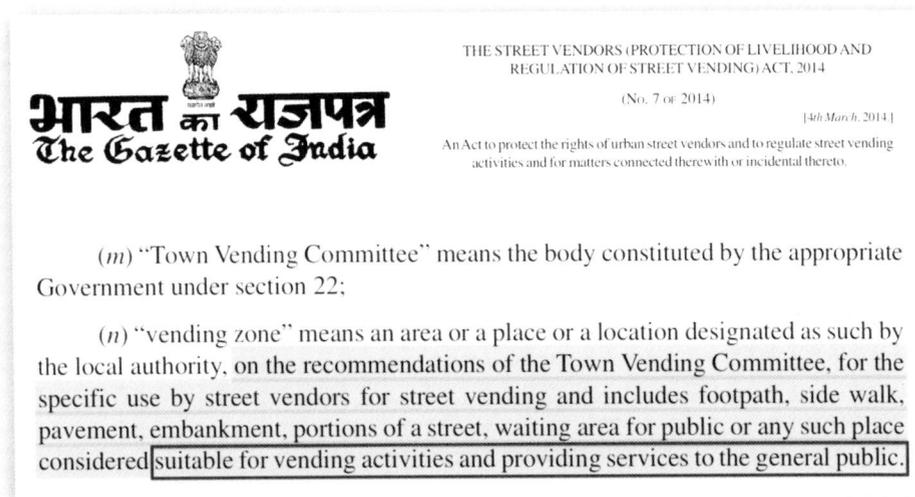

भारत का राजपत्र
The Gazette of India

THE STREET VENDORS (PROTECTION OF LIVELIHOOD AND
REGULATION OF STREET VENDING) ACT, 2014

(No. 7 of 2014)

[4th March, 2014.]

An Act to protect the rights of urban street vendors and to regulate street vending
activities and for matters connected therewith or incidental thereto.

(m) "Town Vending Committee" means the body constituted by the appropriate
Government under section 22;

(n) "vending zone" means an area or a place or a location designated as such by
the local authority, on the recommendations of the Town Vending Committee, for the
specific use by street vendors for street vending and includes footpath, side walk,
pavement, embankment, portions of a street, waiting area for public or any such place
considered suitable for vending activities and providing services to the general public.

3.29 *The Protection of Livelihood and Regulation of Street Vending Act* (2014).

forget the importance of names—names that belong to people and people that belong to places.

Chandigarh was a product of the crisis prevailing in northwest India immediately after Partition and Independence in 1947. The communal riots that accompanied the partition brought a great sense of loss to the uprooted. Displacement from land and the reconfiguration of national identities led to immense cognitive chaos. The Indian province of Punjab was left without a capital; building a new town was offered as a solution. The new capital of Punjab represented something much larger than a provincial city in a strategic region—as the first "planned" city, it would set

3.30 *5ft × 6ft*, under construction.

the stage for how Indian society would radically transform its political conditions and social relations through urbanism.

It was one of the first times that complete control of land development and disposal by a public authority was attempted in independent India. Le Corbusier was invited by the National Planning Commission to create the master plan for Chandigarh. The capital city was built entirely on a "clean slate." The land picked for the project was declared "unfettered by the traditions of the past." The disciplining rationality of the high modernist master plan imposed an "urban order" that had no relationship to the rhythm of everyday life as experienced by Punjabis.

There is an elective affinity between a technocratic state and a uniformly laid out city.[1] The "freeing" of complex tenurial relationships to land reconfigures property. Names of farms, orchards, and the residences of the villagers were replaced with a numerical order. The streets were named after the direction they were facing, and the grid divided the land into sectors based on plot sizes. The land on which the city stands today doesn't have a name, only a number. In Chandigarh, it is known that everything "illegal" has a name.

Chandigarh must be saved from the whims of individuals. The age of personal statues is gone. No personal statues shall be erected in the city or parks of

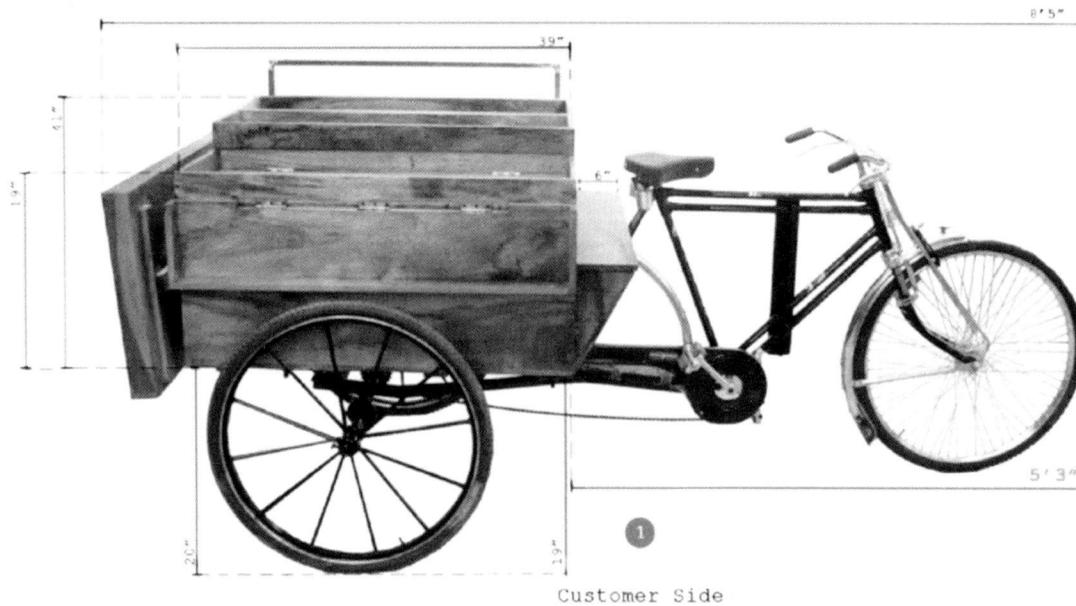

3.31 Gauri Nagpal's *5ft × 6ft (with Circulation Space)*, mobile mode.

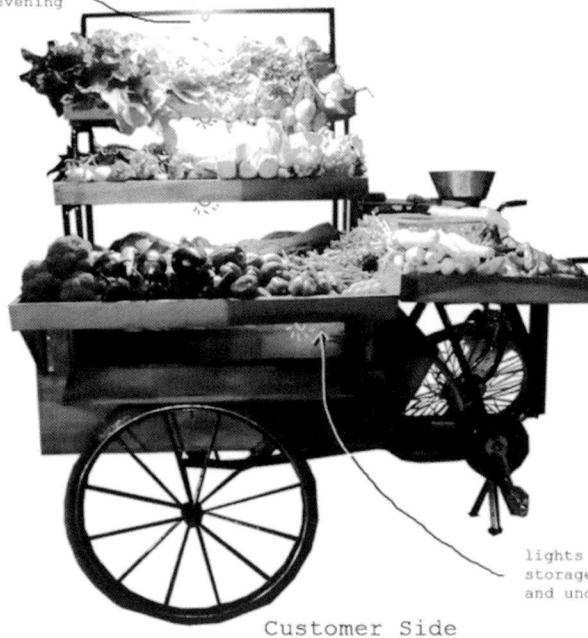

3.32 *5ft × 6ft*, loaded and ready for customers.

Chandigarh. The city is planned to breathe the new sublimated spirit of art.[2]

"Labor colonies"—temporary locations in the periphery—formed the first settlements, residences of the people who built the city. However, formal documentation on tenurial terms was suspended in this case, implying that the housing could be razed at any time. The ephemeral condition of these settlements also meant that the municipal authorities did not have to provide any services. Ananya Roy refers to Agamben's definition of informality as a "state of exception," and underscores that planning apparatus has the power to determine when to enact this suspension of formal rules.[3] The state, therefore, determines what is infor-

3.33 *5ft × 6ft*, with The *Protection of Livelihood ... Act* projected onto the *rehri* in public space.

Labor colonies were not the only rejections of the state's definition of formality in Chandigarh. There was an interdependence between the goods and services needed by the labor force and the new informal commercial enterprises that arose as *rehri* markets. Many hawkers or *rehriwallas* took to the streets and started providing daily necessities and perishable goods. They spent their days going from one location to another and in the evenings gathered in more densely populated sites to form the city's first bazaars. The authorities consistently enforced mobility among informal enterprises to prevent permanent land occupation for commercial purposes by means other than paying market value.

mal by defining formality and determining which forms of informality will thrive and which will disappear. The first phase of Chandigarh's formal development was accompanied by the demolition of the labor colonies. Physical force was not used; instead, all was done by "quiet persuasion."[4] Therefore, the participation of the labor force was necessary for the demolition of their own houses.

Rehriwallas who operate outside the "legal system" are treated with much contempt. Urban local bodies and police authorities exercise wide powers to remove these "obstructions." Until 2014, there was no central law operating in India that would recognize vendors' rights. *The Protection of Livelihood and Regulation of Street Vending Act* (2014) took on the challenge of regularizing vending by offering licenses and giving Town Vending Committees (TVCs) the power to earmark vending zones on commercial land. A recent bylaw passed by the local government states that nothing in an informal market should be "fastened to the ground" and that *rehriwallas* must occupy an area of no more than 5 feet by 6 feet (with circulation space) or risk eviction. Such bureaucratic logics ensure that informality leaves only a little trace on a temporal scale, at the end of the day allowing the illusion of the architectural purity of the city to resume its presence.

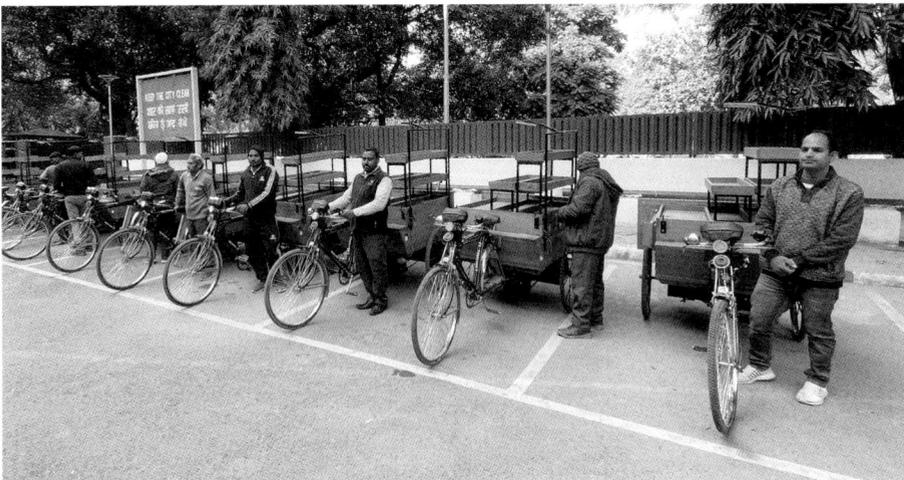

3.34 *5ft × 6ft*, city-approved mass production.

Alongside a team of *rehriwallas*, carpenters, welders, engineers, and mechanics, while studying with Krzysztof at the Harvard Graduate School of Design remotely from India over the course of a year, we developed a *rehri* that abides by every design bylaw regarding street vending policy. Our *rehri* is a coalescence of the history of plans, rules, and, regulations that attempted to shape Chandigarh. However, like the way in which Chandigarh is lived, the *rehri* too is manipulable by the needs and rhythms of everyday life. The *rehri* is modular—for instance, a *rehriwalla* can arrange it to utilize height when width is not available. The design of the *rehri* evolved from conversations in vending zones, bazaars, municipal offices, mechanical workshops, and vendors' homes. This process revealed the need to reframe mobility as agency and not solely as a result of coercion. We next developed a process to incrementally electrify the *rehri* for faster and longer movement in the city.[5]

Solomon Benjamin writes that the story of urban space in India is best read through marks and annotations that overlie each other to form a palimpsest of claims. "The rights of ownership are read against the claims of custody and the thin fabric of legal legibility often buckles under the overlay of ink on ink on ink on paper."[6] Malleability, then, has been and continues to be a resource for autonomy.

The *rehri* tells the story of Chandigarh through its people. It is a monument to the Sector 17 *bazaar* where you will find Kallo with baskets of guavas and cherries. It is also a monument to Om Parkash in 16, brewing the most lovely *chai* with cardamom and cloves. And in sector 23—where you will find the best *golgappas*—in Kishore's dazzling new shop, you will also find the *rehri*, tightly snug in an area 5 feet by 6 feet (with circulation space).

3.35 *5ft × 6ft*, press coverage, Hindustan Times, January 23, 2023.

• **Gauri Nagpal:** Since the writing of this essay, a full fleet of 16 electric *rehris* were launched in the city (in January 2023). The significance was underscored when the mayor of Chandigarh inaugurated this as a wider program. This vehicle, running in a city premised on the erasure of village territorial formation, forms a metaphor for what is the urban today and for a significant life in the future.

Life of Washington Mural

Ben Wood

2020

My public projected artworks reflect core principles learned during my time as both a student and assistant in the Interrogative Design Workshop. My current proposal to animate the *Life of Washington* murals in San Francisco integrates an interrogative approach, aiming to reactualize and repurpose the murals by empowering those estranged by them to create a meaningful new interpretation.

The 2016 presidential election emboldened white nationalism and led to the protest and violence that erupted in Charlottesville, Virginia, around the removal of a statue of Confederate general Robert E. Lee. Monuments honoring Confederate leaders, symbols of slavery, white supremacy, and colonialism, were drawn into a nationwide debate. In San Francisco, the Pioneer Monument, a constellation of statues in the city's civic center that celebrate a legacy of colonialism, have long been considered a racist symbol by Native Americans. One of them, the *Early Days* statue, portrays a Native American cowering and defeated below a triumphant vaquero and a Catholic priest pointing toward the heavens. After decades of calls for the statue's removal, especially by the indigenous community, the 2017 white supremacist rally in Charlottesville, Virginia, precipitated San Francisco's Arts Commission and Historic Preservation Commission to remove the *Early Days* statue. Removing the monument was a landmark of solidarity for the wider California indigenous community and was celebrated by every indigenous person that the Arts Commission knew. In response to the removal, the city Arts Commission sanctioned a new public work of art, designed as a special event, that reclaimed the monument by commissioning collodion plate photographic portraits of 150 contemporary indigenous people. The portraits were projected at night adjacent to the now empty pedestal of the *Early Days* statue. This momentum roused both

activists and local elected officials to begin to question anew other publicly owned symbols of colonialism.

Subsequent to the removal of the *Early Days* statue, San Francisco's Board of Education, consulted by concerned native parents and allies, voted unanimously to whitewash a series of 83-year-old social realist murals by Victor Arnautoff depicting the life of George Washington. One of the 13 murals depicts George Washington pointing toward the west, while a group of pioneering settlers march westward blatantly ignoring a deceased native warrior lying face-down. Another mural shows enslaved African Americans picking cotton. After public outcry and a debate aired across national media, the Board of Education subsequently backtracked and voted instead to cover the murals over. As of this writing the school's alumni are in a legal process with the Board of Education in order to keep the murals in view.

During this process I have been working independently and in cooperation with a range of individuals and community interest groups to come up with empowered ways to create a dialogue with the murals, one that would use digital media and interpretive art in an affirmative way without adversely affecting the historical murals.

In much of my work to date, I have explored a reanimation of history by reviving historic murals in order to spark dynamic conversation about relevant contemporary questions and issues, following the design process of interrogative design. In a time of public calls to reverse the colonial narrative, what would the murals of George Washington say to the descendants of indigenous and enslaved persons today?

While we must not deny the darker side of history embedded within such monuments and murals, their embod-

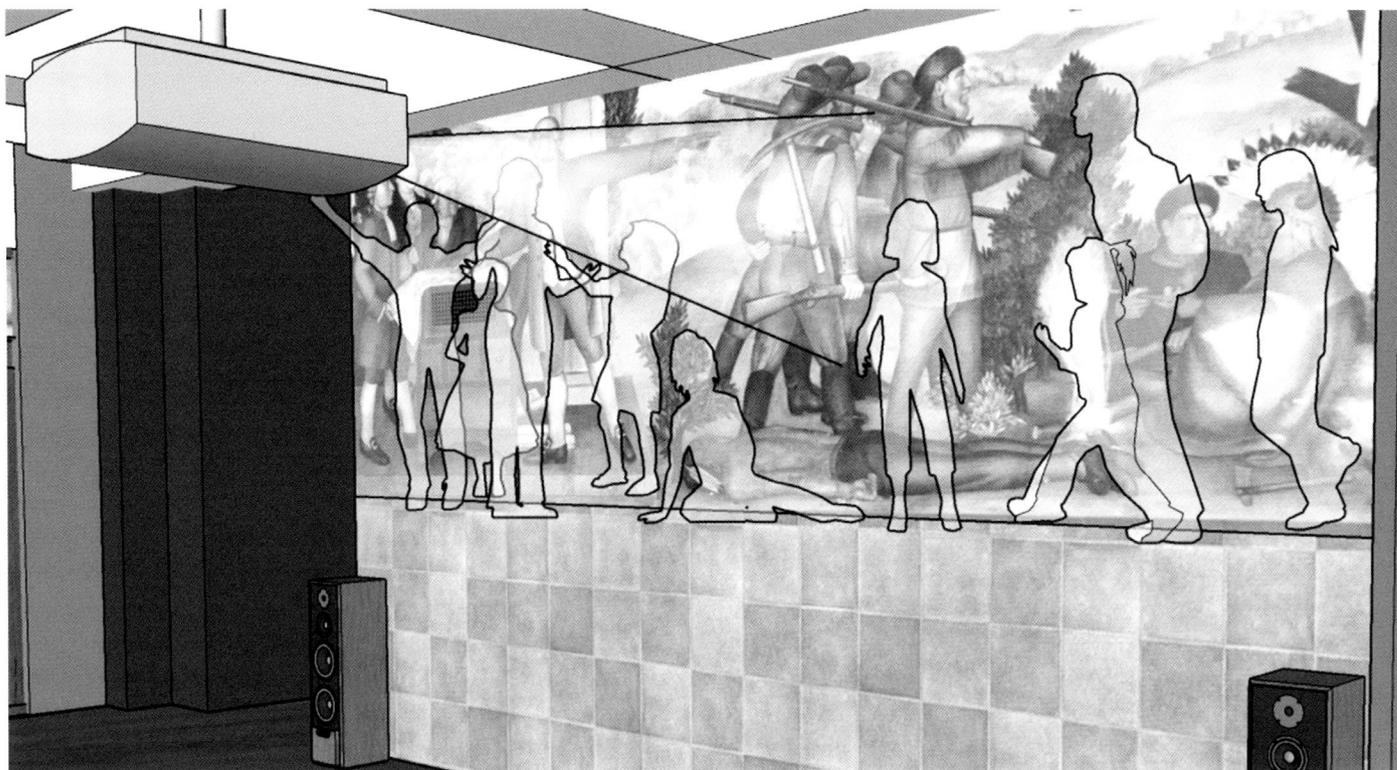

3.36 Ben Wood's proposal for a projection over the mural.

iment of tribalism, elitism, slavery, and subjugation, wouldn't it be more enlightened to swap the white paint or wrecking ball for a projector with artistic displays or socially engaged work, to empower those marginalized and disempowered by the murals?

The artist is afforded a position of privilege through funding commissions or the support of a gallery or museum that are not typically available to marginalized groups. However, many artists work as independent agents without the luxury of institutional support and work in a more do-it-yourself mode, with limited access to equipment and financial resources. To me, an interrogative artist is one who in their daily life and routine seeks to use all of their passion, mind,

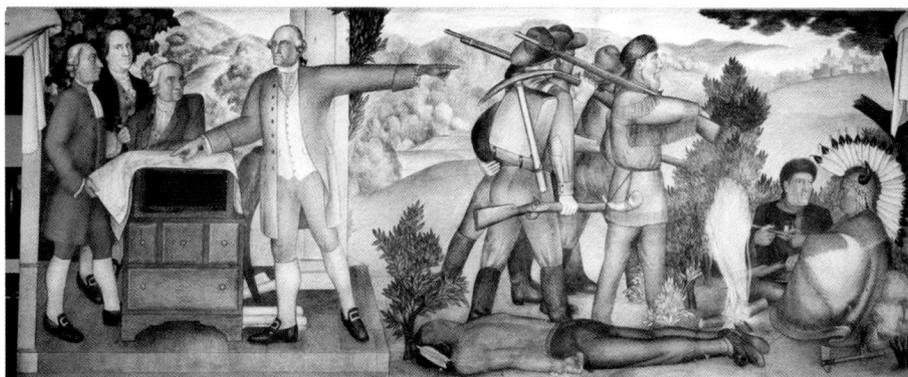

3.37 *Life of George Washington*, Victor Arnautoff, circa 1930.

and energy through their work to make their society better for themselves and for others.

An interrogative artist is one who recognizes that while our civic symbols and mythologies are needed, rather than being held up as sacred and true, they must constantly be questioned and updated in a civic and critical society.

107

CareForce One

Marisa Morán Jahn

2013

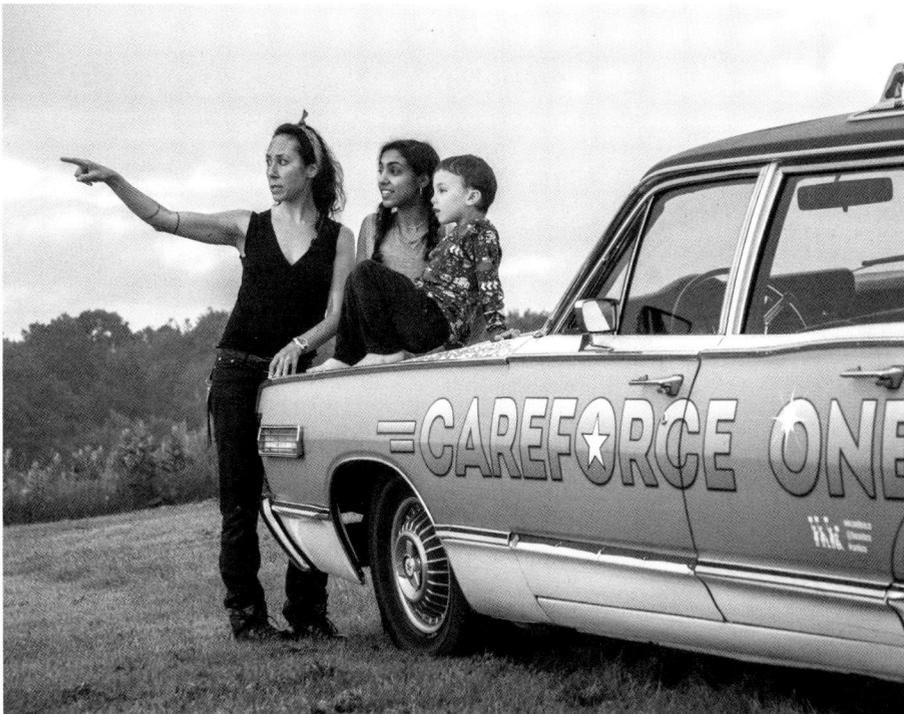

3.38 Marisa Morán Jahn's *CareForce One*.

Buying two antique cars may not have been the best idea. Or it may have been the best idea.

Buying our first ride, the *NannyVan*, came about after an immigrant and women-led movement won a decade-long campaign in 2010 granting domestic workers basic rights in New York State. To get the word out to the state's 250,000 domestic workers, members of the National Domestic Workers Alliance (NDWA) reached out to me. We gradually co-designed a suite of art, tools, a know-your-rights audionovela app, participatory dances, policy toolkits, and a short miniseries film produced by PBS. As the movement started spreading to other states, I need-ed a way to meet domestic workers where they were—something that could also beckon passersby to stop and reflect.

After coming up with a name, I bought the chassis of a bright orange, 1976 Chevy van off Craigslist. My team and I souped it up with parts from seven junkyards, and adorned our car with groovy superhero graphics I'd designed worthy of our superhero collaborators.

After a ceremonial christening and a series of pilot tests, I hit the road with my newborn son and team (Anjum Asharia and Marc Shavitz). We'd park in front of public libraries at toddler storytime hour, at public parks near elementary schools, at transit stops and markets. From the back doors we'd roll out our colorful craft carts, and crank up the jams to instantly create an appealing sense of place. We exchanged stories and information as we crisscrossed the country in the *NannyVan*, creating new tools, resources, artworks, and pit stop roadside choreographies along the way. When the *NannyVan* finally died, we created a second ride, dubbed *CareForce One*—this time with a new focus on engaging domestic employers like myself.

Regardless of our audience, the *NannyVan* and *CareForce One* introduced the terms "domestic workers" and "domestic employers" in ways that invite others to proudly see themselves in these roles, present or future. And here is where the role of art and aesthetics come in. Given that

the topic of domestic labor is often laden with shame for domestic workers and employers alike, we needed visually arresting artifacts that could pique curiosity and command public space through their design and performative activation—or what the artist and my former advisor at MIT, Krzyzstof Wodiczko, might refer to as "interrogative design."

Central to his studio at MIT and his own work, Wodiczko's notion of interrogative design reserves the right for design to ask fundamental questions—to interrogate. For readers new to contemporary design methodology and its pedagogy, a solutions-oriented approach predominates. Yet this narrow understanding of the world assumes that a problem necessarily will have a solution, that the role of design is to work in service of a concept, and that the question is already aptly framed.

Wodiczko's concept of interrogative design, however, restores the critical and philosophical dimensions to design. As both domestic labor and domestic workers are often culturally erased and legally excluded, the most important thing our vehicles could do was to raise questions rather than suggest solutions.

As we pushed the *CareForce One* forward, we weighed the pros and cons. In fact, both vehicles were very poor choices for crisscrossing the country clocking over 20,000 miles. That had been my fault. As we encountered countless mishaps and misadventures with antique parts, cobbled-together substitutes, and car hacks, we strove to turn trauma into lessons learned.

It's important not to overlook the deep sense of pleasure and the spiritual component that arise through the performative engagement with others afforded by an object or artifact. The poststructuralist philosopher Michel Serres describes participation—and subjectivity—as a game with a ball passed between players:

> Over there, on the ground, [the ball] is nothing; it is stupid; it has no meaning, no function, and no value. Ball isn't played alone. ... Skill with a ball is recognized in the player who follows the ball and serves it. ... The "we" is less a set of "I"s than the set of the sets of its transmissions. It appears brutally in drunkenness and ecstasy, both annihilations of the principle of individuation. ... The speed of passing accelerates him and causes him to exist. ... Participation is the passing of the "I" by passing. It is the abandon of my individuality ... [and] the transsubstantiation of being into relation. ... Collective ecstasy is the abandon of the "I"s on the tissue of relations.[1]

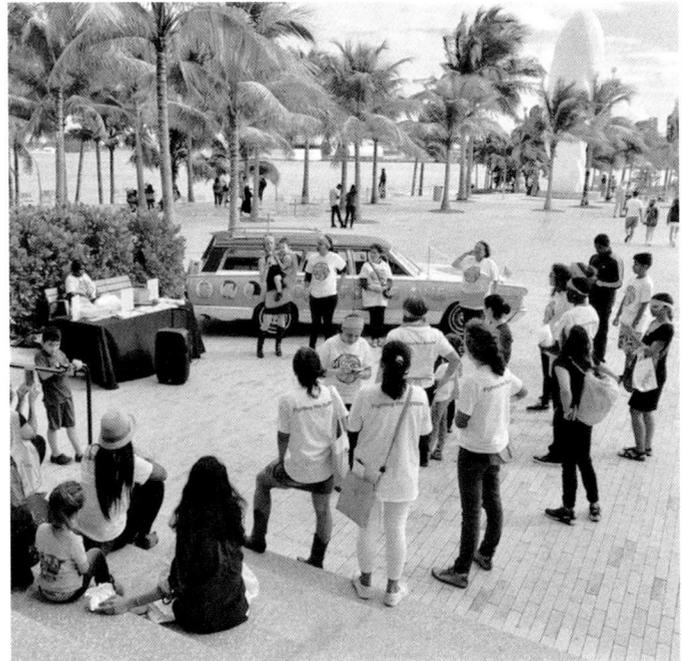

3.39 *CareForce One*, in use.

Serres aptly captures the pleasure ("ecstasy") that arises through the performative activation of the ball—an analogy that emphasizes the ineluctable link between performance and interrogative design.

As if cued in to our reflections, a few guys heading down to party in Miami jump out from their pickup truck to join us in inching our heavy station wagon forward. "It looks fun!" they say. "What the hell is this thing anyways?" And so begins an exchange of stories. In an instant, their participation has transformed our toil into a game which feels awesome.

Toward a Tender Society of Thoughtful Questions and Answers

Harrell Fletcher

Originally published in 2002 in The Organ Review of Arts

- **Harrell Fletcher**: When Ian told me that Krzysztof Wodiczko had included this writing as part of readings for classes at MIT I was very honored, but also surprised that he had ever run across it. I think I wrote the piece for a small arts newspaper that briefly appeared in Portland, Oregon where I had recently moved. It is interesting reading it now twenty years after I wrote it. I think I was in some ways directly addressing the people who I had been encountering in my new city, trying to encourage them to engage in more meaningful conversations than the ones I'd been experiencing. Even now, after all this time, I still think people should get better at asking questions. I've made having students conduct interviews a big part of the Art and Social Practice MFA program that I founded and co-direct at Portland State University. I think that is helping at least a little.

ARTIST ESSAY

Toward a Tender Society of Thoughtful Questions and Answers

by Harrell Fletcher

People often ask how I'm able to entice random strangers into working with me on art projects about their own lives. The answer is that I appear to actually be interested in the person and his or her activities. And what is the best strategy for appearing interested? The answer is to sincerely be interested—in fact nothing else will work. This is not difficult for me, because I actually think that people are interesting. I would even go so far as to say that I have a great fondness for the human race.

This wasn't always the case; as a child and adolescent, I was extremely shy and preferred to stay clear of most people. Dogs, books, and cheeses were my preferred companions. When, later in life, I decided to become a participant in society, I realized that I had no social skills for constructively engaging with people. Small talk had always made me feel dead inside, so that wasn't going to work. Instead, I decided to actively push conversations in the direction of "bigger talk." I asked people real questions about their lives, their work, their histories, their favorite foods, etc. Sometimes this was perceived as

invasive, but I tried to be very sensitive. I became an increasingly capable listener and asker of related follow-up questions. As a result, my social self has been very intentionally constructed. This isn't as bad as it might seem, though. I think everyone's social (and personal) selves are constructed, just not usually very consciously.

As it turns out, people really like to be paid attention to. Perhaps they are even starved for thoughtful attention. From these interactions of mine, I have formed collaborations with people to produce exhibitions and public art projects about aspects of their lives that might otherwise have gone unnoticed, sometimes even by themselves. I've worked with neighborhood residents in Oakland, mall shoppers in a Bay Area suburb, developmentally disabled adults in San Francisco, office workers in Minnesota, and a ten-year-old boy in Seattle, among others. One project that was produced here in Portland involved Cleveland and Joan Williams' lawn sculptures, which had been vandalized. I created twenty reinforcement sculptures that looked like the original three, but were based on the Williams and their friends and family. All of the sculptures were shown at PICA last summer as part of a show I did there and are now permanently displayed in the Williams' front yard. After the project was completed, I continued to spend time with the Williams and eventually bought a house in their neighborhood that had belonged to Cleveland's mother, who had recently died. So, my relationship with the Williams not only developed into an art project; it created a way for me to become part of a neighborhood in a very real way.

Through asking strangers questions, I have learned to have more meaningful interactions with people outside of my work--friends, family, neighbors, sometimes even people at art openings. I try to be willing to discuss subjects that are really important in my life, too. When my sister died last summer, I talked with several people about it (sometimes people I didn't know very well) and found out that most of them had also faced death in some way. It was very comforting, and it caused me to believe that people in general have the ability to relate to all sorts of things if they are given the chance.

Since I've been paying attention, it's become incredibly obvious how few meaningful questions people ask each other. I recommend that people try a little harder. How much do you really know about the people who you encounter on a daily basis? Try asking these people what they really care about. Show them that you are truly interested. Perhaps it will rub off on them, and they will ask you a question back. Whole complex conversations might ensue. You'll learn things from each other, trust and honesty could develop, the world (and the art world with it) might become a better place.

• Editor: And yet this gap between strangers in public space still exists. How can we generate empathy and curiosity and begin deeper conversations about what others "really care about"?

In a face-to-face encounter, there is first a subconscious impulse:

> The other's facial expression or bodily posture affects me before I begin to reflect on it. ... It is dual: a command and a summons. Naked and defenseless, the face signifies, with or without words, "Do not kill me." It opposes a passive resistance to our desire for mastery wherein our freedom asserts its sovereignty.[1]

Once an encounter passes this basic test ("ok, you're not crazy"), there is difficulty of empathy:

> The first set of mistakes we make with strangers—the default to truth and the illusion of transparency—has to do with our inability to make sense of the stranger as an individual. But on top of those errors we add another ... we do not understand the importance of the context in which the stranger is operating.[2]

Fiction and humor can be the bridge to openness. It may be more productive to begin an encounter with absurdity: "What do you do?" "I'm a cosmic neurosurgeon."

Talking to strangers about what they really care about requires what Martin Buber called the "I and Thou" relation: shifting one's relation with another from an "I-It" relation (self/object) to "I-Thou" (self/ other self). Through quick and dynamic dialogue, one's interlocutor transforms from an external thing into a dynamic, shared presence.

4 Public Space

For an introvert like me who spends far too much time scrolling through on-line media, interrogative design poses a creative challenge. Its projects are not online memes or conceptual paper projects. They take place outside, in the clear light of day (or illuminated at night), where they produce instant dialogue between random people. In this way, the city becomes a site of agonistic discourse. Unlike works of speculative design or design fiction, interrogative design projects work with the dynamic realities of spontaneous face-to-face encounters and embodied public space.

What makes a space public? And what makes a city? We can think of example spaces: sidewalks, parks, plazas, malls. These share characteristics of free access, chance, and serendipity; they are socially dynamic sites of open contestation, debate, and politics. Traditionally, there is some expectation of ano-nymity (although our cellphones now make us walking organic vehicles with transponders). Public spaces are often outdoor areas or the result of designed landscapes. Are stores, elevators, university campuses, movie theaters, of-fice lobbies, parking lots, sports fields, vacant lots, airports, and train stations actually public spaces? What unwritten rules and politics are inscribed into these zones, and to what extent can they be modified, hacked, amplified, or détourned for artistic projects?

Henri Lefebvre, interpreted here through David Harvey, develops the concept of "the right to the city," which we can think of as an essential political compo-nent of public space in democratic societies.

> The right to the city is far more than the individual liberty to access urban resources: it is a right to change ourselves by changing the city. It is, moreover, a common rather than an individual right since this trans-formation inevitably depends upon the exercise of a collective power to reshape the processes of urbanization. The freedom to make and remake our cities and ourselves is, I want to argue, one of the most pre-cious yet most neglected of our human rights.[1]

To make and remake ourselves along with the making and remaking of the city, presumably with our participation: interrogative design draws together this back-and-forth dynamic between people, the city, and all their past and future

• **Dana Gordon**: Architecture and especially urban public spaces are a vital element in the "interrogative work" since the seventies and the desire to escape the notion of the white cube.

Nowadays, when society may be channeled into Twitter [X] as the ultimate place for public debate, physical space maintains characteristics that digital media lack, such as confrontation of human bodies in a real world, with concrete implications.

Space conducts multiple significances that we may read simultaneously: from the physical survival level to cultural and even spiritual meaning.

possibilities. It is a form of design that can help individuals become more active performers of their own scripts. This method for designing social communication equipment can enable individuals to interact with one another in ways that might otherwise be too fraught with fear and unacceptable consequences—to produce peace through social interaction and engagement with the public social spaces of the city.

And yet fear (or rather the courage to push through fear) is also an important component of interrogative design. Wodiczko often cites Foucault's writing on the ancient Greek concept of the *parrhesiastes*, the fearless speaker, as an important construct in interrogative design.

> The parrhesiastes is someone who says everything he has in mind: he does not hide anything, but opens his heart and mind completely to other people through his discourse. ...
>
> If there is a kind of "proof" of the sincerity of the parrhesiastes, it is his courage. The fact that a speaker says something dangerous—different from what the majority believes—is a strong indication that he is a parrhesiastes.[2]

One might add to this that the parrhesiastes takes these risks both online and offline, in embodied spaces.

For many populations of underrepresented, marginalized and voiceless people, designers can create instruments and public environments that enable people living under fear to speak, or declare their presence, to exist without shame, or to perform any number of speech acts (see John Searle) that can communicate their lived experiences to others in public space, such as singing, playing, performing visual gestures, playing music and rhythms, or any other number of signs of life in their most dynamic, bold, and joyful forms.

Not only does speaking in public help on a psychological level (particularly in autobiographical narrative forms, or "presentification," as described in the section of this book on "Memory"), but it is also an important component of vibrant democratic processes. Chantal Mouffe has written extensively on the topic of *agonism* as an alternative to the deliberative model of democracy: a political sphere of unresolved differences and positions constantly in tension with one another. The notion of agonistic public space is

an important component in using design projects to help marginalized people assert their own right to public spaces as full democratic participants with active and well-heard voices. In a healthy democracy, people need not feel they must have permission to speak or to exist in a public space. The space is theirs, the right to speak is theirs. If anything, it behooves those of us who are well-privileged to become more active listeners and remedy any blockages in public speech.

Thoreau famously wrote about the essential need for civil disobedience in society. When the government is not just, disobedience is an ethical duty. "Under a government which imprisons any unjustly, the true place for a just man is also a prison."[3]

However, even before concerns of democratic dynamics or the therapeutic possibilities of public space, one might consider Levinas's focus on a foundational building block of civilization: the face-to-face encounter. "The face to face both announces a society, and permits the maintaining of a separated I."[4]

But what about online spaces: are they public? Wodiczko answers the question this way:

> I always feel there is a connection between those two public spaces that cannot be questioned, but can only be made. We can, we must use all the connections between the electronic digital or virtual and physical, because we already know. Okay, for example, after September 11, there was a massive demonstration in New York City against the bombing of Iraq. But nobody gave us a physical space to assemble about some problems. And I realized that an enormous amount of people were communicating via cellphones and listening to speeches. The movement of people was actually directed by media. There's an enormous amount of historical events in physical public spaces that could not have happened so efficiently in so impactful a way without media. So one media helps another media and the opposite is true at the same time, there's so much media in public space, in physical space, it cannot be more right now.
>
> So the only way to handle this actually is to take charge of media in questioning this and countering

Even juxtaposing another instance of the same medium is itself a rare technique. *Fearless Girl*, a sculpture by artist Kristen Visbal, was placed in front of the New York Stock Exchange's *Charging Bull* statue. This intervention provided completely new meaning to the original work and to the environment it inhabits. The gesture, even if temporary, leaves a strong impression on the public's memory of the actual space.

4.1 Photographs of the *Fearless Girl* sculpture intervention.

Building a Language on the Interrogative Form

Zenovia Toloudi

Krzysztof Wodiczko is well known in the art/design and architecture worlds for his large body of works that engage ethics in design/art. Not only has he introduced pioneering typologies to these ethics (e.g., prosthetics, wearables), which have now become a norm in art and education, but Wodiczko has also established a method, interrogative design, setting up certain standards that inspire, among other things, sophistication in design ethics. This sophistication in art/design ethics, rare and indescribable, has influenced generations of artists, designers, and educators, including myself. In my practice and pedagogy, it offered me a vehicle and confidence to think of, and make, form interlinked with ethics and democracy.

The sophistication behind interrogative design matters in order to avoid a superficial or "bureaucratic" approach. Wodiczko himself in the past used the word "bureaucratic" to comment on public art ("bureaucratic aestheticism") and the public domain ("bureaucratic exhibitionism"). Nowadays, it is even more important to acknowledge the "bureaucracy" risk. As we experience a shift in society (and design) to finally emphasize ethics (through a series of movements such as Me Too and Black Lives Matter), we need the critical tools as well as the approach and language to address the issues. The lack of sophistication penetrates at least three areas. First, in the creative world (and beyond), "design" itself has become an umbrella word, making its use meaningless. Second, among creative individuals prioritizing ethics, it is not uncommon for them to make works that are too direct or literal to describe or react to the problem. Such a project essentially becomes a tick in a checkbox to fulfill certain expectations (in the same way as various applicants and employers are now expected to write a statement on diversity, equity, and inclusion rather than practicing daily a truly democratic behavior). It is not uncommon for Wodiczko to discuss the need for humor and play in these projects. Third, in the field of public space (Wodiczko considers it the ultimate place to achieve democracy) there is a separation that exists in literature and practice between those who can describe the problems and analyze the contexts (sociologists, anthropologists, etc.) and those who are form-makers (artists, sculptors, etc.). This compartmentalization might be expected, even obligatory, in libraries and academia, but it does not serve society at large.

But none of the above would matter if we (by "we" I mean us both as creators and as users) would access a more specific language of form that describes those methods and options available to us to transform the world. What can we learn from Wodizcko's interrogative design and offer back to this world?

A Language on/of Form

At the Harvard Graduate School of Design I had the chance to meet and work with Wodiczko (in the classroom, as well as through my doctoral dissertation). I have been interested in form, and more specifically in collective form as social language, as something constructed subjectively through people's preferences and cognitive associations along with creators and other experts' evaluations. To develop an understanding of collective judgments on form, taste, and subjectivity, as part of my doctoral work there, I developed Picanico, an online platform that associated pictures of architectural work (photos, drawings, models, etc.) with user-defined tags (modern, classic, brutalist, etc.), creating a user-defined classification system for architectural typologies. This period as well as my interactions with Wodiczko influenced my approach to ethics, allowing some of my societal and democratic concerns and observations to slowly become an integral part of my creative practice and teaching.

In the last years, I expanded this research outside buildings to public space, and not only to study or reveal but also to create associations between visuals and words. To build this language on/of form which promotes design "tactics" (Wodiczko prefers to use this word rather than "strategies"), I have been trying to create, also together with my students, projects that focus on particular action verbs. This is expressed through the exhibition and research titled "Speak! Listen! Act! A Kaleidoscope of Architectural Elements for Public Space." This ongoing research develops a taxonomy of projects for public space, at the intersection of architecture, art, and urbanism, investigating how design can act as an agency to instigate or reinforce for the public a series of actions such as communication, interaction, collaboration, playfulness, and empathy. In a way, it introduces new typologies for the public space, communication interfaces, and terrains for unpredictable activities where the citizen becomes an active participant. Through responsive designs, ephemeral interventions, participatory events, collective experiences, and happenings, the intention is for architecture to serve the commons, and therefore to become the catalyst for social space and public action.

The main curatorial element in the "Speak! Listen! Act!" exhibition is the presentation of 20 projects through a wall installation in the form of a periodic table of light boxes. Each light box contains a project, represented by one axonometric drawing and one verb. The "X-ray" drawings and the verbs together constitute a language of types and actions to make public space more communicative, interactive, and democratic. In a similar way to how Richard Serra's *Verb List* (1967–1968) served as a guide for his practice and future operations, these projects together with their verbs function as a thinking device for architectural, artistic, and civic operations within the public sphere.

With Others

This language builds on communication among people representing various worlds. In addition, it serves to bridge the knowledge gap that exists based on the compartmentalization (also overspecialization) in disciplines. Furthermore, through its specificity, it allows for the actual transformation of the physical environment to take place (and therefore to change and have positive impact in the world). In all the above, the language helps in dealing with privilege (whether that of class, education, or knowledge), as well as with our approach to otherness. Who are the unprivileged and the unwanted, who are the others we need to be with?

Wodiczko emphasizes that respect for the others comes by emphasizing working with the people (instead of for the people, or about them). In his "Interrogative Design" essay he separates people based on privilege, from those with no access to the tools they need the most, to those with access to tools but without being able to critically take advantage of them. To maintain an authentic approach (speaking from within), while serving the underserved (proactively), it is important to adopt a gradient/spectrum for matters of otherness and privilege. This model of relevancy has been particularly adaptable when working with students, letting them select the group of "others" and the "unprivileged" they can relate to, as an honest way to connect to matters and not separate oneself from the others.

For example, my studio course at the intersection of Art, Architecture, and Public Space (Fall 2018) reimagined the public space of Harvard Square with an emphasis on engaging the less privileged groups of society, as well as addressing civic concerns that are often neglected. The course focused on how physical design and transformation of the environment could inspire civic imagination, even temporarily. Through their installations, interventions, and designs, students employed a variety of media aiming at improving (within the urban context of Harvard Square) general and specific conditions related to the public(s), such as the psychology of the individual, the inner-circle relationships among family and friends, face-to-face interactions as well as conversations among strangers, and equality for education in relation to the broader topic of undocumented students. What became clear through this investigation can be summarized in three recommended approaches: (a) improve human relationships and retreat from other ones; (b) in response to current challenges, establish a design language that can better enable human potential; and (c) start small-scale so we can experience some change quickly (civic imagination), hoping to even-

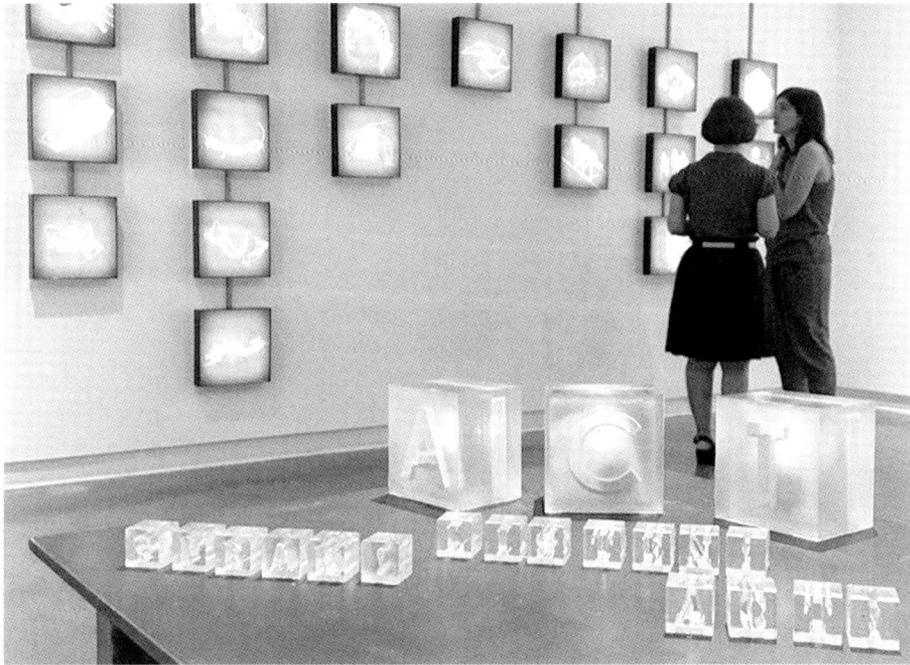

4.2 *Kaleidoscopic Wall* installation (2016).

tually inspire larger-scale developments (policies, planning, etc.).

Participation Is Key

The selection of the project's focus (making it often an audience-specific project) is one way to create a nonhierarchical approach to design and to others. Relying on participation through the format of experimental exhibition is another approach I have used to increase publicness in education.

Claire Bishop also connects the notion of experimentation with participation, particularly in art and educational platforms. In *Artificial Hells*, Bishop devotes a chapter to pedagogical projects, where a class becomes a work of participatory art itself. Although many of her examples are workshops or extracurricular educational activities that do not fall under curricular and institutional rules and expectations, Bishop questions experimentation, equality, and participation in situations that belong to what she calls the "hyper-bureaucratization of education of the western hemisphere." What becomes clear in many of these examples is that to further approach the public or become more

public, the old-style combination of one creator and one large audience needs to break apart. In many of his texts, Jacques Rancière tackles such hierarchical inequalities in relationships between an artist and their audience, as well as between a teacher and their students, through the concept of emancipating the spectator (and student). Krzysztof Wodiczko also breaks the polarity between creator and audience, but in his case there is an intermediate group, whom he identifies as the inner public, consisting of those people who believe in the project and co-create its success, and therefore making others believe in it as well.

Thoughts on the Interrogative

What? "Interrogative," in interrogative design, is a term that might awaken some negative feelings, especially in people who are not familiar with Wodiczko's work. And even if Wodiczko utilizes interviews as a tool, the term does not refer to this process. In his definition, there is an emphasis on the "form," and within his essay he also refers to the "interrogative artifact."

Who? Interrogations themselves are not necessarily like in the movies. As former federal prosecutor Preet Bharara explains, they rely on the art and science of asking questions. In that process, Bharara comments, art is more essential than science, to be able to "read the moment." Bharara brings the example of Hans Joachim Scharff, the "Master Interrogator" during the Second World War, who had learned/practiced interrogation from observation and "osmosis" through a gentle style, soft manner, trust, respect, and intellect. His style influenced the current (acceptable) techniques of interrogation. Therefore, who is the interrogator also matters. One wonders, can the technique of eliciting the truth, in projects as well as in research, be driven by kindness? Can that inspire more gentleness in design?

For whom? And who is the receptor of the interrogation? Not necessarily a person. As literature scholar and Harvard professor Doris Sommer suggests through her work with Pre-Texts, a teacher-training program aiming to develop avid and creative readers, "we interrogate the text." As Wodiczko implies, the form, the artifact, is interrogative.

In my own practice and pedagogy, interrogative form is more of an artifact than a process, more of a thought experiment than an actual experiment. It is an intellectual exercise in releasing power (letting it go) through not-yet-realized projects that exist in exhibitions and other public formats. *Free-See-Saw* is one example of such work belonging to the bigger category of "Tectonics of Democratization," which explores how the physical environment relates to actions, such as negotiating, balancing communicating, and performing.

4.3 *Free-See-Saw* (2019).

Tectonics of Democratization

Free-See-Saw is a hybrid urban furniture and play conceived as a dialectical space for citizens. *Free-See-Saw* accepts the statement that one person's freedom stops where the other's freedom starts. *Free-See-Saw* suggests a free, collective seating space, available to all, while implying the need for negotiation and collaboration through motion and bodily equilibrium in order to share an urban space's resources. It becomes a performance, a space for spectacle, where the role of subject-object, performer-viewer is not clearly defined. *Free-See-Saw* implies the need not simply for participation but also for collaboration, cooperation, and negotiation among citizens.

Tectonics of democratization challenge architecture to reinforce civic responsibility through the integration of instability, balance, and movement in the design. The ex-

pression of fluctuation is captured in the elements, materials, details, and forms of these structures. The constant newly defined situations affect the interactions among citizens, who (now) need to arrange, discuss, and negotiate among each other. And vice versa, users steadily reshape and evolve the structures.

Discussion

Some of the lessons from Wodiczko's interrogative design can be summarized under three principles: (1) Give away power by empowering the unprivileged, therefore creating nonhierarchical relationships among people, and perhaps more democratic environments. Through this process, being gentle, kind, and observing is the priority, with emphasis on developing and practicing empathy. Educational environments and certain institutions (like the MIT Media Lab, where interrogative design was born) can also serve as platforms to test the reinvention of these dynamics among individuals and groups. (2) Learning how to ask important but difficult questions is crucial for first challenging the norm and then reinventing it. An example Wodiczko repeats: once slavery was considered normal and legal—now it is not. The same shift, he suggests,

needs to happen with war. What if we think of war as being illegal? When working on the norm, one should have temporality in mind ("in this design's temporary character"). In Wodiczko's words, "design must not hesitate to respond to the needs that should not, but unfortunately do, exist." The emphasis on the temporary allows for this process of doubting and reinventing the norm to be ethical, and to make sense. (3) Lastly, architects and artists should not be excluded from working on social matters. The question is not whether but how can democracy be embedded in the design. The challenge is to channel the questions, issues, and concerns into a form/design (a shape, a material, an interface), and to even integrate playfulness or humor when working on these ("the form employed in asking questions").

Seeking to identify the elements of interrogative form, as well as what matters to work on, one can start from one's own immediate circle, even from oneself, instead of saving the others elsewhere. I often feel Wodicko can read the souls of people. Who knows, some emphasis on the psychoanalytical aspect in design might prove more effective, at least curing.

References

Bharara, Preet, *Doing Justice: A Prosecutor's Thoughts on Crime, Punishment, and the Rule of Law* (New York: Knopf, 2019).

Bishop, Claire, *Artificial Hells: Participatory Art and the Politics of Spectatorship* (London: Verso, 2012).

Costanza-Chock, Sasha, *Design Justice: Community-Led Practices to Build the Worlds We Need* (Cambridge, MA: MIT Press, 2020).

Rancière, Jacques, *The Emancipated Spectator* (London: Verso, 2012).

Rapti, Vassiliki, and Eric Gordon, eds., *Ludics: Play as Humanistic Inquiry* (Singapore: Palgrave Macmillan, 2021).

Toliver, Raymond F., *The Interrogator: The Story of Hanns-Joachim Scharff, Master Interrogator of the Luftwaffe* (Atglen, PA: Schiffer, 1997).

Toloudi, Zenovia, "Are We in the Midst of Public Space Crisis?," *The Conversation*, June 7, 2016.

Toloudi, Zenovia, "Exhibition as a Pedagogical Tool for Experimental and Public Architecture," *Proceedings of ACSA 104: Shaping New Knowledges* (Seattle, 2016).

Toloudi, Zenovia, "On Architectural Taste and Identity: Experimenting with PICANICO Game," doctoral dissertation, Harvard Graduate School of Design, Cambridge, MA, 2011.

Toloudi, Zenovia, *Technoutopias*, exhibition catalog (Dartmouth College, 2019).

Toloudi, Zenovia, "When Public Space Meets Civic Imagination: The Case of Harvard Square," *Journal of Civic Media*, no. 2 (2021).

Winnicott, Donald W., *Playing and Reality* (London: Tavistock, 1980).

Wodiczko, Krzysztof, *Critical Vehicles: Writings, Projects, Interviews* (Cambridge, MA: MIT Press, 1999).

Wodiczko, Krzysztof, "The Inner Public," *Field*, http://field-journal. com/issue-1/wodiczko, last accessed January 4, 2016.

Wodiczko, Krzysztof, "Return to Parrhesia: Recovering the Capacity to Speak," in *Public Space? Lost and Found*, ed. Gediminas Urbonas et al. (Cambridge, MA: SA+P Press, MIT School of Architecture and Planning, 2017).

Obviously Hostile Design

Antoni Muntadas

- KW repositions the concept of design on the cross-axis of art, social involvement, and the city, as he is an heir of the Russian avant-garde and the Bauhaus.
- The definition or meaning of interrogative design carries on a series of prototypes, experiences, models, and demonstrations that open critical territories for practical and pedagogical issues.
- Throughout the years, during door-to-door studios and courses on MIT, we tried to discuss concepts of art in public spaces and notions of interventions that are basic to our practices.
- When you give content to the word "design," it also shows that design has lost its sense of criticism and interrogation. In this sense, interrogative design not only provides criticism but also proposes alternative designs that can be implemented.
- Confronting how urban design is developing in the cities and how popular it has become for city halls around the world to decide how public design has to be, what I have seen is that urban design has become what I call hostile design. By hostile design I mean the use of materials that the city uses to prevent citizens to use these elements. Obviously hostile design is closely tied to gentrification ("cleaning the city"). Under these parameters, interrogative design also goes beyond design and reflects cultural, political, and social issues.

Here are two cases I have observed in the city of New York that exemplify hostile design:

1. In the new benches I have seen in parks and public spaces, they now have separations embedded in the bench, which prevent homeless people from sleeping on them.

2. I have also noticed wooden walls around the city that are embedded with additional small fixtures all over the wall, in order to prevent people from posting flyers on them.

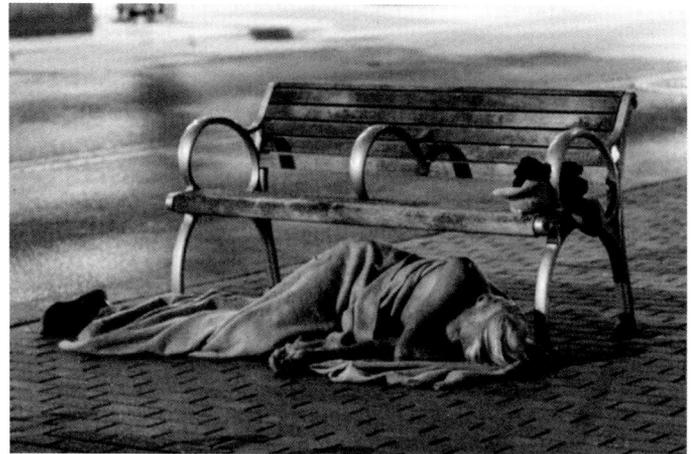

4.4 Public benches in New York.

4.5 Construction barrier.

Civic Stage

Frida Escobedo

2013

4.6 Frida Escobedo's *Civic Stage*, on site.

4.7 *Civic Stage*, in use.

Escobedo, a student of Wodiczko, describes her Lisbon Architecture Triennale project:

> The stage ... put into question the relationship between speaker and audience. Typically, a stage provides direction, where the speaker is standing at a podium. ... But I believe that the voice of the speaker is only as loud as the number of people it reaches, so I proposed a 15m circular stage, faceted at the bottom, so it would act a little bit like a seesaw, literally raising the voice of the speaker as people gathered and listened. And of course it would allow for more playful speculations.[1]

José Esparza describes the project:

> It presents itself as a stage to materialize the multiplicity of arguments and collectively propose, discuss, and create affective strategies for structural change.
>
> In the field of spatial practice, the condition of plurality that Hardt and Negri allude to is visible in the many ways in which architecture is made manifest today. ... To sustain and truly make effective this "multiplicity of singularities," we not only have to realize their potential as a collective, but as Hardt and Negri claim, their ambitions must also be channeled through a political platform.[2]

Nomadic Mosque

Azra Akšamija

2005

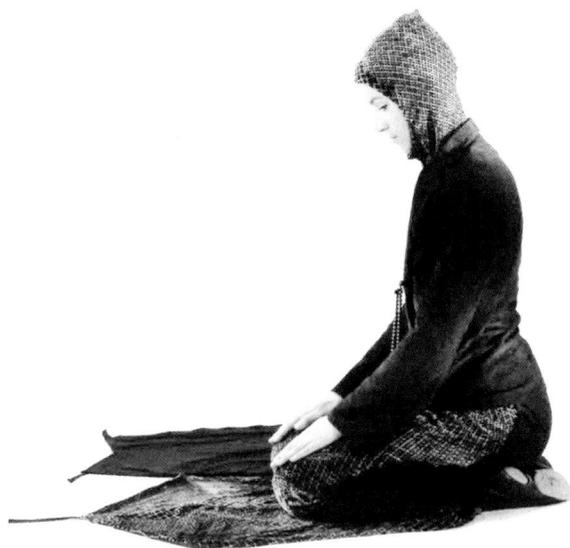

4.8 *Nomadic Mosque*, worn and installed.

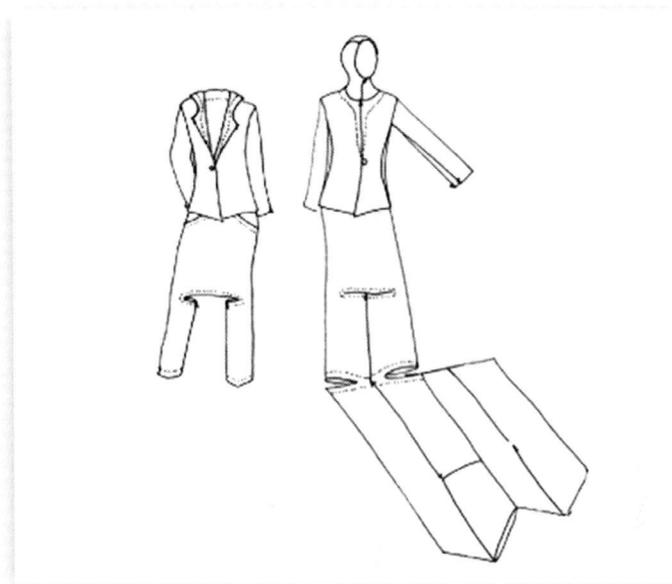

4.9 *Nomadic Mosque*, diagram.

Nomadic Mosque explores various ways of negotiating spatial relationships between Islamic traditions and modernity in the United States and Western Europe by creating wearable mosques, clothing that can be transformed into prayer rugs. While respecting religious restrictions, *Nomadic Mosque* aims to redefine traditional forms and functions of mosques in the contemporary context. The intention is to represent identity and religion as a dynamic process that allows change in time and place. The project reinterprets the concept of the mosque, based on the Prophet Mohammed's phrase "the world as a mosque," as wearable architecture. The *Nomadic Mosque* is a minimal-volume mosque, whose design is based on individual needs and experiences. It is a device to transform any secular space into a prayer space. The wearable mosque not only accommodates the liturgical necessities but also acts as a prosthetic device for the worshiper, communicating his or her prayers, problems, needs, and desires. The project combines a prototype design for a wearable mosque and a five-minute video that shows ritual prayer in various public spaces. Giving a voice to the new young Islamic community, *Nomadic Mosque* operates provocatively to claim a right to visibility and to speak out against marginalization.[1]

paraSITE

Michael Rakowitz

1998

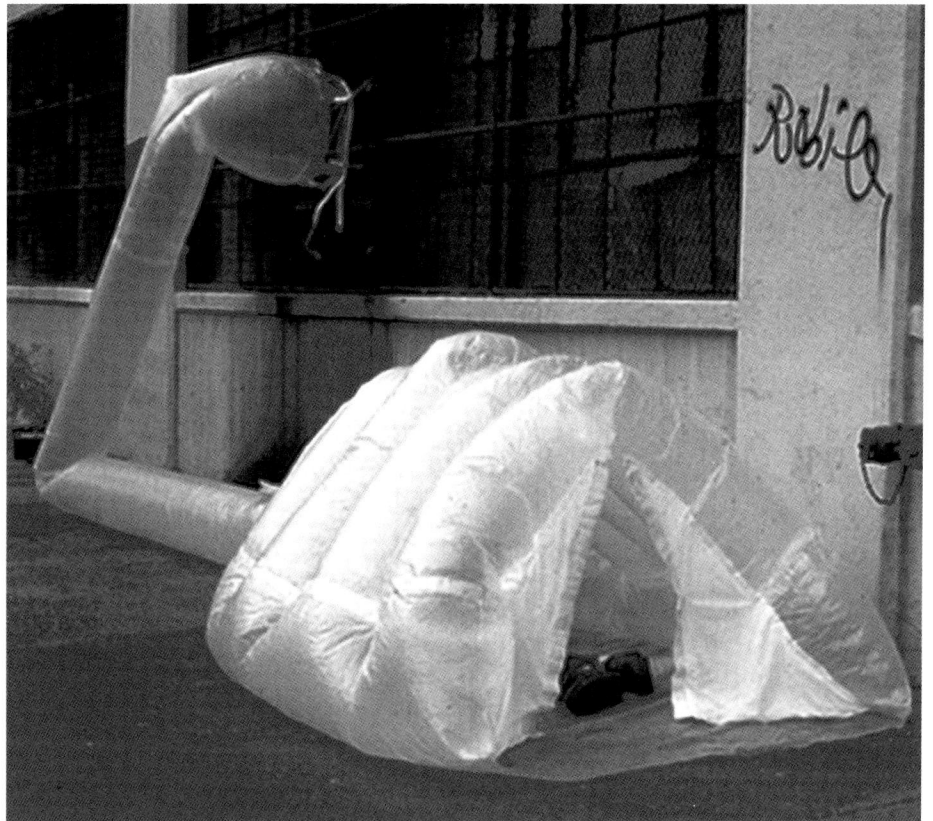

4.10 ParaSITE, prototype.

• **Sofia Ponte:** Michael Rakowitz has designed a refuge that combines two main premises, namely, to be transportable and collapsible—a structure that can both accommodate displaced people and unpredictably be transformed into a transportable volume. paraSITE is a portable object that can be easily folded and disassembled, making it easier to carry around. In its inactive state, paraSITE stores in a small pack with straps for carrying by hand or over the shoulder. In its active state, it transforms into an inflatable structure that fills with air.

ParaSITE shelters are custom built inflatable structures designed for homeless people that attach to the exterior outtake vents of a building's Heating, Ventilation, and Air Conditioning (HVAC) system. The warm air leaving the building simultaneously inflates and heats the double membrane structure. The project began with the distribution of these shelters to over 30 unhoused people in Boston and Cambridge, MA and New York City, and since then, they are constructed and distributed every year in Chicago.[1]

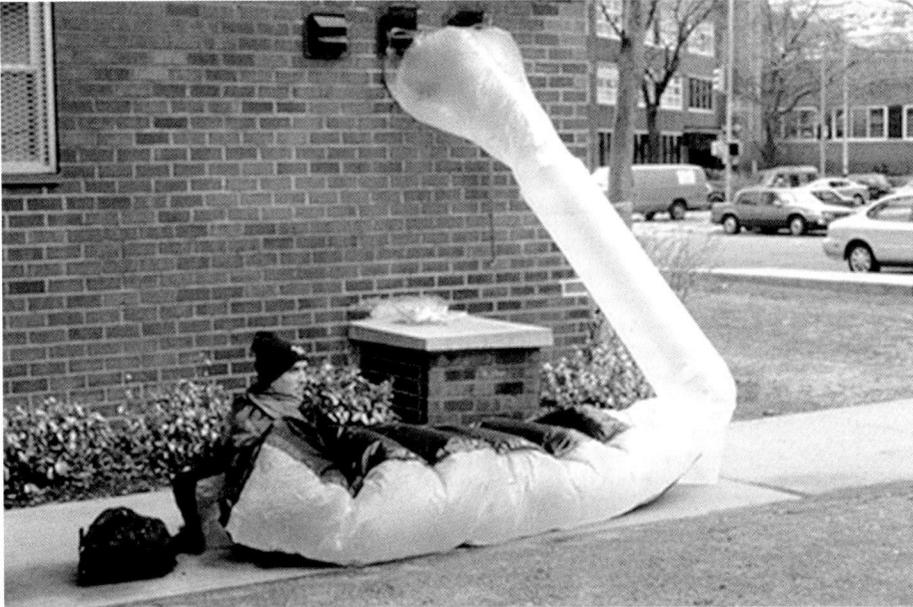

4.11 ParaSITE prototype, occupied.

4.12 ParaSITE prototype, in discussion.

4.13 ParaSITE, working sketches.

- **Sofia Ponte:** The idea of paraSITE is to provide a temporary space with the features of a shelter to be occupied by homeless people. The plastic structure has an adjustable inlet tube, also made of plastic, which can be expanded or tightened to suit the opening of a fan fixed to a building. This connection is established by means of an adjustable lip, elastic cords, and hooks that attach to the metal grids to reinforce this connection. For Rakowitz, the joining of the inflatable structure to the building is the critical moment in the artist's work because it signals the parasitic relationship that this object establishes with the architecture of the city.[2]

- **Sofia Ponte:** In conversation with Michael Rakowitz, the artist highlighted that he is not operating at the level of problem-solving. Rakowitz does not wish to see paraSITE mass-produced or considered as a permanent solution for homelessness. Rakowitz's attraction to intervening in a social order is, in the artist's view, clearly that of someone working as an artist. Although paraSITE maintains a dialogue with utility, this does not mean that it necessarily falls into that category.[3]

- **Sofia Ponte:** Like Krzysztof Wodiczko, Rakowitz designed the first paraSITE prototypes in interaction with the first users. Rakowitz proposed his concept to Bill Stone in April 1997, who saw the project as a scathing response to various Cambridge City Council initiatives to drive the homeless community out of the city center.

paraSITE

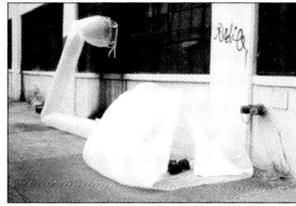

How to build an inflatable shelter that attaches to the exhaust vent of a building's heating system, thereby creating warmth and space in winter.

Designed by Michael Rakowitz.

Materials: 20 garbage bags (1 with drawstring), roll of duct tape or weather-proof packing tape, plastic tarp, thin gage electrical wire, scissors.

Cut the tops and bottoms off ten garbage bags so that they're straight and open on both ends. (In the images, these bags are white.) Arrange in two rows of five each, cut end to cut end, and tape across. Do this bag after bag, creating two long plastic tubes. Be sure to tape both sides.

Cut six more bags in the same fashion and make three two-bag tubes. (In the images, these bags are gray.) Tape the sides of these tubes to one another to form a grid. Lay the grid between the two white tubes.

Cut the inside edges of the white tubes from top to bottom. Tape the newly cut edges of the white tubes to the open edges of the grid. Also tape closed one edge of each white tube.

Make the extension tube by again cutting off the bottoms of garbage bags and taping the open ends together . More bags means a lengthier tube. Attach to the open end of one of the white tubes. Tape shut the open end of the other white tube.

Use a drawstring garbage bag to create the vent attachment. Most bags have two places to pull the string out; cut two more. At each of these four points loop hooks made from foot-long pieces of thin gage wire.

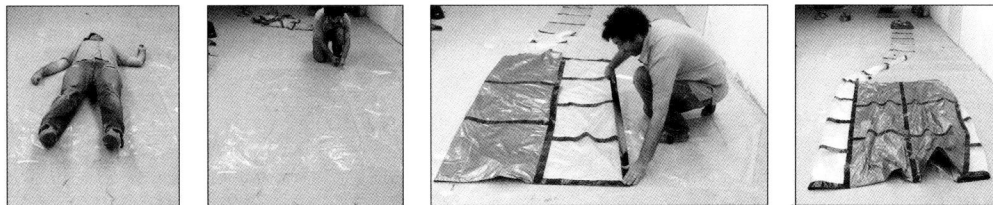

Unfold the plastic drop cloth and mark the desired floor space for the shelter. Cut accordingly. Tape the edges, lengthwise, to the white tubes. Turn the shelter over and it is ready to be inflated.

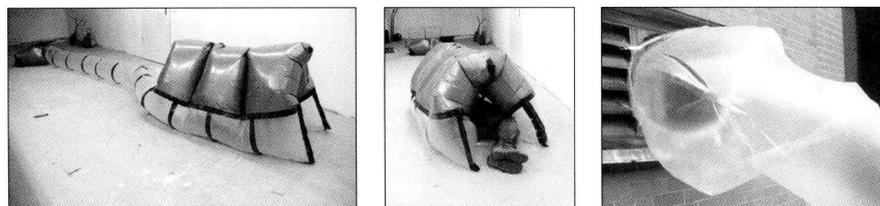

Check the seams for leaks. Any and all holes can be repaired with tape. If more privacy is desired, doors can be added using breathable fabric. The shelter will be warm enough regardless, and the double-membrane structure guards against contact with re-circulated air.

To use, find a suitable exterior heating vent and attach shelter using hooks.

IMPORTANT: Sleep with head at front or back of shelter. In the event of collapse, these areas will be the last to fall, are open to the outside, and the inhabitant will continue breathing free from obstruction.

People's Canopy

James Shen

2014

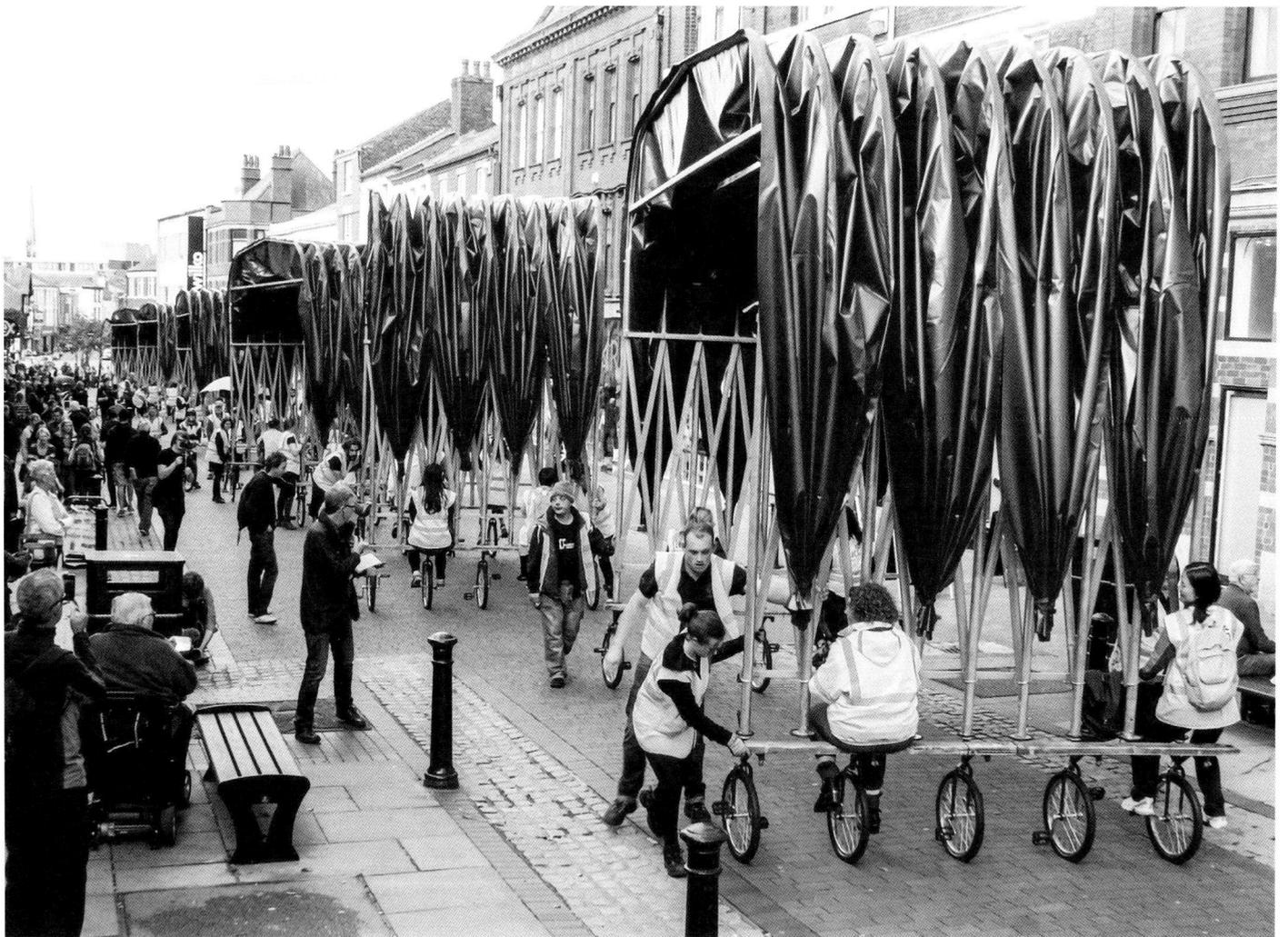

4.14 *People's Canopy*, in transit.

People's Canopy is architecture for events and architecture as event. It consists of retractable canopies that can cycled by citizens, paraded through the city, and expanded over the length of entire streets, linking disconnected public space.

People's Canopy is a two-story-high expandable roof structure on bicycle wheels that can seat up to 10 cyclists. It is designed to collapse to the size of a double-decker bus so that it can be collectively pedaled from one location to another. When parked, a canopy can open like an accordion to 40 feet in length with a span of 32 feet to cover entire streets. Spaces for automobiles are turned into spaces for pedestrians and events.

The design references expandable canopies popular in southern China. These are typically used by small businesses such as restaurants and bars to temporarily expand their spaces into parking lots and streets in an informal way. We adapted them for riding by attaching bicycle wheels and seats.

The design was first commissioned by the city of Preston in the UK and 'Certain Places, an arts program for urban interventions. A series of public events was organized around the *People's Canopies*, which were cycled across the city by its residents as a festivity that linked isolated areas of Preston. In their expanded form the canopies were installed in various locations to connect public squares and markets. These canopied streets housed a

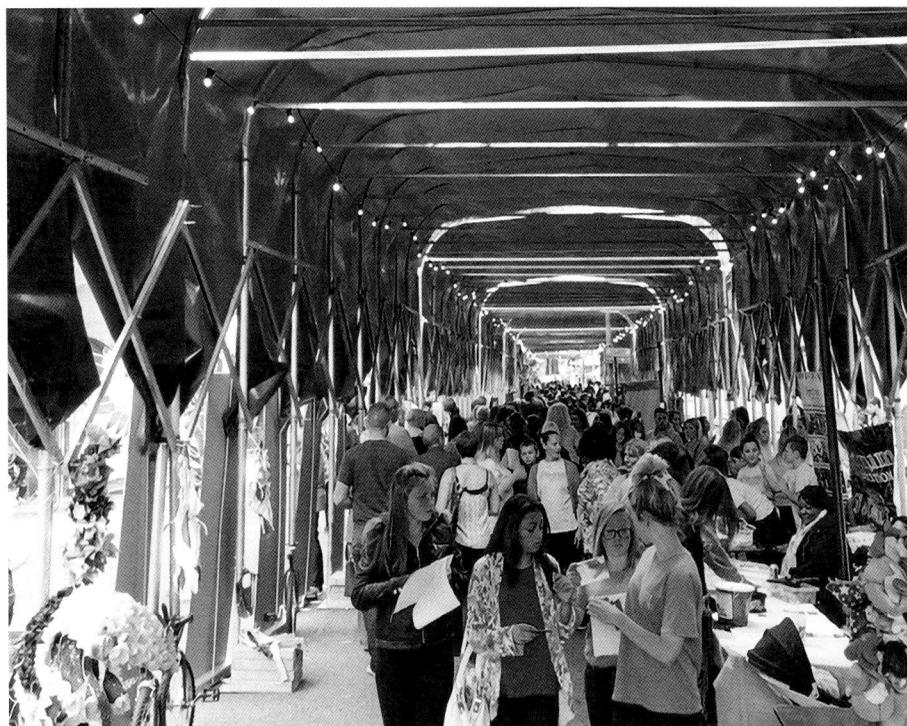

4.15 *People's Canopy*, open.

myriad of cultural events including musical performances, street theater, Preston Pride, and burlesque.

Since their debut in Preston, the *People's Canopies* have been featured in other cities including Leuven, Hong Kong, Beijing, Shenzhen, and Suzhou. In each case they have been deployed to reimagine city spaces by providing a flexible infrastructure for occupation and programming.

With the *People's Canopies* citizens are able to participate in the instant reshaping of their city.

Refuge Wear

Lucy Orta

1992

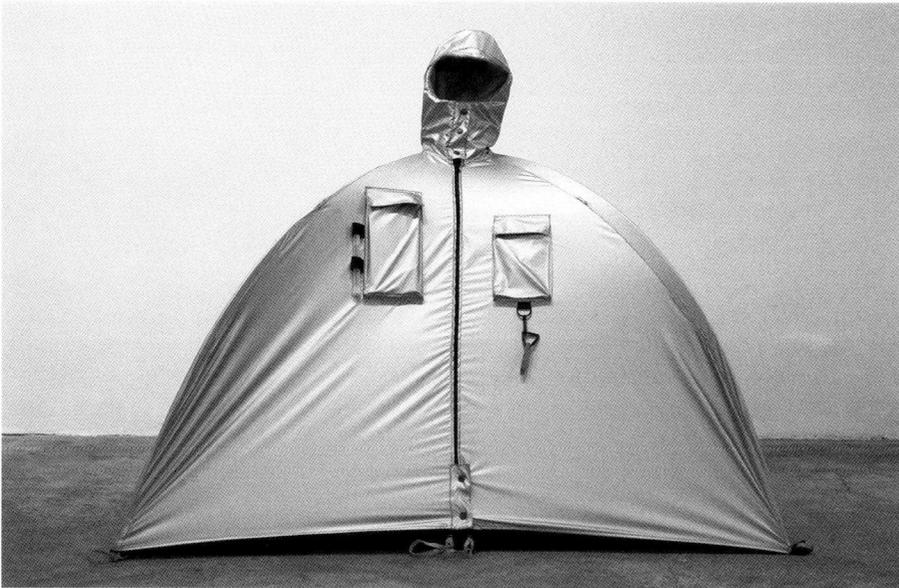

4.16 *Refuge Wear.*

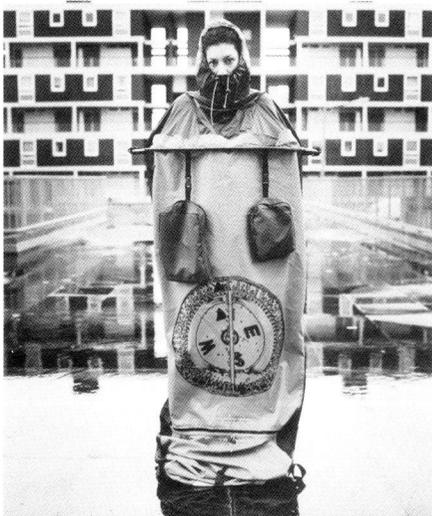

4.17 *Refuge Wear.*

Refuge Wear are temporary shelters that can be transformed into clothing to offer protection from harsh conditions and shelter in emergency situations. The series, which Lucy Orta began working on during a period of economic recession provoked by the Gulf War and subsequent stock market crash, combines a dual response to this unprecedented global crisis. They are poetic responses to the humanitarian aid appeals for shelter and clothing for the Kurdish refugees fleeing the war zones, and to the increasing numbers of homeless people on the streets of Paris.

Refuge Wear are portable habitats that convert into anoraks and backpacks, designed for personal comfort and mobility for nomadic populations. The transformation from shelter to clothing and vice versa is fundamental to the concept of freedom of movement, free will or choice, new relationships and new cultural exchanges, the *homo mobilis*. They incorporate arm and hood appendages, or pockets that contain both functional and symbolic objects. Their ergonomic forms allow for a minimum vital body space, and they employ cutting-edge design innovations such as telescopic carbon armatures that raise the fabric above the chest to eliminate the effects of claustrophobia. The materials contain technical properties such as microporous rip-stop with or PU coatings, metaphors for body comfort and protection.[1]

Interrogative Design, Public Policy, and Distributed Diplomacy

Jean-Baptiste Labrune

Over the last fifteen years, I taught[1] "design" to art, design, engineering, management, and recently to political science and diplomacy students in France, Switzerland, Israel, and the United States. A major part of these classes was about interrogative design (ID). In this text, I examine how the inclusive critical culture that ID sustains can be crucial for institutional and experimental public policy-making, its humanistic evaluation, and concrete deployment at global scale across digitally and biologically distributed communities.

I envision that the integration of ID in the training of future policymakers, diplomats, and participatory actors could beneficially transform institutions, communities, and their natural environments. Instead of turning civil servants and community organizers into designers,[2] there is an opportunity for a culture of critical thinking and evidence-based creative action to grow among them. Of course, this challenge is not easy because the status of ID is in itself a paradox. Too close to art, not close enough to the market and industry, ID could be seen as a mere theory for an elite: "design for designers," as there are "artists for artists."[3] But ID is also a concrete and strategic design practice, as demonstrated through the years by the determination of Krzysztof Wodiczko and collaborators to build physical mockups and functional prototypes with a level of advancement on par with the best product design studios in the world.

ID creates props that are essential to performances that might nourish a public debate or the conflictual participatory organization of a political space. This dissensual and performative nature differs from the recommendation culture of service design and similar methods used in scenario-based strategic activities.[4] As a consequence, the "deliverables" are not beautifully illustrated reports nor redesigned chairs. On the contrary, they are artifacts that slowly involve local communities, whose voices are usu-ally hardly heard in the public sphere, in order to critically think about their situation and welcome them in an unconditional way.[5] For a public hospital, ID might for example question the drastic diminution of public funding from the perspective of nurses, random patients, or cleaning personnel instead of celebrating the "experience" of "users" through "personas."

How do these different artifacts then affect public policy-making? What if political cabinets included a critical design perspective in their practice? And what about places with no schools or functioning institutions? How could we disseminate ID through distributed networks of people? More importantly, how to foster a culture of questions, not solutions?[6]

Teaching ID to Public Policy Students

I have been teaching hybrid and critical design courses and workshops since the beginning of the 2000s, first in underground venues,[7] then in more traditional contexts.[8] In 2008, as I was studying at MIT, I had the chance to discover ID as a theory and a practice through various experiences at the Center for Advanced Visual Studies interacting with the Interrogative Design Group and the Visual Arts Program/Art, Culture, Technology, where I attended a class co-taught by Krzysztof Wodiczko and Ute Meta Bauer, as well as various lectures and presentations.

Before I went to the United States, the notion of ID had been for me a historical landmark in the history of critical design.[9] After reading ID books and going through Interrogative Design Group members' works, PhD theses, and lectures, I realized that the practical mode of operation of ID and its bold ambition to positively tackle sociopolitical challenges, usually in asymmetric contexts, constituted a unique and divergent branch in the history of design and art.[10] I therefore recomposed my interventions in design and art contexts but also progressively in management and political science institutions such as Sciences Po in Paris (the School of Political Sciences) where I introduced, in 2018, a course called Radical Design.[11] This class, in English, regroups international students from all the disciplines, usually at master's level. Students will then work in high-level political places or companies. I also reoriented most of my pedagogical toolkit to three layers (industrial

design, new territories, and ID) that would logically allow students to experience design culture and situate their own critical practice and perspective in it.[12]

Public policy students often have some notions of design, but most of the time they associate it with the concept of design thinking, which comes from engineering and is mostly applied in corporate environments. In order to place the word "design" in a broader context, we first examine through various illustrated examples how the English word is polysemic and how its multiple meanings have been represented by different words in other languages (*progetto/progettazzione* in Italian, *dessein/dessin* in French). Then we examine different periods: origins (Paleolithic to 1850), toward modernism (1851 to 1918), modernist design (1919 to 1968), and contemporary design (1969 to now).[13] Throughout the class, students are asked to create moodboards and visual collages in groups, a challenge in itself due to the lack of practice with graphic design software on the part of most of the students, who end up hacking PowerPoint into Photoshop.

In recent years, different design disciplines have appeared, for example interaction design and specifically the firm IDEO, which is very interesting from an interrogative design perspective since it defines itself in terms of "solutions." Originally created as a product design company, it then pioneered immaterial design such as interfaces for computers. David Kelley, one of its founders, popularized the concept of design thinking; in his words, "We moved from thinking of ourselves as designers to thinking of ourselves as design thinkers. We have a methodology that enables us to come up with a solution that nobody has before."[14] Design thinking comes with a five-step methodology[15] similar to the "double diamond"[16] in engineering. It is a rational way to get efficient and optimal solutions for problems, rather than an interrogative attempt to provoke or scandalize through questioning a system.[17]

Interestingly enough, IDEO and Gillian Crampton-Smith[18]—founder of the Royal College of Art's Computer Related Department and of Interaction Design Institute Ivrea)—collaborated in the eighties. Coming from a background in philosophy, she paradoxically emphasized the ideological baggage that every designed object or activity

contains.[19] In the course, we start from this observation to examine recent design paradigms,[20] discussing the recent trend to rebrand design thinking as speculative design, how different prospective methods[21] in use in strategy circles in ministries and government cabinets[22] compare to those, and how they include, or not, a diversity of voices. And when they do, how this "plurality"[23] or "multitude"[24] can be instrumented into a carefully crafted spectacle of inclusion, usually for lobbying or political communication goals.

In the context of pedagogy, the 2005 Workshop on Interrogative Design[25] available on MIT OCW (OpenCourseWare) provides a good overview of the scope of ID.[26] In this last dimension of the course, we discuss ID and how the direct confrontation with a system of power and the desire to be inclusive are a challenge in their context, where public provocation and radical inclusion are highly controversial. We focus on how ID avoids the trap of the politically correct while still being elegantly disrespectful, or as it is presented in the workshop, "positive." Then we review some concrete ID works[27] and we discuss how easy it is to make a provocative coup and how difficult to incorporate the other into one's world, as a xenological[28] effort and in genuine hospitality.[29]

A practical toolkit of ID for public policy is then introduced, as well as assignments consisting of choosing unrepresented communities (gypsy children wandering in the streets of Paris while their parents are begging, mechanical turk workers, separated immigrants or displaced family members, social workers …) and having groups of three or four students create ID situations related to them. They are asked to create a concept and visually illustrate it through physical and virtual collages and sketches. Also, and this is very important, their concepts are accompanied by a few paragraphs that present the main ideas as well as critical reflection. Many of the concepts they have produced address public policy opportunities and how think tanks and diplomacy might help implement them or not. The class ends with a discussion on the tension between these aspirations as fictions and the challenges of deploying them in existing, often very centralized political structures.

ID and Distributed Diplomacy

Decentralized communities emerged in the 1960s, harnessing the power of the newly created internet to envision radically new ways to communicate and think about complex problems.[30] Rejecting consumerism, many designers such as Papanek[31] criticized the market-oriented approach that led design culture. The Meadows Report[32] called for a transition from growth to global equilibrium. Envisioning a sustainable future would imply drastically rearranging not only the decentralization but also the distribution of wealth, power, and information on the planet. One vector for this could be information networks, but other sociopolitical changes could be addressed by critical practices, including interrogative design.

Moreover, if (or when) the average conditions of human existence degrade suddenly, new forms of kinship and distributed social organization will be needed to maintain democracy, basic living conditions, and peace. In this regard, ID could mobilize actors of such rapid changes in a symbiotic and positive way, especially if ID interventions, objects, and texts were shared not only through decentralized but through distributed networks built, owned, and operated by a diversity of members of communities—a DIY technical challenge but more than anything a very sensitive sociocultural question when it comes to the distribution of power in a family, a rural area, or a city.

In addition to giant walled gardens,[33] decentralized technologies have allowed many inclusive, critical and open technosocial networks[34] to emerge since the sixties, multiplying workshops and places for making, reconfiguring and criticizing technology. However, due to the polyarchic nature of decentralization, most of these places are not unconditionally accessible, and in many ways do not put challenges of power asymmetry, money limitation, and resource scarcity as their priority. In terms of policymaking, these decentralized design-related communities are often going through intense governance feuds, with frequent collapse of part of their social structure, usually when it gets to a certain size and political factors[35] reach a certain threshold.

From a cultural and scientific diplomacy point of view—despite some notable attempts to create alternatives in

Hackerspaces (e.g., hackerspaces.org) and experimental art centers (e.g., Akademie Schloss Solitude "Netzwerk")[36]—these networks often reinforce existing social structures by promoting a few network heads instead of many diverse subgroups connected as a mesh. Strange ideas such as political tinkering, experimental art, programmable matter,[37] biotechnologies, or philosophy do not circulate as freely in some communities as in others, for various historical and contextual reasons. Interrogative design, as a distributed practice and mode of enquiry, could therefore equip nondominant actors with powerful negotiation vehicles, learning-through-design opportunities, and humanistic assessment tools.[38] A distributed diplomatic research network inviting artists, scientists, institutional and community researchers to create experimental tools as well as infrastructures could be a step toward this goal.

Conclusion

Learning and incorporating ID in public policymaking through classes, templates, and cultural artifacts might affect the way centralized institutions design and evaluate their action. All over the world, new distributed diplomatic networks, yet to be invented, could facilitate initiatives questioning their environment, based on scarcity. For instance, inviting children to interrogative design activities through DIY tutorials using minimal resources.[39]

Why distributed low-tech interrogative design workshops? Because there is not yet a NASA for Earth, each child has to build her own spacesuit to be protected from the coming entropic tsunami. Growing up in a deep rural area, she cannot access the internet or is not allowed to for traditional, cultural, or political reasons. Or maybe she lives the "smart city" dream of surveillance capitalism.[40] Like hackers, artists, and scientists who redefine their situation by exapting[41] their environment, she could maybe learn with a few friends in these workshops how to advocate and build her own critical infrastructure and transitional artifacts, using wisely the limited resources of her environment, and feel deeply legitimate in asking her own questions, not only in the circles of her family and friends but hopefully in school and later as a stellar, passionate, and emancipated democratic actor.

When I stand next to my projects in public, there is an intense level of emotional energy. No matter how many times I show my work in person, it is an emotionally charged, unpredictable process. I've been questioned, guilt-tripped, argued with, encouraged, shut down, supported, scolded, praised, and even punched. To take creative work into public space requires courage not only for the artist-designer, but for the participants and viewers also. Outside of the controlled incubator of the gallery, public space is chaotic, contentious, continuous, and tinged with potential danger. Works of interrogative design make use of the energies of public space to further their creative objectives using specific established techniques of performance and street theater. These ways of working give participants some useful structure and emotional distance in complex and emotionally charged work. For artists leading projects in public space, the "fourth wall" is a crucial tool.

Wodiczko calls interrogative design projects "performative speech instruments." The people who use them are "operators" or "performers" rather than "users" (the common nomenclature in the design world). Interrogative design projects are communication devices that fill a void where normal market forces fail to produce results. They are props, vehicles, and physical media for interpersonal exchanges that are otherwise difficult to conduct. This special equipment facilitates public performances that are spontaneous and only partially scripted. Many interrogative design projects include segments of documentary-style prerecorded interviews with people from precarious communities, with industrial design components that are typically formed through participation with the intention to elicit speech acts. The operators of these systems are emboldened to become brave public speakers on the unacceptable and difficult conditions of their own lives. When approached by members of the public, these operators become performers of the stories of their own lives—representing themselves and others like them who are silenced in day-to-day life. The *Homeless Vehicle*, *Desirable Posture*, *Alien Staff*, *Enemy Kitchen*, even the helmet for the *Tijuana Projection* all serve as devices to help performers step into a more confident version of their own selves and pronounce the difficult conditions of their lives, in public, to others who will listen.

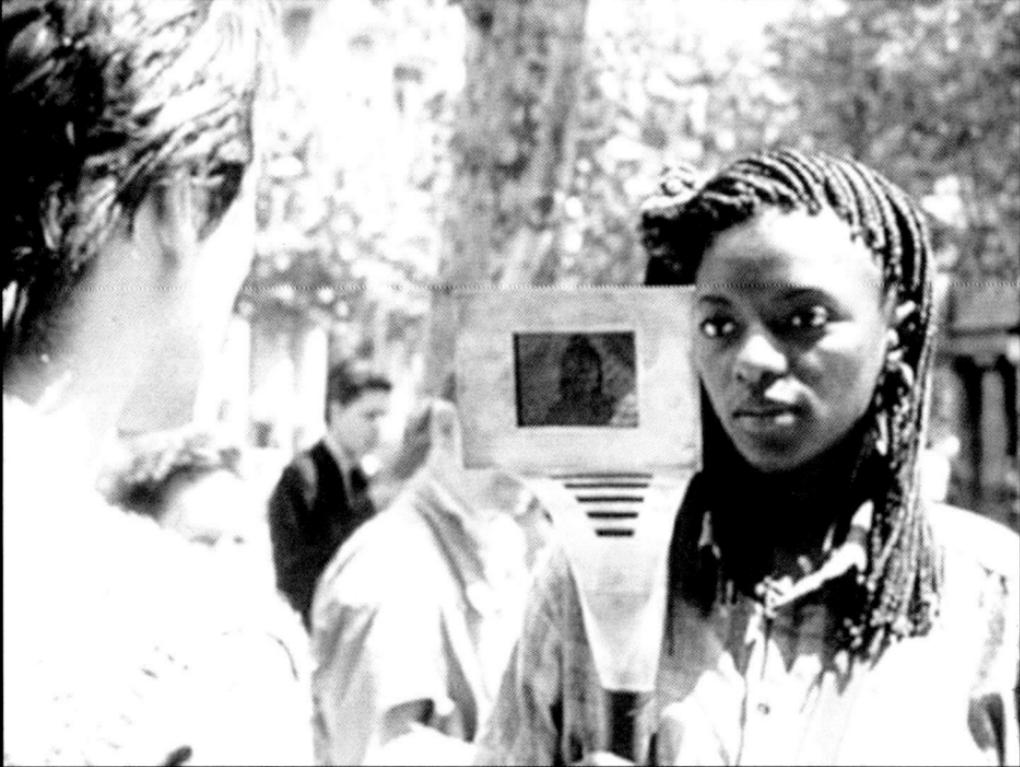

5.1 *Alien Staff*, in use.

From the audience's point of view, these interrogative design performances also have some remarkable qualities that set them apart from conventional street theater and busking, qualities influenced by various theorist-practitioners such as Paulo Freire and Augusto Boal, who showed theater's potential to transform society. Bertolt Brecht's ideas on theater are also particularly important. His creative philosophy was rooted in theater's ability to jolt audiences out of the slumber that conventional entertainment provided. For Brecht, theater should create a context for *thought* and *critical engagement*. He focused on two specific techniques: "alienation" and "interruption." These two ways of structuring performances produce an atmosphere where audiences become more aware of their own presence in the theater and of their own role as free thinkers. Brecht promoted an opposition to the dreamlike hypnotic simulation effects of immersive storytelling. Theater, for him, was a way to hold an audience in the reality of the present.

In Brecht's words, "the aim of [the alienation effect is] ... to make the spectator adopt an attitude of inquiry and criticism in his approach to [an] incident." For example:

> The actor speaks his part not as if he were improvising it himself but like a quotation. At the same time he obviously has to render all the quotation's overtones, the remark's full human and concrete shape; similarly the gesture he makes must have the full substance of a human gesture even though it now represents a copy.

Given this absence of total transformation in the acting there are three aids which may help to alienate the actions and remarks of the characters being portrayed:

1. Transposition into the third person.

2. Transposition into the past.

3. Speaking the stage directions out loud.

Using the third person and the past tense allows the actor to adopt the right attitude of detachment. In addition he will look for stage directions and remarks that comment on his lines, and speak them aloud at rehearsal ("He stood up and exclaimed angrily, not having eaten: ...," or "He had never been told so before, and didn't know if it was true or not," or "He smiled, and said with forced nonchalance: ..."). Speaking the stage directions out loud in the third person results in a clash between two tones of voice, alienating the second of them, the text proper. This style of acting is further alienated by taking place on the stage after having already been outlined and announced in words. Transposing it into the past gives the speaker a standpoint from which he can look back at his sentence. The sentence too is thereby alienated without the speaker adopting an unreal point of view; unlike the spectator, he has read the play right through and is better placed to judge the sentence in accordance with the ending, with its consequences, than the former, who knows less and is more of a stranger to the sentence.[1]

This technique was, of course, developed for stage and theater environments where actors were not writing their own dialogue. Interrogative design projects, on the other hand, tend to take place on the street and in other public venues featuring speakers who share texts they themselves have authored. Nonetheless, Brecht's ideas translate well to these other contexts. For example, with Wodiczko's *Alien Staff* project, the performer stands next to video recordings of themselves, creating an uncanny moment. The double image of the person and their video persona creates a moment of alienation. It interrupts the audience's slumber and helps them ask questions and think critically about the material being presented. These creative works are both performative and strange yet real. Both the performer and the audience are grounded in the present moment.

Critical industrial designers and media artists can employ similar techniques in their own work. Many social problems can be remediated through the design of new "performative speech instruments" to help voiceless and marginalized people speak about their experiences to a wider public, animating public spaces in the process.

Interrogative design can generate new forms of speech.

Alienation Effect

Bertolt Brecht

Originally published 1940; English translation in Brecht on Theatre: The Development of an Aesthetic, translated by John Willett (London: Methuen, 1964)

31 · Short Description of a New Technique of Acting which Produces an Alienation Effect

What follows represents an attempt to describe a technique of acting which was applied in certain theatres (1) with a view to taking the incidents portrayed and alienating them from the spectator. The aim of this technique, known as the alienation effect, was to make the spectator adopt an attitude of inquiry and criticism in his approach to the incident. The means were artistic.

The first condition for the A-effect's application to this end is that stage and auditorium must be purged of everything 'magical' and that no 'hypnotic tensions' should be set up. This ruled out any attempt to make the stage convey the flavour of a particular place (a room at evening, a road in the autumn), or to create atmosphere by relaxing the tempo of the conversation. The audience was not 'worked up' by a display of temperament or 'swept away' by acting with tautened muscles; in short, no attempt was made to put it in a trance and give it the illusion of watching an ordinary unrehearsed event. As will be seen presently, the audience's tendency to plunge into such illusions has to be checked by specific artistic means (3).

The first condition for the achievement of the A-effect is that the actor must invest what he has to show with a definite gest of showing. It is of course necessary to drop the assumption that there is a fourth wall cutting the audience off from the stage and the consequent illusion that the stage action is taking place in reality and without an audience. That being so, it is possible for the actor in principle to address the audience direct.

It is well known that contact between audience and stage is normally made on the basis of empathy. Conventional actors devote their efforts so exclusively to bringing about this psychological operation that they may be said to see it as the principal aim of their art (5). Our introductory remarks will already have made it clear that the technique which produces an A-effect is the exact opposite of that which aims at empathy. The actor applying it is bound not to try to bring about the empathy operation.

Yet in his efforts to reproduce particular characters and show their behaviour he need not renounce the means of empathy entirely. He uses these means just as any normal person with no particular acting talent would use them if he wanted to portray someone else, i.e. show how he behaves. This showing of other people's behaviour happens time and again in ordinary life (witnesses of an accident demonstrating to newcomers how the victim behaved, a facetious person imitating a friend's walk, etc.), with-

136

SHORT DESCRIPTION OF A NEW TECHNIQUE OF ACTING

out those involved making the least effort to subject their spectators to an illusion. At the same time they do feel their way into their characters' skins with a view to acquiring their characteristics.

As has already been said, the actor too will make use of this psychological operation. But whereas the usual practice in acting is to execute it during the actual performance, in the hope of stimulating the spectator into a similar operation, he will achieve it only at an earlier stage, at some time during rehearsals.

To safeguard against an unduly 'impulsive', frictionless and uncritical creation of characters and incidents, more reading rehearsals can be held than usual. The actor should refrain from living himself into the part prematurely in any way, and should go on functioning as long as possible as a reader (which does not mean a reader-aloud). An important step is memorizing one's first impressions.

When reading his part the actor's attitude should be one of a man who is astounded and contradicts. Not only the occurrence of the incidents, as he reads about them, but the conduct of the man he is playing, as he experiences it, must be weighed up by him and their peculiarities understood; none can be taken as given, as something that 'was bound to turn out that way', that was 'only to be expected from a character like that'. Before memorizing the words he must memorize what he felt astounded at and where he felt impelled to contradict. For these are dynamic forces that he must preserve in creating his performance.

When he appears on the stage, besides what he actually is doing he will at all essential points discover, specify, imply what he is not doing; that is to say he will act in such a way that the alternative emerges as clearly as possible, that his acting allows the other possibilities to be inferred and only represents one out of the possible variants. He will say for instance 'You'll pay for that', and not say 'I forgive you'. He detests his children; it is not the case that he loves them. He moves down stage left and not up stage right. Whatever he doesn't do must be contained and conserved in what he does. In this way every sentence and every gesture signifies a decision; the character remains under observation and is tested. The technical term for this procedure is 'fixing the "not . . . but" '.

The actor does not allow himself to become completely transformed on the stage into the character he is portraying. He is not Lear, Harpagon, Schweik; he shows them. He reproduces their remarks as authentically as he can; he puts forward their way of behaving to the best of his abilities and knowledge of men; but he never tries to persuade himself (and thereby others) that this amounts to a complete transformation. Actors will know

137

what it means if I say that a typical kind of acting without this complete transformation takes place when a producer or colleague shows one how to play a particular passage. It is not his own part, so he is not completely transformed; he underlines the technical aspect and retains the attitude of someone just making suggestions.

Once the idea of total transformation is abandoned the actor speaks his part not as if he were improvising it himself but like a quotation (7). At the same time he obviously has to render all the quotation's overtones, the remark's full human and concrete shape; similarly the gesture he makes must have the full substance of a human gesture even though it now represents a copy.

Given this absence of total transformation in the acting there are three aids which may help to alienate the actions and remarks of the characters being portrayed:

1. Transposition into the third person.
2. Transposition into the past.
3. Speaking the stage directions out loud.

Using the third person and the past tense allows the actor to adopt the right attitude of detachment. In addition he will look for stage directions and remarks that comment on his lines, and speak them aloud at rehearsal ('He stood up and exclaimed angrily, not having eaten: . . .', or 'He had never been told so before, and didn't know if it was true or not', or 'He smiled, and said with forced nonchalance: . . .'). Speaking the stage directions out loud in the third person results in a clash between two tones of voice, alienating the second of them, the text proper. This style of acting is further alienated by taking place on the stage after having already been outlined and announced in words. Transposing it into the past gives the speaker a standpoint from which he can look back at his sentence. The sentence too is thereby alienated without the speaker adopting an unreal point of view; unlike the spectator, he has read the play right through and is better placed to judge the sentence in accordance with the ending, with its consequences, than the former, who knows less and is more of a stranger to the sentence.

This composite process leads to an alienation of the text in the rehearsals which generally persists in the performance too (9). The directness of the relationship with the audience allows and indeed forces the actual speech delivery to be varied in accordance with the greater or smaller significance attaching to the sentences. Take the case of witnesses addressing a court. The underlinings, the characters' insistence on their remarks, must be

On the Impossibility of Freedom in a Country Founded on Slavery and Genocide

Dread Scott

2014

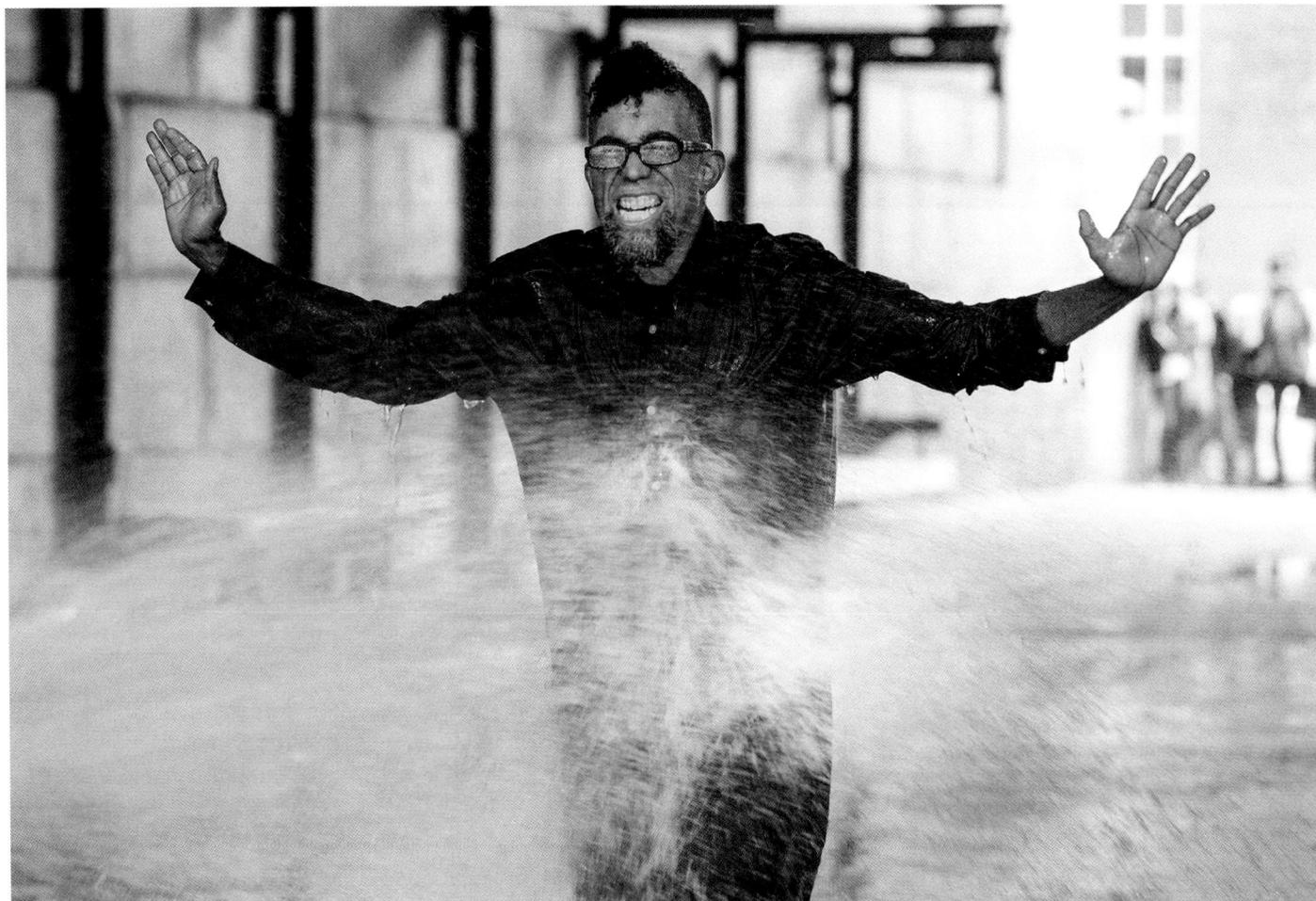

5.2 *On the Impossibility of Freedom in a Country Founded on Slavery and Genocide*, performance still.

On the Impossibility of Freedom in a Country Founded on Slavery and Genocide is a performance about the struggle for freedom. People yearn for freedom and have repeatedly struggled against oppressive governments, economic, political, and social relations. People have taken great risks in a struggle for emancipation and have often been battered in the process. The performance referenced the 1963 Civil Rights struggle in Birmingham, Alabama in which the government used high-pressure water jets from fire hoses against nonviolent protesters and bystanders in an effort to maintain segregation and legalized

141

discrimination. In the performance, I made a Sisyphean attempt to walk forward while repeatedly battered and occasionally knocked down by a water jet from a fire hose. The performance references this history as a metaphor for a larger struggle for freedom and had inescapable references to present-day struggles against racism, most recently witnessed on the streets of Ferguson, Missouri in response to the police murder of Michael Brown.[1]

5.3 *On the Impossibility of Freedom in a Country Founded on Slavery and Genocide*, performance still.

5.4 *On the Impossibility of Freedom in a Country Founded on Slavery and Genocide*, post-performance.

Bibliobandido

Marisa Morán Jahn

2010–ongoing

5.5 The *Bibliobandido* rides into town.

"But our country already has so many bad guys as it is. We can't create a story-eating *bandit*," said one. A few others murmured; they hadn't considered this. Then Koqui (José Alvarenga), a local farmer from El Pital, spoke up. "Listen. Marisa has a good point. You can't do anything with a good character. What makes Bibliobandido fun is that he's mischievous; he's unpredictable. He might do something scary—and for kids, running away and plotting against him is fun! That will get them writing, that's for sure."

While he desperately wanted and hungered to read, Koqui never quite learned how. In elementary school, he and many others left to work the fields sowing beans. After a succession of hurricanes ravaged the region in the late 1990s, washed-out roads and bridges made it difficult for teachers to arrive at their schools. Government corruption and narcotrafficking contributed to the scarcity of educational resources like books and paper and pencils. In addition, the censorship of free speech left many uncertain as to what could be spoken aloud and what should

not be written. Against this backdrop, Koqui and others in this rural 400-person community had identified literacy as their top priority, prompting them to reached out to me to collaborate.

Koqui's impassioned exhortation perhaps stirred his peers' own hunger for stories because promptly thereafter, all the key collaborators unanimously voted that Bibliobandido would be a masked bandit who ate stories. With this as the central crux, the rest of the mythical logic fell into place. It was as if the legend of Bibliobandido tapped into an archetypal imaginary accessible to us all: villains activate saints and saviors; sidekicks and go-betweens mediate between the shadowy underworld and humans; traces and clues help pursuers decode next steps and ulterior motives. The design logic was tacitly guided by the principle that not everything about a villain should be known.

That afternoon, the group immediately got to work translating this mythos into props. They imagined Bibliobandido's back story, workshopped how he might growl, and choreographed his grand entrance only a few days away. They put up signs warning others of his expected arrival. As for Bibliobandido's getaway vehicle, Koqui was the only one with a burro, albeit a stubborn burro whom he alone could ride. Thus, Koqui became the first Bibliobandido—a role he assiduously guarded as the legend grew. Later, when Bibliobandido spread to nineteen surrounding communities, other countries in Central America, and entire library systems in the United States, a myriad of other getaway vehicles were spawned—from subways to motorcycles to imaginary horses whom everyone swore they could hear. So too, the cosmology grew to include archenemies, enablers, extended family members, and patron saints whose quirky personalities represented different localities.

Bibliobandido is a public art and literacy movement I co-created with a rural community in northern Honduras that centers on a masked bandit that eats stories. Ravenous, he pesters little kids until they offer him stories they've written. As Bibliobandido's fame eventually rivaled that of Santa Claus, the project grew over a decade to encompass tens of thousands of youth across 19 partici-

pating Honduran communities. Bibliobandido workshops also spread to North America, taking root in institutions ranging from the Brooklyn Public Library to the Pérez Art Museum Miami, Studio Museum in Harlem, Sugar Hill Museum of Art and Storytelling, and additional universities, festivals, schools, and museums. In 2016, the Seattle Public Library even adopted Bibliobandido as the mascot for their digital media programs.

The philosopher Michel Foucault and my former mentor at MIT, Krzysztof Wodiczko, revive the ancient Greek word *parrhesia*, which refers to the act of speaking freely. This liberty also implies speaking boldly, without constraint, and the moral and civic obligation to speak. In other words, free speech as commons, as communing, as counterpower. In contexts when *parrhesia* becomes the only means to redress authoritarian rule and censorship, Wodiczko points out the power of what he referred to as "performative speech instruments." As he poignantly demonstrated through his own oeuvre that pioneered architectural-scale image projections, participatory storytelling, and beautifully designed objects, a performative speech instrument is a device that enables the disempowered to speak what normally cannot be spoken aloud. In so doing, the performative speech instrument frames the simultaneously precious and powerful voice—and the harmony of other voices that subsequently cascade out from it.

To this I caution that the performance of truth-telling, if framed poorly, can retraumatize or even imperil its speaker. In Honduras, a country known in the recent decade as the most dangerous place for journalists, creative ways of sharing information thus prove all the more critical: they provide cover while still conveying essential information and keeping lines of communication alive. As demonstrated in the *Arabian Nights*, whose female protagonist (Scheherezade) influences her captor through deft storytelling, truth and imagination conjoined challenge structures of power to transform both listener and storyteller alike.

While many commonly assume that I played the role of Bibliobandido, I always abstain. To ensure that local communities adapt the character for themselves, I let them figure out the performative quirks of this villain we love to

hate. I perform a role akin to John the Baptist who pointed to and heralded the arrival of a prophet—and this is how I see myself as an artist: I point out how the otherworldly casts itself in the here and now; I create the frame tale that tucks other stories in between; I design porous structures that invite others to fill in the blanks.

What are these stories like? you might ask. In Honduras, the stories figured favorite semitropical flora and fauna (the ubiquitous leaf-cutter ants, the pendant nests of blue arupendula birds, vines). The stories rework domestic chores and favorite activities (cooking beans, collecting firewood, playing soccer, spear fishing), rendering them fantastical. In the more urban North American contexts, the legend of Bibliobandido plays out over subways and storefronts, negotiating underground tunnels and high-rise-tower elevator shafts.

The tens of thousands of stories engendered by Bibliobandido are not only written but performed: with educators whom I train and who in turn train others, we explore the important intermediary steps preceding the written word and the act of enunciation. We confabulate an idea, sharing it aloud through sketches, gestures, and props. We write it on paper; our fellow editors productively demanding our rewrites. We experiment how to craft the story into a book, measure and cut the paper, and bind its pages. We invent the story anew as we rapturously share it in whispers and declarations, nourishing the appetite of our insatiable listeners. I can't emphasize enough the pedagogical importance of these different acts and gestures that also comprise literacy: they activate all the eight intelligences that Howard Gardner outlines (interpersonal, intrapersonal, ambient, logical-mathematical, musical, visual, bodily-kinaesthetic, linguistic-verbal).[1] Thus, the power of Bibliobandido as a *performative speech instrument* lies not in the artifacts alone but in the orator-participants, what they say, and how they say it.

So too, a pedagogy of Bibliobandido involves recognizing the power of questioning. People old and young often query the mechanics of how the plot works ("How does he actually eat a story?"). When training others, we discuss how to return the answer with a question. "Well, no one really knows. But what do you think it means to crave stories? What does it mean to nourish someone's appetite with stories? Are stories a scarcity?" And of course, people often ask, "What is Bibliobandido? Why are you doing this?" To which we might respond, "What does it mean to invent a new myth? Why now? What myths are useful or transformative for you?" Herein lies a credo of interrogative design: it is not only the creation of objects and their performative engagement but the capacity to ask fundamental questions. Against the prevailing notion that design provides solutions, the much-needed framework of interrogative design liberates us from instrumentalist and productivist logics. Interrogative design implores us to think and make as a way to explore open-endedly, without the hubris of singular conclusion.

It is now fourteen years since Bibliobandido's birth in El Pital. For many of the middle schoolers involved, Bibliobandido was a vivid reframing of their reality. Now as adults, many remain involved in keeping the legend alive with their siblings, children, and young neighbors. The accessibility of the mythos, its invitation to add on, and a hunger for active forms of literacy have been key to Bibliobandido's success. As for myself, Bibliobandido exists beyond my wildest dreams, continuing forward. The contagion for stories endures.

Blendie

Kelly Dobson

2004

5.6 *Blendie*, video still.

Blendie is an interactive, sensitive, intelligent, voice-controlled blender with a mind of its own. Materials are a 1950s Osterizer blender altered with custom-made hardware and software for sound analysis and motor control.

People induce the blender to spin by sounding the sounds of its motor in action. A person may growl low-pitch blender-like sounds to get it to spin slow (*Blendie* pitch and power matches the person), and the person can growl blender-style at higher pitches to speed up *Blendie*. The experience for the participant is to speak the language of the machine and thus to more deeply understand and connect with the machine. The action may also bring about personal revelations in the participant. The participant empathizes with *Blendie*, and in this new approach to a domestic appliance, a conscious and personally meaningful relationship is facilitated.

Machines influence self-conception, expression, social perception, and perception of responsibility and action. *Blendie* is part of a series of machines designed to access and vitalize the interplay of people and machines. Intercommunicative awareness is brought out, and individuals are invited to reinvent their own existence.

In *Blendie* a mix of design, art, engineering, and psychotherapy inform the interaction facilitated between participants and the familiar blender.

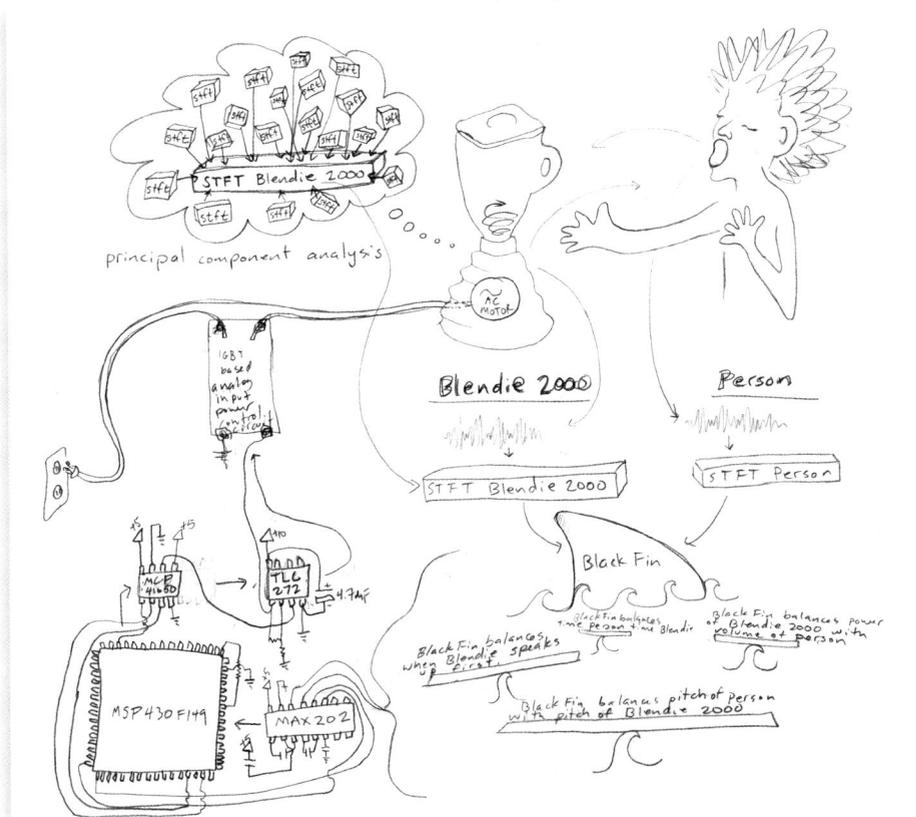

5.7 *Blendie*, system diagram.

Speech is first and foremost that object of exchange whereby we are recognized, and because you have said the password, we don't break each other's necks, etc. That is how the circulation of speech begins, and it swells to the point of constituting the world of the symbol which makes algebraic calculations possible. The machine is the structure detached from the activity of the subject. The symbolic world is the world of the machine.

(Lacan 1988 p.47)

5.8 Excerpt from Dobson's Ph.D dissertation, "Machine Therapy."

• **Editor:** Dobson's PhD dissertation, "Machine Therapy," offers many phenomenal insights into technological design. For example:

Object relations theory, pioneered in the 1940s and 50s by psychoanalysts D. W. Winnicott and Melanie Klein among others, postulates that the self exists only in relation to other objects which one finds externally, or makes and carries internally resonating with things found externally.[1]

When interrogative design suggests the creation of performative speech instruments, operator/performers can become more active in this process of negotiating their sense of self through external objects.

Desirable Posture

Sohin Hwang

2009

5.9 *Desirable Posture*, detail.

Suffering from chronic joint pain that no medical specialist could ease, I decided to make an exoskeletal structure to protect and correct myself so I could walk with a normal posture based on doctors' recommendations. The performance was to walk a corridor from one end to the other, which turned out to be very challenging. While the structure embodied medical idiom, it did not make any sense to my body. It was a long and slow procession. Having finally arrived at the end, in sweat and pain and confusion, I was greeted by someone's firm handshake and eyes that communicated something. What was it?

Desirable Posture is one of my first works, and it also involves one of my first memories of Krzysztof Wodiczko.

Soon after, I learned that this work could easily be explained by his bandage analogy, where an act of protection highlights a wound and trauma. Or maybe it was the concept of cultural prosthetics: an artifact substituting my lack of normalcy. He also often spoke of survival. Many of his works are about real people's survival. For some people, survival, in and of itself, is what matters. Looking back, part of the reason he focused on the problem of survival was for our self-awareness, and ultimately for developing a sense of mutual empathy. That we are all this "some people." But at the time, it was difficult for me to understand, as I was too much of a person with worry and anxiety to think about anything other than my own worries.

Later, as I experienced him more in various situations, I learned that everything he does and speaks of has impacts and is meant to be impactful. It was incredible to observe his presence in public. My colleagues and I were at a heated public discussion where he was one of the panelists. When it ended, we were left in awe. Walking off stage, he let out a few syllables to us in a low voice. "I am acting as an artist." Still in awe, I wondered, is he himself his work as well?

Post-education, I was flitting around different projects and often found myself coming back to *Desirable Posture* to understand the motivation of my works and life.

5.10 *Desirable Posture*, level detail.

Ten years passed and, having overcome the joint pain and now dealing with other types of pain, I came back to Cambridge. It was a more difficult Cambridge than the one I used to know, and I was sleeping too much or too little. One day I was walking along Kirkland Street (with much more stable posture than before), heading to work, swimming in thoughts about the day's plans. I can imagine my own frown. And then. There was Krzysztof standing in front of me. It was surprising and I was very glad. He was different and the same, with his affirming handshake and even deeper eyes. We had a nice catch-up, and the conversation has now faded, but it was a clear winter day, and he was holding a hot cup of to-go coffee from my favorite place. Also, I do remember his handshake, which was in the middle of our conversation, and he was saying something this time. Maybe he has always been very clear.

"You survived."

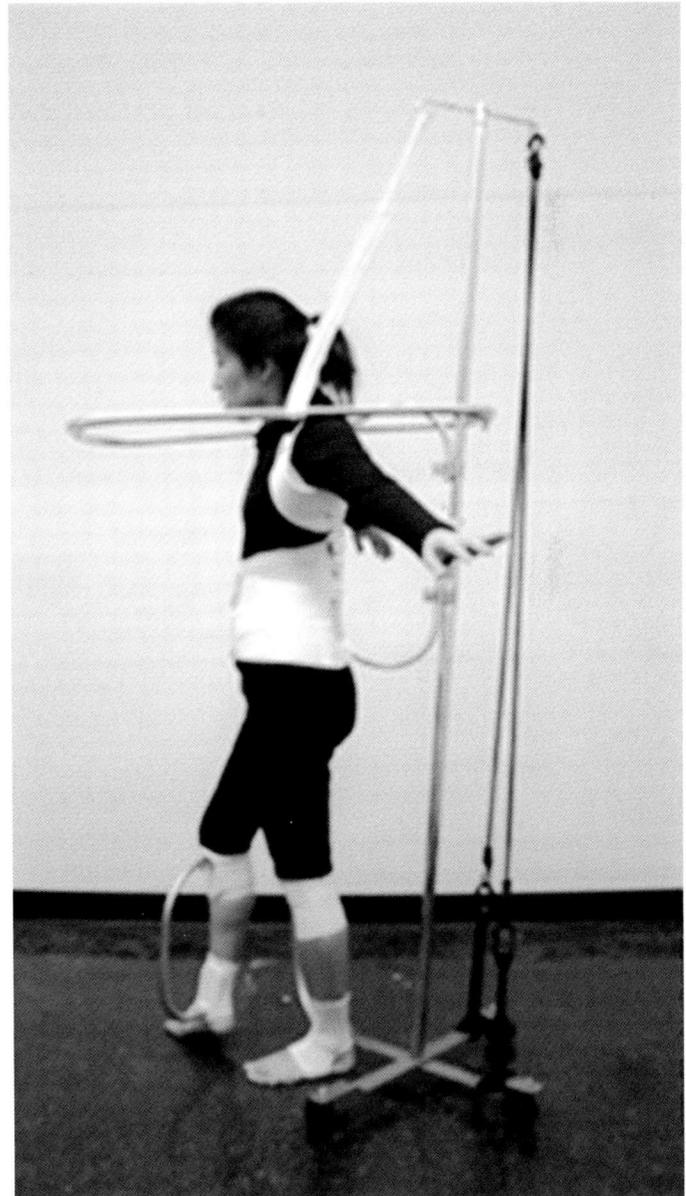

5.11 *Desirable Posture*, movement sequence.

Ægis: Equipment for a City of Strangers

Krzysztof Wodiczko

1999

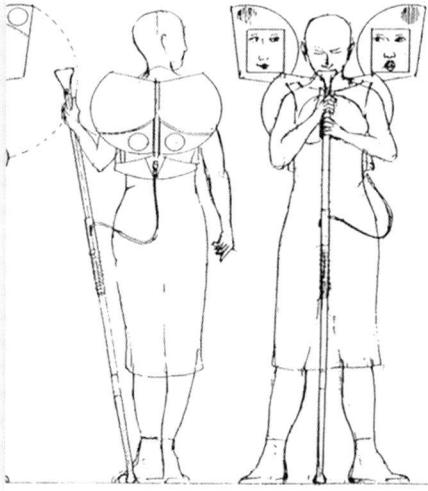

5.12 *Aegis* concept drawings.

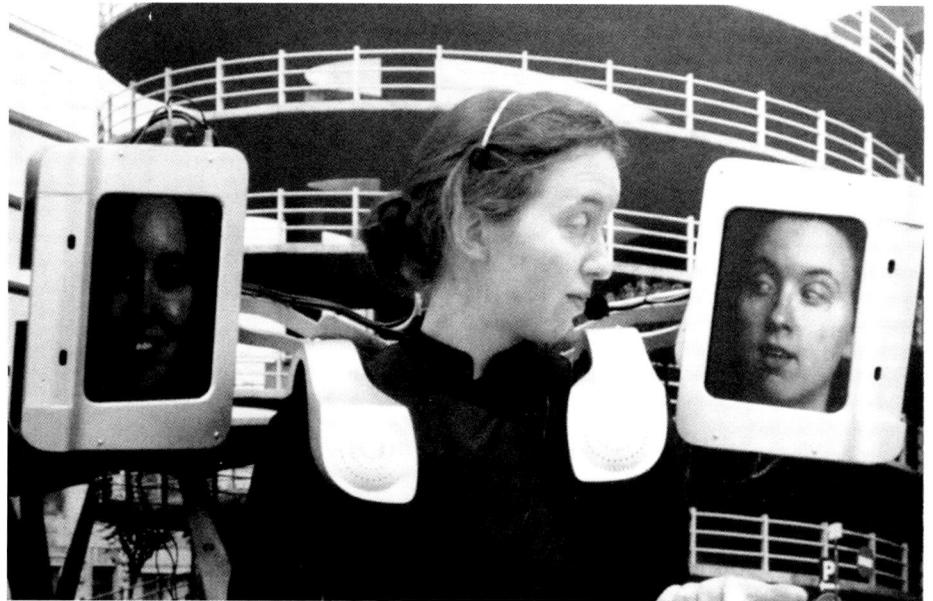

5.13 *Aegis* demonstration, Kelly Dobson.

• **Sung Ho Kim**: The *Aegis* equipment was inspired by mythologies of angels and Athena's armor that becomes a protector and strength of people who are unable to connect socially within society. The equipment is designed to be a social and cultural communication apparatus that expands conversations between the wearer and the public. The project consists of two winglike LCD screens, which lie folded on the wearer's back until activated by a human voice. The screens deploy next to the wearer's face and play back prerecorded videos, allowing new dialectic conversations. The equipment employs two laptop computers for video processing and voice recognition software with microphone. The speakers, motor, and portable batteries allow *Aegis* to become nomadic by nature and to connect with strangers for new discussions across new territories.

The *Ægis*, the last and most technologically advanced of the *Xenological Instruments*, was designed as a dialogic device, allowing the user to dialogue with others and themselves, multiplied in recordings of their own person screened on two monitors. Each screen is connected to a computer with a built-in voice recognition sensor that reacts to certain predefined phrases. The *Ægis* facilitates multidirectional dialogue: the screens displaying the user's faces can be turned toward each other, toward the user, or toward other speakers. This is a device, the artist stresses, "serving the immigrant's art of survival, but also meant for those who experience alienation for other reasons." Preprogrammed dialogues make it possible for the users to talk to themselves about their own alienation. Allowing us to communicate with others as well as to hide behind a prerecorded narrative, the device takes its name from Athena's protective shield.[1]

Differing from these medical artificial organs, the prostheses and apparatuses designed by the artist Krzysztof Wodiczko are used to address social and psychological issues. With Aegis, a project that I contributed to as a student/collaborator, the psychological negotiation of a coherent locatable self is performed.[12] When the wearer

Fig. 2.6 Freud's diagram of the ego and objects. (Freud 1959 p.48).

is ready to deploy the equipment, for example when topics for which the wearer has ambivalent responses are brought up in conversations, the two wings/heads rise up on either side of the person and begin to interact with the person and each other, representing different opinions and reactions to the situation. The content of these various responses is recorded by the wearer and put into Aegis along with keywords of the wearer's choice that will wake up the different responses. Part of the software of Aegis runs a voice-to-text translator that reacts to these keywords. Aegis highlights the ambivalence within everyone on many topics that regularly come up in daily interactions. It calls us to question the social prescription that we are expected to deliver coherent reactions in daily interactions. Such a norm covers over our continual internal negotiations. Aegis both brings this non-neutral dissimulation into consciousness while at the same time offering a new mode of self-negotiation for the performer of Aegis. Worn apparatuses may extend the body and the psyche in ways that resonate with the wearers' relationships with themselves and others.

5.14 Excerpt from Kelly Dobson's PhD dissertation "Machine Therapy."

5.15 Excerpt from Kelly Dobson's PhD dissertation "Machine Therapy."

12 Wodiczko explains: *"The instrument is a piece of equipment designed to represent dual (and often dueling) truths, those living contradictions that both define, depict, and can sometimes destroy individual existence."* < http://web.mit.edu/idg/aegis.html> August 10, 2007. See also Wodiczko (1999).

5.16 Excerpt from Kelly Dobson's PhD dissertation "Machine Therapy."

Enemy Kitchen

Michael Rakowitz

2003–ongoing

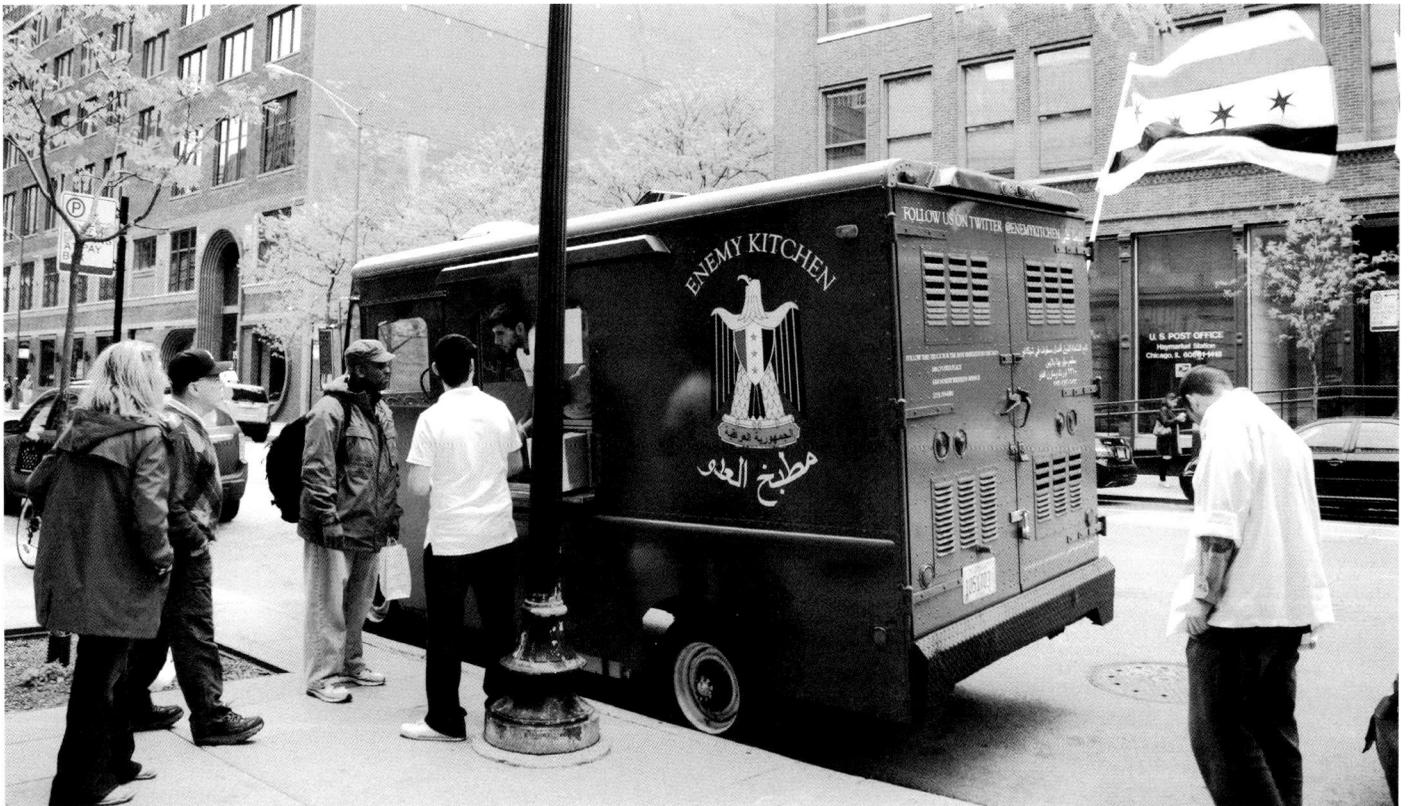

5.17 *Enemy Kitchen,* food truck.

5.18 *Enemy Kitchen,* cooking class.

Enemy Kitchen makes Iraqi culture visible in the United States beyond the daily news to produce an alternative discourse and social space. Helped by my Iraqi-Jewish mother, I teach Baghdadi recipes to audiences, including these students, many of whom have relatives serving in Iraq but few outlets to discuss the war. In 2012, *Enemy Kitchen* evolved to include a food truck in Chicago, with Iraqi refugee chefs and with Iraq War veterans taking orders as sous-chefs and servers, thereby inverting the power dynamic of the war.

Enemy Kitchen

Iraqi Fried Chicken

After eight weekly sessions learning how to cook Iraqi food, the students at the Hudson Guild Community Center in New York City proposed they teach me something about their families' recipes since they now knew so much about mine. Hyasheem asked, "Do Iraqis make Southern fried chicken?" I answered that no, to my knowledge there was nothing like it in Iraqi cuisine. "Well, then let's invent it," he said.

Hyasheem led the way and we cooked the chicken according to his specifications.

2 pounds chicken wings (or parts of your choice)
2 pounds chicken legs (or parts of your choice)
3 cups flour
6 eggs
1 tablespoon salt
2 cups breadcrumbs
½ tablespoon sumac
2-3 tablespoons Iraqi bharat spice mix (cumin, dried limes, turmeric, ginger, chili, curry, cloves, cardamom, dried rose petals, allspice)
1 tablespoon Iraqi date syrup
1 bottle sesame oil

Break eggs into a bowl and beat the eggs to even consistency. In a plastic bag, mix the flour, salt, spices, date syrup and breadcrumbs. Dip a piece of chicken in the egg batter and place in the plastic bag. Repeat until about six pieces of chicken are in the bag. Close bag tightly and shake vigorously, so that the mixture of flour and spices covers each piece.

In a deep pan, pour enough olive oil so that it is about 1/4 of an inch deep. Place on oven burner and let heat for 2 minutes. Place the six pieces of chicken in the pan and fry, turning often, until each side is medium-brown.

Repeat these steps until all the chicken is cooked.

Filmic Design

Alex Milton

Filmic design is a form of interrogative design that explores the scripting of products and lifestyles, products as props and narrative devices, and critiques how consumers busily deconstruct and reappropriate them to conform to their own personal scenarios.

This article argues that designers are largely ignoring the possibility of allowing consumers, recast as "performers," to more actively invest their personal emotional stories in their products, and thus to extend and open up a product's narrative and, potentially, its lifespan.

"Cinema is the industrial design of images, stories, artworks and performances that captures and reiterates all others." Alfred Hitchcock[1]

In a 2003 paper entitled "Filmic Design: A Hitchcockian Design Strategy,"[2] I proposed a "speculative methodology" for narrative-rich design informed by the work and methods of iconic film director Alfred Hitchcock and using the format of a screenplay. It argued that the work of conceptual artists and designers such as Dunne and Raby's *Weeds and Other Aliens*, Noam Toran's *Objects for Lonely Men*, and Paul Granjon's *2 Minutes of Experimentation and Entertainment* had made steps toward a filmic design strategy, and sought to critique these and other "design fiction" provocations by placing them within a broader critical framework.

That paper was the culmination of a body of creative work that explored how users needed to be reconceived as "performers," using designed products to narrate their own personal and/or collective stories. I "performed" my script at a series of exhibitions, conferences, and screenings—cutting excerpts of dialogue from established and imagined characters with filmic design precedents and precursors, set to the projected backdrop of Hitchcock thrillers including *The 39 Steps* and *North by Northwest*.

Building upon Wodiczko's seven propositional steps, outlined in "Designing for the City of Strangers," the climax of these performances was the revealing of a methodology that attempted to create a design language of filmic design:

1—Design Context

The designer must establish the shot or scene, referring to the background of a consumer's life, including everything the consumer thinks, feels, and does, from characterizing behavioral patterns to product perceptions and emotional desires. This is the introduction to the product's context and to the main characters. Sometimes there is only one establishing scene, but in products where parallel consumer stories are used or encouraged, there may be more than one establishing scene or shot.

2—Design Engagement

The moments of initial consumer awareness, purchase, and interaction are profoundly important. The audience will carry notions of genre convention together with a product's cognitive presence, which will need to be played upon and challenged.

3—Design Interaction

The designer disrupts or complicates introducing the plot or major conflict between a protagonist (e.g., driver) and antagonist (e.g., passenger) or between a protagonist and a situation (e.g., crash). Products conforming to a "Hitchcockian" design methodology begin in a state of equilibrium that is upset by some disturbance or conflict. The rest of the product's use is shaped by the consumer's attempt

to confront, struggle through, and resolve these cathexic narratives.

4—Design Experience

Experience refers to the period of ownership and use. During use, customers continually assess the quality of their experiences with the product. In this stage, the designer should strive to engender crisis in the product's use, in which some decision or action on the part of the protagonist is called for, anticipated, or expected.

5—Design Climax

The narrative will climax at the point where the protagonist decides on the next move in their relationship with the product.

6—Design Resolution

The designed product's resolution is akin to the dénouement of a traditional story in which all the events are pulled together and resolved, leading the product's protagonist to arrive at some point of understanding and catharsis. A clichéd "happy ending" may not be a feature of every screenplay, but a product's disposal or death is a key element in determining how the product will form a lasting impression on the consumer.

7—Design Memory

Through product use the protagonist experiences flashbacks moving them back and forth through the editing process, as past events are inserted into a present moment as multiple stories unfold, feeding back audience and product experiences in an iterative cycle to inform the basis for subsequent filmic designs.

8—Designer MacGuffins

The designer must, above all, hunt the "MacGuffin"—creating products that drive the plot forward but are ultimately user-enabled props that perform the role of a conduit for consumers desires.

Where Wodiczko established a set of criteria, this methodology reflects back on the world of film to structure a progressive series of parts or steps that combine into a Hitchcockian universe of red herrings, suspense, passion, humor, and sheer gall. The possibilities of filmic design tantalizingly dangle in front of our eyes, goading us to experiment with the unknown.

Filmic design interrogates objects to find their (and their owners') suppressed, latent, or untold narratives. It seeks to help facilitate the writing, performance, and retelling of narratives about the lives of ordinary, often anonymously designed things, as well as aspirational "designer" objects that often have a predetermined narrative based on brand values and overt displays of consumerism. Like the MacGuffins in Hitchcock films, these things are not the main characters but plot devices that set the story in motion, and these eight experimental (rather than 39) steps aim to encourage designers to create objects that enable users to explore the manifold narratives they can generate.

More recently, Encinas, Božanić, and Šuran have argued that the success of such an experiment "hinges on whether a design object functions as the prop that helps to structure a story, animating a script and connecting fictional objects in the mind of the user, or as a product, creating ad-hoc narratives when a person activates the object through use."[3]

In 2008, Noam Toran and Onkar Kular proposed a cinematic library of objects and accompanying film synopses. They focused on the MacGuffin, a cinematic plot device, usually an object, that motivates a cinematic story. Their research examined the MacGuffin as a unique object typology, existing solely within the constraints of cinema, and defined in shape and function to achieve the singular purpose of driving a filmic narrative. The fictional film plots were then used to generate the MacGuffin object.

The project highlighted the conventions of narrative structure, as well as the varying ways cinematic genres are used as instruments of social critique and could be said to resemble diegetic prototypes that adhere to Bruce Sterling's working definition of "design fiction."[4]

Over the last 15 years we have seen a plethora of speculative and critical design projects which have presented work using filmic representation and design fiction methods. However, they often resort to what Wodiczko refers to as "optimistic design fantasies"[5] that fail to work in the world, instead resembling escapist Hollywood sci-fi films or dystopic narratives such as Netflix's *Black Mirror*. This could be perceived as a creative retreat as a generation of designers disengage from addressing the challenges of the everyday, and instead merely produce designs that operate as critique or physical manifesto that speak to an elitist audience.

We were looking for an alternative approach to design, one that would take an object as a starting point to explore the vast array of stories it generates when it's used: from the mundane to the downright exotic.

The Dutch magazine *MacGuffin* was founded by Kirsten Algera and Ernst van der Hoeven in 2015, playfully taking up Hitchcock's concept of the MacGuffin as a narrative device to reflect on their lingering boredom with the design world, which they felt validated commercial success and "star" designers over meaningful design and its ability to impact everyday lives.

The magazine uses literary and cinematic devices as the underlying concept for each issue. Inspired by the MacGuffin technique, which assigns significance to an object according to its effect on the characters and their actions, *MacGuffin* magazine is an interrogative platform that is less about objects and more about the stories they tell.

Filmic design, as originally envisaged, seeks not merely to question our relationship to and expectations of contemporary design, culture, and consumption, but to demand a reciprocal response from empowered audiences who actively participate in a product's symbolic and functional life cycle, in much the same way that some viewers reappropriate characters and scenes to create fan fiction that challenges Hollywood conventions, Bollywood audiences use musicals as a jumping-off point for playful social interaction and collective choreography, and indie auteurs take Hollywood tropes and purposefully subvert them by holding up a mirror that is at once exploratory and true.

We need to advocate for an approach to design where product placement within a film or TV advertisement, and the narrative opportunities it promotes, don't stop at the point of sale but integrate completely into the life of the product's owner. This is a deliberately disturbing and disruptive approach to product consumption, reinterpretation, and life cycle, and opens up new terrain that requires careful navigation via robust ethics and interrogative design principles.

By explicitly designing products that can operate as viable and open props in the epic narrative of their owners, designers can help owners (and indeed a wider cast of users) transform the course of their lives. Epic stories from classical literature to popcorn Hollywood blockbusters have traditionally revolved around a hero's journey. In narratology, the hero's journey is the common template of stories in which a hero goes on an adventure, is victorious in a decisive crisis, and comes home transformed.

According to design critic Ellen Lupton, a hero's journey can be categorized as one of two contrasting types, a maze or a labyrinth, of which "a maze is a puzzle with hidden turns and dead ends" while "a labyrinth is a fixed path designed to carry a person along a controlled journey."[6] This differentiation is critical in understanding the different roles narrative structures can play in design. Most commercial design follows the "labyrinth" model, where customers are guided from a predetermined point A to

point B while the illusion of choice promoted by contemporary advertising is reinforced. Participatory and interrogative models of design that seek to disrupt this top-down model of product consumption and experience could be classified as adhering instead to the "maze" model, where the user's journey is an open-ended exploration to locate an unknown destination. Filmic design straddles these two realms, acknowledging the need to engage with, and operate within, commercial design constraints while also seeking to move beyond these constraints and empower users to create their own journeys.

Wodiczko's "performative speech instruments," such as his *Alien Staff* which sought to mediate conversation between aliens (the juridical term designating all immigrants whether of legal or illegal status) and the franchised population of a city, and *Mouthpiece*, which was intended to enable immigrants to expand their own narrative into a collective experience, are repositories of user-generated meaning. These instruments suggest an acknowledgment of the richness and complexity of people who combine both natural and artificial qualities of life, and create a situation in which repressed feelings, translated into stories, can be effectively expressed.

If as designers we are prepared to go beyond visual semiotics and instrumental rationality toward an aesthetics of use which acknowledges people's less neatly resolvable feelings and need for poetic functions, we can produce a more narrative-rich user experience that helps unmask, uncover, and address the trauma of real life. By perceiving the user as a protagonist and co-producer of narrative experience, and not just a passive consumer of a product's off-the-shelf meaning, we can continue to thoroughly explore this potential.

Filmic design uses narrative tropes to articulate and communicate open-ended user experiences. For these experiences to be engaging, we need to employ narrative devices and plot structures to ensure that the propositions captivate and enthrall the audience and take them somewhere unexpected. By stirring and releasing emotions, building empathy, articulating values, and conveying action by constructing narrative arcs and creating paths to integrate form and language, one can use a filmic design

framework to develop, evaluate, and sustain a product, experience, or space.

The creation of products as props embraces and fosters the fantastic in everyday life, and offers a critique of how we can create preferable futures, becoming a form of "magical realism," producing a narrative form that focuses on the material object and the actual existence of "things" in the world, rather than speculative design's more abstract realm of dystopic or utopian visions.

It is this shared grounding in notions of truth and reality, as well as the common aims of generating analytical critique and user empowerment, that reveal the shared terrain inhabited by filmic design and interrogative design, helping designers to move beyond design fantasies and begin interrogating our design past, present, and future.

When I read a story or watch a film, like many people, I know when I've been entertained. I laugh, I am moved. I am used to saying what I like and what I don't like. To my id's delight, many of the familiar tropes of science fiction have become part of daily life in the form of actual products and environments. These days, though, with the growing sophistication of digital media and artificial intelligence, I increasingly think about where marketing and simulation end and where the *real* begins. Schizophrenics suffer the assumption that their wild theories are true, and they lack the ability to reality-check and self-correct. They might find it difficult to encounter the world like a lawyer or scientific investigator with the questions, *"Yes, but is it real?"* and *"Can I verify this?"* and *"Where is the proof?"* and *"What if I am wrong?"*

In international relations, the term "realism" relates to an approach to diplomacy that prioritizes an accurate and sober representation of states' self-interest and working with other states despite ideological and rhetorical incompatibilities. Between naive optimism and debilitating pessimism there is realism—realpolitik. Art history, however, gives the word other meanings. In the twentieth century, "realism" was used to describe the Soviet Union's state-enforced approach to art and design that promoted communist ideals through heroic iconography of manual labor and other techniques. The German Nazi regime used similar approaches to policing aesthetics.

More recently, in painting, the term realism (or "photorealism") points to optical accuracy—a kind of alignment or conversation between photography and painting. These two disciplines are now intertwined in a complex hyperreality as the digital mediascape, photomontage tools, 3D animation, and AI-generated images dissolve previously meaningful differences between actual and virtual realities. The question of who or what an artist is has become stranger and more ambiguous than ever.

In the nineteenth century, the term "realism" came into use among preimpressionist artists, notably Gustave Courbet. Realism was a conscious break from previous allegorical styles with their nostalgic depictions of myths from ancient literature and history. The realist artists followed the credo "il faut être de son temps" ("one must be of one's time") and sought to depict scenes from everyday life that were previously considered too lowly or inconsequential for

6.1 *The Stone Breakers*, Gustave Courbet (1849).

portrayal in art. Courbet and his contemporaries brought matter-of-fact images of peasant life and other hitherto unremarkable colloquial moments to the rarefied salons of Paris. It was an aesthetic revolution (simultaneously developed in literature by such midcentury authors as Honoré de Balzac and Gustave Flaubert, that preceded the Paris Commune by two decades) that respected the hardships of working people.

Realism set the stage for a broader array of aesthetic subjects. The call for art to be "of its time" continues to challenge artists and designers today in the face of politically mobilizing nostalgia, emotional mythmaking, blinkered futurism, and the production of other "optimistic fantasies."

In design, realism takes on other characteristics. Anthony Dunne and Fiona Raby write about a spectrum of future-focused strategies in their book *Speculative Everything*. Their explicatory diagram frames what now is popularly called "speculative design." It depicts a timeline that branches out from the present to a range of futures that design can propose. These trajectories range from the *probable* to the *plausible* to the merely *possible*. (One might imagine another point beyond this spectrum for the *phantasmal* futures of "design fiction.")

There are many ways of looking at the future. Architecture has, of course, always been involved in speculating on the future, and today speculative design is a popular technique from corporate R&D labs to collaborative city planning. Science fiction has a much longer history than commonly appreciated. Designing the speculative, the fictional, the imaginary, and the unreal is, of course, important work that can have a positive effect on reality. The film industry lives on the adage, "What is truer than truth? A story."

The process of deciding on what to consider real and what not is where politics and the imagination meet: "If politics has become a struggle for people's imagination this is, in the first place, due to the fact that such a struggle takes place within human beings and not just among them." Politics today is a battle over the imagination, and work that operates on the imagination, either by maintaining preexisting realities or by challenging them through alternatives that encourage people to question prevailing worldviews, becomes political.

What, then, is interrogative design? Works of interrogative design are less speculative and more interested in the present. They tend to focus on confronting and revealing truths rather that imagining the future. Interrogative design is involved in the political work of productive struggle with present realities and spaces. While speculative design might take the form of a meme that imagines a new form of urban design, or a product to solve an unmet need, interrogative design would design something *with a community* of interest that *reveals some profound truths* in the *present moment* and would take that design into *public space* where the work could be completed through its *encounter with people*.

To be "de son temps" is not a simple task. We live lives infused with stories that structure our memories, perception, and planning. It is difficult to see through stories and memories into a fuller version of reality, or even to simply see the parts of society around us that are concealed by authority or camouflaged by routine, banality, repetition, class, or other patterns. Interrogative design (much like Courbet's approach to art) offers ways of sensing the world in a direct and revealing manner. Design interventions of this kind operate with and for *actual people* in *present-day situations* for *near-term reasons*.

If there is any future focus in interrogative design, it is well described by Ernst Bloch's concept of "concrete utopia"—the focus on working productively toward some better future. In Bloch's view, the future of a concrete utopia is malleable and *possible*. It is constrained by realistic possibilities. Ruth Levitas describes Bloch's idea that

> the material world is essentially unfinished and in a state of process—a process whose direction and outcome are not predetermined. The future therefore constitutes a realm of possibility—real possibility, rather than merely formal possibility.

She contrasts Bloch's view to the way most people imagine the future as a narrow antidote to their daily life or as some fantastical and impossible future.

> In the daydream, it often involves not so much a transformed future, but a future where the world remains as it is except for the dreamer's changed place in it—perhaps by a large win in a lottery. Thus, Bloch says, "Most people in the street look as if

they are thinking about something else entirely. The something else is predominantly money, but also what it could be changed into." Or, if a transformed future is imagined, it may be one which could never be affected.

Between design for pain relief and designing castles in the sky, concrete utopia

is anticipatory rather than compensatory. It reaches forward to a real possible future and involves not merely wishful but will-full thinking: "There is never anything soft about conscious-known hope, but a will within it insists: it should be so, it must become so." Concrete utopia embodies what Bloch claims as the essential utopian function, that of simultaneously anticipating and effecting the future. And not all dreams of a better life fulfil this function. While abstract utopia may express desire, only concrete utopia carries hope.

6.2 Speculative design futures diagram.

Optimism for the future emerges from a *realistic* view of possibilities, coupled with a sense of shared agency that the future is, in fact, *possible to modify*— both individually and collectively.

But this realist approach to art and design (or, by extension, the conscious construction of our own mediated lives) seems increasingly difficult. We are inundated by an ever more complicated media sphere, far beyond Baudrillard's concept of simulacra and hyperreality to a near-living machine environment: an opaque technological superstratum that resists any meaningful modification. William Gibson, the noted science fiction author and originator of the term "cyberspace," once predicted that "one of the things our grandchildren will find quaintest about us is that we distinguish the digital from the real, the virtual from the real."

In 1968 one author critical of gaming, Andrew Wilson, recounts an anecdote in his text, "The Bomb and the Computer," in which a high ranking general constantly kept interrupting the planning of the very real conflict in Vietnam in order to call and check on his players in a simulation so that he could see how well he was doing in next year's (imagined) conflict in Bolivia.

If we are to attempt this task of returning to the real and working consciously and optimistically as Bloch suggests, what new forms of reality-testing will help us discern the real from the unreal, or perhaps more usefully, the malleable from the inert? Or is it no longer possible or even meaningful to untangle the schizophrenia of the technological world?

Sherry Turkle suggests two simple techniques as a way of returning to our human roots. Disconnect from all technology on a regular basis, and redevelop the dissipating art of face-to-face, unmediated conversation. Perhaps interrogative design can help create ways to facilitate this kinder renewal of the real, with or without technology. In Antoni Muntadas's words, "perception requires participation."[1]

Do Not Erase the Graffiti

Krzysztof Wodiczko and Kirk Savage

2020

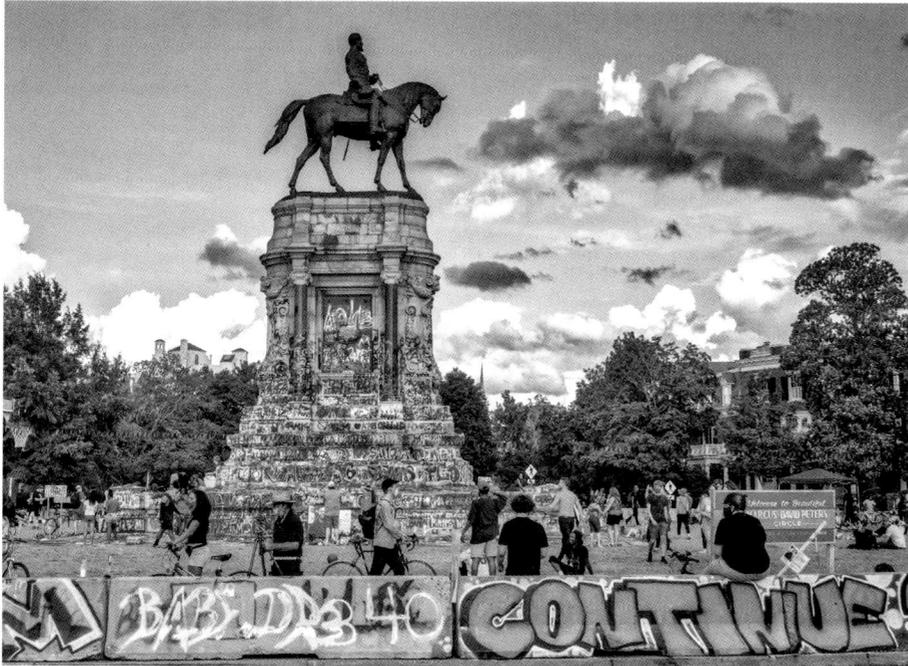

6.3 Robert E. Lee statue in Richmond, Virginia, June 2020.

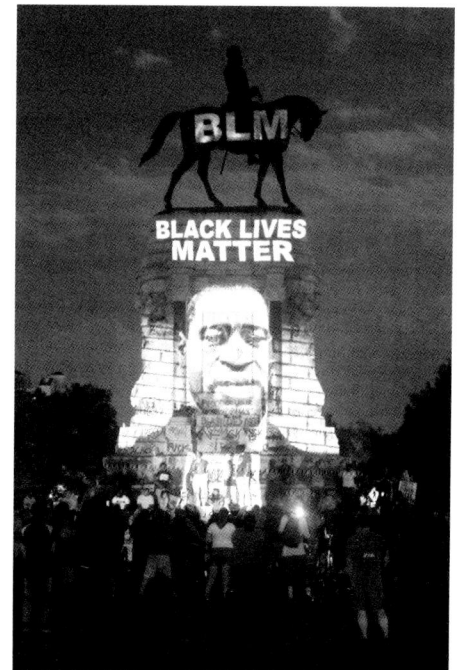

6.4 George Floyd projections at night.

Do not erase the graffiti. Do not clean up ruined monuments.

Those ruins have now become indispensable objects of our collective memory, transitional memorials in the development of anti-racist democracy. Whether the statues stay or not, whether they are replaced or not, the sides of disgraced monuments can live on and flourish as interactive spaces of collaboration, discussion, and action.

Designers and artists have a role to play in this new phase of collaboration. They can work to create effective gathering spaces, and to facilitate dialogue as well as reflection. New media technology can connect one monumental site to another across the country or globe and bring social movements together to share insights and strategies.

If we forget the activism that has brought down those markers of white supremacy, we will have lost the opportunity. This movement has created new strategies of commemoration that encouraged the spontaneous expression and collaboration already on display. And those sites can point toward a future in which monuments do not demand obedience, but inspire social justice.[1]

Speculation and Care

Max Mollon

Interrogative design is not an isolated practice. It is comparable to a range of contemporary and historical design practices, such as critical design, speculative design, or design fiction, to name a few. What are the similarities and differences between interrogative design and these approaches?

The "Bandage Text": A Reference Point

We might start with some striking questions that arise when facing an interrogative design project, such as the *Homeless Vehicle*. Why make shelters so big and bulky? How do these vehicles help homeless people if they don't help them get off the streets? And most of all: What is the point of offering nonpermanent solutions to such societal problems?

An answer to the first of these questions appears in a webpage belonging to the Interrogative Design Group of MIT.[1] This is the "Bandage Text" (2002):

> A bandage covers and treats the wound while at the same time exposing its presence. Its presence signifies both the experience of pain and the hope of recovery. Is it possible to further develop such a bandage as equipment that will communicate, interrogate, and articulate the circumstances and the experiences of the injury? Could such a transformed bandage address the ills of the outside world as perceived by the wounded? To see the world as seen by the wound! In the complexity of the contemporary urban context, the equipment becomes a device for communication and mediation—design as tactical media—its purpose to treat not only the singular human being experiencing suffering, but the external society which produced it. As it facilitates treatment and provides "first aid" to immediate wounds, it will also alert, interrogate, and provoke to prevent the recurrence of injury. Implicit in this design's temporary character is a demand and hope that its function will become obsolete.[2]

In other words, interrogative design employs design as a means of inquiry that exposes questionable and unacceptable conditions of life, while temporarily solving them. By combining art and technology into design, the practice infuses design "with emerging cultural issues that play critical roles in our society yet are given the least design attention."[3]

• **Bruce and Stephanie Tharp:** Following the tenets of "wicked problems" (Rittel and Weber), if homelessness were such a problem then it seems possible to imagine only nonpermanent "solutions," or perhaps permanent interventions (instead of "solutions").

• **Bruce and Stephanie Tharp:** Might the analogy also enable the bandage to act as a participatory site for communication and inscription from this "outside world," the way people traditionally sign and write notes upon plaster casts? What might this mean for a homeless vehicle, for example—pros and cons?

Thus, interrogative design projects are made big and bulky because a bandage needs to be visible. Yet why use a temporary solution rather than simply getting people off the streets?

Interrogative Design within a Body of Practice

A literature review identifies up to 21 terms that evoke comparable approaches.[4] They form a conceptual space to be clarified.

Among these terms, 17 refer to design "programs"[5] (practices carried out or taken up by a group of individuals) and four to "theoretical constructs"[6] (meta-categories that group these practices under different criteria). The four theoretical constructs are reflexive design (which gathers projects inviting us to question values and attitudes unconsciously incorporated into design work), adversarial design (projects revealing societal issues and encouraging the confrontation of opinions), participatory design (which includes the beneficiaries of the design in the course of the design work), and discursive design (which uses the artifact as a vehicle for a message).[7]

In order to keep a balance between precision and conciseness, I will focus on one construct (discursive design), and three programs: interrogative design, design fiction, and speculative and critical design (which merges critical and speculative approaches). Moreover, these programs are contemporary, well documented, and appear similar, so highlighting their differences can help answer our questions.

As a means to find our way through this complexity, we can include the 17 programs in a very large body of so-called critical practices.[8] Their criticality means they question the state of the world (which can be done with different degrees of radicality and in different ways). Critique in this sense is understood in opposition to another and larger corpus of design practices, "affirmative" ones, which participate in perpetuating the state of the world, its values, its power structures, its vision of the future.[9]

Within the corpus of critical practices, the design researcher Ramia Mazé distinguishes three types of criticism that are generally displayed: those whose questioning is directed toward the author's own practice, toward the discipline of design, or toward society at large.[10] Texts and projects of interest in the current essay often verge on the third group.

Overlaying the previous typology, another categorization can be borrowed from the exhibition "Italy, the New Domestic Landscape," put together by the Argentine curator Emilio Ambasz, in charge of the architecture department of the Museum of Modern Art in New York, in 1972. His intention was to make sense of the intense, complex, and often contradictory directions explored by designers of the time.[11] Ambasz proposed to differentiate three prevalent design stances among his corpus: a conformist one, a reformist one, and one of

• **Bruce and Stephanie Tharp:** All systems of categorization are ultimately faced with the question of what happens over time. Will these four constructs ever be able to (better) describe all the qualities, or more qualities (i.e., become a more effective "tool to think and make with")? Are there likely to be more than four as the field matures, or might there be consolidation, assuming that there would be more programs to eventually account for?

• **Bruce and Stephanie Tharp:** Matt Malpass discusses criticality in relation to critical design (practice) and contends that it is distinctive. "It is therefore important to question what criticality can and should do in design practice beyond the forms and traditions of criticism from the humanities and cultural studies" (*Critical Design in Context* [London: Bloomsbury, 2017], 11–12). With the critical theory of the Frankfurt School having so influenced art and design—explicitly and implicitly— notions of opposition, resistance, critique, and criticism become important to understand (and critque!). As the field matures we may better answer: what are the particular capacities, limitations, privileges, assumptions, consequences, and responsibilities of critical design practice?

contestation which combines both enquiry and action. The first of these includes projects that explore the aesthetic qualities of design objects for themselves, while not questioning the sociocultural context in which they are released. The second category demonstrates reinterpretations of existing forms and objects with altered intentions and meanings.[12] The third approach—contestation—gets to the "roots" (in the etymological sense of being "radical") and leads to what has been called Italian "radical design."

Common Points between Related Practices: Design as Media

While the distinction between the reformist and contestation groups is not clear-cut, what is crucial for us is that both react to an unsatisfying state of the world. These designers were very concerned about their role within consumerist society, without being able to control the interpretation or uses of their production,[13] or to make structural changes to the system on which their design is dependent.

Is that observation limited to Italian practices of the 1960s? To answer this question, it seems important to understand what conditions have encouraged the emergence of such practices at other times. Moreover, looking at history may become useful for contemporary practitioners to assess whether these conditions are present today.

Looking at a few historical cases, we can see that as soon as the beginning of the last century, in England, William Morris[14] reacted against the social inequalities induced by the labor conditions regarding the production of industrialized design, distorting the values of the craft. As one answer he used design to imagine a utopian world, which he depicted in fiction. In Italy, radical design[15] (without being reducible to one stance) partly expressed itself against consumerism and the serial standardization of the material conditions of life, going so far as to dynamite the good taste of the bourgeois interior via the development of the kitsch aesthetic. In the 1990s in the Netherlands, Droog design[16] pointed the finger, among other things, at the wastefulness of industrial overproduction. Initiated in the 2000s in England, critical design[17] invited us to question the black box, the invisible, obscure conditions of production and operation of electronic equipment emerging in our daily lives. Within the following decade and internationally until now, speculative design[18] (later called speculative and critical design) questions the blind spots of new technologies and emerging scientific advances. It has benefited from an institutional enthusiasm for the popularization of science,[19] in an attempt to respond to the failure of European civil society to accept GMOs at the beginning of the decade.[20] Since the 2010s and expanding from North America, design fiction[21] has explored similar issues in banal everyday contexts. It initially elaborated on the impact of science fiction movies on innovation (on both scientific funding and market development),[22] in order to create room for critical reflection. A contemporary and growing practice in France, design for debate,[23] has manifested itself in the era of the crises

• **Bruce and Stephanie Tharp:** How might we understand the role of the marketplace within Ambasz's categorization? To what degree might "contestation" actually suggest viable alternatives for broader popular consumption? How might the "radical" be "projective" (see Robert Somol and Sarah Whiting, "Notes around the Doppler Effect and Other Moods of Modernism," *Perspecta* 33 [2002], 72–77) rather than, or while, being critical?

• **Bruce and Stephanie Tharp:** Critical design practice has overwhelmingly addressed broader sociocultural issues, with far less attention to the field/practice of design itself. This is the opposite of critical architecture which overwhelmingly addresses the field/practice of architecture, with comparatively little principal attention to broader social topics (except for the more general theme of environmental sustainability).

of democratic participation, questioning the biases hindering collective questioning processes. As for interrogative design, born in the United States in the 1990s, it has notably manifested itself against the (often unacceptable) living conditions of marginalized populations.

While these historical snippets are partial, and these practices developed beyond the topics of their initial context, this review shows that each practice was particularly anchored in the issues of its time. Without fully generalizing, it allows us to elaborate on Ambasz's observation beyond the Italian practices of the 1960s.

Dissatisfaction regarding the state of the world (or a situation) and a lack of agency to address systemic issues that are bigger than oneself are common conditions that show up repeatedly in this historical sketch—whether regarding the release of a new technology, the wastefulness of an industry, or systemic discrimination.

Those are particular kinds of "wicked problem"[24] because the designer is not in a position to solve them. Such designers are therefore caught in a dilemma: either interrupt their practice, as the most radically critical and effective gesture there is,[25] or continue their problem-solving practice without the certainty of being able to influence the situation. In this way, many practices were built in the counterform of their time, that is to say, within the room left when a "reformism" stance is not fully efficient. Here, using design artifacts for "contestation" and drawing other actors' attention to an issue remain meaningful and complementary ways to act.

While each practice or project has its own balance of reformism and contestation, the primordial shift here is to use the design artifact as a vehicle for discourse, which primarily aims to convey a message and less to be put into function. This is what American designers and researchers Bruce and Stephanie Tharp call "discursive design,"[26] a theoretical construct in which many of the 17 programs evoked earlier fit. This includes interrogative design as it tries to hold up a "critical mirror" to the world, in Wodiczko's words. The artifact, like a bandage, can be understood as "a device for communication and mediation—design as tactical media."[27]

This ability to convey discourse is also the ground on which French media studies researcher Annie Gentès compares design to a "media" in itself. That is, a design artifact, just like a play or a book, can be specifically crafted as a vehicle for a message—like one highlighting the living conditions of homeless people on the streets of New York City.

To summarize, herein lies one of the commonalities that interrogative design shares with its cousin practices. Faced with the inability to solve a systemic situation that is bigger than them, various practices seek to carve out a space

• **Bruce and Stephanie Tharp:** This is a significant impediment to understanding the broad range of critical practice. Not only are newly presented forms of design appropriated by other designers, but they are also differently interpreted by theorists and by other disciplines. Sometimes as a consequence of this appropriation, but also because of subsequent development and maturation, the initial form changes and even the progenitors of the names/categories move on. This seems to be the case with critical design and Dunne and Raby's current relationship with the practice, especially as it was articulated in *Hertzian Tales* (1999). Further, the distinctions between categories often seem to be less important to designers, evidenced through our interviews and interactions with scores of them. Many practitioners today are challenged to articulate especially meaningful differences between, say, speculative design and design fiction, even though they may prefer one over the other.

for the power to act. To do so, they use design as a means of expression, as a media.

In a larger picture, interrogative design, like many practices, is part of the critical stances of discursive design, which carry a discourse on society and its issues. These practices are sometimes grouped together in the large family of social design, or rather "new social design" according to the Finnish researcher Ilpo Koskinen.[28]

Resulting from such wicked problems, these cousin practices develop a particular relationship to actually solving problems. They primarily focus at least as much on issue-raising or question-setting, or at least as much as on problem-solving. However, this relationship to the very "problem" being addressed is a point of divergence between interrogative design and its related forms, which I will now explore further.

Differences: "Usable" Artifacts Addressing "Actual" Problems

Once discursive design is considered as a real communication practice, a whole field of research questions emerge at the intersection of design studies and media studies. These questions can be considered at three different scales: the issue addressed by the project, the artifact itself, and the situation in which the artifact sits and the public it reaches. These questions include, for example: How does the choice of a problem enable design to participate in the construction of publics around it?[29] How can specific elements of discourse be embodied in an artifact to avoid misleading the audience's thinking? How can the communication framework be developed to better reach such an audience?[30]

Here I will focus on the issues chosen by discursive practices. The point is to review the "nature" of the problems addressed. I will compare projects from interrogative design with those from design fiction and from critical and speculative design.[31]

Wodiczko's *Poliscar* is a mobile radio station for homeless people. It allows marginalized voices and their problems to be heard, while inevitably making their presence visible in public space. The project responds to the problems of the invisibilization, isolation, and precariousness of street people. In James King's *Dressing the Meat of Tomorrow*, the plate represents a possible dish of the future, in the form of an MRI scan of a cattle organ. The project addresses the problem of figuring out what an in vitro lab meat should look like if it were to be consumed on a daily basis, and remembering where the meat originally came from. Design Friction's *Soulaje* is a watch simulating the possibility of euthanasia at home. It was used as a provocation during a consultation with elderly home residents to inform the law-making process of the British Council on the Euthanasia Act. The watch solves the problem of softening the last mo-

- **Bruce and Stephanie Tharp:** Discursive design, as we have theorized it, is an umbrella category at the same level of abstraction as critical design practice or conceptual design. It is posited as a more inclusive and useful description of the many types of associated designs (be they one of the 17 "programs" or the other three "theoretical constructs," mentioned earlier). This acknowledges that a "discourse" is not necessarily a "critical discourse," as is often the connotation. The key element is that these are all designs for reflection (though they may offer utility) upon substantive topics—discourses that are deliberately embedded within or engendered through artifacts.

- **Bruce and Stephanie Tharp:** If the inability to solve such problems is due to "wickedness," then are interrogative designers and their ilk on firmer ground than other designers who attempt to solve the ultimately unsolvable? Or, if such problems are capable of being solved, does this speak to the lesser capacities of discursive design, or simply its designers' preferences for media interventions? Or is the interrogative designer merely incapable of solving such solvable problems by themselves, without the involvement of other design or problem-solving partners?

6.5 *Poliscar*, 1991, by Krzysztof Wodiczko.

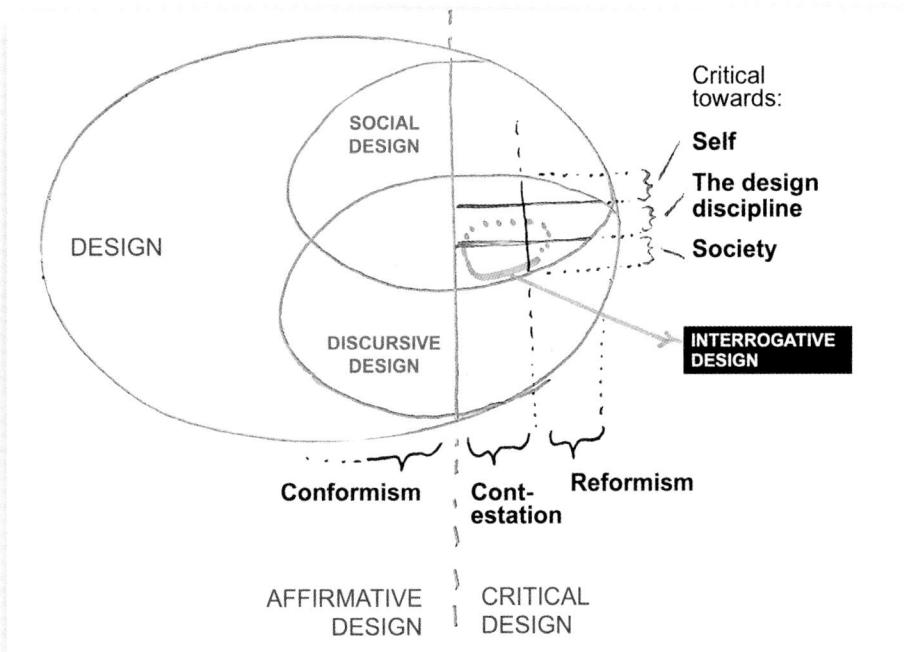

6.6 Interrogative design and related practices occupy a similar space in this Venn diagram.

ments of life by carrying out a medicalized procedure at home, in the near future.

When comparing these projects, it is clear that the three artifacts presented formulate a design response to a "problem," as would any problem-solving approach. But these problems are different in nature. The two last projects—which have respectively been presented as examples of speculative and critical design and design fiction—explore a problem that the public does not yet encounter, or not in this form. That is, either the problem is lived but the solution offered is not applicable (e.g., medically assisted suicide is not legal), or the problem is distant because the state of the world (as experienced by the public) does not

(yet) warrant a design response, even if the situation might one day change (e.g., in vitro meat is not feasible on a large scale at the moment, so dressing it is out of reach for most people). In some cases, imagining another state of the world, with its system, its rules, its interactions, requests a robust work of "world building"[32] close to some works of fiction writing. In contrast, the problems and the solution addressed by *Poliscar* are experienced by the public to whom the project is addressed—both for the users and for the passersby who witness the situation. This is also the case for *Homeless Vehicle*.[33]

These problems and solutions are immediate. Or, in the words of the French philosopher Pierre Lévy, following on Gilles Deleuze, they are not "virtual" but "actual" (in the sense of problems operating today, in the situation and with the audience to which they are deployed).[34] Virtual does not mean unreal or irrelevant (and is not related to virtual reality technologies). For instance, a tree is virtually present in the seeds of a fruit. Hence virtual rather means "distant."

Virtual or actual, each approach has different assets, and can be applied either to the issue addressed or to the design reply formulated. On the one hand, the very nature of speculation makes it possible to tackle issues of the present by exploring their distant consequences. Furthermore, the virtual—and thus fictitious—dimension makes it possible to probe situations that reside at the edge of, or beyond, the credible, the acceptable, the feasible, or even the legal. It allows us to experience them, to simulate them—making the most of the po-

• **Bruce and Stephanie Tharp:** The concept of distance from the problem is interesting. Beyond conventional notions of locality, this also seems to include, at least, issues of applicability, timing, and perhaps feasibility in terms of "warranting" a design response. The value of things has been posited in terms of the distance between the subject and object; the greater the distance between them (the challenge for them to meet), the greater the potential value of the object to the subject. But as presented here, a problem's distance might also involve some notion of the value of the solution to the user and/or audience.

We might also understand design intent more explicitly—the degree to which the project is indeed rhetorical. Some problems may be close but still approached rhetorically, and vice versa.

tential of considering design as a "media."[35] Note that other stances exist. For instance, finding ways to live sustainably on a damaged planet is an "actual" matter of concern that benefits from searching responses that are (yet) "virtual" in order to inspire change.[36]

On the other hand, what is the advantage of facing a problem that is "actual"? The answer loops back with one of my initial questions: Why would interrogative designers want to solve problems only temporarily? Because, while attempting to expose a problem that is too systemic to be solved, design can still provide "first aid" until other actors take up the issue. Like a bandage, the artifact "function will become obsolete"[37] someday, hopefully.

A second remark follows from the previous observations. The choice of a type of problem that is "actual" or "virtual" can be combined with work on the type of artifact designed, and the type of communication situation in which the artifact meets its audience.

In *Soulaje*, as much as in *Dressing the Meat of Tomorrow*, the artifact is shown in the form of a representation (strong images, scale models, videos), and is disseminated in a museum and online media context. In *Poliscar* the artifact is a functional technical device, put into operation. It is disseminated in public space and verges on the performative, before someday reaching an exhibition context or online dissemination.

Discursive design artifacts are commonly not actionable. The function of "being acted upon"—the so-called "teleological" scope[38] of the object—is often secondary. In the case of speculative practices, the teleological function can even be impossible (e.g., legally, in the case of *Soulaje-Protopolicy*). Furthermore, it is one of the richnesses of discursive design representations to give substance to ideas that are not actionable today.

In short, through a discursive and critical approach, interrogative design addresses issues that are actual rather than virtual, and it does so through usable objects (that also work as representations).

While the above projects are useful in illustrating my point in a straightforward manner, it should be borne in mind that the very essence of all discursive design is to have the primary function of "conveying a message," even above being actionable. Both virtual and actual approaches may hence be used in a complementary way for different matters of concern. Rather than locking up these properties as exclusive elements of interrogative design, constitutive of its definition, it seems to me richer to understand them as properties of design available to any practitioner. They can be organized in two continua, rather than in binary polarities (which means two ends of a spectrum can be covered by the same project):[39]

• **Bruce and Stephanie Tharp:** In this sense "virtual" is reminiscent of "theoretical" raised in an analogy attributed to Ettore Sottsass regarding theoretical physics and the value of a similar (distant) approach to design: "[Theoretical physicists] don't make plans for getting to the moon. They think about what sort of physical laws a person going to the moon might encounter."

6.7 Dressing the Meat of Tomorrow, 2006, by English designer James King.

• **Bruce and Stephanie Tharp:** Interrogative design seems to address the tension between the critical and the postcritical, which was being discussed in architecture in the mid 1990s—a decade after the formalization of "critical architecture" (see K. Michael Hays's 1984 article "Critical Architecture: Between Culture and Form"). In art, design, and architecture the distinction seems to hinge upon critical practice's focus upon reflection, in contrast to postcriticality's insistence upon action in the world—that is, criticality's reflection is not enough, given the gravity of the issues being raised.

For interrogative design, both reflection and action are goals. The question raised here is what level of action is appropriate. Following the bandage metaphor, interrogative design offers first aid and communicates the injury. But there is the question of whether first aid is enough, and when more direct, instrumental mitigation of homelessness itself can or should occur.

6.8 *Soulaje* (by the French studio Design Friction), part of the European project Protopolicy, 2015, by Imagination Lancaster.

- Bruce and Stephanie Tharp: Depending on the complexity of the problem and system, issue-raising might be understood as a design choice, more than as a lesser option born of the limited capacity to problem-solve. Might discursive design bring to light certain limitations of traditional problem-solving approaches—are hammers always the right tool for the job? Might this be the goal for the community of practice, accomplished in part by better advocacy and communicating the value of this kind of work? Thinking more broadly and deeply about "the problem," how might we also imagine these two approaches as complementary or at least equally valuable/valid tools in the toolbox?

- Bruce and Stephanie Tharp: Many designers who engage in critical design practice have often operated at the margins of the discipline—feeling even relegated to the sidelines. We hope that prominent work such as Wodiczko's can continue to add visibility and validity to non-commodity-driven design practices.

lived (actual) ‹—|—|—|—|—› distant (virtual)

actionable (teleological) ‹—|—|—|—|—› representation (communicational)

A Bandage that Shows the Way

This essay has attempted to provide concepts to inform contemporary thinking and practices that draw attention to systemic problems, as a way to regain agency when the designer is unable to solve them (on their own), thus adopting a position of issue-raising rather than problem-solving. Among the "new social design," and more specifically the critical part of discursive design, these diverse practices have in common using design as a "media" to carry discourse, which opens up three design spaces: the choice of the issues, the qualities of the artifact that embodies them, and the qualities of the communication situation where the latter meets its audience. In this regard, the issue can be chosen on a continuum from "actual" (experienced by the audience) to "virtual" (remote from the audience), and the design responses can be a mixture of actionable object and representation (in different proportions).

Learning from this, what could be the specific and valuable legacies of interrogative design for contemporary discursive and critical practices of all kinds? Some of the latter practices have been the object of strong Marxist, feminist, and decolonial critiques, initially expressed on MoMA's Design and Violence website, then widely developed.[40] These critiques cannot be reduced to a single element, but in part they can be read from a media perspective as the question of relevantly choosing an "issue" in regard to an audience (therefore walking in the steps of John Dewey). Indeed, some speculative projects address societal issues that are so far removed from the publics they reach, either in time or space, that they seem to deal with issues that are irrelevant. Many projects have addressed issues that are limited to a privileged few on earth. Yet in other cases, it may be crucial to address issues whose effects seem remote (for example, climate change for the last 30 years). The responsibility of the designer is to avoid limiting themselves to their own point of view and privilege, and it also lies in the care they take to generate concern for a "virtual" issue (making publics realize how a distant and radically critical issue is relevant). This is all the more important when the practitioner has the power to access vast means of dissemination to reach the public.[41]

In this regard, the concept of the bandage—a design that both reveals and treats a problem—with its semantic and symbolic richness, may help to avoid the pitfalls imposed by speculation when choosing an issue, by encouraging care for the public, even for the future.[42]

Ustedes (Them)

Krzysztof Wodiczko

2020

6.9 *Ustedes (Them)*, in use.

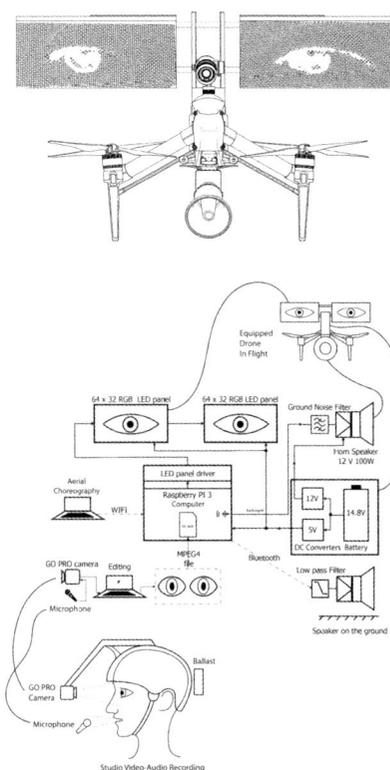

6.10 *Ustedes (Them)*, system diagram.

Ustedes (Them) uses low-altitude drones to generate conversations between individuals of different backgrounds, experiences, and ages. ...

Drones are often associated with images of war and breach of privacy, intrusion and fear, but in the case of *Ustedes (Them)* the drone [was] literally ... made anthropomorphic: during the performance there [were] four drones, each equipped with two screens depicting only the eyes of a person and a megaphone as nose / mouth. ...

During the performance the drones [represented different immigrants from South and Central America] and [gave voice to] different stories not only of immigration, but more generally of social and political marginalization, labor discrimination and abuse, addressing highly topical issues such as coexistence, citizenship, representation, compassion, and equality.[1]

The Aliens Are Coming!

Marek Wasilewski

Interrogative design is a form of social design that aims to create new forms of communication rather than beautiful objects, a form of design that is compassionate and listens to the needs of its users. The concept of interrogative design incorporates the notions of discursivity, dialogicality, and relationality. The word "interrogative" here refers to the activity of asking questions. This type of design is practiced not only by asking questions; its result can also represent a question addressed to our reality.

In Krzysztof Wodiczko's thinking, one finds a combination of rationalism and idealism, which is essential in creating new forms whose task is to effect positive change in the real world. For Wodiczko, designing is a social mission; the artist believes that the role of a designer is to understand the needs of the people who will use the objects they create. This mission is fulfilled not only on the level of product ergonomics but also in the realm of ideas.

This is evident both in his artistic projects and in his theoretical reflections. These always refer to very concrete problems found in social life and art theory. The artist transforms the ideas developed by sociologists, psychologists, and philosophers in creative and often surprising ways, introducing them into the field of art and giving them new, updated meanings. Sometimes he adapts existing solutions to new, previously unforeseen tasks. The artist is constantly looking for new performative situations in which to develop new forms of communication and expression, and ways to provide the users of his projects with new possibilities for functioning in society with the help of devices that change not only how they are viewed by others, but also how they view themselves.

Wodiczko projects his messages onto the surfaces of other existing structures, and in this way reveals and publicizes hitherto hidden meanings. He creates his own new vocabulary of terms and concepts, and creates new instruments specially tailored to his actions in public space. The innovative nature of Wodiczko's design strategy lies in its "cyberpunk," "Mad Max" character. It is "crisis design," i.e., design work undertaken in response to the existential and material crises of individual people. This design is triggered by the economic, climatic, infrastructural, and political crises impacting our cities. These crises demand a change of thinking and unconventional multidimensional interventions of a performative and discursive nature. His is a very ecological design based on the use of various existing elements that have previously never functioned together and modelling new possible combinations to improve their performance.

The instruments designed by Wodiczko are also subject to evolution; in the course of their use and being tested in various situations by different teams of people, they are improved or modified to meet changing needs. In designing instruments for communication, it is necessary to listen to the needs of those who are to use them, to understand their unique position and the resulting limitations. These limitations are most often fear, social isolation, situations of trauma or homelessness, or language and cultural barriers. It is also necessary to discuss the proposed solutions with these individuals so they become part of the design process and not merely its object. Wodiczko's practices nullify the commonly posed question of whether design is art, because through their performative character they bring together technology and the humanities.

A good example of this is a project that involved the use of drones. Drones are devices associated today primarily with military and commercial functions (though one does not exclude the other). Although unmanned aerial units have been around since ancient times, around the beginning of the twenty-first century they began to be used increasingly commonly around the globe in sinister ways.

Drones are used as invisible killers, bringing death from above. They are a perfect modern interface for separating the soldier-operator and their instrument-weapon from the real battlefield and its images, distancing them physically and psychologically from the multiform discomfort of inflicting death. However, the experience of drone oper-

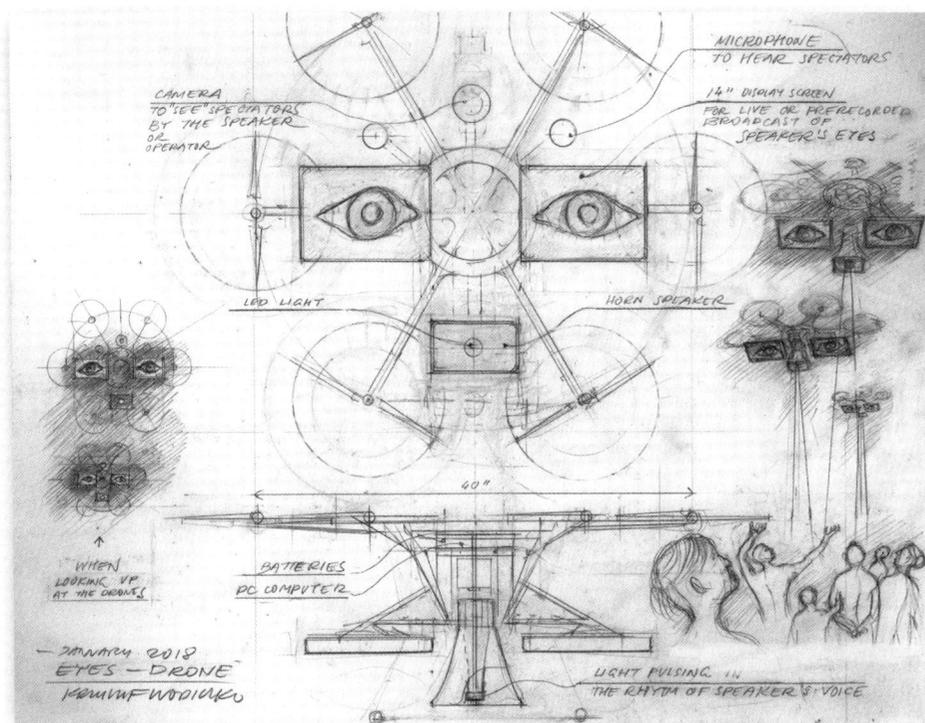

6.11 *Ustedes (Them)*, sketches, Krzysztof Wodiczko.

ators also shows that this separation is merely apparent, that it is not possible to separate a person from the trauma of killing other people. The unprecedented use of drones during the interventions in Iraq and Afghanistan during the so-called "war on terror" initiated by President George H. Bush after the attack on the World Trade Center in New York in 2001 has caused great loss of life and suffering among civilians and triggered protests by international humanitarian organizations.

The military use of drones is controversial not only because of their questionable effectiveness in achieving the intended results (precision surgical strikes on specific targets), but also because they do not comply with the principles of international law.

Drones are more and more commonly used for both spying and policing, and are a permanent element of a powerful surveillance system that monitors the activities of the population and scans borders in an effort to prevent undocumented immigrants from crossing them. Drones are also used in the entertainment, film, publishing, and

sports industries, providing dynamic and powerful bird's-eye views that make strong impressions on us. They are likewise of great potential importance for the economy, offering the possibility of eliminating postal workers and parcel deliverers from the labor market and replacing them with flying machines. Drones today are most notably an increasingly indispensable feature of systems of oppression and control, making us ever more dependent on them as an element of what Giorgio Agamben called a "state of exception." The vague and indeterminate status of drones corresponds perfectly with Agamben's remarks on the state of exception, which, according to the Italian philosopher, is a legal means of relating to life through a paradoxical suspension of the law itself. The notion of a "state of exception," like the actions of drones, is linked to the emergence of a resistance movement. Drones, as weapons in the "war on terror," operate in a legal gray area, killing people who exist outside the protections of the Geneva Conventions and carrying out attacks that are not governed by criminal law.[1] This state of legal limbo corresponds to the physical attributes of drones, which are themselves suspended in the air and operate in the gray areas of a no-man's land.

Krzysztof Wodiczko projects a new, diametrically opposed function onto these functionally and semantically well-defined instruments. Drones, whose main military function is to "silence" exotic Others, are now used to give them a voice. These Others include not only migrants from Iraq and Afghanistan, the "boat people" arriving on Italy's shores, and the Ukrainians and Belarusians coming to Poland; through these remote-controlled flying instruments, "internal Others" are also given a voice in public space, people who become Others because they are alienated

and socially marginalized, such as the Polish LGBT community or Polish Muslims.

An important element of this project is precisely its interrogativity: meeting with different communities, listening to their individual and collective stories, designing tools as a mean of empathizing with their mental and physical condition. I witnessed a meeting between the artist and a local community of Muslims in Poznań. It was a heterogeneous group, with people of different ages, nationalities, and living situations. It included people with different life experiences, including students, blue-collar workers, journalists, and actors. An important place in this group was occupied by Poles who had converted to Islam, as well as Polish-born descendants of immigrant families who, despite speaking the language freely and being familiar with the local reality, feel pushed to the margins of Poland's predominantly Catholic society. The artist had to explain his intentions to a community that did not know his work; he had to subject himself to questioning in order to be able to listen to others. This work was only made possible through the emergence of dialogue and the building of a basis for trust. The visual attractiveness of the idea, its technological aspects, were part of this conversation and helped stimulate interest in the project.

Participants in the project spoke about the problem of fear and alienation, how social stereotypes create unfounded fear, how this fear is manipulated and reinforced by the right-wing and populist media, and how this affects their daily lives and interactions with people.

An equally important element of the project was the creation of a special group comprised of people who were specialists in various fields. The pilots of the drones had to assess the technical limits, such as the maximum weight of the device and the length of time the object could remain aloft, which would affect the structure of the message and the length of the video displayed. They also had to design a special properly balanced bracket for attaching an LCD screen and megaphone to the drone. A separate technical aspect of the project was the production of video and audio recordings and technical processing of them. All of these activities were coordinated by the project's author, who, with his holistic vision, had to work to bring together all the technical, logistical, and social aspects of the project into a single point. The people involved in the technical and social aspects of this multidimensional process form what the artist has called an "internal audience," which, through its wide-ranging connections with the city's inhabitants, supports the project and contributes to its success and understanding by the local communities.[2]

As a result of the artist's work, a symbolic and actual transformation occurs. Wodiczko makes no effort to hide or offset the Otherness of alien features; instead, through a paradoxical exaggeration or even grotesque fragmentation of these features, he attempts to reveal their superficiality. The constructions presented during the artist's drone actions resemble monstrous dragonflies. They arouse curiosity and amusement but also anxiety, bordering on a subconscious repulsion that is characteristic of contacts between *Homo sapiens* and insects, reptiles, and amphibians. These species are clearly present as persuasive elements in hate speech. When one speaks of immigrants and minority groups as locusts, vermin, or parasites, for example, one is denying newcomers and minorities the right to humanity and to be seen as human beings. The artist brings before our eyes images from the dark dreams of xenophobes: the aliens are coming. Wodiczko's flying objects evoke what is repressed and thus "uncanny." These aliens are understood not merely as other people but also as hideous giant hybrid dragonflies with huge human eyes, like something from the world of science fiction stories and films. Wodiczko says,

> We should not be afraid to use tools that have been expropriated by the spectacle industry. We should not be afraid of design, even though it has been co-opted by the kitsch of consumerism. It is the insatiability of novelty that is kitsch today.[3]

Presentations of his drone project are highly theatrical in nature. The premiere showing of the work took place in 2019 in a city park in Milan, on the stage of an open-air theater. This was for security reasons, which prevented the drones from actively mingling with people and interacting directly with the audience. By drawing an invisible (but often visible as the edge of an elevated plane) line between the sender and the recipient, a division is created

between the actors on stage and the audience. The traditional relations within this division, however, are unsettled by the character of the actors, who are "machines." On the one hand, this enhances the uncanny effect of the performance, which depicts biological-mechanical hybrids as insect-humans. On the other hand, it reminds us of the problems facing the contemporary labor market, where there is nobody who cannot be replaced by machines, robots, or intelligent computer programs. We should also remember that the actual "stage" on which Wodiczko's "actors" appear is the city, and the audience is its inhabitants. The city is the place where meetings, dialogues, and the initiation of social change take place, which is what the artist cares about most.

Wodiczko is fond of invoking Bertolt Brecht's theater.

> Brecht's theory of theater and his theory of the role of alienation in the critical cognitive process suddenly overlap with Donald Winnicott's developmental psychological theory of the "transitional object" and Judith Herman's texts about changing one's perspective on one's experiences during the process of recovering from trauma. Alienating oneself healthily, and even allowing oneself to find humor in the melancholic repetition of one's experiences, can also be the task of design art.[4]

Judith Herman, in her book *Trauma and Recovery*, writes about how it is easiest to take the side of the perpetrator of misfortune because

> all the perpetrator asks is that the bystander do nothing. He appeals to the universal desire to see, hear, and speak no evil. The victim, on the contrary, asks the bystander to share the burden of pain. The victim demands action, engagement, and remembering.[5]

In a conversation published in *Czas Kultury* (Culture time), the artist said:

> Design is not only a matter of method, but also of taking into account the user and the function. The combination of function and message—this is what Brecht wrote about. For him, theater was instructional. It was a combination of instruction and en-

tertainment, but also a kind of creative alienation from ourselves. It allows us to see ourselves from a different perspective, in relation to stage characters and actors. It breaks the natural relation to what is going on around us, as well as being didactic. I see that design can also be Brechtian in the sense that, having a utilitarian function—for example, as a kind of "social crisis intervention service"—and responding to people's needs, it can also prompt and articulate the difficult, often inhumane situations that give rise to these needs, needs which should not exist in a civilized world, by showing their absurdity.[6]

It is worth noting several elements of the creative linking of the Brechtian concept of theater to the design of performative devices. Creating absurd tools and absurd situations exposes the social and cultural crisis we face. The very possibility that needs exist for which such devices have been designed is, according to the artist, a scandal. The participation in the project of people experiencing the trauma of alienation is therapeutic in that the participants can look at themselves from the perspective of their presumed spectators, people who also experience feelings of fear, apprehension, and danger when confronted with what is unknown and what they feel can threaten the balance of their lives. Brecht himself explained that the alienation effect

> consists in turning the object of which one is to be made aware, to which one's attention is to be drawn, from something ordinary, familiar, immediately accessible, into something peculiar, striking and unexpected. What is obvious is in a certain sense made incomprehensible, but this is only in order that it may then be made all the easier to comprehend.[7]

Wodiczko's actions and theoretical reflections are an excellent example of how a situation can be created in public space which creatively questions the status quo on many levels and enables uncomfortable questions to be asked.

Discursive Design

Bruce M. Tharp and Stephanie M. Tharp

During the late twentieth century, types of design like interrogative design were commonly understood beneath the broad banners of either "critical design practice" or "conceptual design." Such loose classifications usually indicated that this was work at the fringes of mainstream, technofunctional[1] design. Histories of such "alternative" practices usually begin with radical design in the 1960s and 1970s, and sometimes wedge interrogative design between 1980s Memphis design and Droog design (1993). Or, if Krzysztof Wodiczko's 1994 essay "Interrogative Design" is understood as definitive, then histories place it between Droog and Anthony Dunne and Fiona Raby's critical design of the mid to late 1990s.

After the publication of Dunne's *Hertzian Tales* (1999) critical design took off, and over the last two decades such alternative practices have inched closer to mainstream design. The relative speed and volume of new work has in the process left a bit of a theoretical mess. Design history, theory, and criticism have long taken a backseat to more practice-based concerns, so there is a bit of catchup in making sense of interrogative design and its "critical" and "conceptual" brethren. We suggest a measured approach consistent with the field's maturity. There are currently few academic texts, and PhDs in the area are only recently being minted. The dust is still settling. What we attempt in this essay is to understand interrogative design a little better and in light of its most popular relatives—critical design, speculative design, design fiction, and adversarial design—all beneath the rubric of discursive design.[2]

Given certain challenges with notions of the "critical" and "conceptual,"[3] we find that discursiveness offers more potential when addressing the historic range of work. Discursive design is a means through which ideas (discourses) of psychological, sociological, or ideological import are embodied within, situated as, or engendered through artifacts. They focus on the intellect (tools or media for thinking); in discursive design, artifacts serve purposes that are communicative as much as or more than they are utilitarian.

While the boundaries of the many types of discursive design are not always distinct, we introduce nine dimensions that are applicable across all forms: intention, understanding, message/discourse, scenario, artifact, audience, context, interaction, and impact. These provide a useful language with which academics and practitioners can begin to better understand interrogative design

• **Max Mollon:** The concept of discursive design allows us to conceive of the terms "critical," "speculative" or "adversarial" as concepts that qualify the properties of a design project, rather than as labels of fixed historical movements. This differentiates "critical" discursive design that challenges the status quo from "affirmative" discursive design that perpetuates it. In this respect, a certain fringe of discursive and affirmative design has been close to the mainstream for quite a while: concept cars, some fashion shows, or so-called "future vision videos" (e.g., from Microsoft).

and theorize the field. We see Wodiczko's *Homeless Vehicle* as quintessential interrogative design and focus our analysis there.

Intention

This dimension relates to the designer's rationale for initiating a project/artifact/intervention. From the broadest perspective, discursive projects can exist in various modes: tools for getting publics to reflect, artifacts offering direct operative utility through reflection (e.g., counseling aids), and as research instruments that generate insights in service of broader goals. More specifically, projects can aim to have various intellectual impacts (reminding, informing, inspiring, provoking, persuading) but also can embody various designer mindsets, ranging from earnest inquisitiveness to mischievous disruptiveness.

With the *Homeless Vehicle*, in addition to mitigating the very real sheltering challenges of the homeless, Wodiczko is trying to bring visibility to the problem of homelessness in the eyes of (at least) New Yorkers.[4] He is intentionally provocative, as the physical qualities of the vehicles make evident—they are not discreet, timorous machines. A recurring distinction with interrogative design is its insistence on instrumentally helping while also signaling—the bandage metaphor of healing as well as revealing. Critical design, speculative design, and design fiction, however, are often just rhetorical—they are not solving immediate, lived problems. When used as research tools these can help to better understand immediate problems and therefore contribute to subsequent solutions, as is especially common with speculative design.[5] It is adversarial design that most closely shares interrogative design's concern for practical contributions.

Understanding

Discursive design typically takes on "wicked" sociocultural issues, challenging designers' ability to understand the full complexity of a problem and the likelihood of an easy answer. Indeed, it is a tenet of wicked problems that they have essentially no true solutions, just partial, temporary interventions that themselves are the symptoms of further problems. Given this and other ethical implications, discursive design is often better suited to highlight the failures of given systems than to solve them—tools for thinking. Certainly, the better designers understand the breadth and depth of the issues and implications, the better they can respond responsibly.

Wodiczko demonstrates an understanding of homelessness, which has been an important theme in his work since 1984. More specifically, his participatory design processes engaged homeless support organizations and homeless people, providing direct user feedback on vehicle plans and prototypes. While discursive design sometimes involves ethnographic research to understand problems and inform solutions, it is not necessarily distinguished by deep

- **Max Mollon:** Provocation is a strategy so widespread that it has become an aesthetic canon. However, it is to be questioned in terms of "impact," the ninth criterion of Tharp and Tharp. When it is badly made, its provocation is often a good attention catcher but a bad trigger of reflection and debate because it shocks the sensitivity, polarizes opinions, and sterilizes the debates. The concept of "dissonance," disturbing the social values of an audience, is a good conceptual alternative to provocation.

- **Max Mollon:** Being rhetorical, discursive design's use value is hypothetical, fictitious. It is of the order of a "simulation" of use, which takes place in the heads of the public. From this specificity derives a fundamental property of discursive design: the primary function of the artifact is to "mediate" a discourse. According to the French design researcher Annie Gentès, the artifact and design are then to be seen as "media."

- **Max Mollon:** Addressing wicked problems is one of the primary intentions of design (or of service design, more specifically). However, asking questions rather than solving problems is, in my opinion, a recurring strategy when we are faced with a systemic problem that is beyond us (e.g., racism, poverty, the ethical consequences of science, etc.). This is why what we might call "too wicked" problems can be seen as symptomatic of discursive design. Such problems are a common trigger for most historical approaches to discursive design, whatever their name.

comprehension and full acknowledgment of wickedness. Adversarial design, however, embraces political agonism—recurrent, deliberate debates rather than harmonious, enduring solutions—which certainly aligns well with and recognizes the inherent complexity. However, adversarial design's stance on political agonism—offering recurrent, deliberate debates rather than harmonious, enduring solutions—certainly aligns well with and implicitly acknowledges such complexity.

Message/Discourse

Operating as media and tools for thinking, discursive design conveys, embodies, or engenders messages, even if they are not explicit and might only exist as general questions or suggestions. By presenting their artifact, the discursive designer is communicating that the relevant topic or discourse is worthy of reflection. This form of design leverages the advantages of artifacts as a differently potent means of communication, sometimes using explicit language along with the semantics born of object and context.

Homeless Vehicle clearly achieves interrogative design's goal to "extend the use of the media of communication" and "articulate and inspire communication of real, often difficult lived-through experience, rather than operate as a substitute for it."[6] While its messaging is implicit, critical design is probably most associated with the notion of clear messaging—expression of a critical stance. Often speculative design has a less explicit message and rather communicates an issue more neutrally as a cautionary tale or a "what if." These less partisan approaches are typical when discursive design is employed in support of user research.

Scenario

Implicitly or explicitly, products/artifacts are designed with certain conditions in mind, and these conditions need to be conveyed to ensure proper audience understanding and evaluation. Discursive design's primary agenda is essentially communicative, even as it leverages real or rhetorical usefulness and usability. It is imperative that projects are properly situated in time, space, and culture, since the artifacts typically are not fully earnest problem-solving proposals, despite sometimes looking as if they are. The discursive scenario is the real or rhetorical situation that supports the different conditions or future(s) being suggested by the work.

Interrogative design, especially evident in *Homeless Vehicle*, is unique in that it offers actual use value along with its sign value. It presents a real-world use case—actual homeless people can and did use the vehicle—which also lays bare the discursive scenario that "demands that we [the audience] acknowledge the existence of a specific crisis, reflect upon its causes, and respond to the question it provokes: 'If not this, then what do you suggest?'"[7] Similarly,

• **Max Mollon:** A clear message to the wrong audience can be problematic, and lead to a backfire, that allows designers to question their intended message. Among the different practices mentioned here, interrogative design and adversarial design are among those that weave the strongest match between "context," "audience," and intended "message." The lack of adequacy between these criteria opens the risk that the project will be ignored, received by the wrong audience, be counterinterpreted and offensive.

From a media studies point of view, the decolonial critique initiated in 2016 on the website Design and Violence, against critical and speculative design, takes root partly in this lack of adequacy. A "message" that only concerns an "audience" made up of a privileged few was yet broadcasted in a very broad "context," partly reaching an unintended (i.e., undesigned) "audience" for whom the provocation and the irrelevance of the "message" was hurtful.

adversarial design often incorporates real-world discursive scenarios communicated through facilitators that engage a public for reflection and debate. With speculative design, and even more with design fiction, the discursive scenarios are more propositional and contrived, often presenting alternative futures. They frequently leverage language in support of aesthetic storytelling.

Artifact

Discursive design deploys artifacts that evoke sociomaterial practices that lead audiences toward particular ideas or topics. The unique potential of artifacts—as products, graphics, interactions, services, systems, etc.—is that they visualize and make tangible and experiential what language can only describe. The particular technofunctional and semantic qualities are key to garnering attention, conveying the discourses, and engendering reflection and potential action in the world.

The *Homeless Vehicle* is an "ostentatiously designed object" with a "gleaming metal nose cone ... [resembling] a missile, primed and locked onto some invisible target."[8] "[T]he scandalous needs and functions (such as the need for a homeless vehicle) must be articulated through scandalous design form."[9] Typical of most types of discursive design, it has strangely familiar qualities signifying that something more is going on—there is an intellectual component and an important discourse embodied or enabled through the artifact, often in conjunction with the scenario. As mentioned, with design fiction and some speculative design that rely heavily on language, sometimes the discursive dissonance emerges from textual descriptions of the artifacts and scenarios. And with most discursive types where real technofunctionality is not necessary, the refinement of the artifacts can vary greatly; a mere nonworking physical model or even a rendering or sketch can be effective.

Audience

Discursive design must speak to some audience since it has a communicative agenda—it is audience-centered design. Confusion can arise because other forms of design have users but not necessarily an audience. Discursive design requires both, but user and audience are not necessarily the same person, and the users can be real or rhetorical. Audiences can range from general (whoever happens upon the designer's website) to small and targeted (key governmental officials).

When the *Homeless Vehicles* were deployed on the city streets the audience was New Yorkers. "While pragmatically responding to the homeless' needs the appearance and function of the *Homeless Vehicle* aims at provoking public attention [to] the unacceptability of such needs."[10] Since then and even today, the project attracts new audiences through gallery exhibitions as well as online and in print. This is typically how much critical design, speculative design, and design fiction operates when there are only rhetorical users. One of the key attributes of adversarial design is that designers often take on the responsibility of assembling publics (audiences and possibly users) to which the objects speak.

Context

To distinguish the notion of scenario from that of context, we use the analogy of a theatrical performance: the stage set and play correspond with the discursive scenario, while the context is akin to the theater and its location. The same play can be performed in different theaters, which can affect different audiences and evoke different interpretations in support of various goals. General contexts include the lab, field, showroom, clinic, marketplace, forums, and other print and digital forms of media, all with particular qualities that can influence meaning and response.

Homeless Vehicle was originally situated on the streets of New York (the field),[11] then in the contexts most typical of discursive forms that do not have real-world users—in museum and gallery exhibitions (showrooms), and in print and online. Discursive design is becoming more prevalent in the lab, especially as commercial and other institutions are using forms of speculative design and design fiction in research and development. Adversarial design is often deployed in the field and in forums for direct public engagement. While few critical designs have been able to successfully use the marketplace for dissemination,

crowdfunding platforms and independent retailers usually offer greater possibility than traditional mass marketplaces.

Interaction

Along with the breadth of contexts in which discursive design can be produced and consumed, it can involve numerous forms of interaction. The primary forms of interaction take place between designers, discursive artifacts, and users/audiences. Forms of engagement and dissemination have matured beyond merely viewing prototypes on pedestals and graphics in galleries. Discursive designers can continue to leverage greater types and depths of interactivity throughout phases of production, circulation, and disposition that can contribute to the impact of their artifacts and the discourses that they embody or engender.

Homeless Vehicle stands out, especially during the late 1980s, because Wodiczko worked with homeless people and support organizations to co-create and iterate upon the vehicle's attributes. While directly addressing real needs is a crucial aspect of interrogative design, interacting so closely with prospective users is not crucial to other forms. Based on transcripts of Wodiczko's interactions with homeless persons, it appears that all parties were affected by their involvement in this unique project—in the process, if not the outcome. Less is known about the interactions that homeless users had with New York residents, business owners, and law enforcement, but this capacity was certainly built into the project. And when audiences have come across the project in subsequent decades, knowing that the exhibited vehicles were actually pushed about city streets garners greater attention and adds to the meaning and impact of the work.

Forms of possible interaction are equally available across different discursive types; greater engagement with users and audiences during and after dissemination helps ensure that the project's goals are achieved, and its impacts understood.

Impact

With discursive design, the idea of impact emphasizes the success of the designer's intention—the degree to which the project has promise for or proves out some beneficial result. It is important to understand that discursive design's distinguishing capacity is its ability to get people to reflect on certain discourses or issues and have their awareness, understanding, attitudes, beliefs, and values shift.

Beyond this intellectual impact, as with interrogative design, there is often a desire for preferred action in the world. This can spring from artifacts' value to users but can also arise from stakeholders and audiences feeling compelled to work for social change. While *Homeless Vehicle* has accomplished de-

• **Max Mollon:** Interaction can be understood as a form of public "participation" in the design phase (participatory design) and in the dissemination phase (engagement) of a discursive project. When this dissemination leads to debate and collective intelligence, discursive design approaches can be considered as one of the forms of the "new social design," according to Ilpo Koskinen.

• **Max Mollon:** Impact is a key criterion for advancing the field of discursive design by questioning the fit between a project's means and its ends.
 Does the aesthetic of provocation distract the public from being open-minded when considering the project? Is the mediation of a project in a museum context adequate for the public the project aims at—or is it necessary to meet the public by infiltrating the latter's natural environment (company, research laboratory, TV news show)?

grees of preferred thinking and action, more broadly achieving preferred social conditions remains a challenge.[12] With wicked social problems, change is slow and difficult and conditions shift; design's impact may never reach that far. But the immensity of the challenge does not mean that designers should not strive toward better futures. While critical design, interrogative design, and often design fiction have stronger senses of what preferred thinking, action, and social conditions might be, speculative design and adversarial design can take a more neutral stance where preferred outcomes are ones that only arise through individual reflection or broader community deliberation.

As the discursive design community of practice matures, it is unclear whether its categories will tend to lump or to split, as there is evidence of both. We see the union of the critical and speculative categories as speculative critical design (SCD), while newer forms have arisen like Critical Jugaad,[13] inspired by the decolonizing design initiative. And the impact of the field is not clear as other disciplines appropriate and mix practices, as with forms of strategic foresight and design futuring.

As a relatively young field and community of practice, we are less concerned with tight delineations at this point. We are pleased that there is now greater acceptance than in the earlier days when Wodiczko was blazing trails, and we are confident that with time there will be general agreement upon categories and definitions. In contributing to this process, we suggest that these nine facets of discursive designing—intention, understanding, message/discourse, scenario, artifact, audience, context, interaction, impact—can assist in understanding what makes interrogative design both similar and unique among the growth of discursive forms of design.

Countdown Machine

Add Oil Team

2016

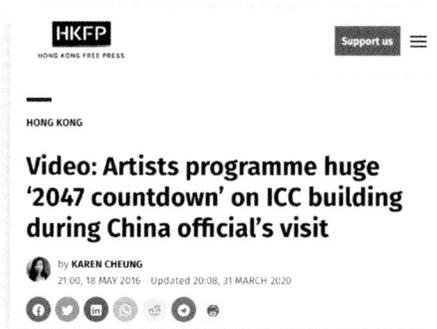

6.12 Countdown Machine, coverage in political press.

- **Pete Fung:** While the countdown clock amplified and broadcasted the emotions and concerns at the time, it is equally interesting to consider the aftermath of such initiatives. Since the introduction of the Hong Kong national security law in 2020, most political messaging (public messaging anyway) have been rigorously silenced or self-censored. It begs the question of what design can do when faced with crackdowns. Can design exist within a completely opposing ideology?

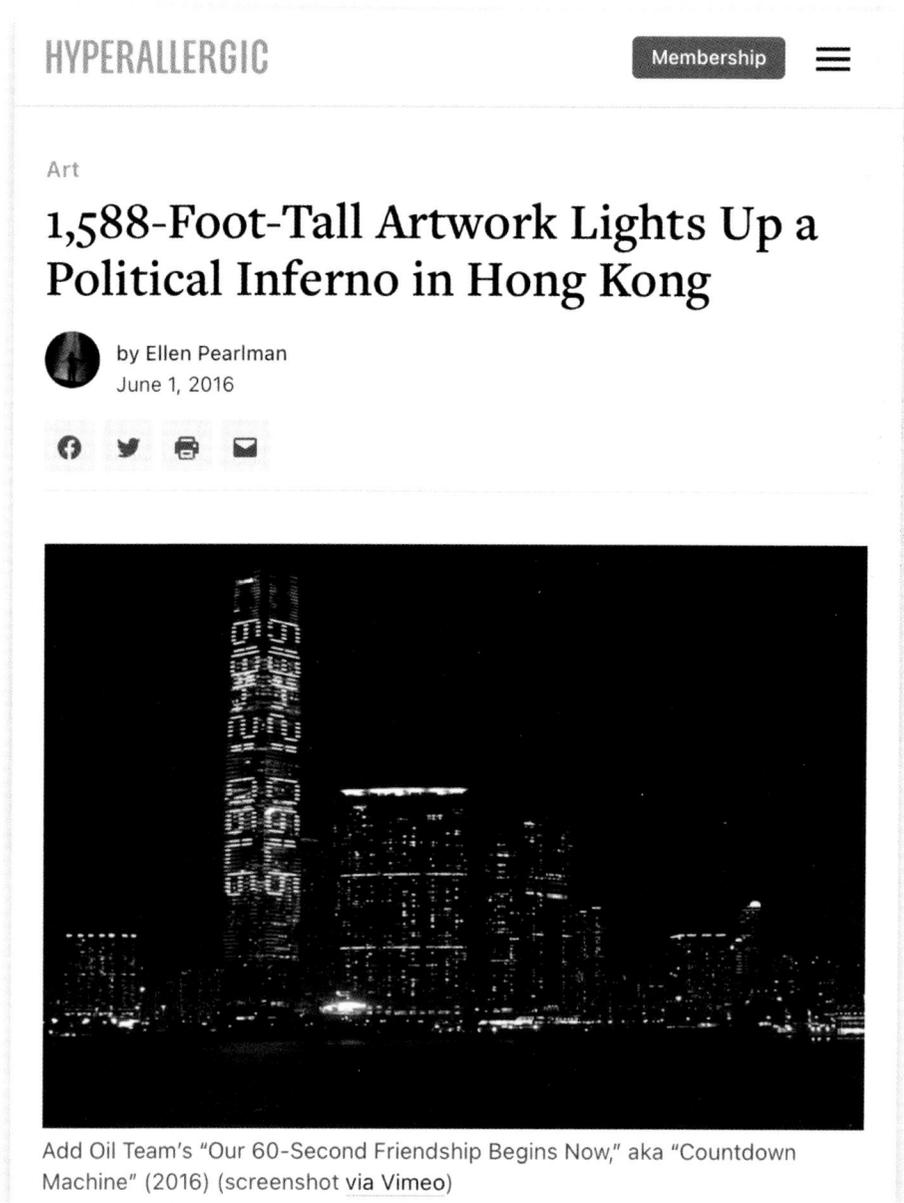

6.13 Countdown Machine, coverage in art press.

Afghan eXplorer

Chris Csíkszentmihályi

2001

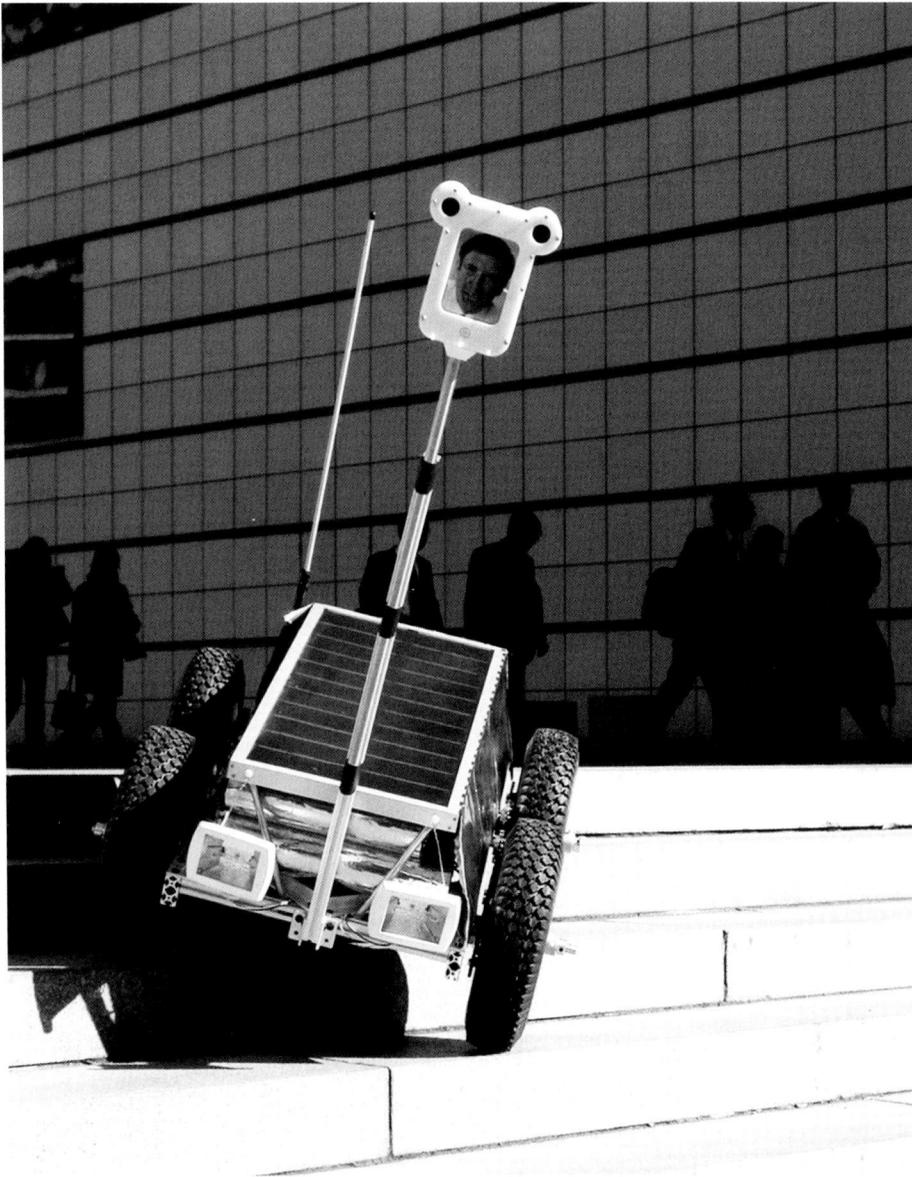

6.14 *Afghan eXplorer*, prototype.

- **Editor:** Afghan eXplorer is a drone for use by reporters in inaccessible war zones. Although never deployed at scale, it generated considerable publicity and brought the issue of press freedom in conflict zones to public attention.

 As Chris Csíkszentmihályi pointed out in numerous press interviews, the United States has prevented journalists from working freely in war zones since the early 1990s. This prototype both suggests a solution and provides a foil for discussion about alternatives.

6.15 *Afghan eXplorer*, press coverage in Salon.com.

6.16 *Afghan eXplorer*, system schema.

Interrogative Software Design

Warren Sack

Excerpt from a lecture presented at the "Critical Praxis for the Emerging Culture Symposium," School of Art and School of Architecture, Washington University, St. Louis, April 16, 2004, organized by Sung Ho Kim and Cynthia Weese

In an interview published last year, Krzysztof Wodiczko said, "For me, a central question is, where are we today regarding democracy with relation to art? How can art influence and be influenced by the process of democracy? I believe that the examination of democracy and public space is a project that should continue."[1]

Those of us who have studied and worked with Krzysztof seek to elaborate on this: How should we continue this project? To believe that art and design have something to offer democracy, and public space is a first step. But, for a number of reasons, it is not possible to simply multiply or reproduce Krzysztof's work: first of all because his pedagogy is Socratic. He teaches his students a lot, but he does it with the method of Socrates. That is to say, when asked to explain and train, he replies that he knows nothing. So his students learn by self-invention.

This sort of pedagogy, which presupposes that students already know something, very effectively points to the second reason why it is not possible to simply reproduce Krzysztof's work. The technological and material conditions of the world are constantly changing, so any sustainable, critical practice needs to regularly proliferate and change. Since Krzysztof's students come to him from many different backgrounds and concerns, even after encountering him we follow different paths and, by so doing we extend his concerns and approaches into areas where Krzysztof himself might not go. Before I met him I was a software designer; when I left his studio I was still a software designer, but hopefully one now informed by the wisdom of Wodiczko.

Under the influence of this wisdom I have adopted a certain focus for my work. I am concerned with these questions: (1) What is a good public space? (2) What is a good public discussion? (3) What kind of software can make public space and public discussion better? The first two questions are obvious outgrowths of several general design problems that Krzysztof has posed and addresses. The third question is also an outgrowth of his questions, but it differs from his work primarily because I seek to address the question through the medium of software. From Krzysztof I learned a number of specific questions and a set of artistic-design criteria for crafting responses to these questions, but in the space of software I have had to reinvent a number of things. What I want to discuss today is how one might follow his ideas to create a Wodiczko-style software. Specifically, what I want to examine are the design criteria one might use to distinguish a good piece of software from a bad piece of software and to point out how Wodiczko-style criteria differ radically from today's conventional methods of software design and evaluation.

What exactly are these criteria? Given Krzysztof's Socratic approach, it is probably unfair to do what I am about to do. But then again, every Socrates has a student who writes down what they say and thereby risks making it fixed, inflexible, and noninteractive. So what follows is an extract from an unpublished dialogue I had with Krzysztof in 1997. We were talking together in a café, as we often did at the time, and I recorded the conversation and transcribed it.

> Warren Sack: Unlike you, many designers do not consider it a part of their work to propose a problem. Rather, they simply respond to what is proposed by a sponsor. Design is imagined as a pipeline where the problem comes in one end and the solution out the other, but the people in the pipeline—the designers or engineers—don't consider it their responsibility to critically examine what's coming in or going out as long as they deal with the problems they are presented with. Conceptualizing design like this—i.e., design as exclusively problem-solving—seems potentially hazardous, as Victor Papanek discussed [in *Design for the Real*

World], raising political, social, and environmental hazards.

Krzysztof Wodiczko: I think maybe the most interesting aspect of what you were doing when I first met you two years ago [in 1995] was the possibility of designing a machine that would make the operator more intelligent by challenging the operator's assumptions and priorities: a machine to reflect and interact with the operator's assumptions, conceptions, preconceptions in a kind of play or game.

WS: What I am trying to do now, and what I was trying to do then, is to design a machine which asks questions rather than one which solves problems.

KW: Those kinds of machines require what Duchamp called "artistic factors." I am sure there will be lots of similarities between what we are doing and Duchamp, but, perhaps, we can propose different artistic factors for design. Let's call users "operators" to emphasize the act of operating rather than consuming and to question the assumption that there is an immediately recognizable use value. Now, the problem is to design equipment which will do three things at the same time. (1) The first is to have an appearance of something useful, however strange it might be, look feel, or sound. "Useful" meaning it has a certain program that is recognizable as a functional program. The functional program attests to certain needs that are initially found. These needs might not be recognized by the market or technology; i.e., the ways in which technologies are programmed, used, or translated into machines. The machine is responding to needs that were not recognized, those that were hidden or neglected, or those that were not recognized before, or that are needs that belong to people who do not have money to buy. It has a kind of pretension to respond to these needs. That is one thing. But then, in this way, it appears set to solve the needs of the operators, make them more intelligent, or to make their lives easier by somehow enhancing their skills, abilities, and senses. This first thing is the entry to the world of the relations between humans and objects, including the environment. (2) The second thing is that the operation of designed machines and systems is directed at the operators and those who observe in such a way that it disturbs them, interrupts them, and somehow inspires them to rethink their assumptions. How can this be done? First, by the very fact that such machines are designed, or should be designed. In other words, the very instinct to use the machines and actually be responsive to the existence of something designed. The very act of designing equipment is already coded. If in designing the equipment one is trying to "publish" on something that otherwise would not be known, i.e., to enlarge the problems of the operator as a legitimate partner in the world of objects, somehow the operator is a legitimate person because of how well the equipment is designed. The act of design somehow causes everybody to recognize the complexity of the operator and his or her needs, which are otherwise unknown, hidden, outside of the culture, outside of the commonwealth, outside of rights. That's the second thing. (3) The third thing is the responses to such equipment could be educational in the sense that the operator could learn a lot through the equipment. It might actually create an appetite for more and more recognition of needs. The operator could become more confident, more self-esteemed and, at the same time, more performative; the operator would somehow become more in charge of the representation and presentation of their own conditions of life, their own ideas and critical points.

To paraphrase, Krzysztof's criteria for the design of equipment are the following. If the equipment is well designed, (1) it should be recognizably functional or useful; (2) it should disturb or interrupt presuppositions or assumptions of and about the operator; and (3) it should provide the operator with the means to represent themselves and their needs.

All of these criteria are clearly critical for the central problem of facilitating democracy with art and design. To design equipment or instruments that will make invisible

people visible and to allow everyone to have their say is to design the material, technical support for a radical, agonistic pluralism; i.e., a kind of democracy even more inclusive than a deliberative democracy. In Krzysztof's words, his aim is to design instruments "to provoke an exchange of opinions."[2]

I am optimistic. I think these design criteria can be met in multiple media, including software. But I would like to point out at least one medium-specific hurdle that needs to be faced by software designers: computers are bureaucracy by other means. Alan Turing's 1936 paper, in which the basic principles of modern computers are first described, spins an extended analogy between bureaucratic techniques (specifically writing, erasing, shifting, and scanning numbers in squares on a paper tape) and the mental activities of a man. The "files," "directories," "folders," and "volumes" of contemporary operating systems; the "tables" and "entries" of database systems; the "rows" and "columns" and accounting procedures of spreadsheets; the common algorithms of "sorting," "queuing," and "categorization," all are reminders of the bureaucratic lineage of the computer and computer science in general. Most graphically, consider the standard, contemporary computer interface—based on the desktop metaphor. This interface was developed as an extended analogy with the furniture, artifacts, and filing techniques of the office—i.e., cutting, pasting, throwing things in the trash.

To understand why this genealogy of computers is problematic, it is easiest to consider the etymology of the term "bureaucracy." The word "bureaucracy," is composed from "bureau"—the office—plus "-cracy"—a term that means government; thus, "bureaucracy" means government via the office, its techniques and organizations. These techniques and organizations were originally developed, especially, in the eighteenth and nineteenth centuries for the requirements of then-new, large-scale social, political, and economic formations, like the nation-state and advanced forms of capitalism.[3]

In tension with bureaucracy are other forms of governance, like democracy; i.e., rule by the "demos," the people, rather than rule by the bureau, the office (holders). Since the 1960s, many conceptual artists have developed means for resisting bureaucracy by repeating and then recontextualizing and reconfiguring its forms for the purposes of more egalitarian forms of governance. These tactics of conceptual art need to be extended and ported to software now that the desk is on the computer.

So, to Krzysztof's three criteria, one must add at least this additional criterion in order to engage in software for democratic purposes. The software designer must, for the good of democracy, challenge the bureaucracy lurking in the very foundations of the computer.

• **Editor:** At their lowest layer, computers work with memory "registers" with "addresses" and "instructions" and "operations" on and between those registers. What would a computer look like without bureaucratic metaphors? Is a non-bureaucratic computer possible? And, as Kelly Dobson importantly points out in her PhD dissertation, how can we affect the machine metaphors that shape what it means to be human?

My first introduction to interrogative design was in a mid 1990s undergraduate art class during a lecture on what was known then as "installation art." I watched a video of Krzysztof Wodiczko speaking about different national cultures' ranking of free speech among their fundamental rights. France places speech ninth, he said, the United States first, recognizing that all other rights flow from it. On this basis, he spoke about how his projects work with free speech between the official memory of public memorials and the real, living traumatic memories of individuals. I saw what he was doing as a phenomenal integration of the Polish culture he came from and an interrogation of the US culture in which he now lived—a culture he was respectful, yet critical of. The First Amendment had written him a blank check and he was using it to heal people and criticize authority through his art.

Interrogative design projects by many other artists also work with official, collective, and personal memory and by acting as mediating systems for public speech acts.[1] To create your own art and design projects that "work through" trauma in this way, it is useful to look at the ideas of Pierre Janet and Judith Herman. They provide recognized clinical approaches to using these speech acts to help people reduce the present impact of past traumatic events. Public art that applies these techniques also can form part of a strategy to help people heal from large disasters and mass traumatic events.

The recalling of traumatic memories is fraught with great risk, yet the act of telling one's life story, cohesively and completely, can have tremendous therapeutic potential. Through specially designed communication equipment, interrogative design provides a kind of therapeutic experience to both speakers (through their preparatory internal work and public speaking) and audiences (through a kind of mirror empathy).

According to clinical psychologist Pierre Janet, autobiographical storytelling can be a healing process through which the effects of past traumas can be rendered practically inert. He suggested that it is useful to think of two kinds of memory:

> "traumatic memory," which merely and unconsciously repeats the past, and "narrative memory," which narrates the past as past. . . . The goal of

therapy is to convert "traumatic memory" into "narrative memory" by getting the patient to recount his or her history.[2]

Transforming traumatic memories into stories puts a safe distance between frightening and destructive events of the past and one's present reality. The use of Janet's process in an arts context, through interrogative design or other approaches, can provide tremendous benefit to participating communities.

Judith Herman developed Janet's ideas further in a multistage trauma recovery process.

In the second stage of recovery, the survivor tells the story of the trauma. She tells it completely, in depth and in detail. This work of reconstruction actually transforms the traumatic memory, so that it can be integrated into the survivor's life story. Janet described normal memory as "the action of telling a story." Traumatic memory, by contrast, is wordless and static. ... The ultimate goal ... is to put the story ... into words.[3]

• **Mark Jarzombek:** With Wodiczko, transparency and deviousness are brought together in a cross-axial relationship. He brings into the public forum the repressed private stories of people who have experienced trauma. He places them in the context of urban history and makes them something to be magnified and enlarged so as to get our attention. In this way, he critiques and one-ups the hidden utopian privacy of the psychotherapeutic disciplines by not only mimicking and replicating the processes of therapy, but also staging trauma as an ongoing hyperreality in the collective tragedy otherwise known as modernity.

Works of interrogative design, such as *Tijuana Projection*, apply these ideas in public artworks by presenting individuals' prerecorded personal testimonies in outdoor public spaces, layering individual memories over state memorials and monuments. The transformation of traumatic memories into narrative memories and their subsequent integration into sites of collective memory provide participants and listeners with means for catharsis and psychological development.

Artists such as Ben Wood and Ekene Ijeoma work with contentious historical murals and monuments whose pasts are being publicly reexamined. Their projects could be said to have attributes of interrogative design when they promote study and dialogue around memories of colonization, racism, and structural and actual violence. Michael Rakowitz and Natalia Romik likewise have created works that delve into intersecting cultural memories through the design of environments that serve both as archives and as vehicles for encountering daily life. All these projects work at the intersection of powerful public nostalgia, official narratives, and a myriad of contradictions and complexities that individual and shared personal memories bring to light.

In the end, the only antidote for the dictatorship of nostalgia might be nostalgic dissidence. Nostalgia can be a poetic creation, an individual mechanism of survival, a countercultural practice, a poison, or a cure. It is up to us to take responsibility for our nostalgia and not let others "prefabricate" it for us.[4]

Importantly, these interrogative design projects serve not as "artistic statements" but as functional communications media for important topics of social concern. They are media that actually mediate, and they have the potential to transform cultures that are stuck in various ways.

Of course, many forms of art share the potential and practical techniques of interrogative design. As Ron Burnett writes, "images are often assumed to be the source of a communications process when they are actually a middle ground for intervention and interpretation by spectators and creators."[5] When visual art is seen this way, it becomes a meeting point for other social processes.

Projects that mediate conflicting collective memories can descend into situations of high animosity and even violence. Indeed, hot wars are often mobilized using differences in cultural narratives that shape group identities. One could see the present war in Ukraine, for example, as a war between the nostalgic narratives of Russian empire and the story of liberal democratic progress in the European tradition.

Interrogative design projects can also make use of advances in the theory of *conflict transformation*—a valuable alternative to the often-ineffective application of *conflict resolution* through negotiation or the brutal techniques of *conflict termination* (peace through the application of force). Robert Baruch Bush and Joseph Folger's "transformative mediation" framework aims to reduce interpersonal and intergroup conflict by transforming it slowly into less destructive forms of conflict. This approach to peace sees conflict as a part of life and seeks to grow empathy and build alternative arenas for the conflict. A key concept in this process involves managing the power imbalances between the parties through mutual *empowerment* during the mediation process and ongoing *recognition* of each other's concerns and positions. These two cornerstones have been shown to improve the outcome of mediation processes in family, business, and geopolitical arenas.[6]

Other simpler and more tactical peace-building techniques also exist, many of which are untested in art and design projects. Boaz Hameiri, for example, has shown that extreme political views can be made more moderate when people reflect on *absurd extrapolations* of their opinions.[7] Such approaches could work well with interrogative design's performative techniques to provide new contexts for critical thinking in democratic societies under encroaching authoritarianism.

The Post-traumatic Turn

Mark Jarzombek

Excerpt from paper originally published 2006 in *Visuality in Modernity*, edited by Lisa Saltzman and Eric Rosenberg (Hanover, NH: Dartmouth College Press/University Press of New England)

10

The Post-traumatic Turn and the Art of Walid Ra'ad and Krzysztof Wodiczko

From Theory to Trope and Beyond

MARK JARZOMBEK

> Assumed to have been hopelessly traumatized by consecutive heartbreaking losses in New York, the Arizona Diamondbacks came home and showed the same lack of respect for the shrinks . . . as they did the Yankees.
>
> —*Boston Globe*, November 4, 2001[1]

Throughout most of the twentieth century, the psychology of trauma was primarily of concern to psychoanalysts, but in recent decades it has found its way under various guises into the work of novelists, artists, historians, literary critics, cultural philosophers, mental health specialists, and journalists. Though this has opened up a domain that was traditionally foreclosed by psychoanalysis, it is possible to see a surfeit. That at least is the opinion of Ruth Leys, who, in her book *Trauma, a Genealogy* (2000), argues against any attempt to "dilute and generalize the notion of trauma," or, worse yet, fill it with "tendentious claims."[2] Leys wants the history of trauma to be closely associated with the empirical and despairs at what she calls the "general postmodernist tendency" to appropriate psychoanalysis and reduce it to a "debased currency."[3]

The trouble with Leys's argument is that it ignores the fact that the psychoanalytical sciences have themselves, in recent decades, set out to redefine trauma from a privileged theoretical premise, focusing largely on sexual abuse, into a matter of broad cultural concern. Today trauma applies to a whole host of painful realities, both man-made and natural, and can even be found in all age groups. In fact, when post-traumatic stress disorder (PTSD) was officially codified in 1980, the resulting gain of legitimacy on the part of the psychiatric disciplines was without doubt its greatest public relations success ever. We have to remember that in the 1920s, a sufferer of "war neurosis," as it was then known, would easily have been diagnosed as having had a problematic relationship with his mother.[4] In the 1960s, "Refrigerator Moms," as they were once called, were accused of causing their children's autism. In the 1990s, it was discovered that some overeager analysts had been pushing patients into having what is now called false memory syndrome.[5] A rape victim, until recently, had to face the possibility of being viewed as having brought on the rape because of her own "masochistic personality disorder."[6] The psychiatric discipline has a lot to answer for, and still does.

The *post*-traumatic as a release of trauma from the obligations of shame and privacy is in no small way an attempt to liberate psychiatry from the dark cloud of its *own* traumatizing compulsions.[7] It is difficult to say what came first in all this, whether it was a lay voice that would not remain silent, or a demand for revision and reform from within the psychiatric discipline itself. There might even have been a gender factor, given the increasing number of women who began to enter the field of psychotherapy in the 1970s. But whether from outside in or inside out, the changes have meant that psychotherapy, once viewed by psychiatrists as nothing more than the testing ground of certain theoretical assumptions, has now reversed roles with psychoanalysis to become the voice of a cultural avant-garde, asserting its own autonomy and its own theoretical and even political weight.

A clear manifestation of the post-traumatic turn came in the days and weeks following the destruction of the World Trade Center, when the news media employed the word "trauma" with such matter-of-fact casualness that one failed to notice that earlier catastrophic events had never been viewed from that perspective. "For Haunted Survivors, the Towers Fall Again and Again" (September 30, 2001); "Treatment Can Ease Lingering Trauma of Sept. 11" (November 20, 2001); "Thousands in Manhattan Need Therapy after Attack, Study Finds" (March 28, 2002), to

Interrogating Monuments

Adam Ostolski

Is there a link between the idea of "interrogative design" and Wodiczko's practice of and with monuments—what has come to be known as "monument therapy"? Is the act of projecting voices and faces (and hands etc.) on the monuments just an evanescent performance, or is it a deep if subtle intervention into the given monuments' very design? What Wodiczko does with the monuments, far from being a simple deployment of them as "screen" for testimonies, is rather an articulation—and rearticulation—of their very implication in the lives of their respective communities. Rather than simply using monuments, Wodiczko does indeed interrogate them—and, through them, invites us to interrogate ourselves.

Once presumably eternal, these days nothing seems more precarious than the life of a monument. In the wake of the Black Lives Matter protests, monuments of public figures associated with enslavement or colonization are being dismantled and removed all over the world—from the United States to South Africa, from France and the United Kingdom to the Carribbean. This spontaneous, mostly bottom-up movement is neither the first nor the only organized effort at questioning monuments. In Eastern Europe, the part of the world once under Soviet control, the prolonged farewell to commemorations from the ancien régime is far from accomplished. From Georgia and Ukraine to Hungary and Poland, communist monuments (or those perceived as such by the authorities)[1] are removed from public view, while the meaning of those erasing gestures remains contested—whether efforts to liberate a society from the imperial grip of Russia, displays of a new nationalist (and sometimes authoritarian) hegemony, or something of both. Other examples of the dismantling of monuments are dispersed or evade an easy reading. They include the removal (in 2019) of the monument to prelate Henryk Jankowski in Gdańsk by a group of unknown persons (Jankowski was a hero of the Solidarity movement, but also a notorious antisemite and recently revealed to the public to have been a child abuser as well), a racist assault (in 1998) at a monument to the abolishment of slavery in Nantes (not the one constructed by Wodiczko and Bonder, but an earlier, figurative work),[2] or the defacement of the Victor Schoelcher monuments in the wake of BLM protests in Guadeloupe and Martinique (in 2020 and 2021 respectively; Schoelcher being the one who abolished slavery in France, this left many well-meaning observers at a loss for words).

To be a monument means to live through a turbulent time. They have indeed, as Wodiczko once prophesied, become "foci of struggle" ("Memorial Projection," 1986).[3] This adversarial moment is a refreshing one, a time of an opening and a new beginning, at least potentially. But it is also, to some extent, troubling, begging the question: to what possible futures does it all point?

The "modern cult of monuments" (Alois Riegl)[4] has always been accompanied by its flipside—blasphemy, profanation, condemnation, or the loss of faith to which they once were a testament. It's part of the deal: to honor some monuments means to scorn some other ones. "The curse"—or threat—"of physical destruction or de-signification" ("Memorial Projection," 1986)[5] provides silent accompaniment to the monument all through its prolonged life. This binary framework—erect or dismantle, worship or despise, defend or deface—still in large part determines, and thus limits, our repertoires of contention. Even though the actual repertoire is sometimes richer,[6] it usually ultimately comes down to the adversarial model, which happens to reinforce the framework of the memorial cult in the very same gesture that erases some of its concrete avatars. The more monuments are deposed or destroyed,

the more deeply entrenched remains the assumption that monuments are there to be worshiped, silent witnesses to the presumably unquestioned unity of the community that endowed them with their lives.

Wodiczko is part of the debate. In his interventions (one written together with Kirk Savage) he tries to facilitate a shift from adversarial to agonistic memorial contestations. In reference to the American revolutionary tradition of public hearings, he aims to invite the power of judgment and use the struggles over dominance as an impulse and an opportunity for deliberation: "The statues and monuments must no longer be telling us and teaching us what we should do, and how we should think. Instead, they must listen and learn from us of what their deeds and their ways of thinking have done" ("Truth and Reconciliation Project," 2020).[7] If monuments can, and indeed sometimes should, be condemned, why not give them a right to be tried by a jury of peers? It is, ultimately, not about statues and their privilege, but about what sort of community we want to become. I read this proposal in light of Wodiczko's and Savage's encouragement to think of "a future in which monuments do not demand obedience but inspire social justice" (Savage and Wodiczko, "Statues That Reinforce White Supremacy").[8] To achieve that, erasing disgraced monuments out of sight is not radical enough. It removes some things claim to command our obedience, but leaves the very principle of obedience intact. While refreshing our memorial pantheon is long overdue and may indeed be an improvement, rethinking our very relationship with statues may take longer, but would cut deeper into the oppressive fabric of our polities.

Incidentally, the displacement to which Wodiczko's thinking induces us today is the very one that happened to his own reflection and practice of monuments. His early writings on the topic—"Public Projection" (1983)[9] and "Memorial Projection" (1986)—are very much part of an artistic guerrilla mindset. A decade later, alongside his thinking in "Interrogative Design" (1994),[10] Wodiczko's practice of monuments became less belligerent and more tender, taking what may be called a therapeutic turn. In interrogative design, in place of seeking to design ready "solutions" to social problems or involve in "melancholic deconstruction," Wodiczko offered metaphors of a "band-age" and a "critical mirror" to our society's ailments. At the same time, he began to develop his method of monument therapy—and it may be claimed that he is as famous for monument therapy in Poland as he is for interrogative design elsewhere. The very word *pomnikoterapia* (monument therapy) aptly carries two distinct but intertwined meanings: we ourselves are healed thanks to monuments, and monuments are healed through new ways we explore to engage with them.

The exchange wherein humans heal statues and statues heal humans may be thus understood as a way of interrogating monuments—and, thus, interrogating ourselves. By combining and mutually illuminating interrogative design and monument therapy, we may broaden our own thinking about—and with—monuments and our practice thereof. Alongside destruction and designification—which remain valid options in some cases—there is a possibility of redesigning/resignifying monuments through artistic/political practice.

Such a practice thus goes beyond both monumentalism and countermonumentalism (James Young).[11] Although monument therapy is to some extent inspired by the approach focused on building countermonuments, it goes further. Wodiczko is well aware of the risk of fetishism in monumental practice, not exempting the fetishism of the sublime. That the two are not the same becomes clear when we look at the one monument actually designed by Wodiczko, the *Memorial to the Abolition of Slavery* in Nantes. It is no ordinary (traditional) monument by any means, but is also evidently not countermonumental. Going beyond the "modern cult of monuments" as well as its inverse, the modern antimonumentalist iconoclasm, it is an effort to constantly involve both locals and visitors in a practice of interrogating: what does it mean to abolish slavery, then and now?

Iconoclasm, whether avant-gardist iconoclasm of the countermonumentalists or popular iconoclasm of spontaneous destruction, may have its merits, but it is not enough. The monuments speak to us because, on our part, we are also monuments. So what does it mean to interrogate monuments not just in any time but precisely now, when so many monuments are looking increasingly

suspicious, are on their way to being dismantled or moved to heritage parks, where they can be both hidden and displayed?

Wodiczko likes to repeat: I have nothing against permanent monuments, on the condition that they constantly change. But are there truly any nonchanging monuments? They do change, like it or not, whether slipping slowly into irrelevance or hastily awakened from their slumber on their way to being torn down—their meanings morph in line with changing context, practices, and fashions. And even their very matter does change, as the Anthropocene debate has recently made us aware, descending slowly into decay (cf. Szerszynski).[12]

The injunction for the monuments to "constantly change" is not an empty one. It is rather an invitation to accompany monuments in their changing, and to rethink our relationship with them. It is, to put it differently, an exhortation to move away from the "modern cult of monuments" and toward an agonistic practice of monuments. Interrogating monuments may be read as an effort to redesign them, not directly, to be sure (or perhaps so—why not?), but in an indirect way—by implicating them in a redesigning of the social and political contexts of which they are part.

Wodiczko's approach is based on one uncommon presumption: that it is not just figures carved in stone or cast in bronze that fall into the category of monuments, it is us as well. Our bodies and our selves are monuments to difficult histories no less than those material signs scattered across urban spaces. We carry within ourselves, in body and mind, past traumas of our ancestors ("The child from the tomb of the Unknown Soldier is in every one of us");[13] we are often sculpted, as it were, by our nations as living monuments ready to die and sacrifice ourselves for the fatherland; and we are also monuments to our own ambitions, dreams, utopias, as well as pretenses and hypocrisies—just like the stone or bronze monuments around us. Like those seemingly inanimate statues, we also carry within ourselves the memories and traumas of historic events, whether dormant or awake, displayed or repressed, or both. That is why monument therapy can relate to both sides of the relationship, stone persons and motion figures—since they have never been truly separate.

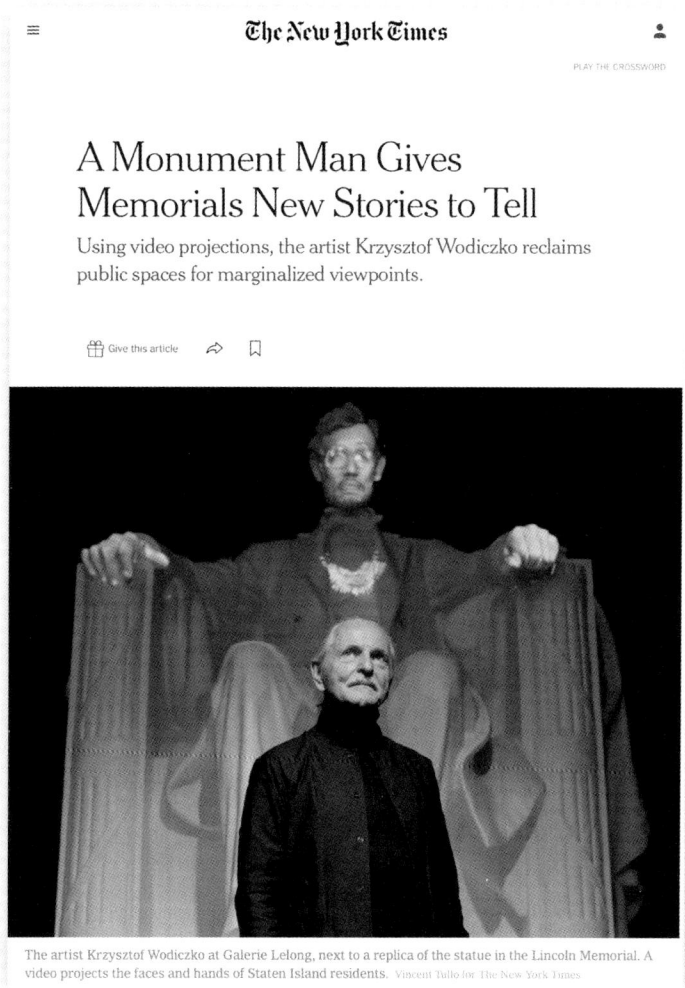

The artist Krzysztof Wodiczko at Galerie Lelong, next to a replica of the statue in the Lincoln Memorial. A video projects the faces and hands of Staten Island residents. Vincent Tullo for The New York Times

7.1 New York Times, January 23, 2020.

Monument therapy invites us to become tender spectators, and thus also "tender narrators"[14] of our lives and dreams. Interrogating monuments, learning to share space with them in their vast diversity and, often, ambiguity, and talking with them as equals is also a way to learn how to live, as equals, with our own diversity and ambiguities. This is no small thing. If, as Zygmunt Bauman said,[15] our modernity is characterized by inability to live with ambiguity, and this very rejection of ambiguity is at the root of both the greatness and the genocidal potential inherent in modern times, then learning to live with ambiguity carries with it a certain promise that goes far beyond the question of what sort of artworks embellish our landscapes.

Truth and Reconciliation at the Sites of Disgraced Monuments

Krzysztof Wodiczko

To speak up, protest, shout back the truth against the disgraced monuments and statues—such as of the slave owning southern or northern military and political leaders—is to speak up, protest, shout back the truth against the still continuing system of racist inequality and oppression. It is an act of speech, via a historic racist monument, addressed against those who directly or indirectly, consciously or half-consciously tolerate, preserve, and benefit from the new forms of racism today. It is also an act of speech directed against the monument itself as a symbolic racist machine that serves the purpose of the perpetuation of racism. It is also an act of speech against the specific racist person immortalized and venerated by the statue or the monument.

The Black Lives Matter movement that inspired the protests against white supremacist monuments has provoked a larger civic focus on systemic racism and social injustice and has contributed to the beginning of proactive discussions on ways to move forward together.

As long as the racist system and its hypocrisies continue, the "lofty" monuments that are historically implicated in its creation and operation must be challenged, confronted, and publicly investigated. The statues and monuments must no longer tell us and teach us what we should do and how we should think. Instead, they must listen and learn from us of what their deeds and their ways of thinking have done. The monuments must acknowledge the centuries-long and lasting impact of the murderous ideologies practiced on the black, indigenous and people of color that they have been symbolically enforcing, perpetuating, and glorifying.

The protesters teach the monuments and statues how they should see their own past beliefs and actions from the point of view of the devastating present in which they are profoundly implicated and for which they must be accountable. The protesters refuse to be taught by the racist past. They want to teach it a lesson.

At the same time, we humans, for better and for worse, share many things with the statues even when we protest against them and oppose their messages. We seem part-statues, while the statues seem part-humans. We tend to mentally project ourselves onto the statues and, in some respect, identify with their monumental condition.

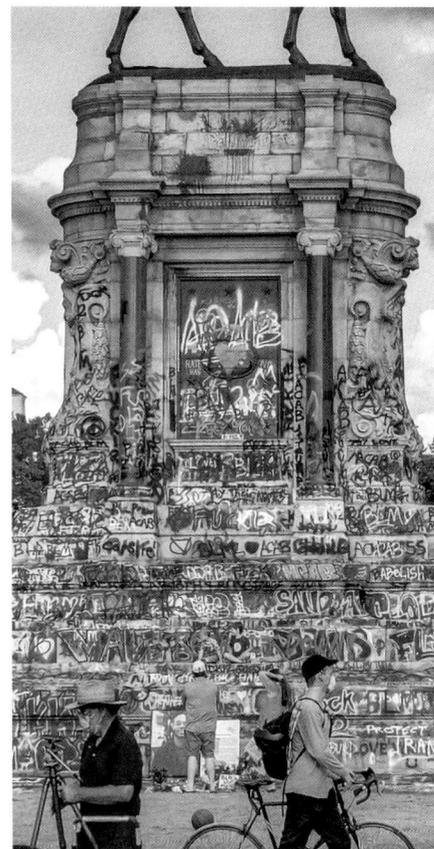

7.2 Robert E. Lee statue in Richmond, Virginia, June 2020, detail.

• **Adam Ostolski:** A monument that went rogue—can it be resocialized? Can any monument be reeducated, or only some of them? How shall we tell one from the other? Most importantly, whether a monument is resocialized, decapitated, or isolated from the society, what do we thus do to ourselves?

The statues resemble us, and we resemble them, perhaps because we are living monuments to ourselves: to our achievements, our pride, our institutional official power or desire for it.

We are the monuments and statues of our hopes and our lofty and heroic civic ideas, visions, and aspirations. Many of us secretly imagine ourselves placed on the pedestals.

Some among us are the living monuments to our own overwhelming life events, and to the heroic live battles that we won or lost but remember, commemorate, and cannot forget. Some, like the war veterans and war refugees, remain frozen in their tragic past, incapacitated by it, and unable to move on—true monuments to their own trauma.

In these ways, the statues seem part-alive and part-dead, existing in between life and death, as we all are. In many ways the statues, as our doubles, reflect and help us to acknowledge our uncanny condition between the reality of our mortality and the dream of our immortality.

All public statues, including the racist ones, seem to inhabit our souls.

With their highly articulated and dramatic gestures, absurd and troubling as they may look, the protesters seem to resemble the very monuments and statues that they oppose and reject.

Should the humans be granted a legal and moral status of "statue-like"?

Should the statues, conversely, be granted a legal and moral status of "human-like"?

We admire the statues' gestures and expressions and their human likeness while being frightened by the very thought that they may "come to life"—that the horrifying past may "come back."

This may be especially—but not exclusively—the case of the souls of the white people, including those who claim to be "not racist."

Speaking back and protesting at the statue of a heroic Union military commander—who never freed his own slaves—one must consider examining, protesting against, and speaking back to one's own potential hypocrisies and double standards.

It seems most appropriate to reflect on one's own existential condition, political position, and historical situation while physically facing the statue or visiting the monument.

The very process of arguing, debating, and defending one's own interpretation of the monument's symbolism against the interpretations of others, protesting or supporting the demands for its removal, proves a social and ethical usefulness in the statue or monument and its site, even in the site from which it has been removed.

In a statement written with my colleague Kirk Savage, a historian of the American Civil War and the Reconstruction-era monuments and statues, we have suggested:

> **Whether the statues stay or not, whether they are replaced or not, the sites of disgraced monuments can live on and flourish as interactive spaces of collective discussion and action. Designers have a role to play in this new phase of protest and commemoration.**
>
> **They can work to create effective gathering spaces and to facilitate dialogue as well as reflection. New media technology can connect one monumental site to another across the country or globe and bring social movements together to share insights and strategies.**
>
> **New strategies of commemoration that encourage the spontaneous expression and collaboration already on display at these sites can point toward a future in which monuments do not demand obedience but inspire social justice.[1]**

The monuments and the statues could indeed function as open agoras and forums for examining, opening, and exchanging testimonies of life in the racist system while bringing up the truth of the racism of the monuments themselves—examining their intended message, their historical context and their present-day meaning through voices of everyone, including the descendants of the black slaves and of the whites who though that could have a right to own them.

Some protesters call for the monuments' removal, some want them to stay, while others suggest various ways of preserving them and making educational use of them.

Why not grant the statues and monuments a chance and a right to be the sites and the subject of special public hearings?

Statues and monuments are and have always been the witnesses and the suspects of civic events, and as such may be suitable to become the sites of open hearings, trials, even tribunals in which they can be judged, defended, sentenced, or acquitted.

Created at one time as a civic act, for the purpose of standing tall in public places, the monuments' and statues' future may be reevaluated and determined as a civic matter as well.

Should the statues and monuments be removed, dismantled, relocated (perhaps to the museums of racism or to special public collections), or kept in their original public sites (perhaps with new inscriptions and supplemental media narratives), or simply be allowed to continue their public service as inspiration and provocation to the new discourses in the context of evolving new events and circumstances? There cannot be a simple answer to these and many other, yet-to-be-formulated, questions, matters, or proposals.

The future of each statue and monument must be discussed case by case in the process of a civic dialogue, with public participation, in which a multiplicity of positions, advice, opinions, testimonies, and ideas will be exchanged: those of community leaders and activists, legal experts, historians of conservative or critical kind, public and community artists, public art experts, curators, and many others.

Monuments and statues erected in the Reconstruction era—these of white supremacist slaveowners—could be effectively used as a cultural reference and a symbolic stage for social, political, and psychological confrontation with racism. Racism is the illness that must be cured from within and from without, because it has been ingrained in ourselves and in our culture over a long time and cannot be simply eradicated by physical act of removal of racist monuments or their destruction or relocation to museums.

Many monuments and statues may be justly removed, but some, especially these of the founders of our republic and its constitution as well as military and political leaders of the Union—however suspect and in part disgraced as they may be—probably will stay.

The total removal and disappearance of the disgraced monuments and statues may become a social and psychological loss, with the lost chance to make use of them for an honest and healthy unracist process toward a racism-free future.

• **Adam Ostolski:** A monument is presumed to carry his or her fixed meaning for eternity. And yet their meanings change over time, and people might disagree over what message a monument actually conveys. How can a monument have only one meaning? How can they have more than just one? Is one meaning better than many, or are many meanings better than one? If one is better, how can it be fixed? If many are better, how many is not too much?

There are thousands of statues and monuments that are still waiting to learn about their fate. They should be subject to a fair and open examination, with the participation of citizens and in a full respect for their often diverse and contesting feelings and judgment. Everyone should have a fair chance to voice, express, testify, and exchange the truth of their witness and experience and add a personal chapter to our collective memory and history of racism: speak, discuss, argue, and judge on behalf of the living and the ancestors—for themselves and for others.

New forms of events and gatherings organized at the sites of suspect monuments, and on the sites of their removal, may be envisaged to help carry even further the social justice process began by the Civil Rights and now continued by the Black Lives Matter movement.

Such events may take a form of free and open fora or tribunals or town hall types of meetings that examine further, in a discursive way—through people's testimonies of their lived experience with racism—the beliefs, ideologies, and actions that such monuments help to tolerate, culturally sustain, and glorify.

One important reference, and a direction to follow, is the truth commission, truth-telling, or truth and reconciliation commission.

According to a widely recognized definition:

> A truth commission (1) is focused on the past, rather than in ongoing events; (2) investigates a pattern of events that took place over a period of time; (3) engages directly and broadly with the affected population, gathering information on their experiences; (4) is a temporary body, with the aim of concluding with a final report; and (5) is officially authorized or empowered by the state under review.[2]

Such commissions adopt an approach of "restorative" or "transitional" rather than "punitive" justice.

Why not offer a chance to the suspected and accused monuments and to the victims and survivors of systemic racism—as well to anyone who wishes to confess their own patterns of racist thinking and racist decisions and actions or inactions—a moral and legal right to speak in such a restorative justice project?

The sites of the disgraced monument can become places open to the public for a special form of truth and reconciliation process, as well as related events and projects: social, political, cultural legal, pedagogical, and artistic.

Such a process should advance an informed dialogue between us and the monuments—listen to them, listen to each other, exchange and examine opinions and facts.

- Editor: Not enough attention has been paid in cultural projects to transforming the interior experience of racism.

- Editor: The South African truth and reconciliation process in 1994 helped produce a massive and largely peaceful political transition from minority white rule to majority black rule. The Canadian truth and reconciliation process, by comparison, seems to have resulted in little structural change. A decade and a half after the launch of Canada's Truth and Reconciliation Commission, only a fraction of its recommendations have been implemented.[3] Studying different truth and reconciliation processes (e.g., in South Korea, Peru, Columbia, Germany) and "lustration" processes (in Poland and other post-totalitarian societies) may help artists produce new communication systems and cultural interventions to continue the unfinished political and social justice efforts of truth and reconciliation processes in their societies.

It could also restore a dialogue between these who defend a monument's right to exist or be spared on some restorative conditions and these who demand its punitive termination or other form of punishment.

It may uncover the truth about the life and deeds of the persons venerated by the monument, and the social, political, and historical contexts of such deeds—helping to understand, albeit not justify, the complex web of intentions and motivations of the monumentalized person or event, of these who commissioned the monument, and of the artists who created it.

It could offer a chance as well for reconciliation between the truth told by the people and truth revealed through the investigation of monuments.

It is crucial that a truth and reconciliation process should be open to both the racist statues and the people: to the suspected or disgraced statues and monuments of white supremacist political and military leaders, and to the African Americans, the Native Americans and other people of color who suffered from the tyranny of racism advocated by these monuments. It should also invite and include white people whose ancestors have contributed to racist policies and practices and who may speak of their own upbringing and the vestiges of the inherited racist patterns of thinking.

The hope behind such a process is in raising the level of consciousness—among and between the perpetrators, victims, and the gathered witnesses of the complex hegemonic mechanism of the racist system in its social, political, economic, psychological, and cultural dimensions—toward educated ways of dismantling it.

For this purpose, the events should also be allowed to be witnessed by the larger public, potentially adding their voice to the confessions and testimonies, through the social and mainstream media.

The truth and reconciliation process should give a chance for the present-day victims of historical racism to open up and speak and present evidence of their suffering, and of the racist policies, rules, and norms and patterns.

In the proposed truth and reconciliation proceedings, the millions of historically enslaved and segregated people may be represented by their direct descendants, by the leaders of the Black Lives Matter movement, by the surviving activists of the Civil Rights movement as well as historians and experts and others.

People who historically enslaved others and who had secured and contributed to the continuity of such an enslavement through a complex of segregation policies may be represented in the proceedings by historians, legal experts, political philosophers, and other experts on racism.

The truth and reconciliation process should be open to those who feel guilty of contributing to any forms of systemic racism through their actions and inactions: through their passivity, ambivalence, absentmindedness, closing one eye to the horrific effects of racial injustice while opening another to their own privileges and benefits drawn from it.

The truth of their public confession will be verified and elaborated by the testimonies of those who have suffered the result of such passivity, inaction, ambivalence, and hegemonic advantages of the privileged.

The designated monuments and statues—perhaps selected through town hall meetings or the municipal election ballot—will join the truth and reconciliation processes, as the important defendants and witnesses. Included in such selection and designation should also be some of the Reconstruction-era statues that were erected against the will of those venerated and commemorated by them.

The monuments that commemorate and celebrate the key founders of American democracy and of the nation but who were slaveowners and who themselves contributed to slavery's legal enforcement and practices—while advocating and fighting for the liberation of blacks—should also be included as well.

Because the statues cannot speak by themselves and for themselves, to express, confess, and explain the truth that they may wish share, the researchers and experts of the cultural and social history of American racism and the monuments from the American Civil War and the Reconstruction era and others will volunteer to represent and help the monuments to have a fair voice in confessing the truth of their deeds and petitioning for forgiveness.

In the hope of honest and fearless hearings, such truth-telling proceedings must uncover cultural and psycho-social complexity and a larger fallout of the racist system, the result of its hegemonic forms and structures.

The process of internalizing racism by its very victims must be confessed and testified by all sides. Racist-like patterns of thinking, divisions, stratification, hierarchies, and conflicts within the black and the white populations enforced by the very racist system must be addressed in the proceedings through special confessions and testimonies.

The proceedings may be broadcast via media networks and disseminated through social media and recorded for archival, educational, scholarly purposes.

The process should also be allowed to be witnessed by the larger public that may be observing and potentially adding their voice to the confessions and testimonies, through the social and mainstream media.

What kind of spatial facilities and structures and media communication systems, social media-based interfaces—temporary, semipermanent, or supplemental to the monuments or statues—should be designed and built for accommodating and staging the hearings, debates, gatherings, events, and the proposed justice and reconciliation proceedings?

There are many other issues and questions, some yet to be formulated, to be addressed as part of the process of planning and designing the proposed project, a subject for discussion among all involved communities.

In whatever spatial and media form and system this proposal may be realized, the hope behind it is that the sites of monuments and statues may become places of undoing and unlearning racism within ourselves, our communities, society, culture through an honest debate, a democratic "agon."

In this way, I believe, the monuments and statues may best continue to function as sites of memory and justice. They will be transformed into un-monuments and un-memorials through the expression, transmission, and dissemination of voices and experiences, inscribed and exchanged.

Not as monuments against racism but as the un-monuments or rather the un-memorials to racism.

Such a discursive memory project may forge creative collective relations among white and black communities: built trust and unity for honest, discursive, conflictual but nonviolent exchange, not for "singing the same song."

Before, however, such public hearings, such a process of truth and reconciliation and restorative justice, before un-learning and un-memorial projects can materialize on the sites of statues and monuments, the specific procedural forms, programs and methods must yet be devised. This also, again, demands an inspirational and functional design of a new kind of physical and media structures and facilities that could be temporarily assembled, or occasionally reassembled at the very sites of the suspected and accused statues and monuments.

In this way, the sites of accused and suspect monuments and statues and the sites of their removal may be designated and designed to function as charged sites of fearless expression, disclosure, acknowledgment, and confrontation of the personal and social truth of racism. They should be designed to become special places for reconciliation—a transformative process toward a work together for an unracist society, against all forms of a continuity of the racist past and against the perpetuation, today and in the future, of our ancestors' crimes and sufferings.

Krzysztof Wodiczko

Written on the 75th anniversary of the Hiroshima bombing

Vinalhaven, Maine, August 6, 2020

Return

Michael Rakowitz

2004–ongoing

7.3 *Return*, storefront.

In 1946, my grandfather, Nissim Isaac David, was exiled from Iraq with his family. Like many Iraqi Jews, they were forced to leave behind a legacy spanning close to half a millennium. After settling in Long Island, his import and export company, Davisons & Co., among the most successful and active in the Middle East, found a new home in New York. The business closed in the 1960s. He died in 1975.

In 2004 I reopened my grandfather's business.

In 2006 I opened Davisons & Co. as a storefront on Atlantic Avenue in Brooklyn.

The company initially functioned somewhat symbolically as a dropbox. Then in 2005 it took the form of a full-fledged packaging center and sorting facility. Members of the Iraqi diaspora community and interested citizens were invited to send objects and goods of their choice, to be shipped free of charge to recipients in Iraq, an exceptional offer at a time when the shipping and trade infrastructure in the country had completely collapsed on account of the war.

In addition to continuing the gesture of shipping items, I wanted to explore the possibility of importing something that was clearly labeled as Product of Iraq. This venture began with the discovery of a can of Second House Products Date Syrup. Though stamped on the back as Product of Lebanon, the date syrup is in fact processed in Baghdad, put into large plastic vats, and then driven over the border into Syria, where it gets packed into unmarked aluminum cans. It is then driven across the border into Lebanon where it receives a label and is then exported to the rest of the world. From 1990 until May 2003, this was one method that Iraqi companies used in order to circumvent UN sanctions. It was still in practice in August 2004, more than one year after the sanctions had been dropped, due to prohibitive "security" charges levied by US Customs and Border Patrol and Homeland Security for any freight bearing the origin of Iraq.

The date syrup led me to dates, which were legendary in Iraq, with a yield of over 600 varieties. I signed a deal with an Iraqi company, Al Farez, to import one ton of dates from the city of Hilla, the first such deal in more than 25 years.

Monuments for a New Era

Ekene Ijeoma

2018

7.4 *Monument for a New Era*, Ekene Ijeoma, 2018

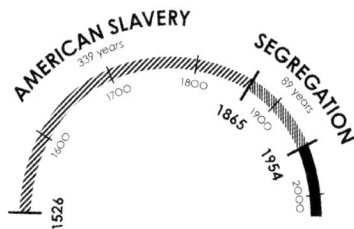

7.5 Zerflin, *But Slavery Was So Long Ago ...*, 2018

This proposal for an untitled artwork was commissioned by the *New York Times* for "Monuments for a New Era," a 2018 article published around the one-year anniversary of the "Unite the Right" rally in Charlottesville, Virginia. This white supremacist rally to protest the removal of a Robert E. Lee statue from the former Lee Park ended with one counterprotester dead and 35 injured.

The *New York Times* selected a few former Confederate monuments from which the statues of generals had been removed and prompted a few artists to respond to the physical and psychological aspects of the remnants. I selected the former Robert E. Lee monument in New Orleans, a monument to the best-known Confederate general who had fought for slavery. His statue had been removed, but the 60-foot pillar on which it once stood remained. Although the statue was out of sight, I did not want the history to be out of mind. In my proposal, I switched the role of the watcher and watched, transforming visitors from spectators of a fixed history to participants in a shared memory.

In my proposal, the six-story stone pillar is painted with color blocks, wrapped in a double helix staircase, and topped with a 360-degree viewing room. The color blocks are based on Zerflin's project titled *But Slavery Was So Long Ago ...*,[1] which shows a timeline of how close we are to slavery. Starting from the bottom of the pillar, it shows 339 years of American slavery in red, 89 years of racial segregation in yellow, and over 64 years of ongoing racial inequality in green. I wanted visitors to feel the changing pace and direction of racial progress as they walked up the steps, rested at the top, and walked back down while passing people coming up. My proposal transforms this pillar into a living monument in which confronting America's history of slavery and segregation and acknowledging their manifestations today becomes an ongoing experience.

Wodiczko offers the notion that "design must attract while scandalizing—it must attract attention in order to scandalize the conditions of which it is born."[2] By bathing the pillar in colorful light and installing a pleasing spiral staircase leading to a shared vista, I hoped to attract viewers who, upon learning what the colors signify and what used to be installed atop the pillar, would be scandalized by the historical recency of slavery, and motivated to take steps to identify and rectify racist oppression in their communities.

Nomadic Shtetl Archive

Natalia Romik

2012

7.6 Nomadic Shtetl Archive

The *Nomadic Shtetl Archive* is a mobile archive, travelling through nine post-Jewish towns in South-Eastern Poland. It will traverse through former shtetls, gathering archival materials, documenting present condition of Jewish legacy and juxtaposing architectural memory of formerly Jewish towns with their current urban reality. ...

The *Nomadic Shtetl Archive* will test new artistic and architectural methods aimed at activating eradicated memories about the Jewish urban legacy. It will generate new knowledge about the urban aspects of former shtetls, and trigger social imagination to deal with the void left after Jewish population. The project responds to the neglect and slow eradication of Jewish heritage in Eastern Europe, as the traces of the former populations disappear, not only from urban reality, but also from public discourse and social memory.

In every town, the archive will stay for one day, serving as a mobile library, meeting spot and a travelling exhibition about the history of shtetls. It will host an intense public program, engaging each town's inhabitants, politicians and other cultural agents in meaningful discussions related to the issue of Jewish heritage.[1]

- Adam Ostolski: I was born in a town formerly German. My husband grew up in a village formerly Ukrainian. There are many places around formerly Jewish. Even the most homogeneous village or town might, after inspection, prove to be formerly multiethnic. Any building, public space, urban or rural settlement can be read as a living monument to ethnic cleansing.

 The word "formerly" suggests a past that still loiters, visibly or otherwise. But what does it mean for a place to be something "formerly"? Is it casting a shadow or shedding light? Between light and shadow, how do you walk?

B'Seder

בסדר

Ian Wojtowicz

2008–ongoing

7.7 *B'Seder* evolving photomontage on February 8th, 2022.

7.8 *B'Seder* remotely connected projection tables.

The Polish-Jewish relationship is the embattled terrain of several collective memories, each with its claim to moral legitimacy, and each charged with fierce and sometimes vehement feelings.[1]

These contested histories are the source of tension and animosity between gentile Poles and Jews to this day. Unlike the German-Jewish relationship, where "the moral rights and wrongs were starkly clear," Poland's past is far more complex.[2]

B'Seder is a mediation system for these collective memories and their complex present. It uses network-connected tables and an evolving photomontage to store and retransmit contested histories. The objects in the image stand in for narratives collected from conversations and media. Using psychological techniques from the ancient technology of memory palaces, Robert Baruch Bush's practice of *transformative mediation*, and Pierre Janet and Judith Herman's methodologies of post-traumatic therapy, the project aims to transform the "embattled terrain" of several collective narratives into a collaboratively authored story.

Many Polish-Jewish intercultural projects focus on creating optimistic myths and "bridge-building" moments.[3] *B'Seder*, however, is like a minefield map. It reveals pain points of discord, untruths, submerged animosities, and blindspots to begin freeing people from the inertia of anti-semitism,[4] clichés, and harmful stereotypes.

World Institute for the Abolition of War

Krzysztof Wodiczko

2011

7.9 Arc de Triomphe: World Institute for the Abolition of War

Un-War: Transforming War Consciousness

Maria Niro

For decades, Krzysztof Wodiczko has used interrogative design to strategically foreground the pressing issues of our times while harnessing the power of public space. The most elaborate provocation in his interrogative design body of work, however, *is Arc de Triomphe: World Institute for the Abolition of War* (WIAW).

In the feature documentary *Krzysztof Wodiczko: The Art of Un-War*, of which the WIAW is a focal point, Wodiczko asserts:

We romanticize war, and monuments are very much a part of this process of telling us that romantic vision of war, the kind of sense of mission and lofty kind of sacrifice that war offers.[1]

The film explores Wodiczko's passion which lies in the cause of "un-war," dismantling the culture of war and how WIAW works toward that end.

WIAW is Wodicko's first interrogative work to use architectural design to analyze war as an institution and man's inability to achieve perpetual peace. This ambitious intervention involves one of the most iconic monuments to war: the Arc de Triomphe in Paris, France. Wodiczko proposes to encase the Arc de Triomphe in a larger structure that would transform the war monument into its complete antithesis: an institution that serves to abolish war and foster world peace.[2]

The WIAW project is embedded in content with integral critical agendas that interrogate time and space, a crucial characteristic of interrogative design.[3] The proposal expands on many elements of Wodiczko's past works in this category, and it is his biggest, boldest, and most comprehensive attempt of its kind.

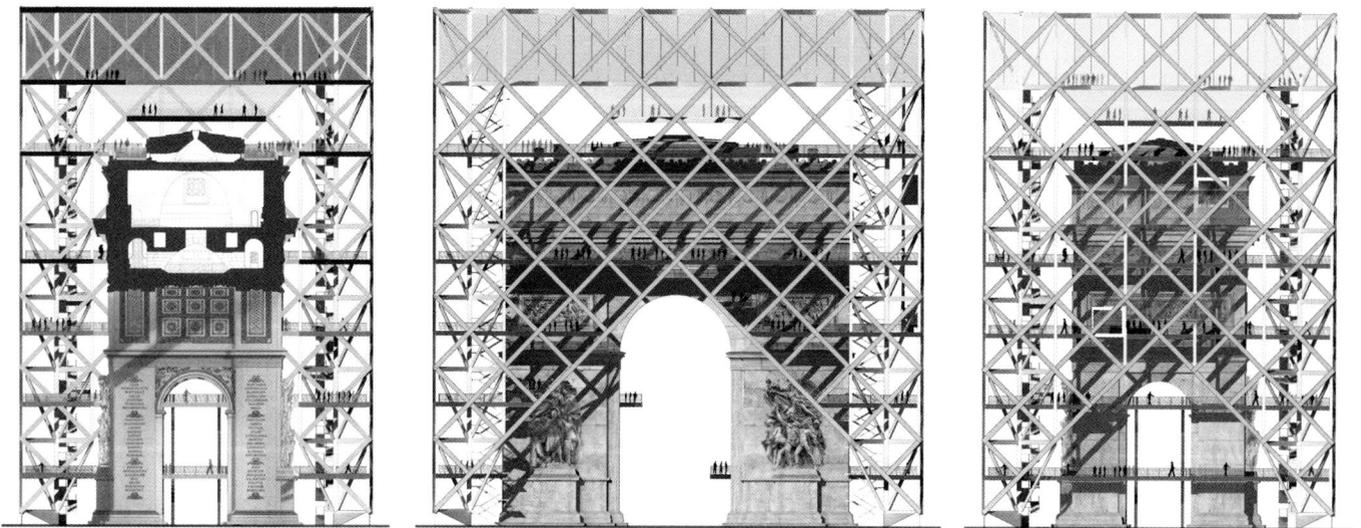

7.10 World Institute for the Abolition of War, section and schematic elevations.

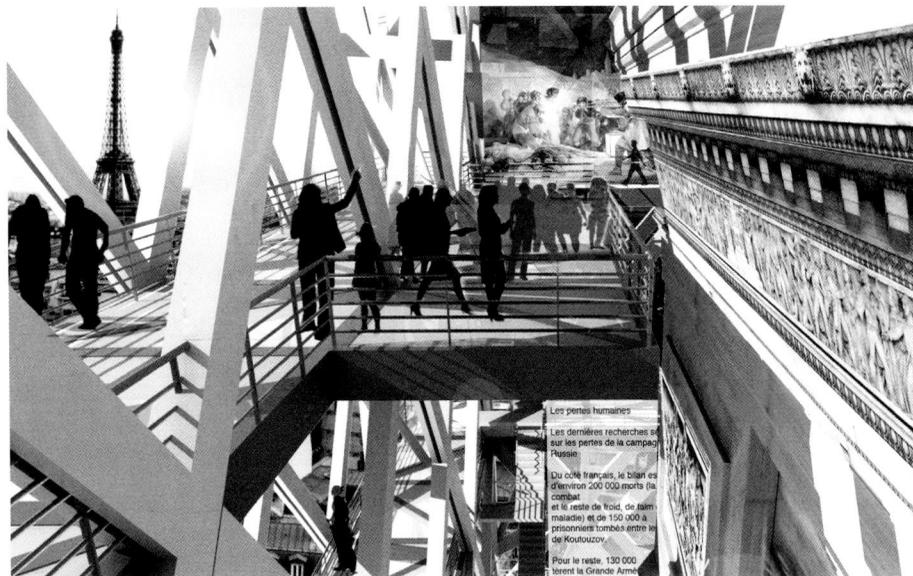

7.11 Interior rendering.

Through a detailed interrogative design, Wodiczko orchestrates a grand institutional environment pedagogical in nature. The structure would consist of a lattice-like frame made of scaffolding to surround the monument, allowing the public to access it via ramps somewhat like the passageways on the exterior of the Centre Georges Pompidou.

Likewise, the WIAW would allow visitors to access the Arc de Triomphe with passageways so that people can get "eye to eye" with the sculptures on the monument and analyze the grand narrative of war inscribed on it.[4]

Although WIAW is only in a proposal state, it could easily be built, and, as we shall see, it may be one of the most necessary interventions of our time. What's interesting is how this proposal functions as interrogative design[5] meant to interrupt our thoughts about the iconic war monument and the culture of war.

The WIAW project, designed to interrogate history and memory, questions what the Arc de Triomphe signifies. Commissioned by French military and political leader Napoléon Bonaparte in 1806, the Arc de Triomphe was inaugurated in 1836 by the French king Louis-Philippe, who dedicated it to the armies of the Revolution and the Empire. For many, the massive triumphal arch symbolizes the courage of those who fought and died for France during the French Revolution and Napoleonic wars.[6] However, for Wodiczko, the monument is a "war machine" that glorifies France's revolutionary and imperial armies and, like many war memorials, perpetuates war:

In today's world, especially the European Community, the Arc de Triomphe, Place de l'Étoile[7] in Paris must be seen as a grotesquely anachronistic symbol. It is a major historical suspect and witness to the most deadly and destructive military and ideological adventures in the history of modern Europe.

Imagining the view of WIAW from a distance immediately raises questions, such as why the historical monument which embodies some of the most beau-

• Adam Ostolski: "I can't help but dream about a kind of criticism that would try not to judge but to bring an oeuvre ... to life," says Foucault. "It would multiply not judgments but signs of existence."[18] How, and for what purpose, can the artist construe a monument as problematic? What judgments are not being multiplied here? What signs of existence are being summoned? Invented, perhaps?

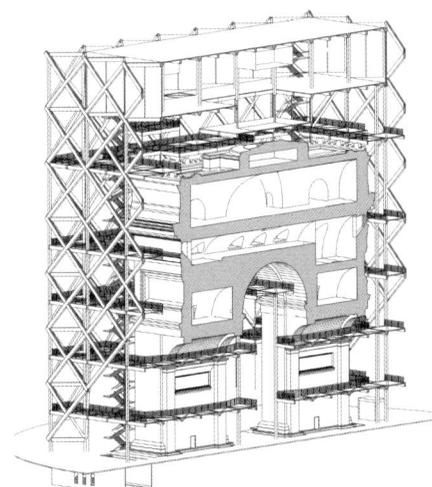

7.12 World Institute for the Abolition of War, isometric section.

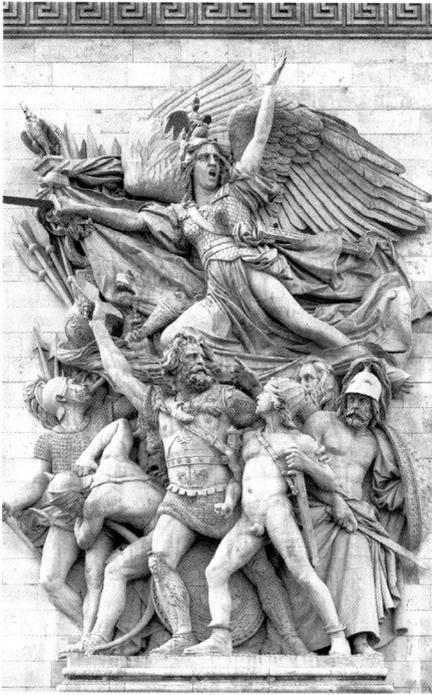

7.13 "La Marseillaise" relief by François Rude on the Arc de Triomphe.

- **Adam Ostolski**: Peace tends to be defined by war: as the lack of, the opposite of, the alternative to war. When letting go of our attachments to "war," can we still hang on to "peace"? With its sense no longer rooted in war, what could peace possibly mean to us?

- **Editor**: How to prevent the unwar project from being co-opted as a military tool? When might un-warring be unethical?

tiful art in Paris would be shrouded by such an enormous, intimidating industrial-like structure. The impact of this bold design approach is intentional.

The appearance of interrogative design may attract while scandalizing—it must attract attention in order to scandalize the conditions in which it is born ... its function will become obsolete.

Indeed, WIAW's design invokes an immediate query as to its existence and meaning. It invites visitors to become active participants in converting the monument to war into an institution aimed at transforming war consciousness. The WIAW would educate, inform, and serve for research and peace activism.

This approach is another interesting critical element of interrogative design:

Design of any object, space, place, network or system must become a technology and a technique of constructing an artifice that would function as an opening through which a complexity of the lived experience can be recalled, memorized, translated, transmitted, perceived, and exchanged in a discursive and performative manner.

Wodiczko's elaborate, detailed 3D drawings and renderings depict[8] the daily pedagogical activity that would take place over the life of the project. Visitors would take part in peacekeeping initiatives by developing plans and conducting practical work toward war's abolition.

The WIAW, as a functional design, aims to address the idea that war (a motif in Wodiczko's oeuvre) has become an outmoded, unsuccessful, and obsolete approach toward peacekeeping. Moreover, war—an institution that is and should not be—could be eliminated once and for all according to Wodiczko, who details this in his book *The Abolition of War*.

While WIAW may appear to be an impossible achievement and the idea of abolishing war may seem idealistic, the wheels to make war obsolete have already been put into motion. The Kellogg-Briand Pact, signed in 1928, also known as the Paris Act, is an agreement that would have outlawed war.[9] And in the context of interrogative design, what better way to articulate the need to abolish war as an institution than by subverting the ultimate monument to war that reinforces the idea of war as just and necessary?

War memorials perpetuate war and cement notions of national, regional, religious, and ethnic identities. They intoxicate us with beliefs in noble sacrifices, just war, revenge, and the heroic defense of honor.

Deconstruction is a crucial aspect of interrogative design and an integral part of the WIAW intervention, as well as of Wodiczko's contextual practice. One could say it's interrogative design's ethos:

Instead of deconstructing itself, design should deconstruct life. Design should unmask and uncover our singular and plural lives, our lived experience, and a

history of this experience from the panopticon of our subjectivity and ideological theater of our culture, no matter how unacceptable and repressed or neglected such experiences may be.

"Un-war," which for Wodiczko signifies a "new state of mind that enables the process of understanding, uncovering, and undoing war," is inextricably linked to the WIAW concept.[10] To "un-war" or undo our war mind, we need to rethink such archaic ideas as that war is necessary and inevitable.[11] An interrogative intervention must shift our thinking. The WIAW intervention can help us to come to a deeper understanding of the culture of war and how we can personally dismantle it, something Wodiczko insists must take place to get to peace. Transforming the Arc de Triomphe, "the biggest war machine in Europe"[12] that perpetuates war, according to Wodiczko, will enable everyone to "un-war themselves."

Artists can play a significant role in dismantling the culture of war. Just as artists have participated for centuries creatively in the culture of war, they can play a significant role in transforming a war-bound world into a war-free civilization, according to Wodiczko.

This aspect of the WIAW is the urgent call for a consciousness shift from a culture of war to a culture of peace. Wodiczko insists we must make this radical shift because "war is entrenched in our singular and collective minds." Like many of his works that question war, Wodiczko wants to disrupt our complacency toward war and get us to ask "why our war mind is so strong."[13] Indeed, "it is an old state of mind and a mental condition installed in us from without, through the culture of war."[14] Undoing the culture of war drives the WIAW intervention forward.

It's not just artists who will participate in dismantling the culture of war through the WIAW; activists, war veterans, refugees, educators, scientists, technicians, designers, philosophers, writers, critical cultural thinkers, lawyers, politicians, doctors, and anthropologists could also take part in this monumental antiwar project's mission.

But can this interrogative project be instrumental in transforming the culture of war into a culture of peacekeeping? Indeed, politicians have not done an equitable job in avoiding conflicts and wars. If anything, these have increased under their watch over the years. Wodiczko maintains, contrary to the narrative inscribed on the Arc de Triomphe, that we have not achieved peace in the past by ending wars, withdrawing troops, and ceasing occupations.

Wodiczko's compelling message to "un-war" and his vision of a warless future expressed through the WIAW intervention may seem like a vast and quixotic—perhaps impossible—project to execute in his lifetime, but it is "the impossibleness of it [that] makes it so important."

The strength of the WIAW design resides in its symbolic significance, even if it were to remain only on paper.[15] For Rosalyn Deutsche, who sees the project as a "disarmament of the Arc de Triomphe," it is a "symbolic gesture and a practical project at the same time." For her the proposal creates provocations, raising questions: "Why is such a project even necessary? What kind of society makes such a project necessary, yet at the same time is not doing anything about it?"[16]

Indeed, what can we do with our new awareness of the potential to create an interrogative design to un-war? Can we use events such as *L'Arc de Triomphe, Wrapped*, an installation designed by the late artists Christo and Jeanne-Claude comprising the Arc completely wrapped in cloth, to remind people that underneath this beauty is a war machine, a symbol of never-ending war, that we should confront, understand, and ultimately use to transform our war minds for peace? The execution of *L'Arc de Triomphe, Wrapped*[17] has set the stage for WIAW to take place.

One can easily imagine the effect the WIAW intervention would have, with its potential to shift collective consciousness, open our eyes to the reality of war, and serve as a beacon of peace. And transforming our consciousness through design is the very nature of interrogative design.

• Translation:

In a daily conversation, when the cranes that surrounded the Arc were just being installed during its packaging, I momentarily confused Christo Vladimirov Javacheff with the Polish artist Krzysztof Wodiczko, also known worldwide for his interventions in public space. ...

The comparison between the two projects led me, almost inevitably, to the hackneyed reflection on the role of art in social, political, and cultural criticism. Initially, it was clear to me that, in contrast to Wodiczko's project, Christo and Jeanne-Claude's work did not question the monument itself in any way, merely offering a playful and temporary experience of the Arc de Triomphe. After watching it day after day, however, I wonder if L'Arc de Triomphe, Wrapped does not allow us to imagine, with all the force and sublimity that only art offers, a world without war memorials and without wars. Wodiczko himself said that there is in the works of Christo and Jeanne-Claude "something utopian," a "concrete utopia" that "advances toward a real and possible future, carrying educated hope and militant optimism." Faced with the heaviness and permanence of one of the main war memorials in Europe, the lightness and mobility that it evokes once packaged; as if we had decided that that pompous old piece of furniture no longer fits in our house and wanted to move it to an attic or mail it to another planet. ...

In these times that are not conducive to utopia, playing with the idea of the impossible, injecting ourselves with that optimism that Wodiczko referred to, is a great gift.[19]

EL PAÍS

Opinión

EDITORIALES · TRIBUNAS · COLUMNAS · CARTAS A LA DIRECTORA · LAS FIRMAS DE EL PAÍS · DEFENSOR DEL LECTOR

TRIBUNA i

El triunfo de la imaginación

Reduciendo ilusoriamente la escala del Arco del Triunfo, la obra de Christo y Jeanne-Claude en París nos transporta al universo de los niños que reposicionan trastos y juguetes para crear ciudades efímeras en las que les gustaría vivir de verdad

En una conversación cotidiana, cuando apenas se estaban instalando las grúas que rodeaban el Arco durante su *empaquetado*, confundí momentáneamente a Christo Vladimirov Javacheff con el artista polaco Krzysztof Wodiczko, también conocido mundialmente por sus intervenciones en el espacio público. Nacido en Varsovia en 1943, hijo de un reputado director de orquesta, Wodiczko creció y se formó en la Polonia comunista y emigró a Canadá a finales de los años setenta. Su arte se sirve del diseño y la tecnología para iluminar aspectos críticos de nuestra sociedad y ofrecer visibilidad a comunidades marginadas. La confusión entre ambos artistas me llevó a descubrir que en 2010 Wodiczko ideó un proyecto para el Arco del Triunfo que, por el momento, no se ha llevado a cabo. Un proyecto *a priori* muy distinto del de Christo y Jeanne-Claude. Planteaba Wodiczko que el Arco del Triunfo, que conmemora las guerras napoleónicas y la Primera Guerra Mundial, no puede sino verse como "un símbolo grotescamente anacrónico" en la Europa actual. Proponía convertirlo en un Instituto para la Abolición de la Guerra, recubriéndolo de una estructura fija de andamios que permitiría observar el Arco como "un espécimen cultural gigantesco, una reliquia del pasado belicoso reconfigurado como un gigantesco objeto de investigación".

7.14 *El Pais*, October 1, 2021.

7.15 L'Arc de Triomphe, Wrapped, Paris, 2021, by Christo and Jeanne-Claude.

Exhibiting and Collecting Interrogative Design

Sofia Ponte

This essay reflects on the processes of converting interrogative design into museum objects.[1] For instance, what values are shaped when the *Homeless Vehicle*, 1988–1989, by Krzysztof Wodiczko is included in an exhibition? Considering that one of the purposes of the work is to establish a performative space between passersby and users, how should a museum display the ephemeral aspects that bear witness to its use? The scarcity of systematized knowledge on the process of musealizing interrogative design led me to study some of the challenges in an era when the role of museums of art is also shifting.[2]

7.16 The *Homeless Vehicle* in the exhibition *"Magiciens de la terre"* at Centre Georges Pompidou, 1989, Paris, France.

Interrogative design outside the museum space is something different from interrogative design in an exhibition venue. The two spaces assume different experiences and, consequently, interpretations. Wodiczko clearly defines interrogative design as "work[ing] in the world" in ways that question the "questionable conditions of life."[3] Inside the museum, it loses this performative articulation with the world and transforms itself into a system of signs of the artist's initial concept. To complicate this phenomenon, interrogative design rarely considers traditional aesthetic values in its material form. In most cases it does not carry the aesthetic signs generally favored by museums of art. Furthermore, exhibiting interrogative design also challenges most common museum strategies used to display artworks, not to mention how, in general, it disturbs museum-goers' understanding of their purpose.

When I started to research this phenomenon in 2011, I positioned myself, without being fully aware of it, among the "skeptics of the museum" who understand musealization as a process that leads to the loss of meaning of certain objects when removed from their original context. For instance, for the skeptics of the museum one does not normally look at an altar, one kneels before it. Placing an altar in a museum forces one to look at it differently, modifying its initial meaning.[4] Today, I consider that the exhibition of interrogative design may help broaden an understanding of some of life's complexities and its representations.

For Martha Buskirk, the transformation of conceptual artworks into museum objects or objects for collection also reveals significant contradictions. The process gener-

214

ates a negotiation about what fundamentally constitutes a work's conceptual project. In fact, for Buskirk, the recontextualization of conceptual artworks in museums is ultimately closer to an "act of authorship than an act of displacement."[5] Considering that interrogative design is essentially conceptual, when analyzed as a museum object it becomes a new iteration of the original idea. In this essay I show how Wodiczko's choices about the display of the *Homeless Vehicle* successfully demonstrate Buskirk's idea, and how the artist's exhibition discourse has contributed to adjusting museum strategies to this segment of contemporary art and design.

Barbara Kirshenblatt-Gimblett, throughout her study of ethnographic objects, considers that museum objects are not simply found and placed in museums: in this process, objects are subjected to a new symbolic order which renews their meaning. This new order provided by the museum context is created by the areas of interest of those who research, exhibit, conserve, and collect such objects. The processes that transform things into museum objects are part of the reality created by the fields that engage with these same objects.[6] Therefore, the institutional culture applied in any museum of art depends on the individuals—artists, curators, museum directors, conservators, educators, exhibition guards, anyone—engaged in the musealization process. All experts in their own field are crucial for providing meaning to objects introduced in such channels of memory and history.

When Wodiczko started to exhibit the *Homeless Vehicle*, which coincided with its deployment in several streets in the United States, he was not exactly exhibiting it as an artwork, at least not in the conventional sense, but displaying it as an "object lesson."[7] When the *Homeless Vehicle* was first exhibited, in the exhibition "Public Image: Homeless Projects" at the Clocktower Municipal Gallery in Lower Manhattan, New York, in January 1988, its display prompted reflections on the precariousness of municipal shelters for homeless people and on the possibilities for improving them. According to Rosalyn Deutsche, this exhibition helped to reignite the public debate that had been problematizing urban development in large cities, extending it to the art world. Representing homeless people, as the artist did, reports a social rupture, and this is always a complicated subject to address.[8] However, for Deutsche, the way this exhibition was organized helped to communicate the presence of homelessness without simplifying the problem, because it "represent[ed] the action and inaction of the local government" in not "curing the problem and [accused] the city of producing it." For Deutsche, Wodiczko's exhibition choices indicated how the artist's perspective on homelessness "diverges[d] from the official ones."[9]

The *Homeless Vehicle*'s presentation included several elements combined in a setup reminiscent of the modes of displaying works of architecture and urban planning: at the center was a prototype, in its extended version, surrounded by diagrammatic drawings illustrating its various functions.[10] Throughout the

7.17 Centre Georges Pompidou, exterior.

• **Adam Ostolski:** Curators set the stage, but what is the function of a visitor in a museum? What can he or she contribute to the lives of objects displayed? As a viewer, I like to think of myself as a small insect carrying pollen. Beyond the facade of a tourist, a connoisseur, a critic, a high school student working on their assignment, a fellow artist, a lover on a fancy date, a member of the cleaning staff—what's hidden there, at any given moment? An art consumer or a co-producer thereof?

215

exhibition, audio-recorded dialogues between the artist, his collaborators, and potential users could be heard concerning the object's design and its social life. There was also an area where the artist projected slides of squares, parks, and streets in New York over which he added drawings of potential users maneuvering the vehicle.[11] For Deutsche, the discourse of this exhibition helped to demonstrate the subtle but encouraging effects of this object in the places where it was designed to circulate, producing a contrasting perspective to this social phenomenon.

In 1989, the *Homeless Vehicle* was displayed in a different situation amid a different form of exhibition discourse. It was integrated into the group show "Magiciens de la terre," curated by Jean-Hubert Martin, at the Centre Georges Pompidou and the Grand Halle of the Parc de la Villette, in Paris.[12] "Magiciens" brought together living Western and non-Western artists, arranging their works in dialogue according to their meanings.[13] The exhibition did not aim at any further political or intellectual focus and consisted mainly of wall and floor painting, sculpture, and installations.[14] Martin aimed to show divergent art phenomena, to show artists from all over the world, and to transcend the traditional framework of contemporary Western culture.[15] To this end, the curator divided artists and artworks into those from the art centers and those belonging to the peripheries. One section represented artists, including African and Asian artists living in the West, whose work expressed aspects of their cultural roots and also Western artists whose work involved cultures other than their own; the other section consisted of artworks ranging from artifacts produced for religious or magical ceremonies and rituals to traditional objects that bore signs of cultural contamination, works that revealed cultural crossings of all kinds, and also works by artists educated in Western schools.[16]

Martin's decision to include the *Homeless Vehicle* in "Magiciens" reflects the general criteria that underpinned the curator's exhibition discourse: a discourse that aimed to show artworks that manifested radicalism in the ideas embedded, originality in relation to cultural traditions, and that disrupted cultural authorities in their local contexts. Martin chose to include the *Homeless Vehicle* because

it was an up-to-date, challenging, and unexpected work of art. The project was placed on the ground floor of the Centre Pompidou, next to its main entrance, an area at the time freely accessible. Its display consisted of one of the prototypes in its extended version and a monitor that broadcast a video showing the vehicle being maneuvered through the streets of New York. Next to it was a caption, as for all artworks exhibited in the show, with the artist's name, place and date of birth, nationality, place of residence, and the title of the work.

In studying the *Homeless Vehicle*'s exhibition path, I realized that Wodiczko anticipated that his works would be subject to a high degree of decontextualization when exhibited and collected. For instance, as a museum object the *Homeless Vehicle* is never represented by a single prototype alone. The work's most frequent arrangement includes several documentary photographs of the vehicle in its original context, documents and objects produced during the design process, videos, texts, and even programs of lectures by the artist and various experts. Along with the exhibition of his instruments, the artist implemented exhibition strategies that helped contextualize his ideas and work, at a time where museums mostly advocated for historical and aesthetic universal truths.

At "Magiciens," for instance, the curator Martin intentionally chose to reduce the captions of the artworks to a minimum so as not to create "a didactic exhibition display or one dependent on a huge number of panels with descriptive texts."[17] To have access to crucial information about any of the artworks, one had to buy the catalogue of the show or perhaps be fortunate enough to meet the artist at the exhibition.[18] It was in the catalogue that the museum-goer was informed about the concept of the artworks and their original context. For decades many curators and artists considered contextualization strategies intrusive, some because of the excessive presence of mediation in the museum context, others because they believed their presence manipulated the museum-goer's experience in paradoxical and rhetorical ways. It was only when museum activity became the subject of several fields of study, not only of art history and conservation but also of anthropology, science, museum studies, and by artists themselves—chiefly the ones whose art practices are embed-

ded in institutional critique—that a growing interest in the structuring of museum content and how to communicate it truly started.

Wodiczko's perception of the challenges around the present and future reception of his ideas, and how relevant it is to understand the nature of the institutional context where these ideas are being collected, communicated, and preserved, is also visible in the acquisition of the *Homeless Vehicle* by museums and collections of art. For instance, the *Homeless Vehicle* acquired, in 1995, by FRAC des Pays de la Loire Contemporary Art Collection consists of a vehicle, five framed drawings, a printed text on a panel, and a video documentary. Both the artist and the institution considered that holding only the prototype would not have been enough to understand all its conceptual and tangible dimensions. The items collected under the concept of the *Homeless Vehicle* not only reflect the initial exhibition model adopted by the artist to display his work; they also have consistently reinforced its link to architecture and urban planning, fields that study ways to redefine the notion of the city. The FRAC des Pays de la Loire art collection is part of a French regional cultural program funded in 1982 by state and regional councils, the Fonds Régional d'Art Contemporain (Regional Contemporary Art Fund), an outcome of the state's decentralization policy. The collection currently holds 600 works, 800 architectural models and maquettes, and more than 15,000 drawings, as well as many architects' collections, encouraging public awareness "about the relationship between an artwork and its (political, social ...) context; a work and its (heritage value, architectural, natural ...) environment; the relationships between art, architecture and design; as well as autobiography and the focus on the body and on performance."[19]

Martha Buskirk notes that when art practices are characterized by symbolic gestures, such as Wodiczko's, "the exhibition is a useful platform to disseminate information about this gesture."[20] However, for Buskirk one of the major contradictions of this kind of artwork is that the artist's gesture is more present in the museum context and in publications than in the streets where it was originally intended to exist. Buskirk has a point, and a relevant one. However, the *Homeless Vehicle*'s exhibition path has en-

sured the longevity of interrogative design by inspiring other artists, designers, and architects to work with their communities and their surroundings, also instigating museum-goers to become aware of the possibilities of art outside the physical grounds of museums.

Not all works of art are subject to such complicated processes of musealization. Because the effect of combining art and life is so intriguing, complex, and variable, it is thought-provoking to include interrogative design in exhibitions. For Wodiczko, interrogative design "must articulate and inspire communication of real, often difficult lived-through experience, rather than operate as a substitute for it."[21] To exhibit this idea, one needs to learn, understand, and capture the many values the artist assigned to the work, but also the values raised by its performative use.

When it comes to the exhibition of interrogative design, artists play a fundamental role in the definition of its museum iteration. Wodiczko started to exhibit his instruments using contextualization strategies that were uncommon at the time. His exhibition approach has been replicated by many other artists and designers who identify with the concept of interrogative design. Today artists are much more engaged than before with the exhibition of their art practices, so it is more common to see their artwork being shown in accordance with their terms. On the other hand, there are also ongoing research projects in the field of museum studies that encourage a better understanding of how art practices such as interrogative design benefit from the museum's activity. Today, perspectives on the exhibition of art tend to be increasingly diversified and optimistic, not only informing about an artwork's meaning but about the cultural dynamics inherent to its display.[22] Today many museums program exhibitions that are events of great inventiveness, and that is why, perhaps, it is so difficult to imagine a world without museums.

The use of new technology in art is now so commonplace that it hardly draws much attention. This book is replete with such projects. Indeed, an artist today could not truly "be of one's time" without involving contemporary technologies. In some cases, technology itself is part of a project's social critique; in others it blends into the background and creates atmospheric conditions for something else.

But what, actually, is technology? The word "art" derives from the Latin *ars* or *artis* for "any knowledge acquired by learning" or "a collection of rules belonging to any trade or profession."[1] Long after Prometheus, the Greek word *techne*, the root of "technique" means "an art or craft ... a set of rules, system or method of making or doing ... [a] device, contrivance" and relates to "things, artificial."[2] Artists, in this old sense, are skilled makers-of-things and knowledge builders. "Art" in the more refined and recent sense of "fine art," is only about 400 years old, founded initially in Italy and then more permanently in the French beaux-arts schools with the transition from influential and secretive guilds to more open academies of design (and later, painting, sculpture, and drawing).[3] Science has a long history dating back to antiquity and was indistinguishable from art during the renaissance, yet only established itself as a significant independent arena during the Enlightenment, a few hundred years ago. The concept of art, science, and technology being separate disciplines is relatively recent and suggests that this connected web of knowledge and traditions are still malleable and their future yet unwritten.

Let us call it "technology" for now. Technology's effects on human civilization both in the long term and in the nearer term are well known, through the prolongation of lifespans, the increase of comforts, myriad new efficiencies in daily life, and all sorts of new sensory capabilities. Kevin Kelly, the founder of *Wired* magazine, brilliantly inverts the question of "what is technology" to ask, "what does technology want?" Kelly's thought experiment is that technology is a form of life and that it self-replicates and evolves, as all life does, within a substrate of other life forms. Just as any organism depends on other kinds of life for sustenance, shelter, communication, and support, "technology" too has a living substrate: us.[4]

Kelly's concept offers a model that affords humans control yet acknowledges that technology has had a form of autonomy for quite a long time. Artificial intelligence, machine learning, and self-replicating machines are only the current edge of a long history of technology directing its own progression. Anyone involved in inventing and developing technological systems will recognize this dual characteristic, with one's creative intention on one hand and the inertia of technologies and the industries that produce them on the other. Most of us make things along the trajectory of the technological herd. We may think we have control over technology, but Kelly suggests that, in fact, technology has an evolutionary momentum all its own.

As an artist and designer, I cannot completely accept this. Artists must shape environments as much as environments shape us. We must be able to bend, break, and build things. We must graft and pleach the technological tree of life. Certainly, artists are all well trained through factory schooling and the "grinding inertia of society"[5] to reproduce new designs along the expected trajectories of "cheaper, faster, better." It may be easiest to go with the flow and make what technology "wants" us to make, but there are other ways of making. We can regain some control.

Steve Jobs, founder of a popular technology company and proponent of digital creativity, famously described technology in terms of efficiency:

> I read a study that measured the efficiency of locomotion for various species on the planet. The condor used the least energy to move a kilometer. And humans came in with a rather unimpressive showing, about a third of the way down the list. It was not too proud a showing for the crown of creation. So that didn't look so good. But then somebody at *Scientific American* had the insight to test the efficiency of locomotion for a man on a bicycle. And a man on a bicycle, a human on a bicycle, blew the condor away, completely off the top of the charts. And that's what a computer is to me. What a computer is to me is the most remarkable tool that we've ever come up with, and it's the equivalent of a bicycle for our minds.[6]

To design technologies with amplification in mind has many benefits, but another approach may be better suited

for the next century. Interrogative design uses the metaphor and pragmatic concerns of *prosthetics* as a guiding framework.

In this worldview, technology has the potential to be a healing, restorative force for missing, lost, or needed functions. Technology, when considered as prosthetics, can have ameliorative effects and, because it inhabits the medical world, is bound by the promise: "first, do no harm."

Steve Mann, the inventor of wearable computing, considered "self-determination and enhanced creative potential" essential to the ethics of prosthetics. To this end, he sets out three criteria of the "existential computer":

1. eudaemonic: the apparatus is subsumed into the "eudaemonic space" of the wearer (e.g. it may be worn, or otherwise situated in a manner that makes it part of what the user considers "himself" or "herself," and in a manner that others also regard it as part of the user, e.g. not a separate object being carried by the user). ...

2. existential: the apparatus is controlled by the wearer. This control need not require conscious thought, but the locus of control must be such that it is entirely within the wearer's domain (e.g. that it behaves as an extension of the body). The functionality of the apparatus must also be potentially known to the user (e.g. although the user may not have the time or ability to completely understand its inner workings, the apparatus must not be built to deliberately obscure or hide its functionality). ...

3. constant: (constancy of both operation and interaction): ... context switching time to mentally engage with the apparatus is near zero.[7]

One might expect that these principles should also apply to all human-sensing or human-actuated technological systems further apart from our bodies.

Sara Hendren writes that "all technology is assistive,"[8] provoking readers to recenter technology in service to people. Wodiczko has likewise provocatively stated that

"everything is prosthetics."[9] If this is so, what does the world look like through the lens of prosthetics? What kind of prosthetic, for example, is Facebook? Does it stand in for a missing family or a vibrant functional neighborhood instead of the one outside? Perhaps it is a prosthetic for retaining one's high school persona. And what is a car but a prosthetic for folding cities back to the size of the ideal walkable village? What kind of prosthetic is a soldier? Surely they are more than just robot-workers.[10] Are they not extensions or projections of a society's written legal and political culture, rendered organic?

The "performative speech instruments" of interrogative design are communication prosthetics, but not only in service of marginalized people. Interrogative design borrows heavily from Victor Papanek's approach to industrial design, which acknowledges that "all people are handicapped in some minor or major way, throughout or for part of their lives."[11] Everyone is or has been disabled at some point in their life, either physically or in some way by societies and cultures around them, or by events out of their control. One might imagine that the future of interaction design, computing, and design in general would serve humanity much better if it were founded on the understanding that "all technology is assistive." Imagine if instead of passing projects through a final check of accessibility regulations, technology design began with Papanek's observation and was more vibrantly augmentative of a more complete range of abilities.

Works of interrogative design expand the notion of prosthetics to include people's inner needs, their practical needs, and the needs of the worlds around them. These views on technology provide a resistive force against technology's inhumane trajectory. When Haseeb Ahmed says "has the world already been made?,"[12] the answer is clearly no. We have work to do to improve it. Kelly Dobson warns that "machines and *machine metaphors* play underestimated roles in cultural iterations of how being human is understood." We underestimate how much even our language around technology can change us. Profoundly, *"what is life* is at stake in *what is an object."*[13]

• **Sara Hendren**: This clinical idea of prosthetics—technologies meant to do a restorative work by fixing or replacing body parts—constitutes the long research field of rehabilitation engineering. Its origins date to war, especially after World War II in the United States. Men were returning from the field, alive but missing body parts and having sacrificed so much for their country. In response, the National Science Foundation created a corpus of research funding for developing the tools and technologies that would provide some material recompense. Rehab engineering continues to this day—tech research that crosses platforms and seeks pragmatic, functional, efficient tools for mimicking the body. But even this clinical research has cultural significance: historian David Serlin's *Replaceable You* details the story of these veterans and prosthetics, showing how the prosthetics' development and distribution were employed not just for functional bodily wholeness but for the strong persuasive story that prosthetics could provide a return, a healing for a nation in recovery too.

Cultural Prosthetics

Krzysztof Wodiczko

Originally published in *Transformative Avant-Garde and Other Writings* (London: Black Dog Press, 2015)

Cultural Prosthetics[1]

2015

Cultural
1 Of or relating to the ideas, customs, and social behavior of a society.
2 Of or relating to the arts and to intellectual achievements.

Prosthetics
1 Specialty concerned with the design, construction, and fitting of artificial devices—prostheses—to replace or augment missing or impaired parts of the body.
2 Pieces of flexible material applied to actors' faces to transform their appearance.

Survivors of psychological and physical trauma are today's estranged, a socially and culturally excluded people. These are the survivors of wars, of forced migration and displacement, tragic accident, abuse, neglect, social exclusion, or personal loss. They may have suffered amputations, physical injuries, or psychological wounds. They are often incapacitated by the overwhelming events that have dramatically transformed their lives. Socially stigmatized, they are treated, at best tolerated, as strangers.

These people need the replacement and augmentation of their missing or impaired body parts, alongside the missing or impaired zones of their minds and their emotional, cultural and social lives. For this we need new transformative tools that challenge both residual and emergent forms of psychological, social and cultural alienation. In addition, bodily or emotional loss may cause another great—sometimes even greater—loss: that of social ties, cultural connection, and ability to communicate.

In the dictionary, prosthetics is defined as a field "concerned with the design, construction, and fitting of artificial devices—prostheses—to replace

222

or augment missing or impaired parts of the body". Cultural Prosthetics adds a new dimension and emphasis to this charge. It is especially concerned with replacing and augmenting peoples' missing or impaired capacity to open up and communicate with others; to restore missing or poorly functioning means of expression; and to restore their interpersonal, community, and social ties, as well as their larger societal connection.

According to the same dictionary the second meaning of prosthetics (in relation to the production of prostheses) is defined as "pieces of flexible material applied to actors' faces to transform their appearance". Cultural Prosthetics too is concerned with the technology and methods that allow for the transformation of the appearance of actors, albeit of a particular social and cultural kind: a transformation that allows those who, while marginalized, alienated, or psychologically and socially disconnected, to be able to appear and be perceived in public space no longer as disabled 'invalids'—useless, inconvenient, and politically irrelevant—but as significant actors on its stage; as legitimate contributors to social change and the democratic process.

In response to such situations, needs and demands, Cultural Prosthetics must define itself and operate as a new techno-artistic and socio-aesthetic field. It must focus on the development and implementation of human-to-media and human-to-human interfaces that inspire, encourage, and assist traumatized and marginalized social and cultural minorities to open up and develop to the point of virtuosity their communicative and performative skills.

Cultural Prostheses

Design and research into cultural prostheses must respond to and articulate the situation of people who need to regain and perfect their lost psycho-social abilities and capacities, as well as the lost meaning of their lives as legitimate actors on the stage of real life, personal and social.

New artistic, technological, and psycho-social means and methods of designing cultural prostheses may focus on the invention of original communicative media artifices, speech-act implements, and performative techno-cultural equipment that counter new forms of social alienation. Cultural prostheses should assist in challenging and 'disarming' cultural prejudice while making the user feel safer in public and private space, and therefore more confident and better equipped to openly share and discuss the critical issues he or she wishes and needs to address.

In addition, Cultural Prosthetics may focus on developing, experimenting and socially implementing specially designed techno-aesthetic devices, tools, equipment, instruments, and other human-to-human interfaces and media-enhanced bodily supplements for the development of cross-cultural communication, public dialogue, individual and collective expression, dissent, and civic engagement.

To be intelligent and effective in addressing and challenging social and cultural alienation through socially inclusive and discursive design, the field of Cultural Prosthetics must extend its research and collaborative practice beyond the limits of any single professional inquiry. It must build cross-disciplinary links between prosthetic technology and the fields of media technology, cultural and media study, anthropology, social psychology, political philosophy, trauma therapy, social ethics, industrial design, art therapy, education, social justice, public health, performative public art, media art, social media, fashion, and other fields.

115

Identity/Cultural Prosthetics

The Survivors of Survivors

The person who assists another person in surviving is a survivor also, and she or he may also be in a need of cultural-prosthetic equipment.

The lost breast or prostate of one member of the family is a lost breast or prostate for an entire family. The lost leg of a father in the fog of war is a lost leg suffered by his entire family. For the family whose members have been physically or psychologically traumatized in war the trauma is of the loss of the persons that they once were.

Cultural prostheses are clearly required not only for survivors, but also for their loved ones, those who suffer traumatic symptoms via secondary trauma: the survivors of survivors.

Family members and partners who are caregivers for those impaired by war, congenital defect, accident, or illness also have a primary need for prostheses, so that they too should have the possibility and means to bear their loss together, without the moral blackmail that prevents them from also being recognized among the wounded and amputees: as survivors in their own right.

What kind of cultural-prosthetic equipment might they both need, and, when appropriate, collectively, in tandem or separately, use or share?

Communicative Prostheses

Technically advanced prosthetic substitutes for parts of our bodies are within reach, but the loss of a breast, eye, hand, foot, arm, or leg also constitute a charged cultural and psychological domain. Responding to the physical and emotional needs of the survivors of such loss, we must envisage innovative psycho-social and techno-aesthetic approaches. Such new cultural-prosthetic equipment can aid in the process of re-coding the 'self' beyond mere substitution and improvement, to empower the impaired with new abilities, including the virtuosity to regain and acquire an invigorated sense of personal and social worth. The design and technology of cultural prostheses must offer its users both inspiration and assistance in the process of developing new forms and skills of communication and expression, which will aid users in resuscitating lost social ties and connections or to create new ones.

In order to proceed, we must respond to the core questions in the development of prostheses. What kind of prosthesis can be designed, equipped, and 'fitted' to overcome survivors' physical, cultural and social impairment? How will our prosthetic design resolve those impaired zones and other aspects of their emotional, family, cultural and social lives? Could, for example, today's technologically advanced prostheses be further enhanced by integrated communications like electronic memory, interactive software, sensors, audio-visual display and projection components, as well as wireless communication and transmission functions?

Finally, via a greater inventiveness, elegance, artistry and symbolic articulation, can we displace, disrupt, and challenge the stereotypical and often degrading perceptions of survivors of illness, displacement, social and cultural exclusion, accident or war? A cultural prosthesis must help its users, wearers, operators, and performers transform themselves into agents who are different from others not by virtue of their psycho-logical and physical disadvantage, but through their new bodily and mental skills and expressive communicative capacities. Cultural prostheses must allow users to be admired, desired, respected, and welcomed as legitimate members of social

116

groups, communities and society at large, as those who can offer a unique and valuable contribution to it.

War Veterans

War veterans suffer—perhaps even more than other survivors—a loss of capacity to communicate and express emotions, to convey their overwhelming feelings and memories of war and post-war events and experiences. For psychological and cultural reasons only a small percentage of them, and almost none of their families or those close to them, speak of this publicly.

Their incapacitation denies them a chance to share their experience with society at large, especially with younger people (including those who might wish to join the military) and to help people learn the realities of war rather than absorbing romanticized media phantasms of war and military recruitment propaganda. Veterans' communicative incapacitation contributes to a distorted public image and imagination of war, leading only to the perpetuation of wars. As a result, the public remain unaware of what they and their families may face in the event that they join the military and go to war. The development of cultural prostheses would therefore play a vital role in helping veterans in the vital task of developing and disseminating a greater societal awareness of war.

117

US War Veterans

Only those who have been through war can tell us what war has done to them and their comrades, to their 'enemies' and to civilians, and what war will continue to do should it occur again.

Unfortunately the wall that separates those who know what war is and those who do not is a thick one. To challenge such a social divide is a difficult task, not only because of the very small number of veterans who are inclined to and able to speak of war but also, and especially, because uninformed and misguided younger people, potential new soldiers and future veterans, are not inclined to listen. They are poisoned by our war-based national and ethnic cultures and by the recruitment propaganda with which they were brought up. They will not listen as they seek an ideological path to noble missions.

In such a situation, to close the divide between the minority who are conscious of war and the unconscious majority who are not requires extraordinary cultural and artistic measures. It requires an invention of some thing in-between, some transitional artifice through which veterans experienced in war can communicate in public. Both war veterans and the path to a war-free world require the design of special kind of cultural prosthesis.

A New Type of War

We are engaged in a new type of warfare in which 80 per cent of soldiers have been trained and desensitized so as to better be able to kill (in contrast to 20 per cent of those who killed in the Second World War). At the same time advanced medical field technology and armor saves more lives. Every US soldier killed leaves 16 comrades who survive. The greater survival rate contributes to a greater number of traumatized veterans, survivors who have killed more 'enemies' and have witnessed more killing and wounding. More of them will return alive and more of them traumatized. An estimated one-fifth of current veterans of the Iraq and Afghanistan conflicts report suffering from PTSD. Upon their return from war, many will live as if dead, or have a deadly and violent life. Many will commit suicide.

Identity/Cultural Prosthetics

In designing cultural prostheses, it is important to stress that many survivors will pass their trauma on to those closest to them, onto their parents, grandparents, wives and husbands, children, and even grandchildren. If we estimate that there are seven to nine people affected by such secondary trauma for every veteran suffering from PTSD, the ripple effect of the trauma will reach an even greater number of people than usual, as an increased number of soldiers with larger families have been deployed from the National Guard and reserves.

According to new research from Stanford University, by 2023 the rate of PTSD among Iraq war veterans alone could rise to be as high as 35 per cent: one-third of all veterans. Considering that some 2.4 million have been through the Iraq and Afghanistan wars, ten years from now there may be 700,000 traumatized in addition to 4,900,000 affected by secondary trauma, who thus become war veterans in their own right—veterans of veterans. There will be a half-million or more traumatized people in the US.

The suicide rate among veterans now eclipses the number of combat deaths among enlisted soldiers, and that rate is rising. The trauma of those who have lost loved ones to suicide will add to the ripple effect. In 2010, 43 per cent of soldiers who took their own lives never asked for or received help. An estimated 145,000 US veterans of all conflicts benefit from homeless-housing programs each year. This number will rise dramatically in the next ten years with the return of soldiers from Iraq and Afghanistan adding to the incidence of trauma among veterans and those left behind, especially children. The US will be facing a major clinical, psychological, social, and cultural crisis for the next 50 years.

Only one per cent of veterans speak out publicly, and almost none of those closest to them do so. Even a small number of veterans appearing in public space and communicating their real war experience could make a big difference.

Given this situation, in order to make a public impact, cultural prostheses should not be designed immediately for a large market and mass production, but can be initially designed with input from and use by a smaller self-selected number of veterans and their families and support groups. Those who choose to begin operating these cultural prostheses will become its 'avant-garde' users and design agents, ready to take upon themselves the task of expressing their critical and philosophical position with respect to war and their existential experience of it. They may advance the use of such prosthetic equipment that aids in the development of their emotional capacity to appear in public and better perform and communicate. In doing so they will generate a population of new users as their co-agents.

To cite Judith Herman, veterans with an intense experience of war, like all trauma survivors, are "living monuments to their own trauma": traumatized but silent. How can they be helped to become active as speaking monuments, rather than silent and passive ones, so they may publicly speak not only for themselves but also on behalf of the silent others? How can we design effective cultural prostheses for them?

My past performative media projects, which take the form of wearable and mobile communicative equipment, developed with marginalized urban minorities (the homeless, 'illegal' immigrants, alienated school youth and war veterans), among them *Poliscar*, 1991, *Alien Staff*, 1992, *Mouthpiece (Le porte-parole)*, 1993, *Dis-Armor*, 1996, *Ægis*, 1998, the *War Veteran Vehicle*, 2009, as well as recent projection-animations of war-memorial statues, will be the basis for further explorations in search of a specific answer of my own to such questions.

118

The Veterans' Helmet

The Veterans' Helmet, at present under development at the Interrogative Design studio at Harvard, is just one example of many potential design approaches in Cultural Prosthetics.

The main objective of *The Veterans' Helmet* is to alleviate the veterans suffering and symptoms of combat stress, to be more confident and less fearful, and to feel more protected when moving through busy and crowded public spaces or places with particularly significant sounds and smells. An important additional task for the helmet is to help people around its user to become more aware of the veteran's war and post-war situation, experience and condition.

The visual appearance of the helmet is as important as its protective and communicative function. It appears partly familiar and partly strange; partly belonging to the past and partly to the future. It should refer to the memory of the destruction of combat while contributing to a new vision and future action. The helmet should be fit for a new, double 'combat' mission: against the user's own silence, social isolation, and exclusion but also toward a war-free world, a world in which there would be no 'need' for more veterans. *The Veterans' Helmet's* appearance must assure the user's readiness for the battle to transform war culture into a discourse of peace, and war armament into disarming cultural equipment.

The helmet should resemble a real combat helmet, while at the same time appearing curiously strange and different: light, elegant and 'Futuristic', as if from the world of science fiction. The design and form of the helmet will emphasize its playful usefulness—evident in the appearance and interactive functions of its protective and communicative components—as elements that visually override the uselessness of the combat-like parts that resemble a real, 'serious' combat helmet. As such, in its function and appearance, for both user and public, the helmet should acknowledge that a terrible war-torn past cannot be changed but that one can live with it in a creatively pro-active, useful and healthier way, thus contributing to a war-less future. The past is a crime story that needs to remain in memory while the future is a science fiction that must be turned into reality. The helmet should both contain the crime story and project such a vision of the future.

In sum, the design tasks for the helmet are the following:

— To protect the user against his or her post-traumatic reaction to certain war-related smells (burning flesh, petrol, human sweat, decomposing animal or human bodies, etc). This may be realized through the use of special smell-detection and "smell-camouflage" units: special software and an interface attached to the helmet, covering the area of the face and nose to inject and disperse smells preselected by the veteran and stored in the helmet.
— To protect the user against his or her over-reaction to certain war-related sounds (sudden explosions, like the sounds of shutting doors, firecrackers, people screaming, etc). This may be realized through the use of sound-detecting microphones and a special software-driven headphone unit that responds to unwanted sounds by activating external noise-cancelling headphones that can project preselected alternative sounds.
— To protect the user against his or her post-traumatic reactions to certain war-related events and crowd situations (the sudden appearance of people from high above, behind, and in peripheral vision, the sudden

119

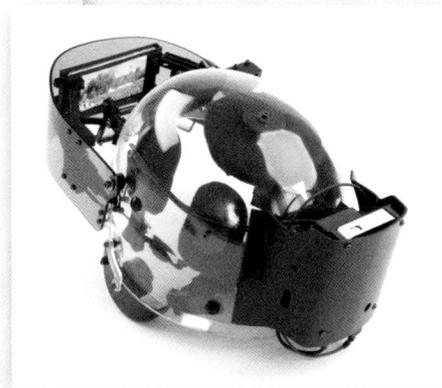

8.1 *Veterans' Helmet.*

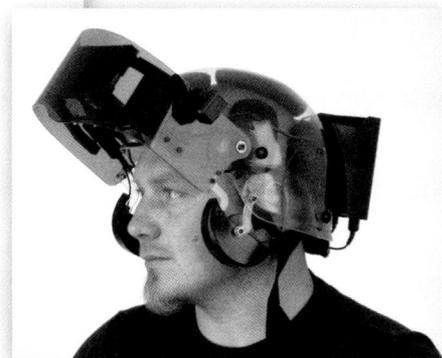

8.2 *Veterans' Helmet,* profile view.

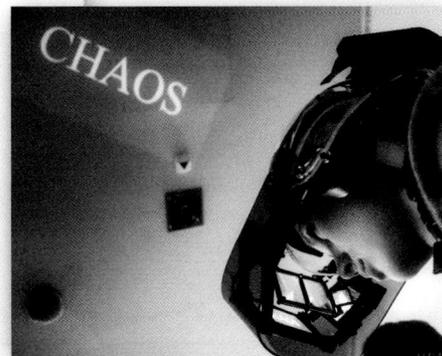

8.3 *Veterans' Helmet,* projected.

approach of another person, the closeness of a crowd, or generally any visual over stimulation caused by crowded places and the like). This could be realized through the use of mini video screens installed at the front of the helmet close to the user's eyes that will survey and display the situation in the user's peripheral vision, transmitted from mini-cameras mounted on the helmet and pointed to the rear and upwards.

— To provide the user with a means of sharing with the public the vivid images experienced by the user in traumatic combat situations (exploding and burning military vehicles, suicide bombings, mortar attacks and the like) especially those corresponding to and triggered by certain sounds and smells. This may be realized through the use of a specially designed unit with a projector and screen or mini–video monitors attached to the helmet, or alternatively a unit for projecting onto ceilings, floors and walls in indoor and outdoor public spaces.

Note: The above function should be part of a special version of the helmet designed exclusively with and for veterans who are less affected by combat stress and willing to speak about combat and discuss it openly in public, in order to inspire and engage public dialogue.

— To secure, when needed, occasional or continuing contact with the user's comrades-in-arms, supporting partners and family members, trauma therapist or other medical personnel and services, through a specially designed communications interface attached to the helmet.

Presentification

According to Judith Herman, a trauma therapist and theorist:

> [S]urvivors' capacity to make themselves visible and perform their testimony visibly and in public is inter-connected, and depends on their success in emerging from their post-traumatic stress. Conversely, the struggle for recovery from trauma—for... finding a narrative voice through testimony—has a greater chance of success when performed as a public speech-act, even more so when directed as a social utterance to and on behalf of others. An... Act of Public Truth-Telling has a restorative power. Psychologist Pierre Janet termed this act 'presentification'.

In supporting the development of veterans' capacity to make themselves visible, active, and communicative in public space through their acts of presentification, there is the tremendous potential for artistic, cultural, pedagogical and therapeutic projects within which the new field of Cultural Prosthetics can play an exceptionally important role.

1 The term Cultural Prosthetics was first introduced in the context of my research (2008) and teaching (2009) as a head of the Interrogative Design Group and director of the Center for Advanced Visual Studies at MIT. See http://act.mit.edu/academic-program/courses/spring-2009/4-3701-interrogative-design-workshop-g-u

Cultural Prosthetics and Pragmatic Access

Sara Hendren

"Let me begin with the fact that I have a prosthetic left leg," wrote media theorist and critic Vivian Sobchack in 2006, "and thus a certain investment in and curiosity about the ways in which 'the prosthetic' has been embraced and recreated by contemporary scholars trying to make sense (and theory) of our increasingly technologized lives." Sobchack's essay took up the late twentieth century's intellectual fashion for the prosthesis as an idea—an object most potent when understood as a metaphor that encapsulated the contemporary body in its pastiche of flesh and machine. Each human, now understood as extended, blended, parts and systems outsourced or enhanced, repaired or remediated in a mix of tools and organs, invited a seemingly endless and romanticized realm of both commentary and artifact. And Sobchack was having none of it:

> Walking around during the day, going to teach a class or to shop at the supermarket, [I do not feel] like Roland Barthes's "reified hero," the "Jet-Man," a mythological "semi-object" whose prosthetically enhanced flesh has sacrificially submitted itself to "the glamorous singularity of an inhuman condition." Not only do I see myself as fully human (if hardly singular or glamorous), but I also know intimately my prosthetic leg's essential inertia and lack of motivating volition.

> ... I am both startled and amused at the extraordinary moves made of and by "the prosthetic" of late—particularly since my prosthetic leg can barely stand on its own and certainly will never go out dancing without me.[1]

Sobchack understood, of course, the universal and vital work of metaphor in making sense of human experience. Her essay goes on to tackle where the metaphorical prosthesis is useful, and where it's misleading and disembodied and therefore denuded of the pragmatic forms of daily access that prosthetic tools make possible. Her work was a call to reinsert disability experience into the humanities' fascination with adaptive technologies, especially where this fascination appears devoid of context and a firm ground in the stuff of everyday life. As historian and likeminded disability scholar Katherine Ott put it in the opening essay to the book *Artificial Parts, Practical Lives*, thinkers and makers who are interested in the extended body and its material culture should remember, in the end, to "keep prostheses attached to people."[2]

Attached to people—that is, taking care to see the primacy of the radically adaptive body doing its very mundane or urgent work of navigation in the world, in life, and in work and in relationships. Scholars and artists should cast a wary eye on the intellectual embroidery that sends prosthetics into pure metaphorical abstraction, where the locality and agency of the human gets so easily lost, where the imprecision of "cyborg" stands in as a generalized term of our time. But Ott also sees this attachment as a generative commitment. She sees the most exciting possibilities open up precisely in the places where prosthetics and the real body meet. Keeping prosthetics attached to people "limits[s] the kinds of claims and interpretive leaps a writer can make," she writes, but in return, an interest in the centrality of disability itself, historically and in the present day, will "excite new narratives and produce unconventional knowledge."[3] It's these new narratives, this unconventional knowledge, and, yes, even the considered and dimensional use of metaphor in Krzysztof Wodiczko's work that helped me understand the role of speculation, the strong sociopolitical role of interrogative design, in my own collaborative practice of making cultural and pragmatic prosthetics with disability as the heart of the matter.

In 2006, the same year Sobchack's essay came out, I gave birth to the first of my three children, a son with Down syndrome named Graham. His was a joyful arrival and an initiation not just into parenthood, but parenthood within a much larger story of disability that was mostly new for my husband and me. I was ignorant of critiques like Sobchack's; I'd not yet begun a long education in disability studies. But prostheses, attached to people—to one specific and much-loved person—arrived very quickly. Here's a partial inventory of the everyday prosthetics that filled up my family's life that first year, modest and workaday tools with no apparent metaphors in sight: orthotic braces, playful chew toys, motorized sensory toys, tiny eyeglasses and the stretchy fabric band that held them in place, exercise balls and yoga mats. The pediatric physical therapy clinics that Graham and I attended were a whole world of material goods made for extending the body in its ordinary and extraordinary functions: lift, push, pull, grasp, carry. The pragmatic access made by these tools was a

wonder of invention, a creative engineering and design process that became visible to me in that first heady year.

But the pragmatic array of tools and technologies alone could not fully address the cultural narrative of disability that was simultaneously rushing in to organize Graham's whole existence: the milestones and percentages; the questions about his level of functioning, whether "high" or "low"; the possibilities and limitations of "inclusive" schooling and the (bleaker) prospects for his employment or financial security; and, most revealing, our uneasy discovery of the rising rates of selective termination following genetic prenatal testing that is diminishing the population of people with Down syndrome worldwide.[4] It was a matrix of the biopolitical arriving in miniature in our house and collecting all three of us in a long-term ecosystem of reciprocal caregiving. Graham needed pragmatic forms of access, but he also needed a cultural world more capacious in its definition of normalcy, more flexible in its structures for needs and desires, less precarious and more robust in its support for human beings outside a tacit or explicit utilitarian logic of personhood. I went looking—it was more like roving or hunting than "research"—for a language of the material that could encompass the biocultural story unfolding for us.

> Designers must work in the world rather than "about" or "upon" it. In an unacceptable and contradictory world, responsive and responsible design must appear as an unacceptable and contradictory "solution." It must critically explore and reveal often painful life experiences rather than camouflage such experience by administering the painkillers of optimistic design fantasies. The appearance of interrogative design may "attract while scandalizing"—it must attract attention in order to scandalize the conditions of which it is born.[5]

I encountered these words from Wodiczko in Graham's early years, when my studio practice consisted of straightforward paintings and drawings. I don't remember the origin—possibly a course on Social Practice art that I took at UCLA one summer—but this idea, that the "optimistic design fantasies" of the world will never do justice to the "unacceptable and contradictory" nature of sociopolitical

life, took immediate root in my imagination. I understood the ways Graham's own story would be caught—between his wishes for self-determination and the limited available futures on offer to him. How could artifacts both disclose the violence of the world and point to some alternative future? How could they juxtapose these messages in the forms usually understood as art to the industrial language of design? It was Wodiczko's naming of the interrogative—the interrogative as an end horizon for design, the possibility for questions to be raised and suspended, indefinitely—that set up my own interest in design for the first time. Where I had previously found a home in fine arts, cordoned off from the concerns of industrial production, now I saw the vernacular of design, of material culture, as a medium for the most powerful sociotechnical questions. What does practical access make possible? (Quite a lot, in necessary everyday terms, as laid out by Sobchack and Ott.) And what does the enigmatic, interrogative design object also make possible? (The language of solutions redeployed as questions, as grit in the system of the regnant order.)

Wodiczko's works like *Alien Staff* and *Mouthpieces* demonstrated these possibilities to me in the realm of culture, while my every day was littered with ingenious designed objects for Graham's dynamic development. There were, of course, plenty of artists making unusual wearable tech, riffing on the prosthetic for beautifully discursive purposes: Stelarc, Rebecca Horn, and Lygia Clark, for example. But Wodiczko's ideas were attached to people in a distinctive way; they were publicly performed by nonexpert collaborators. They had the frame of the street about them, not the contemplative isolation of the gallery. Wodiczko's artifacts were functional; they also brought that grit to the very gears and systems of their use. They posed a disjuncture, without resolving it in the language of solutions. They were prostheses for the politics of immigration, for globalization and national belonging, for externalizing a kind of "exploded view" of artifacts and the forms of assistance they offer, for hidden needs. Hidden needs that are human nonetheless.

Wodiczko's work was not engaged so much with the politics of disability, but I soon discovered the work of his then-colleague at MIT, Wendy Jacob, whose work soon galvanized my own. Jacob had worked with engineer and autistic self-advocate Temple Grandin on further iterations of Grandin's original personal prosthesis she called a "hug machine" or "squeeze box." Grandin's design is a climb-in chamber made of wood and lined with thick padding; powered by an air compressor, it gives its user a deep calming sensory pressure, perhaps akin to enhanced human hugs. Grandin's invention is a clever adaptation for her sensory needs; it's also an object packed with suggestion about the role of furniture in all our lives: as ordinary support, as familiar domestic landscape, and even, in Grandin's case, as an elegant proxy for normative human relations.[6]

Jacob—whose work had long been collaborative, often in dialogue with the sciences and mathematics—contacted Grandin after reading about the design, asking to partner with her on a related prototype. The *Squeeze Chair* that they made together could be used by anyone and for indeterminate purposes, outside the therapeutic. It takes the form of an ordinary upholstered club-style chair, with arms that reach up and in over the sitter and give a tight hug. Like the original, it's powered by an air compressor. But in the *Squeeze Chair*, a sitter needs a companion to activate the pressure. Emotional furniture with its roots in pragmatic access: a set of objects that stand for daily adaptive life and for the poetics of the gallery. An object that is useful but gets liftoff from its use value—including the prosthesis, yes, as metaphor, too.

In those days I also first read designer-thinkers like Graham Pullin in his *Design Meets Disability*, the ideas of Fiona Raby and Anthony Dunne, and academic theorists in disability studies like Rosemarie Garland-Thomson, Lennard Davis, and Michael Bérubé. I went back to graduate school in 2011, this time at Harvard's Graduate School of Design where Wodiczko had just taken the helm of the Art, Design, and the Public Domain Program. My thesis work there was a design of five nested, stacking and portable ramps, designed and engineered for two kinds of city user at once: for skateboarders, whose wheeled mobile gear is used to subvert normative uses of the street, and for wheelchair users, whose passage is too often blocked in a city like mine (Boston) by the "single step entrance"—a gray area in the architectural code of the Americans with

Disabilities Act that allows small businesses to forego ramp provisions. The ramps form an unusual Venn diagram between two sets of city users who rarely appear in the same conceptual space. The project attempts to remix the typical associations that adhere to skateboarders—athleticism, autonomy, play—with the enduring importance of adaptive city navigation via wheelchair access.

My work since then has largely taken shape against the backdrop of engineering, much like Wodiczko's and Jacob's. At Olin College, where I researched and taught for nine years, all students get engineering degrees, and the language of technology is our everyday vernacular. In the classroom and laboratory setting there, disabled artists came to campus to partner on designs they've initiated but had yet to fully realize: A ramped stage structure made with wheelchair dancer Alice Sheppard and her company, Kinetic Light. A portable, collapsible lectern for dwarf stature made in partnership with curator and professor Amanda Cachia. A navigational cane turned into a musical instrument that "plays" the built environment via contact microphone at its end, designed and built with blind artist Carmen Papalia. Each of these tools was built in a context of convivial encounters between disabled and nondisabled partners, and each had a spirit of prototyping that kept disability—its assets and its challenges, its distinctive culture and its universally human attributes—at the center. The prosthetics we built were not romanticized extensions for bodies in some alternate universe. Neither were they exercises in the normative, clinical procedures of rehabilitation engineering. They were instead heavily engineered, built for use, generated by real constraints, whether practical or cultural or both. They are interrogative designs, intended to "attract while scandalizing"—to draw to themselves a public audience with charisma and surprise, to pose new narratives and questions about the disabled body and the construction of normalcy.

Alien Staff: Xenobàcul

Krzysztof Wodiczko

1992

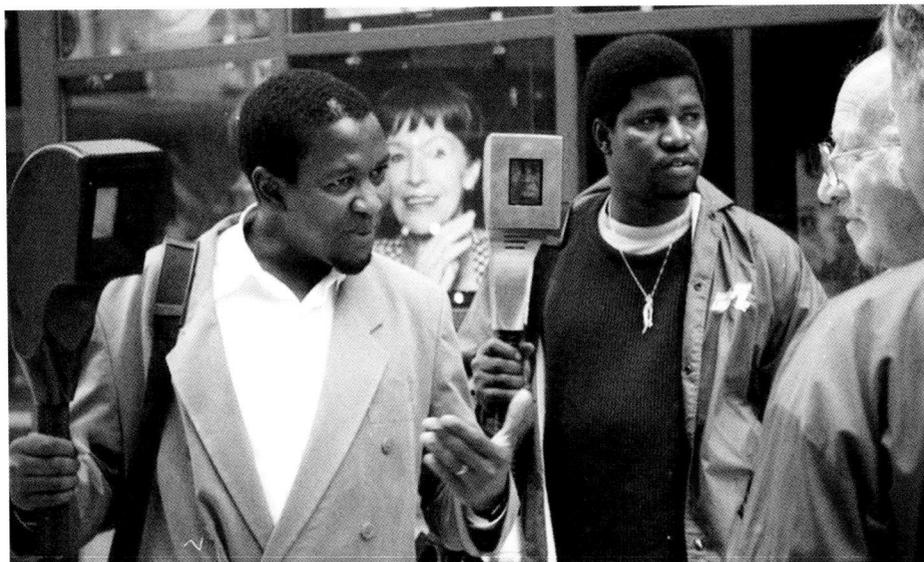

8.4 Krzysztof Wodiczko's *Alien Staff*, in practice.

The first in a series of *Xenological Instruments* designed for immigrants to let themselves be heard in public space. The first version, resembling the staff of the biblical shepherds, was created in Barcelona; the subsequent versions have built-in Plexiglas containers, inspired by the form of the reliquary, where the user can store memorabilia, documents, photographs, etc. The staff is crowned by a hood-like head containing a monitor and a speaker to play back the user's prerecorded statements. A special bag worn on the shoulder contains video players, batteries, walkie-talkie or CB radio. As portable performative instruments, imbued with the user's personal experiences, the staff's purpose was to allow immigrants to present themselves and communicate. "Doubled" with their own image, voice, and memory stored in the staff, the immigrants/users visualized themselves both for him- or herself and for potential viewers/listeners who, approaching the staff, overcame the distance separating them from aliens.[1]

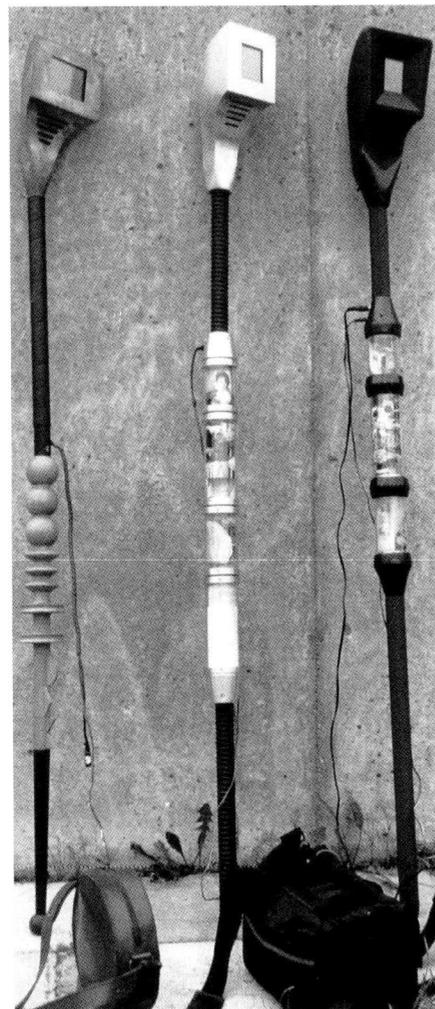

8.5 Three *Alien Staff* prototypes.

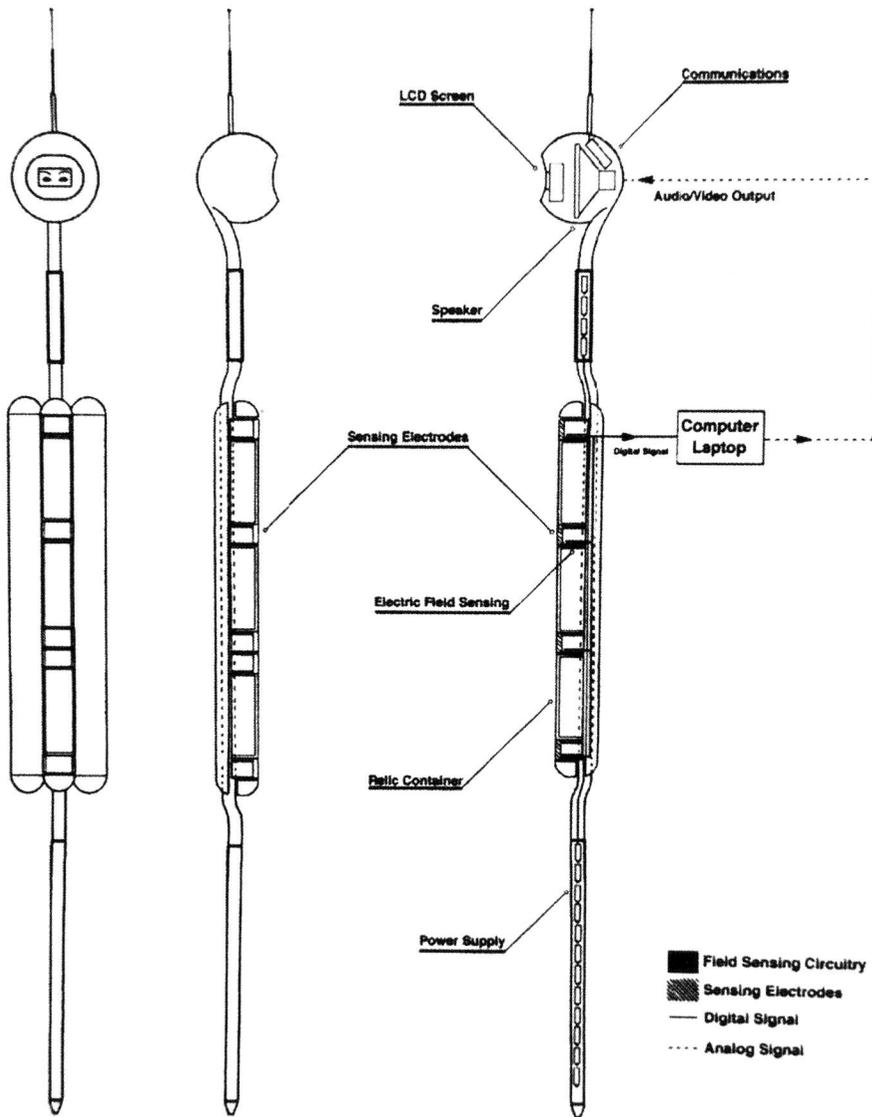

8.6 System design of Krzysztof Wodiczko's *Alien Staff*, developed with Joshua Smith at MIT.

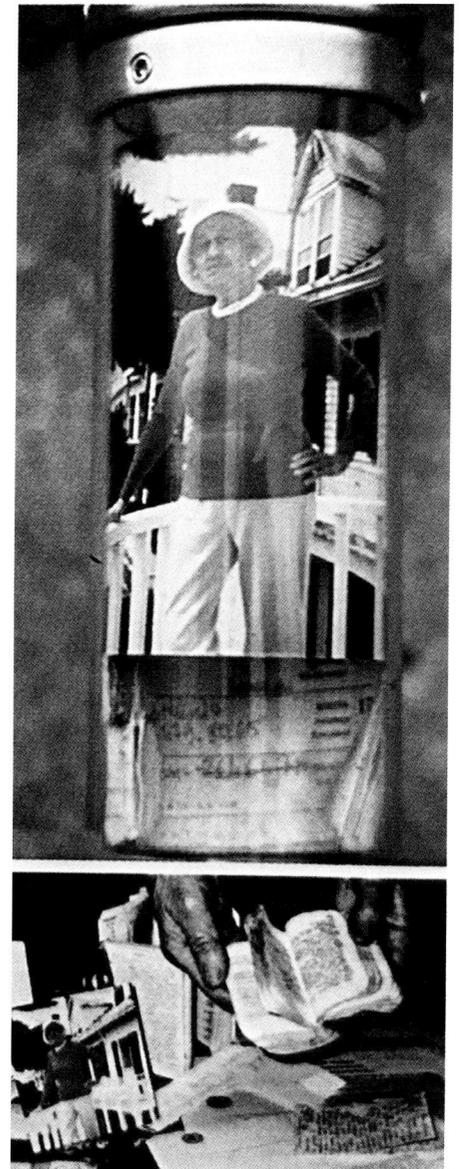

8.7 Mementos embedded within an *Alien Staff* by its operator.

Human Echolocation

Gustavo Romeiro

2021

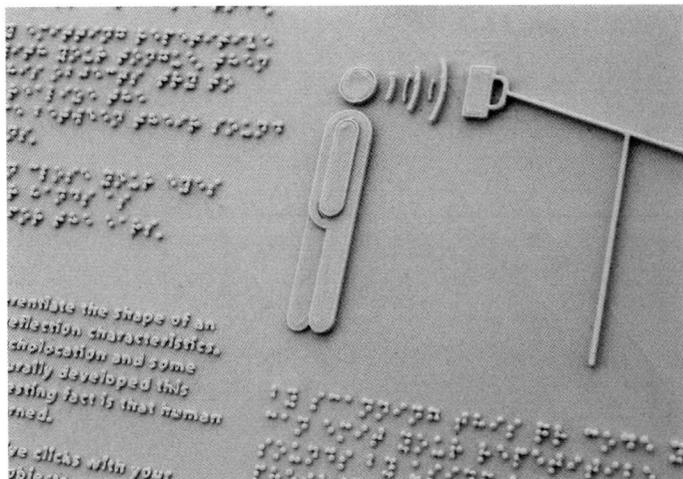

8.8 *Disseminating Human Echolocation*, detail view.

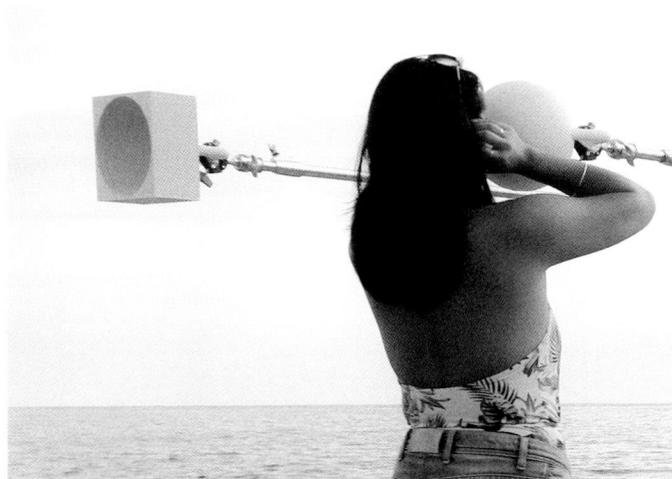

8.9 *Disseminating Human Echolocation*.

Interrogative design aligns with my aesthetic philosophy that art and design should assume a hybrid-liquid nature that infiltrates into any reality. In 2021, I developed a research project, *Disseminating Human Echolocation through Public Art*, that includes a device for human echolocation in public space.

Echolocation is the ability to evaluate an object's position by sensing echoes from that object. Bats, dolphins, whales, shrews, and some birds are animals that mastered this ability. Although this fact is little known, humans can also echolocate. Human echolocators developed a system very similar to bats and dolphins. They emit repetitive tongue clicks and read the echoes produced by these sounds in the environment. By doing that, echolocators create sound images from static and moving objects—literally seeing by sound.

As in any work of interrogative design, I started this project with a serious social concern: the lack of public knowledge about human echolocation and its ability to improve blind people's independence and mobility. My project can be understood as an intertwining of a speculative design perspective with an interrogative design approach. Speculative design can be briefly summed up as designing something dreamy, with utopian optimistic elements—elements that are not usually present in interrogative design, which in general conveys more realistic approaches.

Some scientific studies have shown that when mastered, human echolocation provides great empowerment to blind people and can be learned by anyone. If human echolocation can greatly improve unsighted people's life experience, why is it not being taught everywhere?

To answer this question, I started to focus my work on designing objects to be placed in public space for passers-

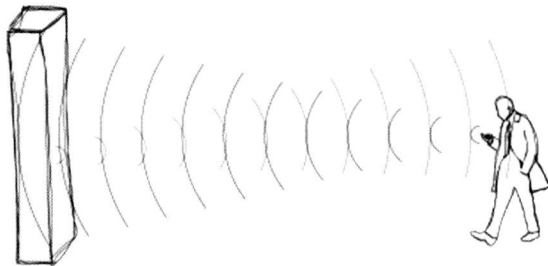

8.10 *Sonar Glasses,* diagram.

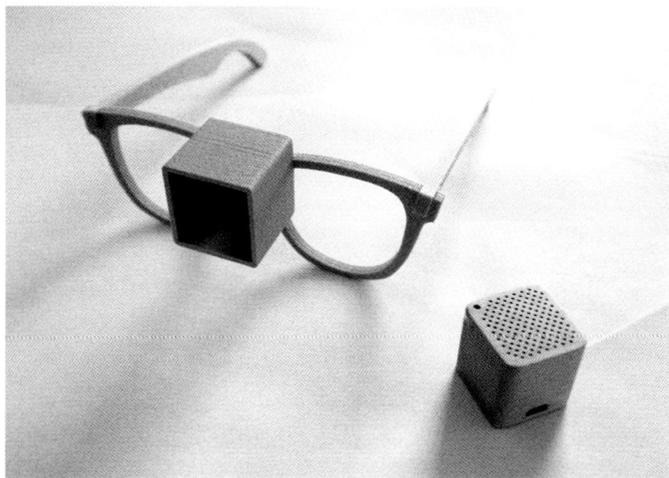

8.11 *Sonar Glasses,* detail view.

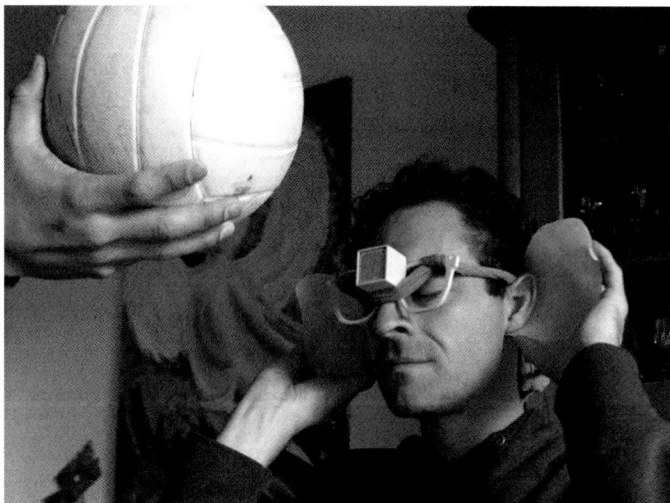

8.12 *Sonar Glasses.*

by to echolocate. My initial work in this context was born with two simultaneous aims. First, attending to a political social issue, to create empathy with the social reality of blind people. Second, to contribute to unraveling a practical problem: how to encourage everyone (sighted and unsighted) to learn echolocation.

I created portable spherical, flat, and concave surfaces, 3D-printed on light gray biodegradable plastic (PLC) and placed at various heights. These objects were accompanied by a sign explaining what human echolocation is, its origin among blind people, and how to start practicing it. The sign is written in Braille and embossed Roman alphabet. It also carries an embossed iconography to support the information and a QR code that allows the user to download a sonar-like application I designed for mobile devices.

Another project, *Sonar Glasses* (2019), uses a portable frame in which I fix a digital sound-emitting source on the forehead of a person. This respects the triangular structure between sound emissions and echo receptors in echolocating animals. It resembles a pair of glasses, carrying a small Bluetooth speaker in the middle connected to a smartphone running the Sonar Application prototype.

I consider all these devices to be simultaneously artifacts and artworks in the context of public art and research tools for investigating effective ways of instigating human echolocation.

Perhaps it is the hybrid nature of my work that converges with the ideas of interrogative design. I initially started designing with a kind of optimistic fantasy, and now I am more interested in the development of a functional object. One that can be perceived as a critical tool in the mobility training of the blind.

To conclude I would say that any activity could benefit from critical ways of thinking such as interrogative design. I would also add that public space can and should be used in an interrogative manner, as an instrument for contesting hidden patterns and unveiling wicked problems.

Body Speech

Ginger Nolan and Carl Solander

2003

8.13 *Body Speech*, documentation stills.

The expression "interrogative design" rings differently today than in 2003 when we enrolled in Krzysztof Wodiczko's *Interrogative Design Workshop* at MIT. Back then, the world was less thoroughly saturated with the idea of design, as this was just prior to the recent spread of "design thinking" and humanitarian design. In attempting to describe what interrogative design entailed, it's thus helpful to distinguish what we were doing in that class—as we engaged iterative, exploratory processes—from contemporary corporate and humanitarian practices that also promote iterative, exploratory processes. The fact that interrogative design did not aim to solve problems is perhaps not sufficient to distinguish it from design thinking, since the latter comprehends what Stanford Anderson and Nicholas Negroponte have called "problem worrying," a form of experimentation in which the problem is not clearly defined in advance but rather develops and shifts throughout the process of experimentation.[1]

• **Carl Solander:** We had a sea of problems to examine that arose through readings and discussions. For me it felt like we were simultaneously developing a vehicle and formulating the territory in which that vehicle would operate. And both the territory and the vehicle developed in parallel through our readings and discussions, sketches, fabrication and deployment of prototypes, and observations of how those prototypes were received. Unlike our work in architecture studios, Interrogative Design did not respond to a program. We tried to place our ideas into a certain territory and to use these little bits of technology to draw attention. The purposefulness of these designs remained somewhat vague in conception, and that seemed to be fine.

237

• **Ginger Nolan:** While certainly there was some evolution of our goals in the process of experimentation, I'd also say that, in contrast to problem worrying, interrogative design entailed some rather definite problems—ones that emerged from the corpus of texts we read and from Wodiczko's own oeuvre. But, as distinct from problem solving, the intent was never to offer pat solutions but rather to provoke public questioning of the conditions enabling the problems we engaged. If I had to define those problems, I'd say that we were concerned with political and technological conditions that led to the suppression of some voices, visions, and ideas. Such suppression might exacerbate (and, in turn, be exacerbated by) uneven access to urban space, goods, and services—these too were problems that concerned us—but those issues of uneven access were still linked to the political-economic conditions that encouraged some voices and ideas to prevail over others, helping normalize social inequalities and violence. Among the many texts we read, Foucault's work on fearless speech (parrhesia) and agonism was especially important in orienting our pursuits.[2] Thus, while our design processes were indeed interrogative, more importantly the devices we designed were meant to interrogate, to publicly provoke questions. It's possible that Wodiczko may have chosen the term "interrogate" as a way to subvert its negative associations with torture cells and police precincts—places where democratic discourse is most utterly dissolved—and restore to the term its more agonistic possibilities.

• **Carl Solander:** I recall the notion of the sublime being celebrated in architectural design studios, and because of that we may have been uncomfortable with these inexpertly formed crude devices that we made. But spatial politics is ugly and evolving. I think the very essence of this type of design thinking is that it must continue to evolve almost more quickly than the process of production, and therefore we should be accepting of the unfinished nature of the things we designed in Wodiczko's course. How would we measure a successful project? Is it one that generates the most discussion and therefore holds the greatest potential for another iteration? There was a liberating quality to the notion that each piece was a prototype that built off the previous failures, and accepting this process we tried to move things in multiple directions at once and not worry so much about the final artifact. It was perhaps sloppy design, but I think that sloppiness allowed us to draw in many different ideas and put something imperfect out into the world without attempting to fully resolve the intent in advance of the deployment.

• **Ginger Nolan:** As Wodiczko's course was largely focused on reading discussions, some of us only began to design during the last weeks of class. For that reason, our own project never became more than a very fledgling prototype, although we imagined different possible directions in which it could develop (should we have further pursued it). It's important to mention that we were architecture students and that most of our courses focused on concerns quite different from those prevailing in the art department where Wodiczko taught. Our architecture studies were dominated by architectural phenomenology, which emphasized the aesthetics of bodily perception and place-based phenomena, with no attention to the politics of corporeal embodiment, the politics of occupying space, and the politics of spatial differentiation.[3] Many of our design teachers privileged transcendent experience over, say, interrogative speech. Retrospectively, I'd say that our project, *Body Speech*, responded to this depoliticization of bodily experience and place, as it raised questions of gender and subject positioning. Very simply, this project was (for me at least) a feminist one that challenged the objectifying condition of being seen rather than being heard, while also raising questions about cultural and gendered norms regarding personal space. For a technical prototype, we constructed a simple belt with tentacles, sensors, and speakers but envisioned these elements ideally integrated into a vest or jacket. It seemed that the clothing should visually assert its cyborg character, not only to provoke attention and convey a certain power to the wearer but also as a challenge to the architectural-phenomenological implication that the ways humans occupied space belonged to a natural, universal human experience. For the prototype, we prerecorded two different sound bytes, "touch me" and "don't touch me"—the former recording activated by motion sensors that could detect motion at some distance, while the latter were activated by someone or something brushing against the small buttons on the ends of the tentacles. We discussed other possible messages to record, but the idea was that recordings could be input by those wearing the belt, who might sing or scream or simply say what's on their mind. Although the project lent itself to a range of possibilities, I personally envisioned it as a way of asserting one's prerogative to speech and to personal space, against one's objectification as a female body.

• **Carl Solander:** I think you brought a strong concept to the project and we ended in a place that pointed to many possible next steps. I recall also a previous iteration in which we had used similar technological bits—sensors, speakers, buttons—and put a small box on the wall in the subway station. The box would call out to passersby and invite them to record their own messages which would overwrite the message that had called them to the box. We observed people interacting with this box and concluded that the context of its discovery was too ambiguous, and that ambiguity may have lent a somewhat sinister air to the object. Reformulating these bits into a wearable device shifted the territory and the vehicle into a more interesting direction. For me it was this process that became the most impactful aspect of the course. That we could be less worried about unveiling a perfect design to an appreciative audience and more engaged with designing out in the open.

Dis-Armor

Krzysztof Wodiczko

2000

8.14 *Dis-Armor, 2000.*

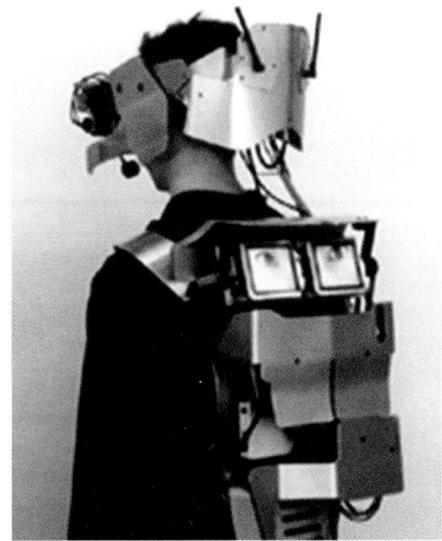

8.15 *Dis-Armor, 2000.*

Dis-Armor is a psycho-cultural prosthetic device designed as a communications tool for school students. It was directly inspired by the artist's meeting with the group of school refusers, Japanese junior high school students who suffer from *hikikomori*, a severe social withdrawal syndrome, at that time affecting Japanese society on an epidemic scale. The project's title serves as a reference to the need for "disarming"—for young people encased in a carapace of silence to open up. The *Dis-Armor* combines modern technology with Japanese cultural traditions; its overall aesthetic and individual elements were inspired by antique samurai armor and warrior-humanoid toys. It was developed in close consultation with child psychologists and school refusers themselves. The device features two mini cameras that film the eyes and send their image to two small-size screens located on the user's back, and the microphone that sends spoken words to the speaker on the user's back. In this way young people who otherwise avoid direct contact with others can communicate by "looking and speaking with their backs."

• **Sung Ho Kim:** The *Dis-Armor* was influenced by samurai armor and Manga robots for Japanese teenagers to assuage the psychological pains of their high school years living without a voice. The equipment is designed for urban youth who have survived or endure violence, neglect, and abuse and desire to heal by overcoming their misplaced sense of shame. *Dis-Armor* provides an opportunity to break their silence and to communicate their experiences in public space by allowing its users to speak through their backs. A speaker below the LCD screens amplifies the user's voice and animates the expression of the face on their back. The wireless connectivity of the audiovisual equipment can work in a network, broadcasting users' voices and eyes to each other.

239

ScreamBody

Kelly Dobson

1997

8.16 *ScreamBody,* in public space.

ScreamBody is the first of the series of *Wearable Body Organs. ScreamBody* is a portable space for screaming. When a user needs to scream but is in any number of situations where it is just not permitted, *ScreamBody* silences the user's screams so the user may feel free to vocalize without fear of environmental retaliation, and at the same time records the scream for later release where, when, and how the user chooses.

Machines influence self-conception, expression, social perception, and perception of responsibility or action. As the interplay of people and machines is accessed and vitalized through custom interaction design and psychotherapeutic techniques, a social awareness is brought out and individuals are invited to reinvent their own existence.

Wearable Body Organs is a series of very visible, spectacular or even carnival play-use objects-devic-

8.17 *ScreamBody*, usage diagram.

es-equipments that offer context-sensitive functionality for their wearer while simultaneously announcing their own need for existence by being used in public without being hidden and small (in contrast to the trend with consumer gadgets and self-help devices, hearing aids, PDAs, artificial organs). *ScreamBody, CryBody, SleepBody, EatBody, HoldBody, FightBody, HideBody, HouseBody* ... rather than being hidden and made to go unnoticed, these "products" are designed to be noticed, as this is key in their functionality—they are social-critical activists.

The wearable apparatuses function as transitional objects—they allow bridges between the person's internal experience and the outside world in situations in which the person would otherwise not be able to find such a bridge. Each apparatus simultaneously acts to call attention to the social repression addressed by the device. Participants access sensorial energy that has been implicitly or explicitly put to sleep by enculturation.[1]

• Sofia Ponte: Dobson's ScreamBody offers an anti-aesthetic dimension, by creating an art project and simultaneously an emotional tool with the purpose of engaging people to reinvent their existence. She explores conceptual relationships between the purposes of art, science, and technology through a unity that gives them both new meaning and novel use.

Mind Controlled Spermatozoa

Ani Liu

2017

8.18 *Mind Controlled Spermatozoa*, in operation.

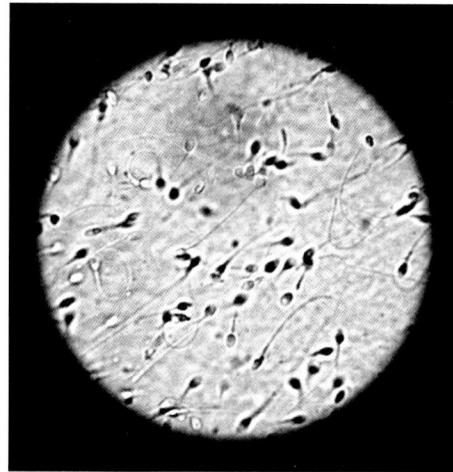

INNOVATION · **Published** June 23, 2017 8:08am EDT

Artist used tech to control sperm with her mind

By Evan Dashevsky | **PCmag**

8.19 Press coverage, Fox News.

8.20 *Mind Controlled Spermatozoa*, microscope view.

Mind Controlled Spermatozoa is a system designed to allow women to control the directional movement of sperm with the agency of their thoughts. The work acknowledges and reflects upon the cultural and scientific discourses that shape the notions of the female body, this work presents a biopolitical feminist work in which a woman controls the motility of spermatozoa through the agency of her thoughts. The intellectual investigation of this project is threefold: (1) to engineer a system that directs the movement of sperm via the signals of brain activity, (2) to communicate the project aesthetically and expressively through art and design, (3) to situate the project philosophically and pose critical cultural questions. It was developed as a response to Donald Trump's statement "Grab them by the pussy" in the 2016 election.

The female body has long been a site of contention where opposing ideologies in religion, politics, and cultural difference play out. The female body has become a vessel by which systems of ideas are manifested. Can a woman

vote or serve in the military? Can she wear pants, or must she be veiled? Does she have agency in deciding her own reproductive health choices?

In the context of interrogative design, this work reflects on the cultural and scientific discourses that shape notions of the female body. Challenging the status quo, in an expression of female empowerment, a woman controls something symbolically male: spermatozoa (sperm). Through the use of a brain-computer interface, she controls the movement of sperm with the agency of her thoughts. Using a brain EEG device to translate thoughts onto a custom circuit on a glass slide, the movement of sperm is controlled through electric fields in a phenomenon known as galvanotaxis.

Investigating the body as a medium of culture, this project raises questions about how we operate in our politically gendered landscape. Using and technology as a medium, the work presents a hope to expand our notions of what is possible in the cultural landscape of reality.

Navigating the divergent connections between art and science, this work challenges the viewer to question what is possible. Whereas our biological understanding of sperm is usually deterministic (i.e., as an inherent homing device racing toward the chemical signatures of an egg) or colored by gendered cultural constructs (i.e., its semiotic use in pornography), this project seeks to invert all preconceived notions. By creating a work that is simultaneously technological, functional, and symbolically potent, it seeks to expand our notions of what is possible, and what is possible to question.

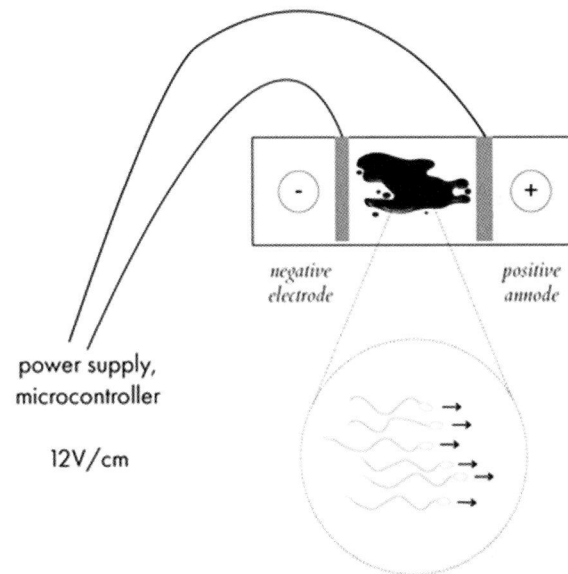

8.21 *Mind Controlled Spermatozoa*, system diagram.

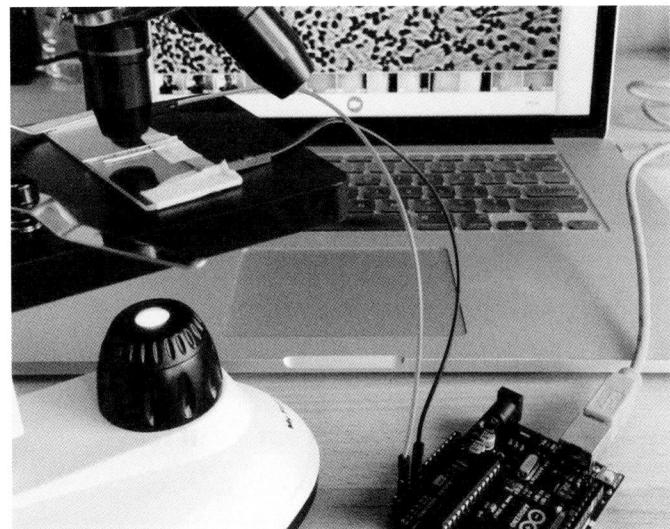

8.22 *Mind Controlled Spermatozoa*, apparatus.

243

9 Ethical Alertness

This last section looks at a feature of interrogative design that could easily have started the book: ethics. In his original essay on interrogative design, Wodiczko writes:

> [Design] needs to increase and sustain the high level of ethical alertness that creates, in the words of Benjamin, a state of emergency understood not as an exception but as an everyday ethical condition, an ongoing motivation for critical judgment toward the present and past to secure a vision for a better future.[1]

Benjamin's words cited above are from his text "On the Concept of History," written during the Second World War:

> The tradition of the oppressed teaches us that the "state of emergency" in which we live is not the exception but the rule. We must attain to a conception of history that is in keeping with this insight. Then we shall clearly realize that it is our task to bring about a real state of emergency, and this will improve our position in the struggle against Fascism. One reason why Fascism has a chance is that in the name of progress its opponents treat it as a historical norm. The current amazement that the things we are experiencing are "still" possible in the twentieth century is not philosophical. This amazement is not the beginning of knowledge—unless it is the knowledge that the view of history which gives rise to it is untenable.[2]

Benjamin's argument is that to normalize fascism (and, one would suppose, other dangerous political movements) within a historical arc is to give up hope and to allow it to continue to reemerge. To live in a constant "state of emergency ... as an everyday ethical condition" means to be ready to oppose injustice, take on reparative actions, and offer, as designers, projects that shape and improve the living conditions of others.

Ethically alert design projects can be as simple as rearranging one's environment to aid in self-care, or they can be more complex applications of intellect and engineering: from elaborate humanitarian engineering projects to works of sophisticated technological production. Works of interrogative design com-

bine participatory design, documentary filmmaking, and public art. Ethical alertness, of course, need not be constrained to the realm of art. During Russia's 2022 invasion of Ukraine, two Harvard students quickly built a website to coordinate ad hoc networks of housing support that were forming throughout Poland for refugees fleeing the conflict.[3] (I myself hopped a plane to Poland and volunteered at various shelters delivering food supplies, drove refugees, and worked to connect the aforementioned database with a similar Polish government system.)

Being ethically alert simply means being ready to do the right thing at a moment's notice. Being ethically alert also means being ready to do nothing, or to deploy *tactical leisure*. In the middle of a state of emergency, one must find small pleasures and comforts, take time to rest, and find time for self-care, joy, and laughter. As artists and designers, we can work productively on projects that fit between leisure and conventional social work.

Being ethically alert also includes, quite crucially, *thinking*.

> Arendt argues that the only reliable source of light in dark times is found in the activity of thinking. From the beginning to the end of her writing life, Arendt situates herself as a thinker even as she warns against the dangers of reason. In *The Origins of Totalitarianism*, her grand inquiry into the roots of totalitarianism in rootlessness, loneliness, and thoughtlessness, Arendt frames her inquiry as an effort of comprehension, by which she means "the unpremeditated, attentive facing up to, and resisting of, reality—whatever it may be." In *The Human Condition*, she explains her project as a "matter of thought" that opposes the thoughtlessness that "seems to me among the outstanding characteristics of our time." And in her engagement with what she saw as the thoughtlessness behind Adolf Eichmann's evil deeds, she asks: "Could the activity of thinking as such be among the conditions that make men abstain from evil-doing or even actually 'condition' them against it?" Thinking, Arendt suggests, is the only reliable safety net against the increasingly totalitarian or even bureaucratic temptations to evil that threaten the modern world.[4]

Thinking through complex topics and dark moments, as opposed to simply *reasoning* through them, takes time. ("Reason, [Arendt] insists, reasons, it does not think.")[5] And during an ethical crisis, being slow can give the appearance of ineptitude or even of opposition to supportive courses of action. Perhaps, then, one of the challenges in ethical alertness is how to ignore one's appearance of doing nothing and *actually think*.

This, of course, assumes one is sensitized to ethical thought and is capable of being ethically alert. One of the challenges of our evolving technological mediascape (or "sensorium" as Caroline Jones describes it) is its effect on our ability to empathize with others. Sherry Turkle writes:

> In 2010, a team at the University of Michigan led by the psychologist Sara Konrath put together the findings of 72 studies that were conducted over a 30-year period. They found a 40 percent decline in empathy among college students, with most of the decline taking place after 2000. The researchers were led to conclude that the decline was due to the presence of mobile technology. Young people were taking their eyes off each other and onto their phones.[6]

Phones, of course, provide each user with a self-reinforcing loop of highly customized content. Interacting with people face to face is slow, inconvenient, difficult, and often disappointing in many ways. "Swiping left" in real life takes tact. Turkle notices that the common impulse is to create technological solutions for this technological condition.

> We want to believe that if technology has created a problem, technology will solve it. But in this case, when our thoughts turn to emotive robots or iPhone apps, we are forgetting the essential. We are the empathy app. People, not machines, talking to each other. Technology can make us forget what we know about life. It is not too late to remember, to look up, look at each other, and start the conversation.[7]

Resensitizing one another to being human is an important component of ethical alertness. To remove our cybernetic implants and reshape the cognitive impressions left by them is a crucial skill set for free people everywhere. It will become increasingly important to be aware of the chang-

ing contours of our technological environments and their effects on us. The world can now completely change with an invisible software upgrade, and we can only hope that we will get the memo.

What does technology want and what is technology doing to us as it becomes increasingly complex, autonomous, and unpredictable? What new forms of reality-testing will we require to discern the real from the simulated? Iyad Rahwan et al. suggest that it is time to begin studying technology with the behavioral tools once exclusively used by the life sciences.[8] They outline six principles for the ethical conduct of this kind of research among scientists. For artists and designers, the message is clear: it is time to look at technology with a similar lens to the one we use for living systems.

And the inverse is true as well: it may be time to afford living systems more technological presence. Global warming, climate change, and the apparent beginning of the "Anthropocene" have precipitated an increased interest in bringing living systems further into the fold of our technological and human social constructs. A return to indigenous thinking is one approach, including legal personhood for animals, plants, and even geological features such as rivers.[9] Under the umbrella of nonhuman agency, opposition to human exceptionalism, designing for the more-than-human, artists and designers can begin to take part in working with the frightening inertia that E. O. Wilson warned us of in 2003: "for every person in the world to reach present US levels of consumption with existing technology would require four more planet Earths."[10]

Today the number is closer to six.

• **Mariana Morais**: Something that happens often is people recording accidents with their phone to share on social media instead of using it to call for help.

Interrogative Design with More-Than-Humans

Orkan Telhan

Interrogative design is a process of thinking and acting with marginalized and underrepresented members of the society. It rests on a broad understanding of empathy, in which the designer works together with their subjects—users, viewers, participants—to develop a set of strategies that can rework asymmetries of power. Whether the marginalized are immigrants, war veterans, or homeless, they present their conditions through a designer—a proxy or a mediator—who tries to advocate for them by providing more grounds for their representation. Within the boundaries of accountability and responsibility, designers can, for example, work toward helping lift the voices of unheard workers in sweatshops or bring visibility to disenfranchised religious believers.

Instead of solving problems or imposing a set of values in the name of "good" design, the accountable designer works with a double empathy, one that resonates not only with the marginalized subject but also with the conditions that cause the marginalization. The designer often empowers their subjects by supporting their capacity to cope with conflict—not to avoid it. What gets designed or redesigned is not only a tool, gadget, or technology but a set of relationships that allow subjects to speak up, gain the right to exist with their difference, and cope better with mainstream, heteronormative, or "white" values.

A strong sense of humanism or humancentric thinking is at the core of these interrogative practices. In this essay, I would like to investigate potential implications of interrogative design for "other-than-human," "nonhuman," or "more-than-human" perspectives. My task here is to ask how designing for new conditions of ethics, empathy, and care can extend beyond human interests. What happens if the subject of marginalization is a burned forest, a dammed river, or the polluted ocean? Is it possible to consider an "intersectional marginalization" among the disenfranchised human subjects while also considering the broader urban, ecological, and climatic contexts? And more importantly, what can interrogative design tell us when there is an conflict between human existence and other beings? What happens when design cannot "improve" the interests of humans without causing more suffering for the environment?

Design in White Nature

To design is to be human. But the idea of the "human" is also subject to interrogation by design. While there has never been an encompassing, universal definition of the human, Western intellectual history relies on an exclusive understanding of humanism that prioritizes white, Eurocentric, and colonial interests. As noted by Zakiyyah Iman Jackson, the concept of "human" is also a construct, a locus of marginalization, the very place where political categories such as womxn, Black, queer, Native, slave, immigrant, disabled are negotiated to institutionalize and maintain hierarchy and dominion.[1]

Over time, the version of the human that serves the interests of the "white"—able, Eurocentric, settler-colonial—members of the species became internalized as the norm, while the rights of "others" get measured against it.

The "other" of the white human is also not limited to "other" humans. What is left in the blind spot are many different kinds and degrees of beings—nonhumans—who are hardly granted any status of representation in the white humancentric worldview. Most Abrahamic religions and their derivative cosmologies assert in their written order the supremacy of the human, so that everything else is created in service to it.

Whether these are forests destroyed for monoculture farming, water basins threatened by commercialization, or urban gardens eradicated through gentrification and privatization, they do not have a place in white imagination other than as resources for exploitation. The colonial imperative not only divests these sites of any political status but also ignores their historical presence in Indigenous and Native worldviews.

White cosmologies yield white natures, not green ones. A very contemporary challenge is to interrogate this white-centric view of nature on behalf of other-beings and to inform design logic with alternative worldviews rooted in care, empathy, and ethics. Prevailing concerns around the climate crisis, environmental justice, and ecological issues are motivating a new generation of designers seeking alternative strategies to design equitable and accountable futures with respect to the needs of environments, or more-than-human interests.

From designing with local, renewable, or fair-trade resources to efforts to minimize mass manufacturing, promoting reuse and upcycling, contemporary designers aspire toward practices that mitigate carbon production, waste, or pollution. Often designers face a dilemma—why design anything if what we create will always have an adverse effect on nature?

With the prioritization of the environment, ecology, or climate also comes an interest in and responsibility toward learning about more-than-human interests. When modern design's goals of making everything "cheaper, better, faster, and more convenient" for humans conflict with the reality of a resource-constrained and overcrowded planet, it becomes important to interrogate this reality. Listening to those with non-Eurocentric worldviews is a place to start. Like the critique of the "human" in (white) humanism, attending to "green" motivations behind environmentalism raises critical questions for designers.

And when there is a conflict of interest between a human and nonhuman, whose side would the interrogative designer take?

Interrogating Power

In this essay, I would like to take up three topics—power, care, and the public—that are central to interrogative design and suggest how they can be interrogated further with non-Western worldviews. Marisol de la Cadena's *Earth Beings* provides a rich portrait of various categories of other-than-human beings that originate from *runakuna* (Quechua, Indigenous) cosmologies in what is currently Peru, and their ways of knowing and being.[2]

Earth-beings, de la Cadena's translation of *tirakuna*, are entities such as mountains, rivers, and lakes, but they are sentient and willful, with characters, desires, and powers of their own. How are their "will(s)" situated? "The sources of the capricious will of humans and earth-beings, how-ever, are different" for de

• **Editor:** How can conflict between human existence and other "earth-beings" be transformed from adversarial to agonistic? Can the communicative quality of those conflicts be increased while its violence is decreased?

la Cadena. Earth-beings also give and take, like humans. "As place, earth-beings give themselves through water, soil, and vitality, and they also demand in return what they enable: crops, animals, food, and human breath."

This dynamic of giving and taking—the political economy of being—evokes different narratives of use, utility, and their exploitation under different regimes of ownership, control, and power. Various beings extend their authority and secure governance by turning their "wills" into State law—a worldview to legitimize their own hierarchy and power. But law, as de la Cadena points out, is also a site of interpretation. Legal matters shaped by the will of the State (the ruling class or the rich) and those shaped by the Indigenous group such as the *runakuna* can be vastly different. Here, bribing with a sheep may determine the ability to access law and may not be the same as undermining or transgressing it. It may help in getting the attention of officials, who tend to keep the "illiterate" waiting. *Runakuna*, who may not read and write in the language of the State, can be punished by huge wait times when they face bureaucracy. The sheep speeds things up. Where the gift of a sheep obtains legal services, the law may not be legal nor the gift. But the sheep here is nevertheless what exposes the currency of negotiation, what disarms the law and makes it the subject of interrogation.

De la Cadena mentions another incident, this time of a thief who is caught stealing horses. He prefers to be handed over to the police instead of being communally judged against the law of the *runakuna*. For the thief, the State law is favorable as it allows more room for negotiation. The police may set him free if he gives them something. De la Cadena, here, points out the practice of law-making by *runakunas* as a way of expanding their will to their territory, becoming the State for their own people, and obliging the thief to pay for his wrong. The thief ultimately receives physical punishment in the form of whipping and strenuous physical exercises. And he promises not to steal again.

In these examples, one witnesses shifts in perspectives toward sources of power, the law, or the will when they are exercised with different communities of humans overlapping at the same place. Foundations of authority or self are contextual and their parameters are not taken for granted.

Interrogative designers do not always design state laws or other worldviews. However, they design many relations around the practices of power for and with their subjects. To empower and advocate for those whose "wills" are oppressed calls for an investment in knowing how the sovereign(s) comes into being and operates. It suggests an opportunity to witness how different wills and worldviews—as people, as sheep, as horses, as State—participate in each other. For interrogative design to address a multitude of stakeholders, an intersectionalist understanding of "wills" such as that of the land, the sheep, or the human must be equally accounted for.

Interrogating with Care

What gets designed and by whom becomes equally important in determining whose will is served and maintained in the non-Western cosmology. When one designs for the "interests" of unrepresented and marginalized land, the design can be equally imposing, self-righteous, and colonial unless the interrogative design process takes on the challenge on understanding the mechanisms of power and hierarchy in that cosmology. One approach is to invest in finding new relationships between design and the practice of care. Caring "for and with" a plot of land or territory is very different from caring for its products for humans (in the form of artifacts, sustenance, or a territory for inhabitation).

De la Cadena brings forth the importance of the relationality between land and its inhabitants. People are not from a place, they are the place—together with other beings: plants, animals, mountains, rivers, and the rain. The place is an event that emerges when people build houses out of its soil, live there, and construct an intra-relationality—similar to Karen Barad's intra-action, or "the mutual constitution of entangled species."[3] Barad's idea distinguishes between relationships among preexisting species, subjects, or things and the relationships that bring entities into existence, in which no agency precedes the relationship or interaction. In Andean cosmology, this interaction, known as *uyway*, refers to "always-mutual care (intra-care). We rear the seeds, the animals, and plants, and they also rear us." The relationship is always reciprocal, and the reci-

procity is not a type of relationship between care-givers, it is rather what gives birth to them. "They grow out of it."[4]

Here it is important to point out that care is not a form of altruism, but rather a form of participation, a commitment to being kin to plant, animal, or earth beings. Breaking ties from place—from kin—is a costly transformation, in which one can no longer return to a prior being, an existence before care.

Similarly, the interrogative design process entangles a complex set of relationships between designers and their subjects. This calls for an opportunity for self-reflexivity such that designers can acknowledge their own investments in caring and being cared for by their subjects. Everybody is transformed during the interrogative design process, after all, as both the designers and their stakeholders continuously design each other.

More-Than-Human Publics

Interrogative design is inherently a public practice. Public places are where civic rights are exercised, traumas voiced and healed, and where othernesses confront each other. However, rather than assume the idea of "public" as a readymade, interrogative design constructs its publics and their various spatial embodiments through engagement. It provides the sociocultural context where different publics can come into being.

How do interrogative designers "see" their public? Through a microscope? Policy documents? Interviews? Making spaces, audiences, and participants public is a generative practice that can also be extended to the process of making more-than-humans visible, of finding alternative ways to discover their form, materiality, and agency. From plants and insects in urban gardens to the sea life traveling through the Pacific garbage patch or the microbiota of a human gut, public spaces appear to different species in different scales and scopes. The interrogative designer must be accountable to the multiple stakeholders and inhabitants of the spaces, but also responsible to the question of who else can participate in making that space. The work involves understanding the relational and entangled nature of all beings in that space—whether it is called a garden, habitat, or public space.

The example of a different sense of the public can be found in Eduardo Viveiros de Castro's interpretation of Amerindian "perspectivism."[5] In this cosmology, who is human, who is jaguar, who is animal, who is people is a matter of point of view. Jaguar sees itself as people but the human as the animal, whereas the human sees the jaguar as the animal and itself as people. All species can be people, but they see different worlds. As McKenzie Wark comments, there is no nature and a multicultural way of interpreting it to save a privileged spot for humans.[6] Multinaturalism accepts that the public of the people involves the human but also expands beyond it.

Interrogative design's efforts to reclaim the public on behalf of the marginalized can pay attention to multispecies cosmology. The diplomacy needed here is not to pick a worldview but rather invest in the relationships to give each party equal opportunities to express the worldview. Publics here are grounds in which sociality of species is negotiated in its complexity and cannot be reduced to the preferences or needs of a single party. Viveiros de Castro unpacks the practices of cultivation, water management, and agroforestry of Amerindians in the Amazons to show how they differ from Western models of engineering that tend to identify and solve problems with (violent) simplification. The Indigenous peoples that reoccupied the semiarid region of the interior of northeastern Brazil after it had been decimated for three decades by national geoengineering methods such as cattle overgrazing, deforestation, and industrial farming demonstrated a different type of engineering that makes them able to cohabit the land with their nonhuman public.[7] Through a different design methodology, dubbed as "geobricolage" by Viveiros de Castro, the Indigenous peoples relied on more complex alliances with the land, which included alliances with scientific institutions as well as new ways to adapt to the shifting needs of the flora and fauna by using different seeds, biofertilizers, organic defensives, soil and spring recuperation techniques learned from a network of communities.

Instead of sifting and sorting ontological differences into a preestablished set of values to fight or defend against, this lens provides a framework of interrogative bricolage that adapts—to be able to work with a multitude of values of

a heterogeneous cosmology, while amplifying the voices of the unheard and unrepresented fauna, flora, and their humans.

Conceptualization of what is more-than-human does not rest on the idea of human, white or not. It rather rests on an ability to interrogate what creates exclusivity and the prohibitive differences of belonging to the same fabric of the "public." It explores the possibilities of designing with alternative voices that exist at the margins of humanity. Ultimately, this allows design to become a self-reflexive framework that also constructs itself in this very process of making and unmaking (with) humans. More-than-human public space also demands an expansion of the geographical, political, or biological boundaries of public space, in which the space is not necessarily defined from the macroscopic lens of the human. The micro and macro biomes of forests, swamps, or oceans or the interiority of the human body itself shared with many other microorganisms challenge the ways in which the interests of various publics need to be acknowledged at multiple levels. Whether the designer works toward the survival of the homeless in urban public space or the vegetation facing extinction in the same urban environment, interrogative design needs to acknowledge that their survival is almost always interlinked and often caused by the same forces.

In this essay, I showed three areas where interrogative design engages with different perspectives on power, notions of care, and work with more-than human publics. Interrogative design rejects templates for critique. Each design process reworks its assumptions specific to its local context and stakeholders and intervenes accordingly. Therefore, extracting a set of specific Indigenous perspectives and apply them to interrogative design should not be done prescriptively.

Different cosmologies can help to expand beyond specific conceptions of "humans" and decenter their interests. They can work toward using human capacity to enable, empower, or restore different agencies with conflicting interests, whether they are microorganisms or ecological-scale relationships. The designer cannot take for granted which authority to trust, rely on, or design for, and

rather must critically interrogate power through its different embodiments and uses.

Interrogative designers can advocate for other ways of knowing and making their stakeholders that may conflict with the "mainstream" forms of knowing and making. Relying only on a single way of modeling and engineering reality—whether promoted as settler, Eurocentric, scientific—without questioning its interests and point of view can result in simplifying and dismissing those whose perspective is not recognized at the table.

Interrogative design may mean acknowledging difference as a precondition for both affirmation and conflict with the other: understanding that the annihilation of difference and the optimistic construction of sameness for the sake of establishing a "normal" mode of existence is the very definition of "ethnocide."[8] Interrogative design often acknowledges the incommensurability of interests as a given and, instead of working toward mitigating difference, works toward extending participation: creating more favorable conditions for otherness so that it can be expressed discursively.

As designers continue to use interrogative design in questioning and critiquing different types of "otherness," welcoming a critique of the human and how it is constructed through different design disciplines as users, consumers, subjects will help them identify the sources of inequality and injustice. A more-than-human humanism is perhaps the new vantage point needed for an intra-relational understanding of design that can invite more beings and their cosmologies to the interrogative process.

Ashland Nyanza Streetlights

Dan Borelli

2016

9.1 *Ashland Nyanza Streetlights*, in use, with blue-, green-, red-, and yellow-tinted lights.

I was a member of the first cohort of students at Harvard's Graduate School of Design seminar on Interrogative Design. In most design-based learning environments I had been involved with, the instructor brought the site, program, brief, and history of the subject as a starting point, as this teaching method fast-tracks students into problem-solving while learning about a new condition. However, the initial prompt in Interrogative Design was for us to bring our own subject matter from our lived experiences into the pedagogical space and begin a process of investigating and questioning a suite of inherited notions surrounding our chosen subject.

Having grown up in Ashland, Massachusetts, the location of one of the first of the ten sites that launched the Environmental Protection Agency's (EPA's) Superfund program, I decided to bring this

CANCER ALERT SOUNDED

State study ties Ashland waste site to an elevated risk

9.2 Cover story in the *Boston Globe*, April 26, 2006.

253

history to the seminar. I always knew this site at the center of Ashland as the Nyanza Superfund site, and I had been taught it was a chemical plant that could no longer harm us. (The plant closed in 1978 and was remediated between 1988 and 1991.) However, during the 1990s friends of mine from Ashland became sick with rare cancers and in late 1998 my friend Kevin Kane was diagnosed with angiosarcoma, like what other kids in town had. Kevin and his family contacted the Massachusetts Department of Public Health, and a cancer study was conducted, concluding in 2006 that the Nyanza Superfund site caused the cancer cluster in my hometown.

As I brought this subject to Interrogative Design, I had a simple prompt: what happened at Nyanza and how has it affected my hometown? I was startled to discover that the source of contamination at the Nyanza plant was in fact my area of academic interest; color. This site in Ashland was one of the first plants in the United States to chemically produce colors, beginning in 1917. I began to learn of firsthand experiences from field interviews with older Ashland folk and their strange encounters with the material histories of color as it spread across the local landscape: purple streams, pink mists, blue snow. Suddenly my focus on the subject of color shifted from a desire to study the phenomenology of the appearance of color to a deeply personal, subjectively driven understanding of the industrialization of color and its vast negative impact on the various ecologies of this site: people, plants, and animals. I had to confront the shared trauma of my own identity, the hidden complicity of the social system that allowed this to happen, and the odd but continuing transferal of blame from responsible parties onto my generation in the statement I often heard, "You kids shouldn't have been playing there."

As I researched community trauma, I encountered the writings of the American psychiatrist Robert Jay Lifton, particularly the memoir of his fieldwork, *Witness to an Extreme Century*. It was in Lifton's fieldwork with Hiroshima bomb survivors and Vietnam veterans that he coined the diagnosis of post-traumatic stress disorder (PTSD). He also discovered the human tendency to "double"—creating a second self to survive the atrocity both as a victim and a perpetrator of extreme violence. Lifton's work be-

came a kind of companion and guide for me as I navigated the people of Ashland and fostered allyship and participation in a public intervention.

During my video interviews with Ashland folks, I noticed the same technique of "othering" one's self, producing a double to speak of oneself in the past that allows one's current self to stay on the surface of everyday life. A process began to unfold as the subjects spoke; their doubling occurs on video, but after editing when that video goes live, they're doubling again as they move from anonymous person to public witness, and during the spectacle of a public intervention they are doubled by witnessing themselves as they are now simultaneously subject and audience.

When a fellow student, Gavin Kroeber, asked to join me, his participation became vital as we developed an "insider/outsider" dynamic. Gavin's presence exposed my own doubling that I was unaware I had buried within myself. It seems simple in retrospect, but Gavin's presence showed me that I was trained, in fact, to not speak about Nyanza, to not question the authority figures who were responsible for our safety as kids, and to not think about the larger ecological impact of contamination in our everyday life. My insider status, though, gave us access to people who had lost loved ones, and this social currency allowed us to gain their trust and begin the slow process of learning what their concerns were. A starting point was marked, and the ground was laid down for a project to unfold in the public space of Ashland. Gavin would eventually move on to his own pursuits in the following semesters, while I stayed with this site for over a decade. One thing became clear: this project was not a commission but a proposition, one that was not problem-solving but problem-making.

While doing listening tours in Ashland, I started to learn more about the EPA's data sets of the contamination in the landscape, and I came across a problem: people were speaking of the contaminants in the past tense, while the EPA had gone on record as saying they'd monitor this site "essentially forever." Why this commitment from the government for oversight in perpetuity? Because the contaminants are still present, active, and posing a threat. Of equal importance to me was that the narrative surround-

ing Nyanza and Ashland was about the technocratic disciplines working on the contaminants, while I was interested in the social histories of the contaminated, the people of Ashland and the inner narratives that they carry.

At this juncture, I came to understand that the EPA's remediation strategy was never a full removal of the contaminated matter out of Ashland but rather a containment on the site, and that system leaked into the groundwater because it was only a cap, not a container. With this knowledge, my role as an artist meant that I was responsible for exposing the community's false assumption that the cleanup eradicated the toxins, and I needed the people to understand that their town was still dirty, that the stewardship of this site is now intergenerational; and I needed them to understand where in public space the contaminants reside. As part of the EPA's work, I discovered they were producing color-coded maps of the contamination in the groundwater, red signifying the highest concentration of toxicity and purple the least. I decided to transpose the EPA's color-coded data to the nearest streetlight, placing colored filters temporarily over the existing white LEDs. This monthlong intervention created a color field in Ashland again, except this time it was communicating public health risk.

Everyone wants to hear that they're fine, that their environment is healthy and they can be assured of a long future, that there's nothing to worry about. I could not say that truthfully to the people of Ashland; rather I had to figure out a way to make the contaminants

9.3 The artist speaking at a local indigenous Nipmuc healing ceremony inside his purpose-built structure.

experiential to the contaminated without further causing harm. By participating in a public intervention, having members of the public literally see themselves give a witness testimonial through video and participating in public walking tours, I began to see my people in Ashland regain their sense of agency over the subject of Nyanza. By encountering their interred "double," they were both attesting publicly to how industrial contaminants can harm across generations while reconciling, and forgiving, their former selves. For me, this aspect of interrogative design projects allows participants to unveil their second selves, and allowing their "other" to be seen, publicly, and openly acknowledging their own doubling helps them resolve their trauma; at least that's the great hope that these collaborations aspire to.

The moment I felt that I had completed the project was when the community told me that they no longer needed me as they formed their own activist group to fight the various parties overseeing the site. You know your work is complete when there's a full transferral of ownership over the issue that's impacting the subject. It was never mine alone, it was always ours, but I can rest knowing that they are now comfortably speaking on their own in public forums.

WildUrban Radio

Dana Gordon

2009

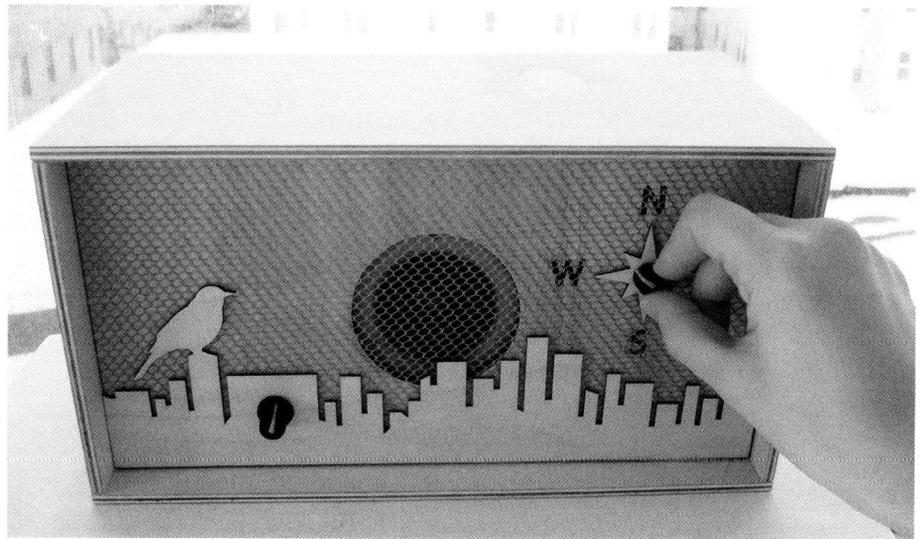

9.4 *WildUrban Radio*.

What are the birds singing about when we're not there to listen? Do you want a dose of nature indoors?

WildUrban Radio is a device that allows us to eavesdrop on our tweeting neighbors by tuning into their streaming channels from our urban environments and synchronizing to their natural pace of life. As we tune into the life of an animal, the suggestion is that we might be able to sync our daily routines with it, creating a new type of bond.

The navigation knob allows exploration of nearby wild audio streaming. The radio in the space gives visitors the opportunity to listen to a variety of live sounds from birds' streaming stations, placed near an animal's territory or nest. Does this allow us a closer link with nature or does it enable a permanent detachment from it?[1]

• Editor: Advanced technologies for communication between humans and animals will be necessary in future forms of ethical alertness. We have endless technologies of control, yet we lack digital tools for interpreting the most basic signals of pain within other organisms — or even just saying "hello." Projects such Rainforest Connection and the Earth Species Project are beginning the process of expanding human-animal vocabularies. What unexpected problems will this bring?

Interrogative Biological Design

Orkan Telhan and Ani Liu

Ani: I have been thinking a lot about how interpretations of science and biology have led to systemic inequalities, especially in regard to race and gender. Recently I started to think a lot about human exceptionalism, as prompted by Orkan's essay, and to think about whether there is any biotechnology that doesn't exploit other species on behalf of humans from a very anthropocentric point of view.

In thinking of projects that challenge this paradigm, one from Jae Rhim Lee comes to mind. The first project I saw of hers is called *N=1=NPK=KIMCHI=N*, where she changed her diet to make her urine more nutritious for plants. They were cabbage plants, which she then fermented and turned into kimchi, and the project existed in a kind of loop. The idea of changing a human diet to benefit another organism I really loved. And it really stayed with me, this project.

Orkan: It's a big spectrum, right? If we start with projects that exploit other living beings to serve the interests of humans, how do we stop exploitation? And then you go the other direction, what happens if humans really work toward designing beneficial things for other species, whether it's plants or microorganisms, taking into account their preferences and their rights of existence?

Ani: What I kept coming back to was: as magnanimous as we can try to be, there is still a human-centered motivation at the end. Are there tools that could transform our seat of subjectivity so that we could design outside of a human point of view?

Orkan: How can we use art or design projects as a methodology to enable this generation of artists and designers to critically reflect on their own practices? What is the "human"? Who is the "human"? Which human's exceptionalism are we talking about? Are we talking about the white

9.5 Jae Rhim Lee, *N=1=NPK=KIMCHI=N* (2006).

settler colonial human? Or are we talking about disenfranchised minorities that also count as human, but were never given the status of the "human" in different times, or even today? Before we dive too much into human exceptionalism, maybe we should admit that the right to be "human" was never given to certain collective groups.

Interrogative design, as a methodology, helps us ask questions and to make humaneness more accessible to those who were not given the right to be treated as humans.

Ani: When we were talking about interrogative design and the kind of work we do, I kept thinking about it in com-

parison to the scientific method. Both start with question-forming and developing a methodology to tackle the questions. Of course, interrogative design has a different metric of success than a scientific paper. We're in a moment where we're all in a pandemic and there is a relationship between society and science. Unfortunately evidence-based truths are under attack. We see this with vaccines, which have shifted beyond science and utility and have become entrenched in politics, folded with markers of identity. How can we encourage more of the population to believe in science-backed vaccines? On the other hand, there are also really troubling histories of sexism and racism in the pursuit of knowledge. I think that's one of the things that draws me into folding interrogative design into disciplines like biology, which is based in science, because it really channels that tension between science and culture, fact and knowledge adoption. Interrogative design and bio-art and bio-design are uniquely good at addressing these tensions. Some of these questions that you're asking in terms of who gets to have personhood, those are rooted in both, right?

Orkan: I'm not an expert on race studies, but there is a painful history in which scientific methods were used to invent the idea of race to be able to privilege the rights of a certain group over others. This is the politicization of science and using methods of knowledge production in service of a particular ideology.

What we are doing with our practice, if I were to call it "interrogative biological design," is to reveal some of the complicated histories of science and engineering that served these problematic ideologies and omitted others. This is not to say that there's a problem with science with a small "s." Science with a capital "S" has always been in service of different ideologies. And even if we don't use the word "science," and say "knowledge production," interrogative design can help us produce knowledge beyond science and engineering. These could be different types of knowledge (including scientifically informed ones) about different communities, about different kinds of silenced voices that were not given the rights to express themselves in the space of knowledge production.

How do we make sure that we have equitable, fair, and accountable methodologies that listen to the right people and help facilitate the production of alternative kinds of knowledge, as opposed to only subscribing to knowledge that promotes the interests of a specific interest group such as white settler colonialists?

Ani: This is one of the ways that interrogative design is a strength. It is inherently participatory. It's a conversation. It provokes dialogue. Bio-art and bio-design are also inherently participatory. And then you incorporate frameworks for structuring and sharing them. It's very urgent that all art does this now: by becoming participatory, it can hope to include diverse voices that transcend the author's own.

Orkan: Here's a question for you. Interrogative design is inclusive and rests on the idea of dialogue between designers and their subjects. When we talk about the non-human, what is the role of the dialogue? Or how can we substitute dialogue with something similar? You cannot have a dialogue with a mountain the same way you can with exploited workers in Mexico or homeless people or war veterans. If we would like to foreground the interests of landscapes, entire ecosystems, forests, animals, plants, what are the right models of engagement? What methodology or framework can we pick up from interrogative design to be able to have a dialogue with them?

Ani: That's such a good question. I think about this a lot when I work with plants. It's complicated, because the communication is on the same semantic plane as our language—it exists in biochemical signatures. And even though I produce a lot of biochemistry in my body, it's not a native language to me. I became really obsessed with learning through total immersion. I think there were days, maybe weeks, maybe a month where I didn't see any people and all I did was exist with plants. I have hopes that it changed my human-centered way of living, even if briefly. I think that, as artists, you do kind of get into an obsessive mode where you're transported to a different plane. And sometimes I feel like one starts to touch upon a different way of being.

Orkan: What you said resonates with me quite a bit. My take on that is influenced by native ways of knowing and indigenous knowledge production, some of which have

very good understandings or practices of listening. In interrogative design we learn to get better at asking questions. It becomes very performative. But there is also the opposite side: listening. What happens when you embrace the power of listening? Where you don't provoke? Where you don't ask the question, but you just listen or take in? You might use the word "immersion," but it's more like "taking in" what is already there. What is coming from the other subject? Whether it's a plant or a forest or animal, they don't speak the same language that you speak. Expecting them to speak it is human exceptionalism. What happens if you just let the thing be itself, and you try to tune to it, whether it's biochemical signals or the animal growling at you? I don't know if interrogative design has ever explored the art of listening or the power of listening to something and getting better at it. Because it's also about tuning and accepting things as they are. It's about discovering things that you were not exposed to before.

Ani: I really love that. It kind of turns it on its head. Instead of question-asking, it's listening and question-receiving. It brings to mind that tension between turning on and off the intellectual and reason-based part of me versus the intuitive part. I receive the world and its signals differently when I turn each on and off, and sometimes simultaneously in some threshold mixture.

Orkan: Yeah. You can always talk to your lover, but holding your lover's hand is a very different type of communication, right? There is no need to do anything other than just holding the hand, but we are so tuned to talking, talking, talking and explaining everything cognitively.

Editor: You both have both created provocative works that have in turn generated substantial publicity. It shows the potential of interrogative design to begin public conversations. What was your process like?

Ani: One of the first projects that comes to mind for me, that caused a lot of discussion, was made in 2016 right after Donald Trump won the election, right after he had said, super-misogynistically, "grab them by the pussy." I participated in so many protests where a lot of the signage and metaphors were around the phrase "the pussy grabs back." I started learning a lot about biopolitics and reproductive control, and isn't it shocking that in today's America, reproductive rights are still something to fight for? From a research standpoint, I was interested in myths of biological determinism that attempt to demonstrate the superiority of testosterone over estrogen and other pseudo-scientific myths like that. I found the political landscape deeply problematic, and I made this piece called *Mind Controlled Spermatozoa*, where I control the movement of sperm in a performance art piece.

The mechanism involved is called galvanotaxis, which is a phenomenon by which some single-celled organisms will move directionally in an electric field. I was interested in what it meant metaphorically and symbolically for women to control sperm, given the history of men controlling female bodies and female reproductive systems.

At some point I got on Fox News. And then I got a lot of emails. It was also very interesting to talk to people about the piece in person.

I want to foreground this by saying that, in addition to the conversations that I had with the public, I also had a lot of existential questions for myself, too, because this work was in response to very violating regimes of control. In the artwork, I control sperm myself, and I really struggled with the idea of: do you fight control with more control? It wasn't the most elegant solution. But as a maker, you have to make and learn, make and learn. As I was struggling with these ideas internally, I was also having conversations with the public. It was a moment of great growth.

A lot of women would come up to me and say that the piece felt so liberating. Someone tried this and actually cried and expressed how she spent so much of her life taking birth control, changing her own body, while often feeling such a lack of control around interactions with sperm. And it showed me that this kind of metaphorical performance and movement on a petri dish could somehow move someone. And I got a lot of responses from men who would say, "This is so violating," and it was really interesting, because the sperm was not in their body and was not from them at all. And yet they could experience a sense of visceral violation. And that would lead to conversations around the very real regimes of control that are happening to women's bodies, like forced genital mutilation, sterilization, withheld healthcare.

I would also get a lot of comments like, "This is utterly unnatural." (I think that unpacking the term "natural" or "unnatural" can have its own hour-long conversation.) And then also some men would say, "I can already control sperm, why would you invent an apparatus to control sperm?" These were the kinds of conversations I found meaningful to provoke through the work.

It's interesting that once you make the work and it enters a kind of public discourse and social psyche, it transforms and has its own life.

• Mariana Morais: That's very interesting. The anarcha-feminist María Galindo says that fighting within the power structures is not a solution because the power relations are the problem themselves.

Orkan: It's so nice to hear Ani talking about this and seeing some parallels. But some of her work has circulated so much more in public and provoked so many interesting responses. I always wondered: what happens if some of this happens to my work? But let me explain. You know, Ani gave a talk last year at Penn, and she was talking about how Fox News interpreted one of her pieces and then, literally, the next day Fox News misinterpreted one of my pieces, and the whole thing exploded.

So misinterpretation is an interesting starting point. I think it's pretty common in a lot of interrogative design projects. Because we tend to ask "what if" questions like "What if you do this in a particular way? What if you can control the sperm? What if instead of eating animal meat, you start eating human meat as your primary source of nutrition?," which was my case. So we make work primarily to ask these kinds of provocative questions. But then ultimately, when the public witnesses these questions, they respond in a different way. I don't necessarily call this "misinterpretation," because we don't ask questions looking for clear answers. We pose these questions so that people will respond and reflect.

These projects are also made for the broader culture. We make these projects for Fox News, for the people who write about them, for journalists, for scientists. They are for debate and discussion. I always think that is the purpose of the work: it is not about just speculation for the sake of speculation, but how can it mobilize certain assumptions, certain values, certain comfort levels so they get rediscussed.

As with Ani's case, I had a lot of pushback to my project. People hate to think about themselves as something edible. Some people blamed us. (It was a collaborative piece with scientist Andrew Pelling and product designer Grace Knight.) People blamed us for using science to criticize God, called us liberal democratic scientists using science to pose an ideological position that is actually against right-wing values, and so on. We got hate mail, death threats—a big range of responses. But I'm not so worried about the responses themselves. When a lot of people see this piece, they focus on cannibalism, but the project is not really about cannibalism, but rather the hypocrisy of humans and humans' relationship to the environments they have. Nobody wants global

9.6 Andrew Pelling, Grace Knight, and Orkan Telhan, *Ouroboros Steak* (2019).

warming, right? But we also do not want to change our dietary habits, which can mitigate some of its root causes.

We also talked about consent. We love consent. My project violates a lot of our assumptions about our relationship to each other in a society. We don't want to break the rules of consent. But when we consume animals, plants, trees, ecologies, we never ask their consent. We just consume them indiscriminately.

Going back to the question "What does it mean to really get the consent of a forest before you chop it down?"—there are cultures that have been thinking about or asking these kinds of questions for a long time. There are native cultures that have been thinking about killing whales and coming up with ways to kill the whales. Not the way industrial whaling is doing it. Or chopping trees, but not the way industrial forestry is doing it.

Ani: I really love that project. It's one of those projects that kind of embeds itself into the cultural psyche. You can't forget it afterward.

• **Editor:** The book of Isaiah, with some of the oldest writing about peace, contains some phrasing around the eventual end of violence in human societies ("swords into ploughshares") and between species ("lion and lamb"). There is also a prescription for a new kind of diet. It's not vegetarian and it is decidedly not paleo. The diet for people in this utopian future is "milk and honey," often interpreted to mean abundance. Another interpretation is that we consume only what other organisms naturally produce for food.

Obviously human meat isn't kosher, but would lab-cultivated steaks fit this utopian diet? Your new ethical questions orbit some very old concepts.

• **Mariana Morais:** Your comment reminded me of Francis Alÿs's work *When Faith Moves Mountains*.

Headless Women in Public Art

Mariana Morais

2018

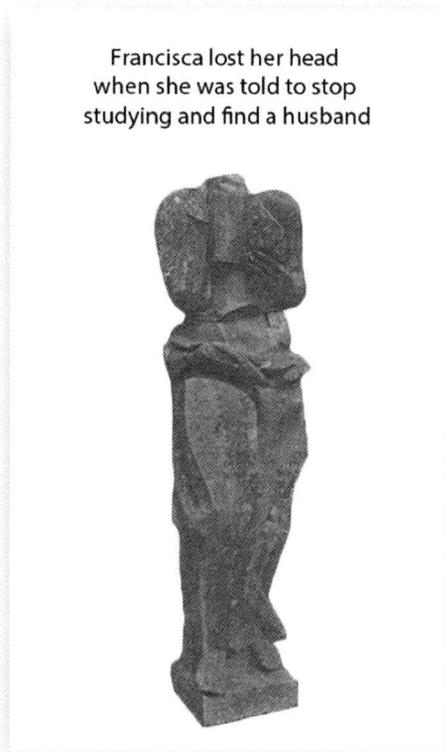

Francisca lost her head when she was told to stop studying and find a husband

9.7 *Headless Women and Other Events,* poster.

9.8 *Headless Women and Other Events,* installation.

The concept of interrogative design starts from the premise that the world as it stands is "unacceptable and contradictory."[1] It is a concept created to critically investigate our complex and often painful lived experiences instead of seamlessly concealing them.

Since 2018, I have been wheatpasting posters in the public space of Porto, Portugal. The posters, part of a bigger project called *Headless Women and Other Events*, were created to critically reflect on how the society's cultural and social frames are transmitted to permanent public art and how they affect the current gender dynamics in public space.

One of the notions of interrogative design that is most valued in my research is the idea of deconstruction. A design that is interrogative does not try to maintain or restore the present social structures but rather to take them apart, revealing their interior no matter how uncomfortable this might be. In other words, interrogative design seeks to free life from cover-up solutions in order, in Wodiczko's words, to "scandalize" so the problems can be faced and finally addressed. Permanent public artworks perpetuate representations and narratives of a specific society over the decades, and consequently generate great contrasts when they no longer relate to the current social structure—as has been demonstrated in recent protests in North America, Latin America, and Europe, where monuments of colonizers and enslavers are being seriously questioned. In Porto, I found that the most common representations of women in public art are traditionally sexist and discriminatory and the narratives surrounding them are often exclusionary and cruel. Numerous monuments contain naked female figures, sometimes headless, positioned passively in front of a male figure that looks powerful and virile. The uncanny aspect of these headless figures installed in the city's public spaces disturbs me a lot—it almost makes me "lose my head."

In my perspective, it is the deconstructive aspect of interrogative design that uncovers the chaos of our "difficult lived-through experience" and consequently scandalizes. I believe that the deconstructive aspect and its scandalizing consequence have a disruptive effect. This disruptive effect should create discomfort, but it should also cause curiosity and ideally a sense of involvement that is not only intellectual but also emotional. In this aspect, the disrup-

tive effect does not align with Brecht's interruption effect, as it not only appeals for the spectator's intellectual empathy but also for their emotional response.

Through photography cutouts, repetitions, and recombinations, I created a series of 16 low-fi wheatpaste posters. The act of cutting and reassembling the photographs shows the posters' inherent intention to deconstruct the permanent sculptures and thus to portray a different kind of narrative. They are objects of resistance that hope to sustain a certain level of ethical awareness. Making and sharing the posters allowed me to look into my unpleasant experiences in public spaces and turn them into something that is relatable and fruitful. It allowed me some sort of control over those experiences. The posters aim to invert the essentialist logic that I identified in Porto's public art by using humor and irony to question issues such as the imposition of standards of beauty, sexual harassment, female sexuality, and the fetishization of the female body. The idea with these objects is not to rewrite the stories of the public sculptures, but to revisit the common narratives associated with women and the female body, to highlight their heavy historical legacy. The posters were placed on the walls of vacant buildings in Porto with the objective of encouraging a broader participation in the debate on gender dynamics in the city. In other words, they appeal to both intellectual and emotional responses.

I believe that emotional—more than intellectual—involvement is rather unavoidable, especially when it comes to applying interrogative design in the public sphere as opposed to a more controlled and "protected" environment such as Brecht's theater. Artistic and design manifestations in public space become accessible to those who have never entered a museum, art gallery, or theater. Thus, as their narratives take on another dimension, they are susceptible to other approaches, making it harder to predict the public reaction. The disruptions caused by the wheatpaste posters, however small, encouraged interactions between artists and the city, people who see the posters and the city, and between passersby and artists. The posters I pasted also showed the address for my Instagram page (instagram.com/headlesswomeninpublicart). This page was created to register my interventions as well as to share reflections on public art in a more general sense. Not long after I put up the *Headless Women* posters, I received photographs of people's interactions with the posters and many messages of support. Some people even wrote their own input on the

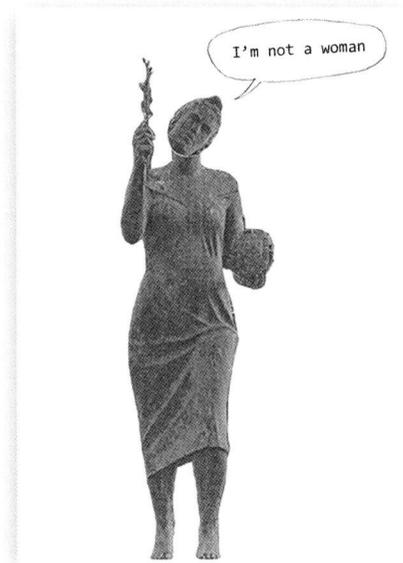

9.9 *Headless Women and Other Events*, poster.

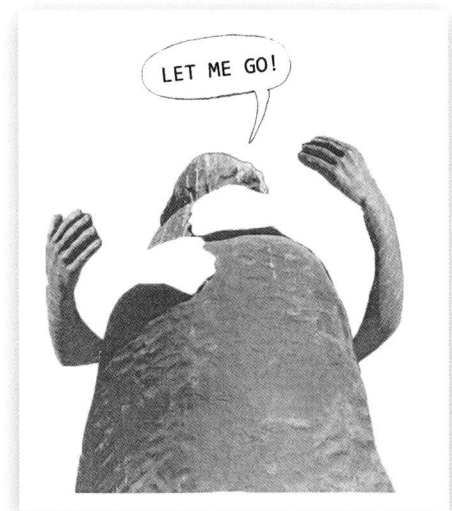

9.10 *Headless Women and Other Events*, poster.

263

9.11 *Headless Women and Other Events*, poster.

9.12 *Headless Women and Other Events*, deinstallation.

posters, and because of that I have also made the poster designs available online so they can be filled out and printed by anyone interested in pasting them around a city (headlesswomeninpublic.art/narratives).

The interrogative nature of the posters allowed not only for virtual interactions but also for interactions in real life. While I was putting up some posters, people passing by stopped to look, photograph, or directly talk to me. Wheatpaste posters' ephemeral nature and small size give them an informal character which makes them generally considered acts of vandalism. The discomfort and disapproval of passersby was also seen in the tearing off of the posters. The most intense interaction took place on a Sunday afternoon in May 2019, when I was putting up some posters on Rua de Cedofeita. A woman stopped by and asked me to remove the posters. She told me, with some sense of authority, that she worked in Porto's tourism sector and my intervention was contributing to making the city ugly. I explained to her that what I was doing was not permanent, and that the posters are easily removed. I also tried to explain the reason why I was doing the intervention, without success. Before leaving, she threatened to call the police as, in her understanding, I was committing an act of vandalism.

Instead of discouraging me, the strong reactions help me to situate my work in public space and public opinion. They are proof of the disruptions caused by the posters; of the chaos they have conveyed. Rather than avoiding the strong reactions, I am willing to accept them for what they are: a result of a disruptive intervention in a democratic society. It is interesting that of all the people passing by, the one who engaged with me the most was someone from the tourism sector. Tourism is a field that normally highlights the city's greatest aspects while concealing its problems, which are considered unattractive and bad for business. These are necessary reactions that propel me to comprehensively look into my work, to review it, to question it and to keep on checking its relevance. The spoken and unspoken negotiations between the passersby, myself, and public space allowed by the posters' "interrogativeness" are necessary for the conversation to evolve and, ultimately, an evidence of how interrogative design is still relevant today.

Nanohana Heels

Sputniko!

2012

Chernobyl in 1986 and Fukushima in 2011: two cities and two dates, distant in time and space, that bear testament to the devastating, long-lasting consequences of nuclear power plant accidents. When British-Japanese designer Sputniko! (Hiromi Ozaki) learned that Belarusian scientists had discovered that rapeseed blossoms absorb radioactive substances from soil, she imagined flowers as an ideal partner to restore the lands torn by the Fukushima Daiichi nuclear disaster. This idea developed into *Nanohana Heels*, in collaboration with shoe designer Masaya Kushino: shoes whose mechanical high heels plant rapeseeds (*nanohana* in Japanese) with each step—thus turning a stroll into a light, dynamic, reparative act.[1]

9.13 *Nanohana Heels*, outdoors.

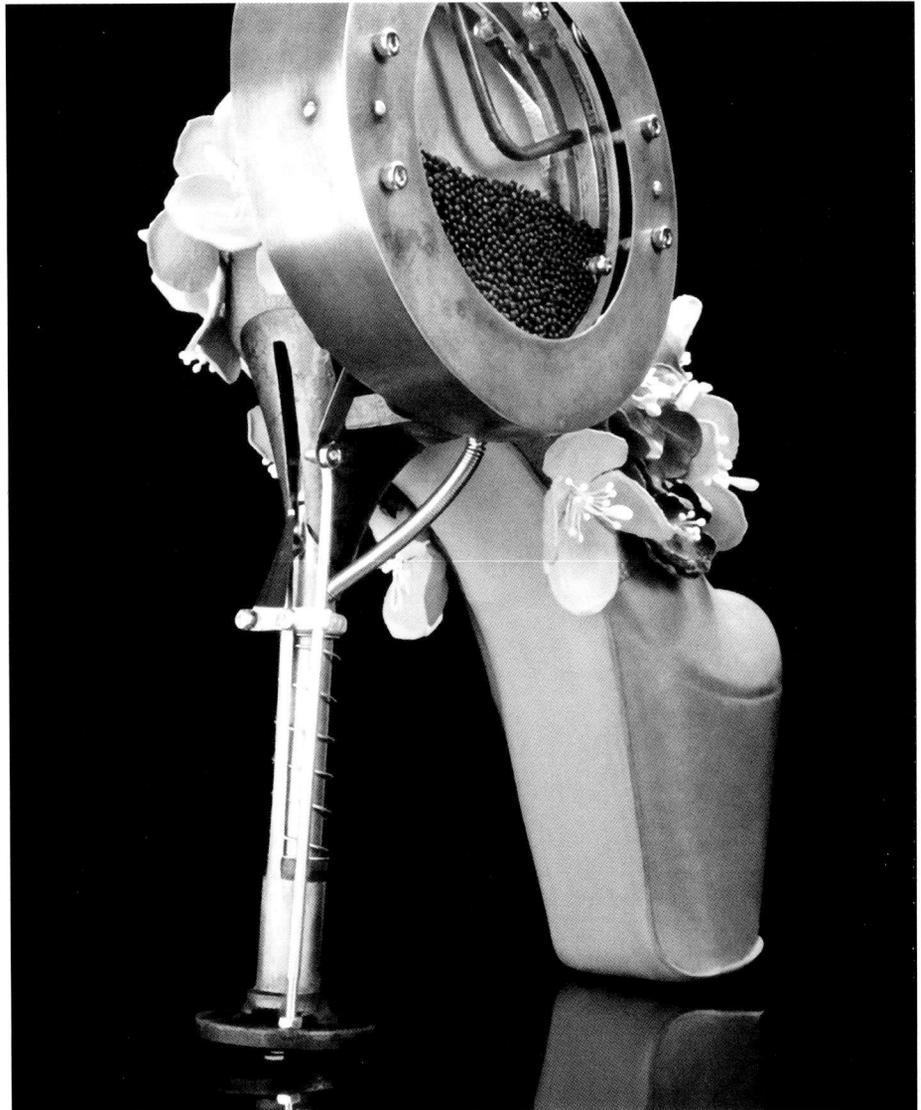

9.14 *Nanohana Heels*, detail.

The 70th Anniversary of the Hiroshima Bombing

Krzysztof Wodiczko

Originally published online in 2015, reprinted in *Transformative Avant-Garde and Other Writings* (London: Black Dog Press, 2020)

70th Anniversary
of the Hiroshima Bombing

2015

Nuclear weapons have changed everything except the way we think.

Albert Einstein

To Artists

Seventy years ago Hiroshima and Nagasaki were destroyed by nuclear weapons. The atomic bomb that exploded over Hiroshima killed women and children in addition to soldiers. Within three miles of the explosion 60,000 out of 90,000 buildings were demolished. Out of Hiroshima's estimated population of 350,000, almost one third—approximately 70,000 people—died immediately. Within three years the total death toll from radiation and wounds reached 200,000 and as of today stands at 297,684.

As a site, Hiroshima epitomizes our living memory of destruction and disregard for human life. It is the historical and ethical referent that compels us to condemn all acts of war and urges us to end the perpetuation of war.

Questions concerning 'why' Hiroshima and Nagasaki were bombed with nuclear weapons are pointless and ethically insulting, implying that there might be acceptable explanations and 'logical reasons' to justify the atrocities. The cause was the war itself. If there had not been a war, there would have been no bombing of any kind.

There would be no war—and no Hiroshima bombing—if there had occurred a change in our 'way of thinking'. Our eternal assumption that conflict can be 'resolved' by war, and that 'the path to peace is war' must be changed. 'The way we think' is assumed to be immutable by our national cultures. In fact, all nations, nation-building societies, and their governing bodies cultivate such a notion.

To end the perpetuation of war requires ending the perpetuation of the very idea of war. International laws, treaties, and UN conventions are only pieces of paper as long as they remain contradicted by the actual practices of nation-states

War/Un-War

and statehood-seeking groups that everlastingly drag their ideological patterns, rituals of culture, and cult of war through the centuries.

The processes of preparing for, waging, and commemorating war are seen as essential elements of history, rooted in human psychology, and admired as a martial cultural tradition that, with a powerful intensity of emotion, remains central to the lives of those who participate in it.

354

The motivation to fight and die in war is preserved by a war culture that manifests itself through uniforms, war games, parades, military decorations, and war memorials (including statues and shrines, triumphal arches, cenotaphs, victory columns, and other commemorations of the dead), as well as the creation of war art and military art, martial music, and war museums, not to mention the popular fascination with weapons, war toys, violent video and computer games, battle re-enactments, collectibles, military history, and literature.

The Culture of War makes men and women face death willingly, even enthusiastically. War is a destructive, self-destructive mass operation, and the Culture of War reinforces its social pathology and its function as "an end in itself."

Some facts are so enormous that we do not see them. The largest such fact is that war poses a mortal danger to our civilization. Our blindness results in tolerance, passivity, and silence when faced with the international legitimacy and popular acceptance of the Culture of War. Such silence and passivity is closely related to our denial, blaming of others, and inadequate effort in taking action toward eliminating war. It leads us to the point of annihilation through nuclear warfare. Public attitudes are a symptom of the contradictory condition in which we claim a critical stance against war, while simultaneously we pay taxes that support war and enthusiastically attend war parades and war films, with their necro-orgiastic spectacles.

Changing such a deeply rooted cultural acceptance of war needs a proactive approach that combines critical interventions that disrupt, ridicule, and unmask our hypocrisy with new transformative projects: projects that engage the cultural and pedagogical sphere, directed to all, but especially the young.

We must contribute to this complex task through our own individual and collective experimental and proactive projects. We must do so through collaboration with those from other fields and disciplines, engaging anyone who can contribute their commitment, experience, knowledge, sensitivity, and talent to the cause.

As psychoanalyst Hanna Segal has pointed out, "The war manifestations are despised and regularly denigrated as atavistic and irrational while secretly or openly embraced and celebrated." The Culture of War consolidates this psychological division of our souls. To challenge such a schism requires an exceptional investment of political will, ethical energy, cultural imagination, intellectual depth, and artistic vision.[1]

In such a complex war-ending project, the preferred term should be 'Un-War' rather than the word 'peace', because peace is not a simple matter. To end wars, one must first confront the social and cultural phenomenon of war and recognize how firmly war is entrenched in our singular and collective minds. Un-War is the new state of mind that enables the process of understanding, uncovering, and undoing war. It acknowledges that war exists as something hidden within us, which must be brought symbolically and culturally to our singular consciousness before matters erupt into bloody conflict. The other implication of the term Un-War is that war is an old state of mind and a mental condition installed in us from without, through the Culture of War. We must culturally uninstall it.

Transformative Avant-Garde and Other Writings

Editor: A common pacifist approach is to avoid all study of war under the premise that ignorance is a form of protest against militarism. Yet, as George Friedman recently said, this attitude may be ineffective and even counter-productive. "You may not be interested in war, but war is interested in you."[1]

How would someone like President Eisenhower have responded to Wodiczko's un-war concept?

The task of dismantling the Culture of War requires the creation of new methods of transforming all war-based and war-bound cultures toward a Culture of Un-War as a global, national, regional, and urban project. We must do so on through the laboratories and experimental zones that are provided to us by arts funding, art education, art production and art-disseminating media, institutions, organizations, agencies and centers. We must also do so with non-artistic governmental and non-governmental organizations, institutions, and networks.

Culture, especially popular, artistic, and media culture, is the field in which we work. We, the artists, know of the larger national culture—an essential part of which is the Culture of War. We know it all too well. Such knowledge has been for a long time based on our own direct experience with it.

In fact it is we ourselves—artists and designers, including architects—who are profoundly implicated in reinforcing and disseminating the culture and cult of war. Since ancient times artists of all kinds—visual, sound, performance, and mixed-media—have been major contributors to the culture of war; think of the massive presence in museums of military art and the participation of artists in war propaganda efforts and in designing symbolically and visually effective uniforms, armor, and camouflage, as well as hundreds of thousands of artistically conceived war monuments, memorials, and shrines that promote war as a way to make peace, or as a way of admiring killing and death as a noble duty and a sacred sacrifice.

If artists and designers have contributed to war through its aesthetic reinforcement, phantasms, war mobilizations, and indeed through *tools for* warfare itself, they can certainly contribute to the opposite: the creation of a un-war culture and the construction of a new consciousness toward a war-free civilization based on the global abolition of war.

Fortunately we also know war culture through our noble tradition of opposing war, of opposing both war itself and the culture and cult of war throughout at least four centuries of anti-war art which engages visual arts, performing arts, media arts, music and poetry and literature projects, movements, and campaigns.

We are prepared.

A number of important artists have questioned the assumptions surrounding war: Francisco Goya, Honoré Daumier, Édouard Manet, George Grosz, Otto Dix, Käthe Kollwitz, Pablo Picasso, Hans Haacke, Leon Golub, Nancy Spero, Yoko Ono, Barbara Kruger, Jochen Gerz, Ben Shahn, Walid Raad, William Kentridge, and collectives such as Publixtheatre Caravan are just some examples of past and present anti-war artistic endeavors. Significant parts of this tradition include, after the First World War, Ernst Friedrich's *War Against War* project and the Anti-War Museum in Berlin (shut down by the Nazis in 1933), as well as John Heartfield's photomontages satirizing the Nazis. Following the Second World War, there was also Robert Filliou's Fluxus proposal for exchanging war monuments between adjacent countries and Yoko Ono's 'art for peace.' The Vietnam War ended in part thanks to resistance movements supported by anti-war artists. Artists have long been involved in conflict-transformation initiatives, war-related post-traumatic stress relief, and cross-cultural communication projects. Many war veterans and members of their families have become artists so as to better heal their emotional wounds and publicly share their war experiences, while addressing society's lack of a truthful emotional comprehension of war.

355

9.15 President Eisenhower's farewell address, January 17, 1961 (video still).

16

Only an alert and knowledgeable citizenry can compel the proper meshing of the huge industrial and military machinery of defense with our peaceful methods and goals, so that security and liberty may prosper together.

AKIN TO, and largely responsible for the sweeping changes in our industrial-military posture, has been the technological revolution during recent decades.

IN THIS REVOLUTION, research has become central; it also becomes more formalized, complex, and costly.

9.16 President Eisenhower's farewell address (excerpt from reading copy of speech).

War/Un-War

— Design of special portable or wearable media equipment for discursive re-reading of the textbooks, history books, and national literature with a suggested new critical and analytical approach to wars and conflicts while inserting missing data, including the missing groups and individuals who contributed to averting the wars.
— Development of new pedagogical art projects that engage people in informing their perception and discussion on war impact on specific civilian populations abroad, as well as in one's own country and home town.
— Design of new computer-based or wearable Un-War equipment for interpretative and analytical ways of watching war and military action films, including military recruitment advertisements, and war-saturated TV 'history' channels.
— Design of tools for gatherings, civic actions, and protests as an alternative or a supplement to official war-related commemorative or celebratory occasions and events (also to be used for performative actions that engage war and war-related monuments).
— Special deconstructive and playful artistic and design projects for the recognition and development of critical distance to one's own hidden desire and fascination with war (which contradicts one's own resentment to it), and for openly discussing such issues with others, especially in the public domain.
— Development of new communicative cultural and art projects with war refugees and war veterans to help them to open up and share their war and post-war experience and challenge our ideas—especially among young people—about the reality of war and its existential and mental problems and cross-generational fallout.

There are, of course, many other possible methods, techniques, and contexts for Un-War projects. This is a call for us—artists and designers—to join each other in a global project to recognize and dismantle, through our projects and actions, the culture of war both from within and without ourselves. To educate our societies and nations about war, we must build a new vigilance toward a culture based on mediation and a sense of common interest that is dynamic, 'agonistic' and open, cherishing healthy, and creative conflicts but never violent—a Culture of Un-War.

1 Segal, Hanna, *Psychoanalysis, Literature and War: Papers 1972–1995* (edited and introduced by John Steiner), Abingdon: Routledge, 1997.
2 Rotblat, Józef, from his Nobel Peace Prize acceptance speech, 1995.

357

— Design of special portable or wearable media equipment for discursive re-reading of the textbooks, history books, and national literature with a suggested new critical and analytical approach to wars and conflicts while inserting missing data, including the missing groups and individuals who contributed to averting the wars.

— Development of new pedagogical art projects that engage people in informing their perception and discussion on war impact on specific civilian populations abroad, as well as in one's own country and home town.

— Design of new computer-based or wearable Un-War equipment for interpretative and analytical ways of watching war and military action films, including military recruitment advertisements, and war-saturated TV 'history' channels.

357

— Design of tools for gatherings, civic actions, and protests as an alternative or a supplement to official war-related commemorative or celebratory occasions and events (also to be used for performative actions that engage war and war-related monuments).

— Special deconstructive and playful artistic and design projects for the recognition and development of critical distance to one's own hidden desire and fascination with war (which contradicts one's own resentment to it), and for openly discussing such issues with others, especially in the public domain.

— Development of new communicative cultural and art projects with war refugees and war veterans to help them to open up and share their war and post-war experience and challenge our ideas—especially among young people—about the reality of war and its existential and mental problems and cross-generational fallout.

There are, of course, many other possible methods, techniques, and contexts for Un-War projects. This is a call for us—artists and designers—to join each other in a global project to recognize and dismantle, through our projects and actions, the culture of war both from within and without ourselves. To educate our societies and nations about war, we must build a new vigilance toward a culture based on mediation and a sense of common interest that is dynamic, 'agonistic' and open, cherishing healthy, and creative conflicts but never violent—a Culture of Un-War.

1 Segal, Hanna, *Psychoanalysis, Literature and War: Papers 1972–1995* (edited and introduced by John Steiner), Abingdon: Routledge, 1997.
2 Rotblat, Józef, from his Nobel Peace Prize acceptance speech, 1995.

Acknowledgments

A heartfelt thank you to Krzysztof for creating interrogative design and allowing us to advance the idea (in time, if not in quality). I hope we avoided monumentalizing you and instead illustrated your framework well enough for others to lean on and glean from.

I owe much gratitude to all the contributors to whom, along with Professor Wodiczko, this book belongs. The ideas, advice, criticism, and productive disagreements of our inner-public editorial meetings helped shape this volume. Orkan Telhan, Ben Wood, Warren Sack, J. B. Labrune, Garnet Hertz, Nitin Sawhney, Chris Csíkszentmihályi, and Sung Ho Kim provided encouragement at important moments. Thank you to Barry Shell, Hank Bull, and Ron Burnett for critiques on early drafts. Mark Jarzombek, Zenovia Toloudi, and Azra Akšamija were all strong supporters of decentering the historical narrative of interrogative design while honoring Krzysztof's work in marginalia. Sara Hendren and Kelly Dobson's perspectives on technology's ameliorative promise have greatly improved the quality of these pages, charting transformative approaches beyond interrogative design. Conversations with Michael Rakowitz were fun and profound, refocusing me on art's important role in democratic life. Dan Borelli, the curator of Harvard's exhibition on Krzysztof's oeuvre, provided insightful practical advice and encouragement. Maria Niro's contemporaneously developed film kept higher objectives in view, beyond the world of art. The many permutations of this project were guided by these people and many others, with kindness, to a better result.

Thank you also to Gediminas Urbonas and Jeremy Grubman for archival research, to Vicky Lum and David Carson for design advice, to Larry Tesler for the technical infrastructure, and to Victoria Hindley, Gabriela Gibbs, Matthew Abbate, Jay Martsi, and Yasuyo Iguchi at the MIT Press for so improving the form of this book. I am also very grateful for production support from the Art, Culture, and Technology program at MIT and the Polish Cultural Institute of New York. Dziękuje serdecznie.

Life would not be the same without my father's continuous levity and wisdom nor my mother's lifelong enjoyment of composition (and recomposition). Jessica, Luna, Noah, (Indy), my immediate family, you worked through all my ups and downs. This book is yours too. May you leaf through it someday and decide it led to a better world for you, your chavarim, and your own future mishpachot.

POLISH CULTURAL
INSTITUTE
NEW YORK

ART
CULTURE
TECHNOLOGY

MIT

Notes

Preface

1 Bruce Sterling, "Disobedient Electronics: Call for Submissions," *Wired*, November 16, 2016, https://www. wired. com/beyond-the-beyond/2016/11/disobedient-electronics-call-submissions/.

1 Introduction

1 "The Science in Science Fiction, Interview with William Gibson," NPR: *Talk of the Nation*, November 30, 1999. (The quotation is spoken around 11:50.)

2 George Will, *Suddenly: The American Idea Abroad and at Home, 1986–1990* (New York: Free Press, 1992), 223.

3 Christoph Lakner and Branko Milanović, "Global Income Distribution: From the Fall of the Berlin Wall to the Great Recession," *World Bank Economic Review* 30, no. 2 (2016), 203, doi:10.1093/wber/lhv039.

4 Richard G. Wilkinson, "The Impact of Inequality," *Social Research* 73, no. 2, "Fairness: Its Role in Our Lives" (Summer 2006), 714, http://www.jstor.org/stable/40971843.

5 Susan Martin, "Climate Change, Migration, and Governance," *Global Governance* 16, no. 3 (2010), 397, http://www.jstor.org/stable/29764954.

6 House Permanent Select Committee on Intelligence, House Select Committee on Energy Independence and Global Warming, *National Intelligence Assessment on the National Security Implications of Global Climate Change to 2030* (June 25, 2008).

7 Hannah Knowles and Abby Ohlheiser, "Doomsday Clock Is 100 seconds to Midnight, the Symbolic Hour of the Apocalypse," *Washington Post*, January 23, 2020, https://www. washingtonpost.com/weather/2020/01/23/doomsday-clock.

8 "List of Ongoing Armed Conflicts," *Wikipedia*, https:// en.wikipedia.org/wiki/List_of_ongoing_armed_conflicts.

9 Office of the Director of National Intelligence, "Intelligence Community Assessment: Assessing Russian Activities and Intentions in Recent US Elections. ICA 2017-01D," *National Intelligence Council* (January 6, 2017), https://www.dni. gov/files/documents/ICA_2017_01.pdf; Scott Shane and Vindu Goel, "Fake Russian Facebook Accounts Bought $100,000 in Political Ads," *New York Times*, September 6, 2017, https://www.nytimes.com/2017/09/06/technology/ facebook-russian-political-ads.html.

10 Yuval N. Harari, "Why Technology Favors Tyranny," *Atlantic* (October 2018), https://www.theatlantic.com/magazine/ archive/2018/10/yuval-noah-harari-technology-tyranny/568330.

11 Thomas Homer Dixon, *The Ingenuity Gap* (New York: Vintage, 2000), 1.

12 Jaron Lanier, *Ten Arguments for Deleting Your Social Media Accounts Right Now* (New York: Henry Holt , 2018), 5.

13 "Every time you go to a source for information, you renew a relationship between writers and readers that may be centuries old." Wayne C. Booth, Joseph M. Williams, and Gregory G. Colomb, *The Craft of Research* (Chicago: University of Chicago Press, 2003), 17.

14 Jean M. Twenge, Gabrielle N. Martin, and Brian H. Spitzberg, "Trends in U.S. Adolescents' Media Use, 1976–2016: The Rise of Digital Media, the Decline of TV, and the (Near) Demise of Print," *Psychology of Popular Media Culture* 8, no. 4 (August 20, 2018), 329, https://doi.org/10.1037/ ppm0000203.

15 Ziming Liu, "Reading Behavior in the Digital Environment: Changes in Reading Behavior over the Past Ten Years," *Journal of Documentation* 61, no. 6 (December 1, 2005), 700, https://doi.org/10.1108/00220410510632040.

16 Krzysztof Wodiczko, in discussion with the editor, April 6, 2019.

17 Krzysztof Wodiczko, "Inner Public," *Field: A Journal of Socially-Engaged Art Criticism* (Spring 2015), 28.

18 Krzysztof Wodiczko, "Statement of Purpose," *Interrogative Design Group*, accessed May 11, 2019, http://web.archive. org/web/20010422045615fw_/http://web.mit.edu/idg/ purpose.html; original date April 22, 2001.

19 Krzysztof Wodiczko, in discussion with the editor, May 7, 2019.

20 Krzysztof Wodiczko, in discussion with the editor, May 7,

2019.

21 Ruth Levitas, "Educated Hope: Ernst Bloch on Abstract and Concrete Utopia," *Utopian Studies* 1, no. 2 (1990), 17.

22 Levitas, "Educated Hope," 17.

Interrogative Design

1 Interrogative Design Workshop, https://web.mit.edu/idw, accessed Feb 20, 2024.

Homeless Vehicle

1 Eric Roth, executive director of Bowery Mission, New York, interviewed by Derek May in *Krzysztof Wodiczko: Projections* (1991), National Film Board of Canada.

2 Krzysztof Wodiczko, interviewed by Derek May in *Krzysztof Wodiczko: Projections* (1991), National Film Board of Canada.

3 M. R. Burt, "Homelessness: United States," in *International Encyclopedia of the Social and Behavioral Sciences*, ed. Neil J. Smelser and Paul B. Baltes (Oxford: Elsevier Science, 2001), 6895–6899.

4 Krzysztof Wodiczko, *Critical Vehicles: Writings, Projects, Interviews* (Cambridge, MA: MIT Press, 1999), 84.

5 See Sam Tsemberis, *Housing First: The Pathways Model to End Homelessness for People with Mental Illness and Addiction* (Center City, MN: Hazelden Publishing, 2010).

Ethical Media Art: A Seminar

1 Krzysztof Wodiczko, "Cultural Prosthetics," in *Transformative Avant-Garde and Other Writings* (London: Black Dog Press, 2011), 116.

The Interrogative Design Group

1 Carol Tavris and Elliot Aronson, *Mistakes Were Made (but Not by Me): Why We Justify Foolish Beliefs, Bad Decisions, and Hurtful Acts* (Orlando, FL: Harvest Book, 2008), 197.

Beyond Interrogative Design?

1 Dick Hebdige, "The Machine Is Unheimlich," *Sightlines* (Walker Arts Center, August 30, 2012), 9.

2 Rosalyn Deutsche, "Uneven Development: Public Art in New York City," in *Evictions: Art and Spatial Politics* (Cambridge, MA: MIT Press, 1998), 73.

2 When Is Design a Question?

1 Krzysztof Wodiczko, "Interrogative Design," in *Critical Vehicles: Writings, Projects, Interviews* (Cambridge, MA: MIT Press, 1999), 17.

2 George Loewenstein, "The Psychology of Curiosity: A Review and Reinterpretation," *Psychological Bulletin* 116, no. 1 (1994), 91.

3 David Graeber, *Debt: The First 5000 Years* (Brooklyn: Melville House, 2011), 104.

4 Ronald D. Vale, "The Value of Asking Questions," *Molecular Biology of the Cell* 24 (March 15, 2013).

What Is a Question

1 Lani Watson, "What Is a Question," *Philosopher's Magazine* (3rd quarter 2018).

2 *The Oxford English Dictionary*, 3rd ed. (2010), s.v. "question."

3 *Google*, "what is a question—Google Search," https://www.google.com/search?q=what+is+a+question, accessed December 13, 2021.

4 *Dictionary.com*, "Question," http://dictionary.com/browse/question, accessed December 13, 2021.

5 *Wikipedia*, "Question," http://en.wikipedia.org/wiki/Question, accessed December 13, 2021.

6 *The Collins Concise English Dictionary*, 8th ed. (2012), s.v. "question."

Slope : Intercept

1 Sara Hendren, *Slope : Intercept*, https://web.archive.org/web/20170622132826/http://slopeintercept.org/about/, accessed May 22, 2022.

The Emancipati Ensemble

1 Orkan Telhan, *The Emancipati Ensemble* (2013), https://www.orkantelhan.com/#/emancipati-ensemble/.

2 Irshad Manji, *The Trouble with Islam: A Wake-up Call for Honesty and Change* (Toronto: Random House of Canada, 2003).

When Is a Museum?

1 Arjun Appadurai, *Right to Research* (Montreal: McGill-Queen's University Press, 2006).

2 Clementine Deliss, *The Metabolic Museum* (Berlin: Hatje Cantz Verlag, 2020).

Museum Dissensus Instrument

1 In Fred Wilson's 1992 intervention *Metalwork*, at the Maryland Historical Society, he moved slave shackles from one part of the museum and placed them next to the fine silver dinnerware in another part of the museum. The project was part of an invited artist residency, but imagine if public rearrangements of this kind were part of the structure of museums. Some museums could become complex and ener-

getic inside-out archive-collage-colleges, not unlike how Wikipedia builds reliable truth and scholarship through patchwork open-access editing and transparent debate and proof.

The Paradox of Contradiction

1 Michael Huemer, "In Defense of Illegal Immigration," in *Open Borders: In Defense of Free Movement*, ed. Reece Jones (Atlanta: University of Georgia Press, 2019); also see my "Dislodged from History, Confronted by Walls: Picturing Migration as a Global Emergency," in *Refugees and Migrants in Contemporary Film, Art, and Media*, edited by Robert Burgoyne and Deniz Bayrakdar (Amsterdam: Amsterdam University Press, 2022), and my "The Migrant Image: Fear of 'Replacement' and the Resurgence of White Nationalism," in *Terrorism and the Arts: Practices and Critiques in Contemporary Cultural Production*, edited by Jonathan Harris (New York: Routledge, 2021).

3 Participation

1 Daniel Kreps, "Peter Gabriel, Pussy Riot Show Support for Hong Kong Protestors," *Rolling Stone* (November 24, 2014), https://www.rollingstone.com/music/music-news/peter-gabriel-pussy-riot-show-support-for-hong-kong-protestors-42886, accessed February 24, 2020.
2 Nicolas Bourriaud, quoted in Claire Bishop, *Artificial Hells* (Brooklyn: Verso, 2012), 11.
3 Stephen Pinker, "Language as a Window into Human Nature," *RSA Animate* (February 10, 2011), https://www.youtube.com/watch?v=3-son3EJTrU&t=7m42s, accessed February 24, 2020.
4 Bishop, *Artificial Hells*, 2.
5 Bishop, *Artificial Hells*, 9.
6 Bishop, *Artificial Hells*, 11.
7 Bishop, *Artificial Hells*, 11.
8 Bishop, *Artificial Hells*, 23.
9 Bishop, *Artificial Hells*, 22.
10 Bishop, *Artificial Hells*, 22.
11 Bishop, *Artificial Hells*, 37.
12 Sasha Costanza-Chock, *Design Justice* (Cambridge, MA: MIT Press, 2020), 6.
13 Bishop, *Artificial Hells*, 23.
14 Finn Kensing and Jeanette Blomber, "Participatory Design: Issues and Concerns," *Proceedings of the Conference on Computer Supported Cooperative Work (CSCW)* (1998), 7:167.
15 Chantal Mouffe, "Deliberative Democracy or Agonistic Pluralism?," *Social Research* 66, no. 3 (1999), 745–758.
16 Liesbeth Huybrechts, Henric Benesch, and Jon Geib, "Institutioning: Participatory Design, Co-design and the Public Realm," *CoDesign* 13, no. 3 (2017), 148–159.
17 Per-Anders Hillgren, Anna Seravalli, and Mette Agger Eriksen, "Counter-hegemonic Practices: Dynamic Interplay between Agonism, Commoning and Strategic Design," *Strategic Design Research Journal* 9, no. 2 (2016), 89–99.

The Inner Public

1 Seyla Benhabib, "Toward a Deliberative Model of Democratic Legitimacy," in *Democracy and Difference* (Princeton: Princeton University Press, 1996).
2 Chantal Mouffe, "Deliberative Democracy or Agonistic Pluralism?," *Social Research* 66, no. 3 (1999), 745–758; Chantal Mouffe, "Artistic Activism and Agonistic Spaces," *Art and Research* 1, no. 2 (2007), 1–5.
3 Ruth Leys, *Trauma: A Genealogy* (Chicago: University of Chicago Press, 2000), 105.
4 Judith Lewis Herman, *Trauma and Recovery* (New York: Basic Books, 1997), 175.
5 Jacques Rancière, *The Ignorant Schoolmaster* (Stanford, CA: Stanford University Press, 1991), 13.

Before Commodity There Was Care

1 Édouard Glissant, *Poetic Intention*, trans. Natalie Stephens (Brooklyn, NY: Nightboat Books, 2010).
2 Giorgio Agamben, *Means without End* (Minneapolis: University of Minnesota Press, 2000).
3 Bertolt Brecht, *Brecht on Theatre: The Development of an Aesthetic*, translated by John Willett (London: Methuen, 1964).
4 See Anna-Leena Siikala, *Itämerensuomalaisten Mytologia* [Mythology of Finnish tribes by the Ostrobothnian Sea] (Helsinki: SKS, 2012); Anna-Leena Siikala, *Suomalainen shamanismi* [Finnish shamanism] (Helsinki: SKS, 2019); Marja-Liisa Honkasalo, *Reikä sydämessä: Sairaus pohjois-karjalaisessa maisemassa* [A Hole in one's heart: sickness in the north Karelian landscape] (Tampere: Vastapaino, 2008); Lotte Tarka, Professor of Folkloristic Studies, Helsinki University, Finland, private interview, 2019; Kansanlääkintäseura [Society for Folk Medicine], https://www.kansanlaakintaseura.fi/eng.

The Practice of Interrogative Design

1 Rural Studio, http://ruralstudio.org.

5 ft × 6 ft (with Circulation Space)

1 James C Scott, *How Certain Schemes to Improve the Human Condition Have Failed* (New Haven, CT: Yale University Press, 1998), 55.

2 Charles-Édouard Jeanneret (Le Corbusier), "Edict of Chandigarh" (1959), https://chandigarh.gov.in/know-chandigarh/edict-of-chandigarh.

3 Ananya Roy, "Urban Informality: Toward an Epistemology of Planning," *Journal of the American Planning Association* 71, no. 2 (2005).

4 Madhu Sarin, *Urban Planning in the Third World: The Chandigarh Experience* (London: Mansell, 1982), 147–158.

5 Since the writing of this essay, a full fleet of 16 electric rehris was launched in the city (in January 2023). The significance was underscored when the mayor of Chandigarh inaugurated this as a wider program. This vehicle, running in a city premised on the erasure of village territorial formation, forms a metaphor for what is the urban today and for a significant life in the future.

6 Solomon Benjamin, "Occupancy Urbanism: Radicalizing Politics and Economy beyond Policy and Programs," *International Journal of Urban and Regional Research* 32, no. 3 (2008), 719–729.

CareForce

1 Michel Serres, *The Parasite*, trans. Lawrence R. Schehr (Baltimore: Johns Hopkins University Press, 1982), 225–226, 228.

Toward a Tender Society of Thoughtful Questions and Answers

1 Emmanuel Levinas, *Totality and Infinity: An Essay on Exteriority*, trans. Alphonso Lingis (Pittsburgh: Duquesne University Press, 1969), 84.

2 Malcolm Gladwell, *Talking to Strangers: What We Should Know about the People We Don't Know* (Boston: Little, Brown, 2019), 199.

4 Public Space

1 David Harvey, "The Right to the City," *New Left Review*, 2nd ser., no. 53 (September–October 2008), 23–40.

2 Michel Foucault, "The Meaning of the Word," in *Fearless Speech* (Los Angeles: Semiotext(e), 2001), 12–15.

3 David Thoreau, "Resistance to Civil Government," in *Aesthetic Papers* (Boston: Elizabeth P. Peabody, 1849), 14.

4 Emmanuel Levinas, *Totality and Infinity: An Essay on Exteriority* (Pittsburgh: Duquesne University Press, 1969), 68.

5 Krzysztof Wodiczko in conversation with Rosalyn Deutsche and Erika Naginski at Harvard Graduate school of Design, November 12, 2021.

Civic Stage

1 Open House Lecture: Frida Escobedo, "Split Subject," Harvard Graduate School of Design, November 5, 2019, https://www.youtube.com/watch?v=OrZN-ttK7FI&t=26m53s, accessed May 14, 2022.

2 José Esparza, Lisbon Architecture Triennale, exhibition catalog.

Nomadic Mosque

1 Azra Akšamija, "Nomadic Mosque" (2006), https://www.azraaksamija.net/nomadic-mosque/.

paraSITE

1 Michael Rakowitz, "paraSITE" (1998–ongoing), http://www.michaelrakowitz.com/parasite.

2 Sofia Ponte, in conversation with the artist.

3 Sofia Ponte, in conversation with the artist.

Refuge Wear

1 Lucy Orta, "Refuge Wear Intervention London East End" (1998), https://www.studio-orta.com/en/artwork/99/refuge-wear-intervention-london-east-end-1998.

Interrogative Design, Public Policy, and Distributed Diplomacy

1 Radical Design: lectures, workshops, and courses at Sciences Po, Sénat, X, École des Mines, HEC, École des Arts Décoratifs, HEAD, ZHdK, HIT, CU Atlas, MIT: https://jbla-brune.com/teaching/.

2 As proposed by design thinking and more recently the corporate versions of speculative design.

3 E.g., Marian Zazeela or La Monte Young.

4 Participatory design, design-thinking, prospective scenarios.

5 Jacques Derrida and Anne Dufourmantelle, *Of Hospitality*, trans. Rachel Bowlby (Stanford, CA: Stanford University Press, 2000).

6 Mitchel Resnick, Amy Bruckman, and Fred Martin, "Pianos not Stereos: Creating Computational Construction Kits," https://web.media.mit.edu/~mres/papers/pianos/pianos.html.

7 Experimental art places (Mains d'Oeuvres, Mediamatic), hackerspaces and networks like Dorkbot.

8 Academia, art and design schools (Aix-en-Provence, Arts

Décos, Beaux Arts, Interaction Design Institute Ivrea, Hyperwerk Basel).

9 Anthony Dunne, *Hertzian Tales: Electronic Products, Aesthetic Experience, and Critical Design* (Cambridge, MA: MIT Press, 2008).

10 Not afraid of disciplinary crossovers and dedicated to operationalizing some of the twentieth century's most provocative intellectual visions, it appeared as a great way to radically explore new ideas for my students, even if they would not be able to prototype functional objects or craft public situations due to constraints of time and resources at their schools.

11 At the invitation of Maxime Marzin, one of its directors.

12 Interrogative design as a way to analyze technosocial environments but also to generate new strategies and provoke unstable situations that could foster unconditional participation and expression of unrepresented communities.

13 Across these periods, we insist on some key moments, such as Henry Cole's Great Exhibition in 1851, the Arts and Crafts movement, Christopher Dresser (a botanist turned minimalist pioneering collaboration with industrial firms), Loos's "Ornament and Crime," the Wiener Werkstätte, Michael Thonet, his rationalized factory and no. 14 chair that is a marvel of mass production, leading to the idea that design is actually industrial, not merely a craft. After the traditional modernist gems (Mies van der Rohe, the Bauhaus) and quotes (form follows function, less is more) we look at postmodernism from an aesthetic and style perspective (StudioDaDa, Alchimia) but also as a political critique of consumerism, notably from groups from the radical period in the sixties in Italy (Superstudio, Archizoom) and low-tech designers in the United States (Papanek, the *Whole Earth Catalog*). We then finish by some more recent examples and considerations on contemporary design and its channels of distribution and differentiation.

14 Linda Tischler, "Ideo's David Kelley on 'Design Thinking,'" *FastCompany.com* (January 14, 2009), https://hci.stanford.edu/dschool/resources/readings/Kelley-fastcompany.htm.

15 Empathy, defining, creativity, prototyping, and evaluation.

16 "Double Diamond (design process model)," https://en.wikipedia.org/wiki/Double_Diamond_(design_process_model).

17 Indeed, in a corporate culture, brutally confronting the power structure of an organization would often mean risking losing a client, or worse, facing legal retaliation. Design thinking does not handle this asymmetry "by design," being itself immersed in a business-inclined culture focusing on finding optimal solutions.

18 Creator of the Computer Related Department at the Royal College of Arts (as well as Anthony Dunne's PhD and Fiona Raby's MPhil advisor). Later, Crampton-Smith and Phil Tabor would create some remarkable interaction design institutes, the most famous being IDII (Interaction Design Institute in Ivrea, Italy, early 2000s) where among other things were created different boards that allow designers to rapidly prototype with electronics.

19 "Behind every artifact lurks an ideology" (https://www.youtube.com/watch?v=JJfCin12sxo).

20 Service design, design thinking, participatory design, intermediary objects, curatorial design (Droog), design fiction, radical atoms and HCI visions, critical design, speculative design, and ID.

21 By think tanks (RAND, Institute for the Future), Arts and Sciences programs, or "futurologists."

22 Christine Raynard and Camille Boulenguer, "Gouvernance, démocratie participative et 'design thinking,'" *France Stratégie*, https://www.strategie.gouv.fr/debats/gouvernance-democratie-participative-design-thinking.

23 *Plurality University Network*, https://www.plurality-university.org/.

24 Nicolas Colin and Henri Verdier, *L'âge de la multitude* (Paris: Armand Colin, 2015).

25 Krzysztof Wodiczko, "Interrogative Design Workshop: Syllabus," *MIT OpenCourseware*, https://ocw.mit.edu/courses/architecture/4-370-interrogative-design-workshop-fall-2005/syllabus/.

26 In recent years, political philosopher Chantal Mouffe has initiated a call for a passionate, dissensus-based, adversarial and inclusive—in one word, "agonistic"—form of democracy. Earlier, social philosopher Michel Foucault recalled "parrhesia," an Athenian right to frank, "fearless" and open speaking, the right that, like the First Amendment in the US, demands a "fearless speaker" who must challenge political powers with criticism and unsolicited advice. Can designers and artists respond to such democratic calls and demands? Can they do so despite the (increasing) restrictions imposed on our liberties today? Can the designer or public artist operate as a proactive agent and contribute to the protection, development, and dissemination of fearless speaking in public space? Can new radical-democratic designs provide conditions for change toward a more open, agonistic, and inclusive society?

27 These could be projections (a form of graffiti using photons, whose legal and political status is ambivalent), vehicles (displaying their critical mass in the public sphere), or in-

struments (inviting users to develop a sense of mastery and allowing improvisation).

28 Krzysztof Wodiczko, *Critical Vehicles: Writings, Projects, Interviews* (Cambridge, MA: MIT Press, 1999).

29 Didier Anzieu, French psychoanalyst and continuator of Winnicott, describes this as the "capacity of the artist to accept the gaze of the other, to lower his guard to give birth to its work as a differentiated object, being able to be subject to criticism."

30 Pioneers like Vannevar Bush, J. C. R Licklider, and Douglas Engelbart envisioned a future where all information would be freely accessible everywhere on earth (Memex) and in the universe (Intergalactic Network) while extending our cognitive abilities through new collective means of thinking and agency (NLS, Augmentation Research Center).

31 Victor Papanek, MIT engineer and designer, advocate for inclusive and ecological design. He designed for the handicapped, the Third World, the sick, the poor, and people in need and wrote: "In an environment that is screwed up visually, physically, and chemically, the best and simplest thing that architects, industrial designers, planners, etc., could do for humanity would be to stop working entirely."

32 The 1972 report *The Limits to Growth*, commissioned by the Club of Rome, used a computer model (World3) based on the works of Jay Forrester at MIT to simulate exponential economic and population growth with a finite supply of resources.

33 Facebook, Alphabet, Twitter, VK, Yandex, RenRen, Tik Tok, WeChat, Weibo, and similar social networks.

34 The Well, Critical Making, Digital Nations, OLPC, Fablabs, Dorkbot, Makerspaces, Hackerspaces, and other online forums, tutorials, decentralized groups (IRC, ActivityPub, Matrix).

35 Visibility, notoriety, funding … see for instance http://peer-production.net/.

36 *Journal of Peer Production*, "HACKLABS AND HACKERSPACES—TRACING TWO GENEALOGIES," http://peer-production.net/issues/issue-2/peer-reviewed-papers/hacklabs-and-hackerspaces/

37 Hiroshi Ishii, Dávid Lakatos, Leonardo Bonanni, Jean-Baptiste Labrune, "Radical atoms: beyond tangible bits, toward transformable materials," *ACM Interactions* 19, no. 1 (January-February 2012), 38–51, https://doi.org/10.1145/2065327.2065337.

38 Distributed observation methods, combining participant-observation and empirical mixed-methods.

39 Marcelo Coelho and Jean-Baptiste Labrune, "Zero: Design Workshops with Minimal Resources," http://zero.mit.edu.

40 John Laidler, "High Tech Is Watching You," *Harvard Gazette* (March 4, 2019), https://news.harvard.edu/gazette/story/2019/03/harvard-professor-says-surveillance-capitalism-is-undermining-democracy.

41 Exaptation phenomena are defined as functional reconfigurations based on contingent, unpredictable rules. In a technological context, these may include, for example, episodes of technology change by their users, using rules that were not foreseen by the system designers (see https://jblabrune.com/phd/ and https://www.slideshare.net/jb.labrune/exaptation).

5 Theater

1 Bertolt Brecht, "Short Description of a New Technique of Acting Which Produces an Alienation Effect," in *Brecht on Theatre: The Development of an Aesthetic*, ed. and trans. John Willett (London: Methuen, 1964), 138.

On the Impossibility of Freedom in a Country Founded on Slavery and Genocide

1 Dread Scott, "On the Impossibility of Freedom in a Country Founded on Slavery and Genocide," https://www.dread-scott.net/portfolio_page/on-the-impossibility-of-freedom-in-a-country-founded-on-slavery-and-genocide/

Bibliobandido

1 See Howard Gardner, *Frames of Mind: The Theory of Multiple Intelligences* (New York: Basic Books, 1983).

Blendie

1 Kelly Dobson, "Machine Therapy," (doctoral dissertation, MIT, 2007), https://dspace.mit.edu/handle/1721.1/44329. 30.

Ægis: Equipment for a City of Strangers

1 Krzysztof Wodiczko, "Ægis: Equipment for a City of Strangers," https://www.krzysztofwodiczko.com/instrumentation#/new-gallery/.

Filmic Design

1 Louis Phillips, "The Hitchcock Universe: Thirty-Nine Steps and Then Some," *Films in Review* 46 (1995).

2 Alex Milton, "Filmic Design – A Hitchcockian Design Narrative," 5th European Academy of Design, 2003, http://www.ub.es/5ead/PDF/8/Milton.pdf.

3 Ivica Mitrović, James Auger, Julian Hanna, and Ingi Helgason, eds., *Beyond Speculative Design: Past — Present — Future*, SpeculativeEdu; Arts Academy, University of Split,

2021.

4 Torie Bosch, "Sci-Fi Writer Bruce Sterling Explains the Intriguing New Concept of Design Fiction," *Slate*, March 2, 2012, https://slate.com/technology/2012/03/bruce-sterling-on-design-fictions.html.

5 Krzysztof Wodiczko, "Interrogative Design," in *Critical Vehicles: Writings, Projects, Interviews* (Cambridge, MA: MIT Press, 1999), 17.

6 Ellen Lupton, *Design Is Storytelling* (New York: Cooper Hewitt, Smithsonian Design Museum, 2017).

6 Realism

1 Krzysztof Wodiczko, "Interrogative Design," in *Critical Vehicles: Writings, Projects, Interviews* (Cambridge, MA: MIT Press, 1999), 18.

2 Bruno Latour draws attention to two terms in French for the future: *le futur* and *l'avenir*. The former is our projection forward from the present, while the latter is that which is, in fact, coming toward us ("à venir" meaning "that which is to come"). *Le futur* is a human social construct and the future that has now lost most of its previous cohesiveness and meaning, while *l'avenir* is the undeniable new reality that is on its way. Latour goes on to cite Benjamin's discussion of Klee's angel of history, who moves forward in time but faces the past and surveys the wreckage left behind. The work of history is to somehow sort this wreckage into something meaningful. Latour imagines the *Angelus Novus* turning around to face *l'avenir* in all of its awe and undeniable reality (https://www.sciencespo.fr/executive-education/video-bruno-latour).

3 Anthony Dunne and Fiona Raby, *Design for the Unreal World* (Hasselt: Z33 House for Contemporary Art, 2018), 35.

4 Ruth Levitas, "Educated Hope: Ernst Bloch on Abstract and Concrete Utopia," *Utopian Studies* 1, no. 2 (1990), 17.

5 Levitas, "Educated Hope," 17.

6 Levitas, "Educated Hope," 15.

7 Andrew Leonard, "William Gibson: The Rolling Stone 40th Anniversary Interview," *Rolling Stone*, posted November 7, 2007, https://web.archive.org/web/20080216012821/http://www.rollingstone.com/politics/story/17227831/william_gibson_the_rolling_stone_40th_anniversary_interview/print.

8 Catherine McMahon. "Playing War: A Short History of Games and Simulation," in *The Typhoon Continues and So Do You* (Long Island City, NY: Flux Factory, 2011).

9 Sherry Turkle, *Reclaiming Conversation* (New York: Penguin Books, 2016).

10 Quoted in "Muntadas: An Unintentional Pioneer," *El Pais*, posted December 4, 2011, https://english.elpais.com/elpais/2011/12/04/inenglish/1322979642_850210.html.

Do Not Erase the Graffiti

1 Written in correspondence between Krzysztof Wodiczko and Kirk Savage, 2020. See: https://youtu.be/SA3lhM-83WvE.

Speculation and Care

1 Wodiczko taught at MIT from 1991 and directed the Center for Advanced Visual Studies from 1995 (http://web.mit.edu/idg/wodiczko.html).

2 The "Bandage Text" and the Interrogative Design Group's statement can be found on interrogative.org: http://web.archive.org/web/20010616210420fw_/http://web.mit.edu/idg/purpose.html (Web archive before May 2002).

3 http://web.archive.org/web/20021031004022fw_/http://web.mit.edu/idg/index.html (Web archive, after June 2002). Find also a personal archive of the "Bandage Text" and the Interrogative Design Group statement online: http://maxmollon.com/permalink/PHD_Appendix-CH1-Interrogative_Reflective.pdf.

4 See the detailed literature review in Max Mollon, "Designing for Debate" (PhD thesis, PSL University/ EnsadLab, 2019), 33.

5 The notion of program is inherited from Annie Gentès, "The In-Discipline of Design: Bridging the Gap between Humanities and Engineering," *Design Research Foundations* (Cham: Springer International, 2017), 160, 199; and Johan Redström, *Making Design Theory* (Cambridge, MA: MIT Press, 2017), 39. The 17 examples are: interrogative design, critical design, cautionary tales, conceptual design, contestable futures, design fiction, radical design, speculative design, design for debate, future probe design, contestational design, counterfunctional design, ludic design, critical engineering, critical making, critical software, and critical technical practice.

6 A theoretical construct is "a tool to think and make with—rather than a means of naming a movement" according to Carl DiSalvo, *Adversarial Design* (Cambridge, MA: MIT Press, 2012), 17.

7 See, respectively, Phoebe Sengers et al., "Reflective Design," in *Proceedings of the Decennial Conference on Critical Computing (CC)* (Aarhus, Denmark, 2005); DiSalvo, *Adversarial Design*; Susanne Bødker, "Creating Conditions for Participation: Conflicts and Resources in Systems Development," *Human-Computer Interaction* 11, no. 3 (Sep-

tember 1996), 215–236; and Bruce M. Tharp and Stephanie M. Tharp, *Discursive Design: Critical, Speculative, and Alternative Things* (Cambridge, MA: MIT Press, 2019).

8 Critical practices commonly do three things: expand beyond design's limited institutional market-oriented mission; question the social role of (conventional) design; and build upon the last century's history of playful forms of critique achieved through art and design. See James Pierce et al., "Expanding and Refining Design and Criticality in HCI," in *Proceedings of CHI '15* (New York, 2015), 2083–2092.

9 The opposition between affirmative and critical was proposed by Dunne and Raby in their "Critical Design Manifesto."

10 Ramia Mazé, "Critical of What? / Kritiska mot vad?," in *Iaspis Forum on Design and Critical Practice: The Reader*, ed. Magnus Ericson et al. (Stockholm: Iaspis; Berlin: Sternberg Press, 2009), 378–398.

11 Emilio Ambasz, *Italy, the New Domestic Landscape: Achievements and Problems of Italian Design*, exh. cat. (New York: Museum of Modern Art, 1972).

12 An example of this resemantization strategy is Enzo Mari's *Proposta per un'autoprogettazione* (1973), an attempt to design a conventional chair while cutting ties with the industry in terms of economy, production, and distribution. For comparable recent approaches, see Thomas Twait's *Toaster Project* (2008) or Laurent Tixador's *Multriprise (Electric Plug)* (2017).

13 "It really seems as though I am responsible for everything since I work for industry … how can one destroy the Capital? How to make industry without design?" Ettore Sottsass Jr., "Tout le monde dit que je suis méchant (Mi dicono che sono cattivo)," *Casabella*, no. 376 (1973), reprinted in *Design, l'anthologie*, ed. Alexandra Midal (Geneva: Haute École d'Art et de Design, 2013), 317.

14 William Morris, *News from Nowhere*, first published in 1890.

15 Neil Spiller, *Visionary Architecture: Blueprints of the Modern Imagination* (London: Thames and Hudson, 2006). For a specific account of aesthetic design strategies see Emanuele Quinz, "Prologue, a Slight Strangeness: Objects and Strategies of Conceptual Design," in *Strange Design*, ed. Jehanne Dautrey and Emanuele Quinz (Villeurbanne: it: éditions, 2015), 10–51.

16 Renny Ramakers and Gijs Bakker, *Droog Design: Spirit of the Nineties* (Rotterdam: 010 Publishers, 1998).

17 Anthony Dunne, *Hertzian Tales: Electronic Products, Aesthetic Experience and Critical Design* (Cambridge, MA: MIT Press, 2005).

18 Anthony Dunne and Fiona Raby, *Speculative Everything: Design, Fiction, and Social Dreaming* (Cambridge, MA: MIT Press, 2013).

19 These outreach programs are called "public discourse" in the United States, "public engagement" in the United Kingdom, and "scientific vulgarization" in France.

20 Great Britain, Department of Trade and Industry, *The Government Response to the House of Lords Select Committee on Science and Technology, Third Report: Science and Society*, vol. 4875 (London: H.M. Stationery Office, 2000). Extracted from Jacob Beaver, Tobie Kerridge, and Sarah Pennington, eds., *Material Beliefs* (London: Goldsmiths, University of London, and Interaction Research Studio, 2009), 8, http://research.gold.ac.uk/2316/.

21 Julian Bleecker, "Design Fiction: A Short Essay on Design, Science, Fact and Fiction," March 18, 2009, http://drbfw5wfjlxon.cloudfront.net/writing/DesignFiction_WebEdition.pdf.

22 David Kirby, "The Future Is Now: Diegetic Prototypes and the Role of Popular Films in Generating Real-World Technological Development," *Social Studies of Science* 40, no. 1 (September 30, 2009): 41–70.

23 Mollon, "Designing for Debate."

24 Wicked problems are design problems that seem impossible to solve due to being ill-defined or unknown. Richard Buchanan, "Wicked Problems in Design Thinking," *Design Issues* 8, no. 2 (Spring 1992), 5–21.

25 Matt Kiem, "When the most radical thing you could do is just stop," https://medium.com/@mattkiem/when-the-most-radical-thing-you-could-do-is-just-stop-1be32db783c5, March 12, 2014.

26 Tharp and Tharp, *Discursive Design*.

27 Wodiczko, "Bandage Text."

28 Ilpo Koskinen, "Agonistic, Convivial, and Conceptual Aesthetics in New Social Design," *Design Issues* 32, no. 3 (July 2016): 18–29.

29 Carl DiSalvo, "Design and the Construction of Publics," *Design Issues* 25, no 1 (January 2009); Noortje Marres, *Material Participation: Technology, the Environment and Everyday Publics* (New York: Palgrave Macmillan, 2016); Bruno Latour, "From Realpolitik to Dingpolitik, or How to Make Things Public," in *Making Things Public: Atmospheres of Democracy*, ed. Peter Weibel and Bruno Latour (Cambridge, MA: MIT Press, 2005).

30 A number of these questions have been listed, and part of them have been addressed in Mollon, "Designing for Debate."

31 Programs cannot be reduced to one project or one author.

However, the projects selected here reflect a general trend shared by a majority of the projects claimed in these programs.

32 Leah Zaidi, "Worldbuilding in Science Fiction, Foresight, and Design," *Journal of Futures Studies* 2, no. 12 (2019).

33 *Homeless Vehicle* addresses an actual problem, which is the precariousness induced by the forced mobility of homeless people, and their lack of income (or of devices to accumulate income, such as a shopping cart).

34 Pierre Lévy, "Qu'est-ce que le virtuel?," *La Découverte/Poche*, no. 49 (1998); Gilles Deleuze, *Différence et répétition* (Paris: PUF, 1968).

35 For an account of this question, see Mollon, "Designing for Debate," 206.

36 For example on a different issue, Burton-Nitta's *New Organs of Creation* (2013–2019) deals with an "actual" problem (Brexit, synonymous with difficulties in getting along with one another) and proposes a "virtual" solution (an opera sung via a new type of synthetic larynx that overwhelms us at the cellular level): https://www.burtonnitta.co.uk/NewOrgansOfCreation.html.

37 Wodiczko, "Bandage Text."

38 Annie Gentès, *The Indiscipline of Design* (Stenberg Press, 2019).

39 Climate change, again, is an "actual" issue that is quite "virtual" for many publics (yet). Drawing attention to the issue through discursive design could mean making the matter more "actual" than it is.

40 T. Schultz et al., "What Is at Stake with Decolonizing Design? A Roundtable," *Design and Culture* 10, no. 1 (January 2, 2018), 81–101.

41 Whether by making the front page of the *Times* like Auger & L'oiseau's Audio Tooth implant (2001), or gathering 9,000 people a day at MoMA, as in the exhibition "Design and the Elastic Mind" (2008).

42 Tony Fry, *Defuturing: A New Design Philosophy* (London: Bloomsbury, 2020).

Ustedes (Them)

1 "*Ustedes (Them)*," as described by More Art, a public art commissioning nonprofit organization in New York City (https://www.krzysztofwodiczko.com/instrumentation#/ustedes/).

The Aliens Are Coming!

1 Giorgio Agamben, *State of Exception* (Chicago: University of Chicago Press, 2005).

2 Krzysztof Wodiczko, "The Inner Public," *Field: A Journal of Socially Engaged Art Criticism* (Spring 2005).

3 "Demokrację mierzy się stosunkiem do obcych, Krzysztof Wodiczko rozmawia z Markiem Wasilewskim," *Czas Kultury* (2016, no. 3).

4 "Osobiste i publiczne, egzystencjalne i polityczne, Krzysztof Wodiczko w rozmowie z Markiem Wasilewskim," in *Odszkolnić Akademię*, ed. Marek Wasilewski (Poznań: Galeria Miejska Arsenał, 2018).

5 Judith Herman, *Trauma and Recovery: The Aftermath of Violence—From Domestic Abuse to Political Terror* (New York: Basic Books, 1997), 7–8.

6 "Demokrację mierzy się stosunkiem do obcych."

7 Bertolt Brecht, "Short Description of a New Technique of Acting Which Produces an Alienation Effect," in *Brecht on Theatre: The Development of an Aesthetic*, ed. and trans. John Willett (London: Methuen, 1964), 143–144.

Discursive Design

1 Behavioral archaeology provides a very basic set of categories to describe how artifacts are used. While technofunctions are utilitarian; sociofunctions act as signs or symbols, making social facts explicit without words; and ideofunctions encode or symbolize ideas, values, knowledge, and information. Michael B. Schiffer, *Technological Perspectives on Behavioral Change* (Tuscon: University of Arizona Press, 1992).

2 It should be noted that many references to our notion of discursive design mistakenly suggest that it is another distinct type of critical or conceptual practice (Bruce M. Tharp and Stephanie M. Tharp, *Discursive Design* [Cambridge, MA: MIT Press, 2019], 86, n.6). Rather, we posit it as an umbrella category or a "genus" for the various "species" like interrogative design and design fiction.

3 In general, criticality from an academic perspective is strongly associated with critical theory and comes with criticisms of elitism as it attempts to enlighten and emancipate. More colloquially critical design can be understood as being negative and criticizing more than inspiriting and positive. And while critical design was initially defined in opposition of the marketplace (see Dunne's *Hertzian Tales*), more current instantiations of this practice are being found in commercial industry. "Conceptual design," "concept design," and "design concepts" are used in commercial contexts and describe projects that are not finalized—in process—as well as speculative projects like concept cars. For more, see Tharp and Tharp, *Discursive Design*, 84–98.

4 "While pragmatically responding to the homeless' needs the appearance and function of the Homeless Vehicle aims

at provoking public attention [to] the unacceptability of such needs." Tharp and Tharp, *Discursive Design*, 449.

5 Strange Telemetry's Senescence project combines formal foresight work, participatory design methods, public engagement, and speculative and critical design (SCD) to create imagery that sparks conversation about future government policies and services. They "worked with members of the public to generate evidence for a Government Office for Science (GO-Science) Foresight project exploring the challenges and opportunities of an aging society. This project marks the first active use of speculative design in UK government policy processes" (Strange Telemetry, "Senescence: Speculative Design at the Policy Interface," http://www.strangetelemetry.com/speculativedesignandageing-1/, accessed November 8, 2017.

6 Krzysztof Wodiczko, "Interrogative Design," in *Critical Vehicles: Writings, Projects, Interviews* (Cambridge, MA: MIT Press, 1999), 17, 16.

7 Dick Hebdige, "The Machine Is Unheimlich: Krzysztof Wodiczko's Homeless Vehicle Project" (Walker Art Center, August 30, 2012), https://walkerart.org/magazine/krzysztof-wodiczkos-homeless-vehicle-project.

8 Dick Hebdige, "Redeeming Witness: In the Tracks of the Homeless Vehicle Project," *Cultural Studies* 7, no. 2 (1993), 176, 180.

9 Krzysztof Wodiczko, communication with the author, August 13, 2013.

10 Krzysztof Wodiczko, communication with the author, August 13, 2013.

11 This also raises the question of the impact of the exact same or somewhat adapted homeless vehicles within other geographic, cultural, and political contexts, e.g., in Portland, San Diego, Montgomery, Topeka, Guadalupe, Karachi, Moscow, Dubai, Beijing.

12 Indeed, this is one of the most common, if not somewhat misplaced, criticism of *Homeless Vehicle*; it does not offer political solutions to the broader problem of homelessness.

13 Deepa Butoliya, "Critical Jugaad: A Postnormal Design Framework for Designerly Marginal Practices," PhD diss., Carnegie Mellon University, 2018.

Interrogative Software Design

1 Patricia Phillips, "Creating Democracy: A Dialogue with Krzysztof Wodiczko," *Art Journal* (Winter 2003).

2 Phillips, "Creating Democracy."

3 Consider Max Weber's concise statements on the "characteristics of bureaucracy":

"Modern officialdom functions in the following specific manner:

"There is the principle of fixed and official jurisdictional areas, which are generally ordered by rules, that is, by laws or administrative regulations.

"The regular activities required for the purposes of the bureaucratically governed structure are distributed in a fixed way as official duties.

"The authority to give the commands required for the discharge of these duties is distributed in a stable way and is strictly delimited by rules concerning the coercive means, physical, sacerdotal, or otherwise, which may be placed at the disposal of officials.

"Methodical provision is made for the regular and continuous fulfilment of these duties and for the execution of the corresponding rights; only persons who have the generally regulated qualifications to serve are employed."

Max Weber, *Economy and Society: An Outline of Interpretive Sociology* (Berkeley: University of California Press, 1979), part III, chapter 6.

7 Memory

1 J. L. Austin, H. P. Grice, John Searle, and others define speech acts as utterances and *other forms of expression* that convey information (including the mutual recognition of intended meaning) transmitted from one person to another using various conventions.

2 Ruth Leys, *Trauma: A Genealogy* (Chicago: University of Chicago Press, 2000), 105.

3 Judith Herman, *Trauma and Recovery* (New York: Basic Books, 1997), 175.

4 Svetlana Boym, "Nostalgia and Its Discontents," *The Hedgehog Review* (Summer 2007), 18.

5 Ron Burnett, *How Images Think* (Cambridge, MA: MIT Press, 2004), 40; my emphasis.

6 Joseph E. Folger and Robert A. Baruch Bush, "Transformative Mediation and Third-Party Intervention: Ten Hallmarks of a Transformative Approach to Practice," *Mediation Quarterly* 13, no. 4 (1996), 266.

7 Boaz Hameiri, Eden Nabet, Daniel Bar-Tal, and Eran Halperin, "Paradoxical Thinking as a Conflict-Resolution Intervention: Comparison to Alternative Interventions and Examination of Psychological Mechanisms," *Personality and Social Psychology Bulletin* 44, no. 1 (2018), 122–139.

Interrogating Monuments

1 Magda Szcześniak and Łukasz Zaremba, "Paranoid Looking: On De-communization," *Journal of Visual Culture* 18,

no. 2 (2019), 209–233.

2 Krzysztof Wodiczko, *Socjoestetyka: Rozmawia Adam Ostolski* (Warsaw: Wydawnictwo Krytyki Politycznej, 2015), 273–275.

3 Krzysztof Wodiczko, "Memorial Projection," *Critical Vehicles: Writings, Projects, Interviews* (Cambridge, MA: MIT Press, 1999), 49–52.

4 Alois Riegl, "The Modern Cult of Monuments: Its Character and Its Origin," trans. Kurt W. Forster and Diane Ghirardo, *Oppositions* 25 (1982): 21–51.

5 Wodiczko, "Memorial Projection."

6 Ben Davis, "Monuments across the United States Re-emerged as Targets of Rage over a Weekend of Widespread Protest," *artnet.com* (June 1, 2020), https://news.artnet.com/art-world/monuments-across-the-united-states-re-emerged-as-targets-of-fury-over-a-weekend-of-widespread-protest-1876542.

7 Krzysztof Wodiczko, "Truth and Reconciliation Project at the Sites of Disgraced Statues and Monuments" (in this book).

8 Kirk Savage and Krzysztof Wodiczko, "Statues That Reinforce White Supremacy" (unpublished text), 2020.

9 Krzysztof Wodiczko, "Public Projection," in *Critical Vehicles*, 44–48.

10 Krzysztof Wodiczko, "Interrrogative Design," in *Critical Vehicles*, 16–17.

11 James E. Young, *At Memory's Edge: After-Images of the Holocaust in Contemporary Art and Architecture* (New Haven: Yale University Press, 2000).

12 Bronislaw Szerszynski, "The Anthropocene Monument: On Relating Geological and Human Time," *European Journal of Social Theory* 20, no. 1 (2017), 111–131.

13 Jakub Majmurek, "Wodiczko: Dziecko z Grobu Nieznanego Żołnierza jest w każdym z nas" (The child from the tomb of the Unknown Soldier is in every one of us), *Krytyka Polityczna* (November 10, 2013), https://krytykapolityczna.pl/kultura/sztuki-wizualne/wodiczko-dziecko-z-grobu-nieznanego-zolnierza-jest-w-kazdym-z-nas/.

14 Olga Tokarczuk, "The Tender Narrator" (December 7, 2019), https://www.nobelprize.org/prizes/literature/2018/tokarczuk/lecture/

15 Zygmunt Bauman, *Modernity and Ambivalence* (Cambridge, UK: Polity, 1991).

Truth and Reconciliation at the Sites of Disgraced Monuments

1 Krzysztof Wodiczko and Kirk Savage, "Statues That Reinforce White Supremacy," unpublished essay (2020).

2 Priscilla Hayner, *Unspeakable Truths: Transitional Justice and the Challenge of Truth Commissions* (London: Routledge, 2010), 11.

3 After almost eight years, only 13 of the 94 "Calls to Action" of the Truth and Reconciliation Commission of Canada have been completed (https://www.cbc.ca/newsinteractives/beyond-94).

Monuments for a New Era

1 Zerflin, "But Slavery Was So Long Ago ...," https://zerflin.com/item/slavery-long-ago/

2 Krzysztof Wodiczko, "Interrogative Design," in *Critical Vehicles: Writings, Projects, Interviews* (Cambridge, MA: MIT Press, 1999), 16.

Nomadic Shtetl Archive

1 Natalia Romik, "Nomadic Shtetl Archive," https://www.facebook.com/Nomadyczne-Archiwum-Sztetla-Nomadic-Shtetl-Archive-289476394735718, accessed May 23, 2022.

B'Seder

1 Eva Hoffman, "Complex Histories, Contested Memories: Some Reflections on Remembering Difficult Pasts," *Occasional Papers of the Doreen B Townsend Center for the Humanities* 23 (2000), 9.

2 Hoffman, "Complex Histories, Contested Memories," 10. Hoffman also describes the importance for Poles to understand Jewish perspectives as part of their process of understanding themselves. For North American Jews, the need to appreciate Polish perspectives is less urgent since predominant Jewish narratives have long since cut ties with Poland, psychically and emotionally. The thinly overlapping Venn diagram of Poles and Jews cannot see clearly through their own stereotypes of the other, yet for Poles, this opacity is particularly harmful.

3 Bridges do not do well in times of conflict.

4 Daniel Jonah Goldhagen, *Hitler's Willing Executioners* (New York: Knopf Doubleday, 2007), 46.

Un-War: Transforming War Consciousness

1 Maria Niro, dir., *Krzysztof Wodiczko: The Art of Un-War* (New York: Crossing Waters, 2021), https://www.un-war.com. Subsequent quotations from Wodiczko are also from this documentary unless otherwise specified.

2 Niro, *Krzysztof Wodiczko: The Art of Un-War*.

3 Krzysztof Wodiczko, "Arc de Triomphe: World Institute for the Abolition of War," *Harvard Design Magazine*, no. 33

4 Speaking about the Arc de Triomphe, Wodiczko states that "people have to get eye to eye with those reliefs" (Niro, *Krzysztof Wodiczko: The Art of Un-War*).

5 Krzysztof Wodiczko, "Interrogative Design," in *Critical Vehicles, Writings, Projects, Interviews* (Cambridge, MA: MIT Press, 1999), 16.

6 Lorraine Murray, "Arc de Triomphe," *Encyclopaedia Britannica*, https://www.britannica.com/topic/Arc-de-Triomphe, accessed November 6, 2021.

7 Place Charles de Gaulle, historically known as the Place de l'Étoile, is a large road junction in Paris, France, the meeting point of twelve straight avenues (hence its historic name, which translates as "Square of the Star") including the Champs-Élysées (https://en.wikipedia.org/wiki/Place_Charles_de_Gaulle).

8 Krzysztof Wodiczko, "Arc de Triomphe: World Institute for the Abolition of War," in *Transformative Avant-Garde and Other Writings* (London: Black Dog Press, 2011), 322.

9 Wodiczko, "Interrogative Design," 17.

10 Krzysztof Wodiczko, "The Culture of War," in *Transformative Avant-Garde and Other Writings*, 329.

11 See Department of State of the United States of America, Office of the Historian, "The Kellogg-Briand Pact," https://history.state.gov/milestones/1921–1936/kellogg

12 Wodiczko, "Arc de Triomphe," in *The Abolition of War* (London: Black Dog Press, 2012), 36.

13 Wodiczko, *The Abolition of War*, 36.

14 Wodiczko, *The Abolition of War*, 6.

15 Wodiczko, *The Abolition of War*, 6.

16 Interview with Rosalyn Deutsche, in Niro, *Krzysztof Wodiczko: The Art of Un-War*.

17 *Wikipedia*, "L'Arc de Triomphe, Wrapped," https://en.wikipedia.org/wiki/L%27Arc_de_Triomphe,_Wrapped.

18 Michel Foucault, *Politics, Philosophy, Culture: Interviews and Other Writings, 1977–1984* (New York: Routledge, 2013), 326.

19 Olivia Muñoz-Rojas, "El triunfo de la imaginación" (Triumph of the Imagination), *El Pais* (October 1, 2021), https://elpais.com/opinion/2021-10-01/el-triunfo-de-la-imaginacion.html.

Exhibiting and Collecting Interrogative Design

1 Much of the research and ideas for this essay were used in my book *Transformar arte funcional em objeto museal* (Lisbon: Editora Caleidoscópio and DGPC, 2020). My purpose was to study the concept of "function" in recent art and design through *Homeless Vehicle, paraSite* by Michael Rakowitz, and *Victory Gardens +* by Amy Franceschini.

2 The debates about the mission of museums of art are being increasingly fueled by recent ideas on climate change, postcolonialism, feminism, and heritage, to name a few. Contributions are coming from various fields, and significant changes are already being made in current exhibition discourses.

3 Krzysztof Wodiczko, "Interrogative Design," in *Critical Vehicles: Writings, Projects, Interviews* (Cambridge, MA: MIT Press, 1999), 17, 16.

4 David Carrier, *Museum Skepticism: A History of the Display of Art in Public Galleries* (Durham: Duke University Press, 2006). Carrier indicates that critics of museums of art, while not being exactly against the existence of museums, question their values, their methods of representation, and their communication strategies. This debate goes as far back as the establishment of the Musée du Louvre in 1792.

5 Martha Buskirk, *The Contingent Object of Contemporary Art* (Cambridge, MA: MIT Press, 2005), 14.

6 Eilean Hooper-Greenhill, *Museums and the Shaping of Knowledge* (New York: Routledge, 1992).

7 Barbara Kirshenblatt-Gimblett, *Destination Culture: Tourism, Museums, and Heritage* (Berkeley: University of California Press, 1998).

8 In the 1990s, homelessness became a growing social and cultural concern. Its development, according to the International Encyclopedia of the Social and Behavioral Sciences (2001), was due to the significant increase in the cost of housing, but also due to the unemployment crisis felt in the 1981–1982 recession.

9 Rosalyn Deutsche, "Uneven Development: Public Art in New York City," *October*, no. 47 (1988), 46.

10 Deutsche, "Uneven Development," 45.

11 Deutsche, "Uneven Development," 46.

12 "Magiciens de la terre" took place between May 18 and August 14, 1989. It was held as part of the celebrations of the bicentenary of the French Revolution, and today it is studied by many scholars as a pioneer exhibition anticipating the globalization of art. Jean-Hubert Martin was assisted by a curatorial team comprising Mark Francis, Aline Luque, and André Magnin.

13 Lucy Steeds, *Making Art Global* (London: Afterall Books, 2013), 24–92.

14 Steeds, *Making Art Global*.

15 Benjamin Buchloh, "The Whole Earth Show: An Interview with Jean-Hubert Martin," *Art in America* (May 1989), 150–158 and 211–213.

16 Annie Cohen-Solal, *Magiciens de la terre, retour sur une*

exposition légendaire (Paris: Centre Pompidou, 2014).

17 Buchloh, "The Whole Earth Show."

18 The "Magiciens" catalogue includes additional information about all the artworks in the exhibition. Wodiczko's section comprises several images of the vehicle circulating in New York, diagrams, an excerpt of the essay "Homeless Vehicle Project" (1988) by the artist and David Lurie, and an essay about society at the time.

19 Retrieved from https://fracdespaysdelaloire.com/en/see-the-collection/, accessed May 21, 2022.

20 Martha Buskirk, *Creative Enterprise: Contemporary Art between Museum and Marketplace* (London: Bloomsbury Publishing, 2012), 320.

21 Wodiczko, "Interrogative Design," 16–17.

22 Maria Lucia Loureiro, "Musealisation Processes in the Realm of Art," in *The Thing about Museums: Objects and Experience, Representation and Contestation*, ed. Sandra Dudley et al. (London: Routledge, 2012), 69–78.

8 Prosthetics

1 J. E. Riddle, *A Complete English-Latin and Latin-English Dictionary for the Use of Colleges and Schools: Chiefly from the German* (London: Lonman, Brown, Green, and Longmans, 1843).

2 Robert Scott, Henry Stuart Jones, and Roderick McKenzie, *A Greek-English Lexicon* (Oxford: Clarendon Press, 1925).

3 Arthur D. Effland, *A History of Art Education: Intellectual and Social Currents in Teaching the Visual Arts* (New York: Teachers College Press, 1990), 67.

4 Kevin Kelly, *What Technology Wants* (New York: Penguin Books, 2011).

5 Daniel Jonah Goldhagen, *Hitler's Willing Executioners* (New York: Knopf Doubleday, 2007), 46.

6 "Steve Jobs, Computers Are Like a Bicycle for Our Minds," in *Memory and Imagination: New Pathways to the Library of Congress*, dir. Julian Krainin and Michael R. Lawrence (1990).

7 Steve Mann, "Smart Clothing: The 'Wearable Computer' and WearCam …," http://wearcam.org/personaltechnologies/, accessed December 10, 2021.

8 Sara Hendren, "All Technology Is Assistive," *Wired*, October 16, 2014, https://www.wired.com/2014/10/all-technology-is-assistive/, accessed May 23, 2022.

9 Krzysztof Wodiczko, in conversation with the editor, Winter 2010.

10 See Karl Čapek's play *R.U.R.*

11 Victor Papanek, *Design for the Real World* (Chicago: Chicago Review Press, 2005), 68.

12 Haseeb Ahmed, "Has the World Already Been Made?," https://haseebahmed.com/HWBM-x1-2011-solo-Jan-van-Eyck-Academie-Maastricht-NL, accessed May 23, 2022.

13 Kelly Dobson, "Machine Therapy," PhD dissertation, Massachusetts Institute of Technology, 2007, 26, https://dspace.mit.edu/handle/1721.1/44329.

Cultural Prosthetics and Pragmatic Access

1 Vivian Sobchack, "A Leg to Stand On: Prosthetics, Metaphor, and Materiality," in *The Prosthetic Impulse: From a Posthuman Present to a Biocultural Future*, ed. Marquard Smith and Joanne Morra (Cambridge, MA: MIT Press, 2007), 18.

2 Katherine Ott, *Artificial Parts, Practical Lives: Modern Histories of Prosthetics* (New York: NYU Press, 2002), 2.

3 Ott, *Artificial Parts, Practical Lives*, 2.

4 Sarah Zhang, "The Last Children of Down Syndrome," *Atlantic*, December 2020, https://www.theatlantic.com/magazine/archive/2020/12/the-last-children-of-down-syndrome/616928/.

5 Krzysztof Wodiczko, *Critical Vehicles: Writings, Projects, Interviews* (Cambridge, MA: MIT Press 1999), 17.

6 For a description of Grandin's Squeeze Chair origin story, see Oliver Sacks, "An Anthropologist on Mars," *New Yorker*, December 27, 1993.

Alien Staff: Xenobàcul

1 Krzysztof Wodicko, "Alien Staff: Xenobàcul," https://www.krzysztofwodiczko.com/instrumentation#/alien-staff/, accessed May 9, 2022.

Body Speech

1 Nicholas Negroponte, "Robot Architects," in *The Architecture Machine: Toward a More Human Environment* (Cambridge, MA: MIT Press, 1970), https://mitp-arch.mitpress.mit.edu/pub/ka5ljgsg/release/1; and Stanford Anderson, "Problem-Solving and Problem-Worrying" (lecture, Architectural Association, London, March 1966).

2 Michel Foucault, *The Government of Self and Others: Lectures at the Collège de France, 1982–1983* (Houndmills, UK: Palgrave, 2010); Michel Foucault, *The Courage of Truth: Lectures at the Collège de France 1983–1984* (Houndmills, UK: Palgrave, 2011). See also Chantal Mouffe, "Deliberative Democracy or Agonistic Pluralism?," *Social Research* 66, no. 3 (Fall 1999), 745–758.

3 I'm thinking of Sara Ahmed's analysis of spatial bodily orientation in *Queer Phenomenology* (Durham: Duke Univer-

sity Press, 2006).

ScreamBody

1 Kelly Dobson, "ScreamBody," https://web.media.mit.edu/~monster/screambody/, accessed May 10, 2022.

9 Ethical Alertness

1 Krzysztof Wodiczko, *Critical Vehicles: Writings, Projects, Interviews* (Cambridge, MA: MIT Press, 1999), 16.

2 Walter Benjamin, "On the Concept of History," in *Selected Writings: 1938–1940* (Cambridge, MA: Harvard University Press, 1999), 392.

3 Avi Schiffmann and Marco Burstein, *Ukraine Take Shelter*, http://ukrainetakeshelter.com.

4 Roger Berkowitz, *Thinking in Dark Times: Hannah Arendt on Ethics and Politics* (New York: Fordham University Press, 2009), 5.

5 Berkowitz, *Thinking in Dark Times*, 5.

6 Sherry Turkle, "The Assault on Empathy," *Behavioral Scientist*, January 1, 2018, 5.

7 Turkle, "The Assault on Empathy," 7.

8 Iyad Rahwan et al., "Machine Behaviour," *Nature*, April 25, 2019, 477.

9 Nitin Sawhney, "Te Awa Tupua: Sacred Rivers and Cooperative Urban AI Ecosystems," in *DIS '20: Proceedings of the 2020 ACM Designing Interactive Systems Conference*.

10 Edward O. Wilson, *The Future of Life* (New York: Vitage Books, 2003), 23.

Interrogative Design with More-Than-Humans

1 Zakiyyah Iman Jackson, *Becoming Human: Matter and Meaning in an Antiblack World* (New York: NYU Press, 2020).

2 Marisol de la Cadena, *Earth Beings: Ecologies of Practice across Andean Worlds* (Durham: Duke University Press, 2015). This section of the essay refers to pages 245–253 of her book.

3 See Karen Barad, *Meeting the Universe Halfway: Quantum Physics and the Entanglement of Matter and Meaning* (Durham: Duke University Press, 2007).

4 De la Cadena, *Earth Beings*, 101–103.

5 Eduardo Viveiros de Castro, *Cannibal Metaphysics*, trans. Peter Skafish (Minneapolis: University of Minnesota Press, 2007), https://www.upress.umn.edu/book-division/books/cannibal-metaphysics.

6 McKenzie Wark, "Eduardo Viveiros de Castro: In and Against the Human," *Verso blog post*, June 12, 2017, https://www.versobooks.com/blogs/3265-eduardo-viveiros-de-castro-in-and-against-the-human.

7 Eduardo Viveiros de Castro, "On Models and Examples: Engineers and Bricoleurs in the Anthropocene," *Current Anthropology* 60, no. 20 (August 2019), https://www.journals.uchicago.edu/doi/pdf/10.1086/702787.

8 Term coined by Pierre Clastres.

WildUrban Radio

1 Dana Gordon, "WildUrban Radio," *Science Gallery, Trinity College Dublin*, https://dublin.sciencegallery.com/homesick-1/wildurban-radio, accessed May 22, 2022.

Headless Women in Public Art

1 Krzysztof Wodiczko, "Interrogative Design," in *Critical Vehicles: Writings, Projects, Interviews* (Cambridge, MA: MIT Press, 1999), 18.

Nanohana Heels

1 Sputniko!, "Nanohana Heels," https://sputniko.com/Nanohana-Heels-1, accessed on May 10, 2022.

The 70th Anniversary of the Hiroshima Bombing

1 George Friedman, "Is There a Global War Coming?," *Brain Bar*, https://youtu.be/kwnPgscg0vU.

Back Cover

The text on the back cover is a paraphrased reference to the work of Krzysztof Wodiczko and printed with his permission. Sources: Krzysztof Wodiczko, *Critical Vehicles: Writings, Projects, Interviews* (Cambridge, MA: MIT Press, 1999), 17, and Krzysztof Wodiczko, "Inner Public," *Field: A Journal of Socially-Engaged Art Criticism* (Spring 2015), 28.

Contributors

Add Oil Team

Add Oil Team is a Hong Kong-based artist collective focusing on the political situation of the city. Its previous projects included *Add Oil Machine* (2014) and *Countdown Machine* (2016). Add Oil Team was initiated by Sampson Wong, Jason Lam, Chu Cheuk Ying, Kwan Kai Yin, Jeff Wong, Kitty Ho, and their friends.

Azra Akšamija

Azra Akšamija is an artist and architectural historian, Director of the MIT Future Heritage Lab, and an Associate Professor in the MIT Art, Culture, and Technology Program. Akšamija investigates the politics of identity and cultural memory on the scale of the body (clothing and wearable technologies), on the civic scale (religious architecture and cultural institutions), and within the context of history and globalization. Her work explores creative responses to conflict and crisis through transcultural aesthetics, artistic approaches to preservation, co-creation pedagogy, and in so doing, provide a framework for analyzing and intervening in contested sociopolitical realities.

Akšamija's recent academic research focuses on the representation of Islam in the West, and on destruction and restoration of cultural heritage in the Balkans and the Middle East and North Africa region. This research informs her artistic practice, which translates cultural heritage from different contexts toward the development of new methods for preservation and creation of future heritage. Her work has been published and exhibited in leading international venues such as at the Generali Foundation Vienna, Valencia Biennial, Gallery for Contemporary Art Leipzig, Liverpool Biennial, Museums of Contemporary Art in Zagreb, Belgrade, and Ljubljana, Sculpture Center New York, Secession Vienna, Manifesta 7, Stroom The Hague, the Royal Academy of Arts London, Jewish Museum Berlin, Queens Museum of Art in New York, Design Week Festivals in Milan, Istanbul, Eindhoven, and Amman, Qalandiya International, London Biennale—Manila Pollination 2016, and the Fondazione Giorgio Cini as a part of the 54th Art Biennale in Venice. In 2013, she received the Aga Khan Award for Architecture for her design of the prayer space in the Islamic Cemetery Altach, Austria.

Dora Apel

Dora Apel is an art historian, cultural critic, and author. Her work focuses on visual culture and politics, engaging with issues of trauma and memory, sex and gender, racial and ethnic oppression, globalization and capitalism.

Her most recent book, *Calling Memory into Place*, explores the dynamic nature of memory and memorials, the ways in which memory can be mobilized for social justice, and the ways in which memory is physically embodied, including her family's experience of the Holocaust. Her other books include *Beautiful Terrible Ruins: Detroit and the Anxiety of Decline*; *War Culture and the Contest of Images*; *Imagery of Lynching*; *Memory Effects: The Holocaust and the Art of Secondary Witnessing*; and *Lynching Photographs* (coauthored with Shawn Michelle Smith), as well as numerous essays and articles, which can be accessed at www.researchgate.net.

She is the W. Hawkins Ferry Endowed Chair Professor Emerita of Modern and Contemporary Art History at Wayne State University.

Dan Borelli

Dan Borelli is an artist and Director of Exhibitions at Harvard University's Graduate School of Design. His art practice focuses on environmental justice, contaminated com-

munities, and how research-based art can address shared traumas. His current project, *Unfriending the Atom*, started in 2021, is an ongoing collaboration with the scientist Marco Kaltofen. This project places the material samples from Kaltofen's field science in a graphic communication system that accurately conveys the exotic radioactive data that he finds from the mundane objects associated with the various productions of nuclear materials, either in energy or weaponry. Borelli's long-range and socially engaged artwork *Illuminating Futures: Ashland and Nyanza* makes public hidden narratives of cancer clusters, human loss, activism, and ultimately regeneration surrounding one of the first Superfund sites in the United States, and received funding from ArtPlace America, the National Endowment of the Arts, Harvard's Initiative in Learning Technology, and an ongoing collaboration with the Laborers Union New England Training Academy. Additionally, he has given guest lectures, public talks, and keynotes at a variety of venues such as the Rhode Island School of Design, the Massachusetts College of Art and Design, Arizona State University, the US Water Alliance, the National Park Service, Drexel University, and Senator Patrick Leahy's Center for the Environment.

Chris Csíkszentmihályi

Chris Csíkszentmihályi is European Research Area Chair at Madeira Interactive Technology Institute and is director of the the Rootio Project, a sociotechnical platform for community radio.

Csíkszentmihályi has been a professor at colleges, universities, and institutes, including Distinguished Visiting Professor of Art and Design Research at Parsons the New School for Design. He cofounded and directed the MIT Center for Future Civic Media (C4), which was dedicated to developing technologies that strengthen communities. He also founded the MIT Media Lab's Computing Culture group, which worked to create unique media technologies for cultural and political applications. Trained as an artist, he has worked in the intersection of new technologies, media, and the arts for 16 years, lecturing, showing new media work, and presenting installations on five continents and one subcontinent. He was a 2005 Rockefeller New Media Fellow, a 2007–2008 fellow at Harvard's

Radcliffe Institute for Advanced Study, and has taught at the University of California, San Diego, Rensselaer Polytechnic Institute, and Turku University.

Rosalyn Deutsche

Rosalyn Deutsche is an art historian and critic who teaches modern and contemporary art at Barnard College/Columbia University. She has written extensively and lectured internationally on such interdisciplinary topics as art and urbanism, art and the public sphere, art and war, art and psychoanalysis, and feminist theories of subjectivity in representation. Her essays have appeared in *Grey Room*, *October*, *Artforum*, *Art in America*, and *Society and Space*, among other journals, in many exhibition catalogues and anthologies, and in numerous translations. Deutsche is the author of *Evictions: Art and Spatial Politics* (1996), *Hiroshima after Iraq: Three Studies in Art and War* (2010), and *Not-Forgetting: Contemporary Art and the Interrogation of Mastery* (2022).

Kelly Dobson

Kelly Dobson is an artist and engineer working in the realms of technology, medicine, and culture. Her projects involve the parapraxis of machine design—what machines do and mean for people other than the purposes for which they were consciously designed.

As a working artist, she completed two master's degrees and a PhD at MIT while a member of the Computing Culture Group in the Media Lab and the Interrogative Design Group in the MIT Program in Art, Culture, and Technology. Areas of investigation include voice, identity, prosthetic social extensions, public performance, reappropriation of domestic appliances, new materials innovation, and companion machines.

She has earned prestigious fellowships and awards for her work in technology and art, including the Rockefeller New Media Artist Fellowship, Franklin Furnace Fund for Performance Art Award, and VIDA Art and Artificial Life honor. Her work is featured in many publications and has been exhibited internationally including at Witte de With in Rotterdam, Círculo de Bellas Artes in Madrid, the Millennium Museum in Beijing, Goldsmiths College in Lon-

don, Fringe Exhibitions in Los Angeles, and The Kitchen, Eyebeam, Exit Art and the Museum of Modern Art in New York City, among other venues.

Kelly has taught at Cornell University and the Oslo National Academy of the Arts as a visiting professor, and worked as a researcher at MIT's Center for Advanced Visual Studies. She has enjoyed teaching and learning with the Rhode Island School of Design community part-time in the Digital + Media and Textiles departments during 2005–2009 and full-time in the Digital + Media department from 2009 to the present. Kelly Dobson was nominated for a John R. Frazier Award for Excellence in Teaching at RISD in 2010.

Frida Escobedo

Since founding her eponymous practice in 2006, Frida Escobedo has developed a distinctive approach driven by the conviction that architecture and design represent, above all, a crucial means to interrogate and comment on social, economic, and political phenomena. In this formulation, art, both contemporary and historical, serves as an indispensable touchstone. Defying the traditional boundaries of the architectural discipline, the studio's creative output operates at a wide array of scales and mediums, encompassing buildings and experimental preservation projects, temporary installations and public sculpture, limited-edition objects, publications, and exhibition designs. Informed by an unmistakable material sensibility and intuitive feeling for pattern, Escobedo's work is at once unmistakably architectural and yet frequently blurs the boundary between architecture and art.

Harrell Fletcher

Harrell Fletcher received his BFA from the San Francisco Art Institute and his MFA from California College of the Arts. He studied organic farming at the University of California, Santa Cruz, and went on to work on a variety of small community-supported agriculture farms, which impacted his work as an artist. Fletcher has produced a variety of socially engaged collaborative and interdisciplinary projects since the early 1990s. His work has been shown at the San Francisco Museum of Modern Art, the de Young Museum, the Berkeley Art Museum, the Wattis

Institute, and Yerba Buena Center for the Arts in the San Francisco Bay Area; the Drawing Center, Socrates Sculpture Park, the Sculpture Center, the Wrong Gallery, Apex Art, and Smackmellon in New York City; DiverseWorks and Aurora Picture show in Houston; Portland Institute for Contemporary Art in Portland, Oregon; the Center on Contemporary Art and Seattle Art Museum in Seattle; Signal in Malmö, Sweden; Domain de Kerguehennec in France; The Tate Modern in London; and the National Gallery of Victoria in Melbourne, Australia. He was a participant in the 2004 Whitney Biennial. Fletcher has work in the collections of the Museum of Modern Art, Whitney Museum, New Museum, San Francisco Museum of Modern Art, Hammer Museum, Berkeley Art Museum, De Young Museum, and FRAC Brittany, France. From 2002 to 2009 Fletcher co-produced Learning to Love You More, a participatory website with Miranda July. Fletcher is the 2005 recipient of the Alpert Award in Visual Arts. His exhibition "The American War" originated in 2005 at ArtPace in San Antonio, and traveled to Solvent Space in Richmond, White Columns in New York City, the Center for Advanced Visual Studies at MIT, PICA, and LAXART in Los Angeles among other locations. Fletcher is a Professor of Art and Social Practice at Portland State University in Portland, Oregon.

Pete Ho Ching Fung

Pete Ho Ching Fung is a designer and writer based between Vancouver and the Netherlands. Informed by his nomadic way of living, his work explores the poetics and politics around the knowledge structures that underpin our lived experiences—the languages we use, the aesthetics we subscribe to, as well as the way we come to categorize them. Moving between words and images, interventions and collaborations, theoretical and artistic research, his work has been exhibited and published at Onomatopee, Het Nieuwe Instituut, and Helsinki Design Museum, among others. He teaches at Emily Carr University of Art + Design and at Design Academy Eindhoven.

Dana Gordon

Dana Gordon is an architect, an interaction designer and a professor at Interdisciplinary Center Herzliya. She prac-

tices architecture and design while continuing academic research. Her perspective aims to expose the hidden social angles in design, using speculative design and critical approach. She explores physical objects, new technologies, and their significance in our contemporary culture. Her work was exhibited at various design centers such as the Victoria and Albert Museum and Science Gallery Dublin.

She graduated from the master's program of Interaction Design Institute Ivrea in 2006. Before that she earned her BArch degree from Bezalel, the Academy of Art and Design, Jerusalem, and worked as a senior architect and a project manager at GK1 in Tel-Aviv. Between 2008 and 2010 she was a part of the Interrogative Design Group at the MIT Center for Advanced Visual Studies.

Sara Hendren

Sara Hendren is an artist, design researcher, writer, and professor at Northeastern University Colloege of Arts, Media and Design. Her lab and projects include collaborative public art and social design that engages the human body, technology, and the politics of disability—things like a lectern for short stature or a ramp for wheelchair dancing. She also cofounded the Accessible Icon Project, co-created a digital archive of low-tech prosthetics, and has a long-running obsession with the inclined plane.

Hendren's work has been exhibited at the Victoria & Albert Museum, the DOX Centre for Contemporary Art, The Vitra Design Museum, the Seoul Museum of Art, and other venues and is held in the permanent collections of the Museum of Modern Art and the Cooper Hewitt Museum. Her first book, on the unexpected places where disability is at the heart of design in everyday objects and environments, is forthcoming from Riverhead/Penguin Random House in summer 2020. She has been an Eric & Wendy Schmidt Fellow at the New America think tank, a Logan Nonfiction Fellow at the Carey Institute for Global Good, a Tatlock Fellow at Vassar College, and the recipient of a 2017 Public Scholar grant from the National Endowment for the Humanities. At Olin, she is also the principal investigator on a three-year initiative to bring more arts experiences to engineering students and faculty, supported by the Mellon Foundation.

Garnet Hertz

Dr. Garnet Hertz is Canada Research Chair in Design and Media Arts and is Associate Professor in the Faculty of Design and Dynamic Media at Emily Carr University. His art and research investigate DIY culture, electronic art, and critical design practices. He has shown his work at several notable international venues in 15 countries including SIGGRAPH, Ars Electronica, and DEAF and was awarded the 2008 Oscar Signorini Award in robotic art. He has worked at ArtCenter College of Design and the University of California, Irvine. His research is widely cited in academic publications, and in the popular press including the *New York Times*, *Wired*, the *Washington Post*, NPR, *USA Today*, NBC, CBS, TV Tokyo, and CNN Headline News. More information is available at conceptlab. com.

Sohin Hwang

Sohin Hwang is an artist and writer working on issues around art, technology, and society. Her recent project involves performance art and cybernetics in the mid twentieth century with an attention to materiality, producer-audience relationships, and the formation of publics. Her research and artworks have been presented in research institutions and experimental journals. She taught at Harvard University as a College Fellow after finishing doctoral research at the University of Oxford as a Clarendon Scholar. Currently she is working on an monograph for Specter Press/Workroom Press and a new research project on the Bering Strait. She enjoys imaginary gardening.

Ekene Ijeoma

Ekene Ijeoma is an artist who focuses on the overlooked or shared aspects of sociopolitical trends and interpersonal dynamics through the lenses of personal observation and analytical exploration. His works include sound, video, sculpture, installation, and performance.

His work has been exhibited and performed at the Bemis Center for Contemporary Art (2021), Contemporary Art Museum of St. Louis (2021), Museum of Contemporary Art Denver (2020), Contemporary Art Museum of Houston (2020), Kennedy Center (2019, 2017), Museum of

the City of New York (2019, 2018), Neuberger Museum of Art (2016), Storefront for Art and Architecture (2015), and Museum of Modern Art (2015), among others. His practice has been supported by grants and fellowships including from the New York State Council on the Arts (2021), Creative Capital (2019), Map Fund (2019), Kennedy Center (2017), and New York Foundation for the Arts (2016) among others.

He is an Assistant Professor of Media Arts and Sciences at Massachusetts Institute of Technology and the Founder and Director of the Poetic Justice Group at the MIT Media Lab. Currently, his work with the Poetic Justice Group is focused on how art can address the scale of sociopolitical issues through distributed, multisite, and participatory public artworks that are accessible over the phone, online, and soon on the streets.

Marisa Morán Jahn

An artist, filmmaker, and creative technologist of Ecuadorian and Chinese descent, Marisa Morán Jahn's artworks redistribute power, "exemplifying the possibilities of art as social practice" (*Artforum*). Characterizing her playful approach, MIT CAST writes, "[Jahn] introduces a trickster-like humor into public spaces and discourses, and yet it is a humor edged with political potency." She is the founder of Studio REV-, a nonprofit organization that co-designs public art and creative media with low-wage workers, immigrants, and women.

Jahn's work has been featured at venues ranging from worker centers and public spaces to civil sectors (United Nations, the Obama White House), festivals (Venice Biennale of Architecture, Tribeca Film Festival), and museums (Museum of Modern Art, Walker Art Center, Asian Art Museum, New Museum, Art Brussels). Her work has been widely covered by the *New York Times*, *Artforum*, *Art in America*, BBC, CNN, Univision, *Los Angeles Times*, *Wall Street Journal*, *Hyperallergic*, *Architectural Review*, and others. Jahn is an awardee of Creative Capital, Anonymous Was a Woman, and Sundance/Rockefeller Foundation.

With Rafi Segal, Jahn is the coauthor of *Design Solidarity: Conversations on Collective Futures* (Columbia University Press). Jahn lectures internationally and regularly teaches at Columbia University, MIT (her alma mater), and Parsons/The New School where she is an Assistant Professor and the Associate Director of the Integrated Design program.

Mark Jarzombek

Mark Jarzombek is Professor of the History and Theory of Architecture at MIT. Jarzombek works on a wide range of topics both historical and theoretical. He is one of the country's leading advocates for global architectural history and has published several books and articles on that topic, including the groundbreaking textbook *A Global History of Architecture* (Wiley Press, 2006) with coauthor Vikramaditya Prakash and with the noted illustrator Francis D. K. Ching. He is the author of *Architecture of First Societies: A Global Perspective* (Wiley Press, 2013), which is a sensitive synthesis of First society architecture through time and includes custom-made drawings, maps, and photographs. Urban destruction in the modern era is another focus of Jarzombek's work. His *Urban Heterology: Dresden and the Dialectics of Post-Traumatic History* (Lund, 2001) takes on the issue of how erasure and rebuilding in Dresden force us to rethink the conventions of urban history. Jarzombek also recently published a book that interrogates the digital/global imaginaries that shape our lives, *Digital Stockholm Syndrome in the Post-Ontological Age* (University of Minnesota Press, 2016). His most recent book is *Architecture Constructed: Notes on a Discipline* (Bloomsbury Press, 2023).

Jaekyung Jung

Jaekyung Jung is interested in tracing ambivalence in the everyday life of the city, which stands between what is ethically right and wrong. He employs moving images and archives to reveal such interests. His works have been exhibited at the 23rd Brno International Biennial of Graphic Design (Moravia Gallery, Brno, Czech Republic, 2008), "Public Space? Lost and Found" (MIT Media Lab, 2014), "Art(ificial) Garden: The Border between Us" (National Museum of Modern and Contemporary Art, CheongJu, Korea, 2021), "Signaling Perimeters" (Nam-Seoul Museum of Art, Seoul, Korea, 2021), and "Ones Who

Inhabit the Twilight Zone" (ARKIPEL, Jakarta, Indonesia, 2021), among others. His recent solo exhibitions include "Cosmographia" (Seoullo Media Canvas, Seoul, 2019), "The Realm of Ghosts" (Sinchon Theater, Seoul, 2020), "A Scene" (Sinchon Theater, Seoul, 2021), and "Commedia" (Shhh, Incheon, 2022). Jung holds a BFA from the Rhode Island School of Design, a master of science in visual studies from MIT, and a PhD in art and media history, theory, and criticism–art practice concentration from the University of California, San Diego. Recently he worked as a director for the public art project *Reflect* (209, Dapsimni-ro, Dongdaemun-gu, Seoul, 2021–2024), a commissioned project supported by the Seoul Metropolitan Government and the Ministry of Culture, Sports and Tourism. Jung is a participating artist in the Korean Pavilion of the 18th Venice Biennale International Architecture Exhibition in 2023. His work is a part of the permanent collections of the National Museum of Modern and Contemporary Art (MMCA), MMCA Government Art Bank, and Seo-Seoul Museum of Art in South Korea. Jung is a founder of Shhh, an art space focusing on time-based art research and exhibition based in Incheon, South Korea.

Sung Ho Kim

Sung Ho Kim earned his master in science in architecture studies from the Massachusetts Institute of Technology. He was a project designer for Nasrine Seraji in Paris and for Wellington Reiter in Cambridge, Massachusetts. He served as a principal researcher for the Interrogative Design Group at the Center for Advanced Visual Studies at MIT.

Kim is the endowed Raymond E. Maritz Professor of Architecture at Washington University in St. Louis, engaged in research with biology and computer science. He received the 2018 Emerson Excellence in Teaching Award. He was a founding director of Axi:Ome llc of Providence, Rhode Island, in 2001 and has been co-director of Axi:Ome llc of St. Louis with Heather Woofter since 2003.

Kim's primary research field is design practice, developing various commissions globally with international competitions. He is focused on teaching experimental design that bridges technology, science, and ecological investigations.

Jean-Baptiste Labrune

Jean-Baptiste Labrune is a researcher and diplomat. He founded Radical Design Studio in 2010, after a postdoc in active materials design at the MIT Media Lab and a PhD in computer sciences and creativity at the Institut National de Recherche en Sciences et Technologies du Numérique (INRIA). He was then a professor of Arts and Sciences at the École des Arts Décoratifs in Paris. He is currently jointly working at the French embassy in Tel-Aviv and the University of Tel-Aviv and is a research affiliate at MIT and a lecturer at Sciences Po Paris and the École des Mines de Paris. His interdisciplinary practice focuses on "exaptation," the science of hacking and creative reconfigurations, or how people repurpose things in ways that were not anticipated by their creators. He develops DIY tools and courses exploring these notions in the context of resource scarcity, programmable biomaterials, and critical learning-through-design in the ZERO initiative he cofounded with Marcelo Coelho at the MIT Design Department.

Pia Lindman

Pia Lindman works with performance art, healing-as-art, installation, microbes, architecture, painting, and sculpture. In *Nose, Ears, Eyes* (São Paulo Biennale, 2016) Lindman gave treatments to members of the audience and made paintings based on the visions she saw during these treatments. Recent exhibitions include "Chewing the Tundra" at Kunsthalle Exnergasse, Vienna, Austria, 2022 (co-curated Lindman/Gretarsdottir), solo show "subsensorialXYZ in SOLU space" (Bioart Society), Helsinki, 2019, "Photomonth 2020" in KAI Art Center for Tallinn, Estonia, and "Not Without My Ghosts," Hayward Gallery Tours, UK, 2019–2022. Publications include "Big Toe, Brain, Rock" in *Slow Spatial Reader, Chronicles of Radical Affection*, ed. Carolyn F. Strauss (Valiz Books, 2021), and "Rehearsing Hospitalities Companion 1," 2019, Frame Contemporary Art, Finland. Lindman will show in the Finnish Pavilion at the 60th Venice Biennial in 2024 and is commissioned to create a collective performance for the European Capital of Culture Trenčín 2026. From many years of investigation into the body and its place within cultural spaces, Lind-

man's work has moved beyond the human body proper to multiple realms of organic and inorganic life.

Ani Liu

Ani Liu is an internationally exhibiting research-based artist working at the intersection of art and science. Her work examines gender politics, labor, reproduction, simulation, and sexuality. Integrating emerging technologies with cultural reflection and social change, her most recent work examines the biopolitics of care work and motherhood. Her work has been exhibited at the Venice Biennale, Ars Electronica, Kunstmuseum, the Queens Museum, and MIT Museum, and has been featured in the *New York Times*, *Art in America*, *National Geographic*, *Vice*, *Mashable*, *Gizmodo*, TED, PBS, the *Brooklyn Rail*, *Hyperallergic*, and *Wired*. She is currently an Associate Professor of Practice at the University of Pennsylvania.

Matthew Mazzotta

Matthew Mazzotta works at the intersection of art, activism, and urbanism, focusing on the power of the built environment to shape our relationships and experiences. His community-specific public projects integrate new forms of civic participation and social engagement into the built environment and reveal how the spaces we travel through and spend our time living within have the potential to become distinct sites for intimate, radical, and meaningful exchanges. Each project starts by creating temporary public spaces for listening—"outdoor living rooms"—as a way to capture voices from local people that might not attend more formal meetings. Stemming from this approach are experiences that involve people from a range of backgrounds working together to create new models of living that contribute to local culture beyond the economic realm.

Mazzotta received his BFA from the School of the Art Institute of Chicago and master of science from MIT's Program in Art, Culture, and Technology. He is a fellow at several institutions including TED, Guggenheim Foundation, Smithsonian Institution, Fulbright Program, as well as a Loeb Fellow at Harvard University.

Alex Milton

Alex Milton is a design academic, researcher, and practitioner. He is Head of the School of Design at the National College of Art and Design (NCAD) in Ireland. His work focuses on participatory design, creative pedagogy, and design for policy—developing national design strategies and running national design initiatives.

He has authored eight books including *Product Design* (published by Laurence King and translated into four languages). His creative work has been exhibited at numerous international venues including MUDAC Lausanne, Designers Block Milan, the Irish Museum of Modern Art, the National Museum of Scotland, and 100% Design London.

He has taught at Edinburgh College of Art, Heriot-Watt University, University of Dundee, Edinburgh Napier University, Central Saint Martins, and the Central Academy of Fine Art, Beijing. He has been a visiting professor at Manchester Metropolitan University, Aston University, and University College Dublin and an Erskine Fellow at the University of Canterbury, New Zealand.

Max Mollon

Sometimes described as a futurist specializing in itching hair, Max Mollon probes f(r)ictional futures, brings back various conversation pieces from them, and confronts them in ethical and social debates. He is also a designer, teacher at Sciences Po, researcher at PSL/EnsadLab and member of the scientific committee of the Design and Innovative Public Action Research Chair (École du Design de Nantes 2017).

His works have been dedicated to design fiction since 2010, punctuated by doctoral research for a thesis strongly anchored in the practice of design. They allowed him to create in 2017 a monthly seminar, the first third-place of participatory research on these practices in France (the Design Fiction Club).

Trained in Switzerland (Haute École d'Art et de Design, Geneva, 2010), he gradually moved away from R&D (Orange Labs, Bell Labs) and international design exhibitions (St-Etienne 2013, Milan 2010, 2011, Lift-Geneva 2010,

2013), and founded What if?, a design-for-debate bureau, in 2014. The latter accompanies public consultation missions (for ethics commissions), internal debates (for INRA research labs), or explores major issues not addressed by politics (including the Politique-Fiction.fr project, 2017 and CrispRfood.eu, 2018).

Mariana Morais

Originally from Recife (1991), Mariana Morais holds a degree in architecture and urbanism from Universidade Federal de Pernambuco, Brazil. During her studies, she was granted a scholarship which allowed her to complete a one-year mobility program in architectural design at Parsons School of Design in New York City. She holds a master's degree in art and design for public space from Universidade do Porto and a specialization in curating, urban culture, and spatial practices from Escola Superior Artística do Porto. She has developed an artistic and research practice on the representation of women in works of public art. She lives in Porto, Portugal.

Antoni Muntadas

Antoni Muntadas was born in Barcelona in 1942 and has lived in New York since 1971. Through his works he addresses social, political, and communications issues such as the relationship between public and private space within social frameworks, and investigates channels of information and the ways they may be used to censor or promulgate ideas. His projects are presented in different media such as photography, video, publications, the Internet, installations, and urban interventions.

He is currently Professor of the Practice at ACT in the Department of Architecture at MIT and at the Università Iuav de Venezia in Venice.

Muntadas has received several prizes and grants from sources including the Solomon R. Guggenheim Foundation, the Rockefeller Foundation, the National Endowment for the Arts, the New York State Council on the Arts, Ars Electronica in Linz, Laser d'Or in Locarno, the Premi Nacional d'Arts Plàstiques awarded by the Catalan Government, the Premio Nacional de Artes Plásticas 2005,

and the Premio Velázquez de las Artes Plásticas 2009 granted by the Spanish Ministry of Culture.

His work has been included in international events and venues such as Documenta VI and X, Kassel (1977, 1997), the Whitney Biennial of American Art (1991), the 51st Venice Biennial (2005), and others in São Paulo, Lyon, Taipei, Gwangju, and Havana. At the Venice Biennial in 2005 Muntadas exhibited *On Translation: I Giardini* in the Spanish Pavilion.

Gauri Nagpal

A trained urban planner, Gauri works on issues of persistent inequality, structural deprivation, and environmental degradation in the Global South. She has focused on addressing complexities of informality and economic stratification in urban India. Gauri began her research career as a fellow at the Indian Institute of Human Settlements, Bengaluru, and holds dual master's degrees in urban planning and design studies from Harvard University. She is currently working on several international development projects with the World Bank and the Ford Foundation.

Maria Niro

Maria Niro is a New York City-based film and sound artist and a member of New Day Films—a filmmaker-owned and -run distribution company providing social issue documentaries to educators since 1971. Her work includes long-form documentary and experimental shorts. Her film *The Art of Un-War* is a feature-length documentary chronicling the life and political work of Krzysztof Wodiczko.

Niro's films address various social issues including technological innovation and mass destruction, war and trauma, voyeurism, surveillance and the camera, political tension, war, technological innovation and mass destruction, the voiceless disenfranchised, and collective consumption. To date, she has completed one feature-length documentary and over 40 short films with original sound she's created, including video art shorts for the Lincoln Center for the Performing Arts website. Her films have screened and exhibited in galleries, museums, and in theaters worldwide including the National Gallery of Art, Harvard

University Art Museums, Whitechapel Gallery, Microscope Gallery, Queens Museum, Lincoln Center for the Performing Arts, Anthology Film Archives, Exit Art Gallery.

Niro pursued film and media studies at the New School for Social Research/New School University. She proudly serves on the advisory board of More Art, a nonprofit organization that supports collaborations between professional artists and communities to create public art and educational programs that inspire social justice.

Ginger Nolan

Ginger Nolan is an assistant professor of architectural history at the University of Southern California. Her work engages issues of social justice, race, and media technologies. She has published two books with the University of Minnesota Press: *The Neocolonialism of the Global Village* (2018) and *Savage Mind to Savage Machine: Racial Science and Twentieth-Century Design* (2021). She is currently working on a book on the relationships between twentieth-century African American insurance companies, civil rights struggles, and urban development.

Robert M. Ochshorn

Robert M. Ochshorn is a software engineer, cultural theorist, and media researcher based in San Francisco. He develops unusual digital interfaces to observe and activate sound, video, and language. He is interested in how new communication tools enable new social practices, and vice versa. Ochshorn is cofounder and CEO at Reduct.Video.

Lucy Orta

Lucy Orta is an artist whose practice investigates the boundaries between the body and architecture, exploring their common social factors, communication, and identity. She uses the media of drawing, couture, sculpture, performance, video, and photography to realize a singular body of work that includes *Refuge Wear* and *Body Architecture* (1992–1998), portable, lightweight, and autonomous structures that question issues of mobility and survival; *Nexus Architecture* and *Connector*, visualizing the concept of the social link shaping modular and collective structures; *Life Guards* (2004–ongoing), reflecting on the body as a metaphorical supportive framework; and *Genius Loci* (2012–ongoing), exploring the body and its relation to place-making.

Her work has been the focus of major shows at Musée d'Art Moderne de la Ville de Paris, France (1994); Wiener Secession, Vienna (1999); Museum of Contemporary Art, Sydney (1999); University of South Florida Contemporary Art Museum, for which she received the Visual Arts Award from the Andy Warhol Foundation (2001); and the Barbican Centre, London (2005). She is the youngest female artist to be the focus of a publication in the Phaidon Press contemporary artist collection (2003).

Adam Ostolski

Adam Ostolski is a sociologist, activist, and opinion journalist, and a faculty member at the University of Warsaw. His academic interests include discourse analysis, social movements, medical sociology, and collective memory. He has published on such topics as the legacy of World War II in Poland, museums, monuments, Polish-Jewish relations, and decommunization. He is a founding member of the left-wing milieu and journal *Krytyka Polityczna* (Political Critique) and sits on the editorial board of the *Green European Journal*. Together with Krzysztof Wodiczko he published *Wodiczko. Socjoestetyka* (Wydawnictwo Krytyki Politycznej, 2016), a book consisting of 17 interviews with Wodiczko covering topics from biography to the methodology of artistic interventions.

Sofia Ponte

Sofia Ponte is an artist, sometimes curator, and an assistant professor at IADE—Universidade Europeia, in Lisbon, Portugal. She is an associate researcher at the Research Institute of Design, Media and Culture (ID+) in the Unexpected Media Lab group. Ponte earned a PhD in art and design, with a specialization in museum studies, at the University of Porto (2016). She graduated in fine arts–sculpture from the University of Porto and earned an MS in visual studies at the Visual Arts Program at the Massachusetts Institute of Technology (2008).

297

Michael Rakowitz

Michael Rakowitz is an artist living and working in Chicago. His work has appeared in venues worldwide including dOCUMENTA (13), PS1, the Museum of Modern Art, the Massachusetts Museum of Contemporary Art, Castello di Rivoli, the 16th Biennale of Sydney, the 10th Istanbul Biennial, Sharjah Biennial 8, Tirana Biennale, National Design Triennial at the Cooper-Hewitt, and Transmediale 05. He has had solo exhibitions at Tate Modern in London, Lombard Freid Gallery in New York, Alberto Peola Arte Contemporanea in Torino, and Kunstraum Innsbruck. His public project *Return* was presented by Creative Time in New York in 2006. He is the recipient of a 2012 Tiffany Foundation Award, a 2008 Creative Capital Grant, a Sharjah Biennial Jury Award, a 2006 New York Foundation for the Arts Fellowship Grant in Architecture and Environmental Structures, the 2003 Dena Foundation Award, and the 2002 Design 21 Grand Prix from UNESCO.

Rakowitz is Professor of Art Theory and Practice at Northwestern University and is represented by Rhona Hoffman Gallery, Chicago; Jane Lombard Gallery, New York; and Barbara Wien Galerie, Berlin.

Gustavo Romeiro

Gustavo Romeiro is a product designer at Critical TechWorks, a BMW Group and Critical Group software company. In 2021, he graduated as a master of art and design for the public space from the Faculty of Fine Arts, University of Porto. He also has a postgraduate degree in human-computer interaction from the Faculty of Engineering at the University of Porto and a bachelor of communication in advertising and marketing art direction from the Escola Superior de Progaganda e Marketing, Rio de Janeiro.

Natalia Romik

Romik is a graduate in political science, practitioner of architecture, designer, artist. In 2018 Romik was awarded a PhD at the Bartlett School of Architecture, University College London, with a thesis "Post-Jewish Architecture of Memory within Former Eastern European Shtetls." She combines academic research with methods of contemporary art and architecture to explore (post-) Jewish architecture of memory. Romik has been awarded numerous grants including the London Arts and Humanities Partnership and the Scholarship of the Minister of Culture and National Heritage of Poland for the project Jewish Architecture of (Non-)Memory in Silesia. From 2007 to 2014 she cooperated with the Nizio Design studio and was a consultant for, among others, the POLIN Museum core exhibition design, coauthor of the revitalization of a synagogue in Chmielnik. Romik is a member of the SENNA architecture collective, responsible for designs including the exhibition at the Museum of Jews in Upper Silesia in Gliwice and a permanent exhibition at the Brodno Jewish Cemetery in Warsaw entitled *Beit Almin—Eternal Home*. In 2018 she co-curated the exhibition "Estranged: March '68 and Its Aftermath" (POLIN Museum of Polish Jews, Warsaw). She is a member of the Association of Polish Architects and is currently the scholarship holder (postdoctoral research) of the Gerda Henkel Stiftung with the project: Hideouts: The Architectural Analysis of the Secret Infrastructure of Jewish Survival during the Second World War.

Warren Sack

Warren Sack is a media theorist, software designer, and artist whose work explores theories and designs for online public space and public discussion. He is Professor of Film + Digital Media at the University of California, Santa Cruz, where he teaches digital arts and digital studies. He has been a visiting professor in France at Sciences Po, the Fondation Maison des Sciences de l'Homme, and Télécom ParisTech. His artwork has been exhibited at the San Francisco Museum of Modern Art, the Whitney Museum of American Art (New York), the New Museum of Contemporary Art (New York), the Walker Art Center (Minneapolis), and the ZKM (Karlsruhe, Germany). His scholarship and research have been supported by the Paris Institute for Advanced Study, the American Council of Learned Societies, the Sunlight Foundation, and the National Science Foundation. He received his PhD from the MIT Media Lab and was an undergraduate at Yale College. His book *The Software Arts* was recently published by the MIT Press in the Software Studies series.

Kirk Savage

Kirk Savage is William S. Dietrich II Professor of the History of Art and Architecture at the University of Pittsburgh, specializing in art of the United States and memory studies. He has taught and written about public monuments and public art as they intersect with issues of loss, trauma, deindustrialization, militarism, and racial justice. As a scholar and teacher, he takes seriously the responsibility to reckon honestly with the past, bearing in mind Ta-Nehisi Coates's admonition, "You must struggle to truly remember this past in all its nuance, error, and humanity." With much of the world now finally turning its attention to the legacies of white supremacy built into the memorial landscape, Kirk has been working more intensively with artists, planners, preservationists, and activists in the public sphere who are looking for new ways forward. He is proud to be serving on the board of directors of the innovative organization Monument Lab.

Nitin Sawhney

Nitin Sawhney is currently a Professor of Practice at Aalto University in Helsinki, Finland. His research, teaching, and creative practice engage the critical role of technology, civic media, artistic interventions, and participatory research in contested spaces. Nitin completed his PhD at the Massachusetts Institute of Technology and previously studied at the Georgia Institute of Technology. He has taught at the MIT Program in Art, Culture, and Technology and was a research affiliate with the MIT Center for Civic Media. Sawhney served as an Assistant Professor of Media Studies at The New School from 2011 onward, where he established the Engage Media Lab to support participatory media, research, and civic agency among youth and marginalized communities. He has conducted research with Palestinian youth in the West Bank, East Jerusalem, and Gaza, cofounded the Boston Palestine Film Festival, and co-directed the documentary film *Flying Paper*, about the culture of kite-making and flying among children in Gaza, with support from *National Geographic*. He also conducted artistic and curatorial research in Guatemala examining historic memory through films, exhibitions, and site-specific performance interventions. Sawhney is an associate editor for the *International Journal of Child Computer Interaction*. In 2018 he was awarded a prestigious faculty research fellowship with the Graduate Institute for Design, Ethnography and Social Thought, supported by the Andrew W. Mellon Foundation.

Dread Scott

Dread Scott is a visual artist whose work is exhibited across the United States and internationally. In 1989, his art became the center of national controversy over its transgressive use of the American flag, while he was a student at the School of the Art Institute of Chicago. Dread became part of a landmark Supreme Court case when he and others defied a federal law outlawing his art by burning flags on the steps of the US Capitol. He has presented a TED talk on this.

His work has been included in exhibitions at MoMA PS1, the Walker Art Center, Cristin Tierney Gallery, and is in the collection of the Whitney Museum, the National Gallery of Art, and the Metropolitan Museum of Art. He is a 2023 Rome Prize Fellow and has also received fellowships from the John Simon Guggenheim Foundation, Open Society Foundation, and United States Artists as well as a Creative Capital grant.

In 2019 he presented *Slave Rebellion Reenactment*, a community-engaged project that reenacted the largest rebellion of enslaved people in US history. The project was featured in *Vanity Fair*, the *New York Times*, by Christiane Amanpour on CNN, and was highlighted by artnet.com as one of the most important artworks of the decade.

Sanjit Sethi

Sanjit Sethi has two decades of experience as an artist, curator, and cultural leader. Sethi's previous positions include Director of the Corcoran School of the Arts and Design at George Washington University, Director of the Center for Art and Public Life, Barclay Simpson Professor and Chair of Community Arts at the California College of the Arts; and Executive Director of the Santa Fe Art Institute. Additionally, Sethi has taught at the Srishti School of Art, Design, and Technology; the Massachusetts Institute of Technology; and the School of the Art Institute of Chicago.

Sethi received a BFA from New York State College of Ceramics at Alfred University, an MFA in ceramics from the University of Georgia, and an MS in advanced visual studies from the Massachusetts Institute of Technology. Sethi has been awarded numerous grants and fellowships, including a grant from the Robert Rauschenberg Foundation and a Fulbright fellowship in India. He serves on the boards of the Alliance for Artist Communities, the Jerome Foundation, the Association for Independent Colleges of Art and Design, and Moving Arts Española.

Sanjit Sethi is the 19th president of the Minneapolis College of Art and Design.

Samein Shamsher

Working at the intersections of design, education, and community organizing, Samein Shamsher's approach to design and research draws on methods of creative ethnography and narrative environments, seeking to develop sites of intervention where the personal and political overlap. His work has been exhibited in Milan, Eindhoven, and Vancouver; he is currently a PhD Mellon Fellow at San Francisco University's School of Interactive Arts and Technology and the Digital Democracies Institute, researching possibilities for social transformation through critical and radical design imaginaries.

James Shen

James Shen is Principal at People's Architecture Office. He received his master of architecture from the Massachusetts Institute of Technology and a bachelor of science in product design from California State University, Long Beach. He is currently Senior Research Fellow at the Harvard Joint Center for Housing Studies. Shen was a Loeb Fellow at Harvard and an Innovation Fellow at MIT's China Future City Lab. He has taught at MIT's School of Architecture and Planning and Harvard's Graduate School of Design.

People's Architecture Office (PAO) is an international practice with offices based in Beijing and Boston. Founded in 2010 by James Shen, He Zhe, and Zang Feng, the firm is a multidisciplinary studio dedicated to design innovation that leads to a more inclusive and connected society. Areas of focus include housing, education, and urban regeneration.

People's Architecture Office is the first architecture firm certified as a B-Corporation in Asia and serves as a model social enterprise. *Domus* named PAO as one of the world's best architecture firms of 2019 and *Fast Company* listed PAO as one of the world's ten most innovative architecture companies in 2018. Recognition for the studio's work includes the Aga Khan Award, the Wold Architecture Festival Award, and the Architecture Review Emerging Architecture Award. PAO's work has been exhibited at the Venice Architecture Biennale, the Harvard Graduate School of Design, the London Design Museum, and recently as a retrospective at Design Society.

Carl Solander

Carl Solander has over 20 years of experience practicing architecture. Before founding Reverse Architecture, he worked at Howeler + Yoon Architecture in Boston and several small practices in New York City. He graduated from Columbia University in 1999 with a BA in architecture and completed a master's in architecture at the Massachusetts Institute of Technology in 2005. He is a frequent lecturer, teaching courses on building technology at the Harvard Graduate School of Design and at MIT and has taught design at MIT, Wentworth Institute of Technology, and Northeastern University. He is an active member of the Boston Society of Architects and is the co-chair of the Belmont, MA Historic District Commission. He has a passion for great design and tirelessly seeks to improve his knowledge of building methods and technology in order to deliver high-performing, innovative, and inspiring architecture.

Solander is a registered architect in Massachusetts and Maine. He is a member of the American Institute of Architects, the Boston Society of Architects, and the Northeast Sustainable Energy Association. He is a certificate holder with the National Council of Architectural Registration Boards, a LEED Accredited Professional, and a Certified Passive House Consultant with Passive House Institute US.

Sputniko!

Born in 1985, Sputniko! is a Japanese/British artist based in Tokyo. Sputniko! is known for her film and multimedia installation works which explore the social and ethical implications of emerging technologies. She has recently presented her works in exhibitions such as the 2016 Setouchi Art Trienniale (where she created her first permanent art pavilion at the Benesse Art Site on Teshima), Milan International Design Triennale "Broken Nature" (2019), and Future and Arts at the Mori Art Museum (2019). From 2017, Sputniko! became a Project Associate Professor at the University of Tokyo, where she is furthering her work with the Royal College of Art–IIS Design Lab. From 2013 to 2017, Sputniko! was an Assistant Professor at the MIT Media Lab, where she directed the Design Fiction research group. She is currently an Associate Professor of Design at Tokyo University of Arts. She has had pieces included in the permanent collections of museums such as the Victoria and Albert Museum and the 21st Century Museum of Contemporary Art, Kanazawa.

Richard Streitmatter-Tran

Richard Streitmatter-Tran is an artist based in Ho Chi Minh City, Vietnam and Lecturer in Art and Media Studies at Fulbright University Vietnam. He was a cross-registered student from the Massachusetts College of Art when he enrolled in two semesters of the Interrogative Design Workshop at MIT in 2001–2002. His work can be found at www.diacritic.org.

Orkan Telhan

Orkan Telhan investigates critical issues in cultural, environmental, and social responsibility. Telhan is the Director of Foundry Engineering at Ecovative and Associate Professor of Fine Arts–Emerging Design Practices at the University of Pennsylvania School of Design (on leave). He holds a PhD in design and computation from MIT's Department of Architecture. He was part of the Sociable Media Group at the MIT Media Laboratory and a researcher at the MIT Design Laboratory. He studied media arts at the State University of New York at Buffalo and theories of media and representation, visual studies, and graphic design at Bilkent University, Ankara. Telhan's individual and collaborative work has been exhibited internationally in venues including the Istanbul Biennial, Istanbul Design Biennial, Milan Design Week, Vienna Design Week, the Armory Show 2015 Special Projects, Ars Electronica, ISEA, LABoral, Archilab, Architectural Association, the Architectural League of New York, MIT Museum, Museum of Contemporary Art Detroit, and the New Museum of Contemporary Art, New York.

Bruce M. Tharp

Bruce, along with his wife and fellow Stamps faculty member Stephanie M. Tharp, established their creative studio, materious, in Chicago in 2005. "Materious" is an archaic word that means both "substance" and "substantive," reflecting their concern for imbuing deep meaning, messaging, and value within domestic products. At times aiming for provocation and pertubation while at others for sustenance and service, their practice spans the four fields of commercial, responsible, experimental, and discursive design. This four-field approach to design theory and practice was conceptualized by them and has been incorporated into design thinking and classrooms across the globe.

They have patented and licensed designs that are sold commercially, been awarded commissions from Moet-Hennessy and the Art Institute of Chicago, and also engage in self-production and wholesale/retail sales. Materious has exhibited in global design capitals like Milan, Paris, and New York, with their work represented commercially in Japan, China, Singapore, Australia, Russia, across Europe, Canada, Mexico, and Central and South America.

Their book *Discursive Design* presented a realm of expanded design practice that they have helped to problematize and legitimize over the past decade.

Stephanie M. Tharp

Stephanie Tharp received a master of industrial design degree from the Rhode Island School of Design and a bachelor of mechanical engineering from the University of Michigan. From 2002 until 2014 she was Associate Professor and Program Chair of Industrial Design at the

University of Illinois at Chicago's School of Design. She has work experience with Ford Motor Company, the Massachusetts Institute of Technology, Armstrong Industries, and amazon.com.

She creates objects with an interest in the physical substance as well as the substantiveness of the designed objects. She hopes to connect with people beyond mere utility in addressing important contemporary psychological, sociological, and ideological concerns. She engages in design explorations that aren't driven by commercial constraints, but sometimes might be capable of existing within the market. Of special attention is the domestic sphere—a space in which artifacts have a particular capacity for intimate engagement with individuals.

Tharp has exhibited her work nationally and internationally and is the recipient of several design awards, including Future Furniture Competition Winner from *Interior Design* magazine, and Best in Show from Design Within Reach's Modern+Design+Function Chicago Furniture Now Competition. She has lectured and presented nationally and internationally and has received grants from Motorola, the Consortium to Lower Obesity in Chicago Children, and the OVCR Arts, Architecture and Humanities Award at the University of Illinois at Chicago.

Zenovia Toloudi

Zenovia Toloudi is architect, artist, and Assistant Professor of Architecture at Studio Art, Dartmouth College. Her work critiques the contemporary alienation of humans from nature and sociability in architecture and in public space, and investigates spatial typologies to reestablish cohabitation, inclusion, and participation through digital, physical, and organic media. The founder of Studio Z, a creative research practice in art, architecture, and urbanism, she has exhibited internationally, including at the Biennale in Venice, the Center for Architecture, the Athens Byzantine Museum, the Thessaloniki Biennale of Contemporary Art, and the Onassis Cultural Center. She has won commissions from Illuminus Boston and The Lab at Harvard. Her work belongs to permanent collections at Aristotle University and the Thracian Pinacotheca.

Marek Wasilewski

Marek Wasilewski is a graduate of Academy of Fine Arts in Poznań, Poland, and Central Saint Martins College of Art and Design in London. He has been awarded the British Council, Fulbright, and Kosciuszko Foundation scholarships. He is a professor at the University of Arts in Poznań and director of the Municipal Gallery Arsenal in Poznań. He is a member of AICA. In the years 2000–2017 he was editor in chief of the cultural magazine *Time of Culture*. He has published in magazines such as *Art Monthly*, *Springerin*, *PAJ: A Journal of Performance and Art*, *Switch on Paper*, the *International Journal of Education and Art*, and *Respublica Nova*. He is the author of the books *Absent Art* (1999), *Sex, Money and Religion—Conversations about British Art* (2001), and *Is Art a Mad Dog?* (2009), and contributed to *Art in Times of Populism and Nationalism* (2021) As an artist he works in the fields of video art, photography, and installation.

Lani Watson

Lani Watson is a philosopher. She is fascinated by questions—what they are, how we use them, and why we ask them. Her research focuses on the practice of questioning in everyday life and how it allows us to have conversations, challenge each other, gather information, and understand our world. She has a special interest in the way we use questions to learn, both in and out of the classroom. She argues that good questioning is a vital skill that should be taught in schools. She uses philosophy, educational theory, and experimental psychology to present a case for teaching the skill of good questioning as well as the intellectual virtues of curiosity and inquisitiveness. She also explores the role that good questioning plays in initiating and guiding discussion and the wider implications of this for questioning practices in diverse contexts, such as business, healthcare, law, and journalism.

Watson is currently a Research Fellow at the University of Oxford. She was previously a Leverhulme Early Career Fellow at the University of Edinburgh and a Research Fellow at the University of Oklahoma. She completed her PhD at the University of Edinburgh in 2015. Her forthcoming book about questions is titled *Q: The Hidden Power of Questions in a World That Wants Answers*.

Krzysztof Wodiczko

Krzysztof Wodiczko, born 1943 in Warsaw, Poland is renowned for his large-scale slide and video projections on architectural facades and monuments. He has realized more than 90 such public projections in Australia, Austria, Belgium, Canada, England, Germany, Holland, Northern Ireland, Israel, Italy, Japan, South Korea, Mexico, Poland, Spain, Switzerland, and the United States.

Since the late 1980s, his projections have involved the active participation of marginalized and estranged city residents.

Simultaneously, and internationally, he has been designing and implementing a series of nomadic instruments, vehicles, and other cultural equipment with the homeless, immigrants, alienated youth, war veterans, and other operators for their survival, communication, and expression in public space.

Since 1985, he has held many major retrospectives at such institutions as the Walker Art Center, Minneapolis; Muzeum Sztuki, Łódź; Fundació Antoni Tàpies, Barcelona; Wadsworth Athenaeum, Hartford, Connecticut; La Jolla Museum of Contemporary Art, San Diego; Contemporary Art Center, Warsaw; the Zacheta National Gallery of Art, Warsaw; DOX Contemporary Art Center, Prague; Bunkier Sztuki Art Center, Kraków, Poland; List Visual Arts Center, MIT; Hiroshima City Museum of Contemporary Art; in FACT in Liverpool, as a part of the Liverpool Biennale; and the Museum of Modern and Contemporary Art, Seoul, South Korea.

Wodiczko's work has been exhibited in Documenta (twice), Paris Biennale, Sydney Biennale, Lyon Biennale, Architectural Biennale in Venice (International Pavilion), Whitney Biennial, Yokohama Triennale, International Center for Photography Triennale in New York, Montreal Biennale (2014), in the exhibition *"Magiciens de la terre"* at the Centre Georges Pompidou, and in many other international art festivals and exhibitions.

He received the Hiroshima Art Prize "for his contribution as an international artist to world peace" and represented Poland and Canada in the Venice Biennale. He is also the recipient of the Skowhegan Medal for Sculpture, the Georgy Kepes Award, MIT, the Katarzyna Kobro Prize, and "Gloria Artis" Gold Medal from the Polish Ministry of Culture.

Professor of Art Design and the Public Domain, Emeritus at Harvard's Graduate School of Design, he was formerly director of the Center for Advanced Visual Studies and the head of Interrogative Design Group at MIT.

He has taught at the Warsaw School of Social Psychology (SWPS) and was a Distinguished Visiting Professor at the Weitzman School of Design at University of Pennsylvania. Since 2013 he has taught as a Visiting Professor at the Media Arts Department of the Academy of Fine Arts, Warsaw.

Before beginning his full-time work at MIT (1992) and at Harvard (2010), Wodiczko held full-time academic positions in such institutions as the Nova Scotia College of Art and Design (intermedia art), New York Institute of Technology (history of modern art and basic design), University of Hartford (photography), Cal Arts (photography and public art), and École Supérieure Nationale des Beaux-Arts, Paris (atelier focusing on critical art and public space). He also taught part-time at Ontario College of Art (industrial design), Cornell University (public art), the Cooper Union (public sculpture). Academy of Fine Arts in Warsaw (basic design), Warsaw's Polytechnique (industrial design), Trent University's Cultural Studies, Peterborough, Ontario (history and theory of the artistic avant-garde), and New York University (therapeutic dimensions in contemporary art).

His essays and projects have been published in *October*, *AA Files*, *Art in Theory*, *Design Culture Reader*, *Academy X: Lessons in Art + Life in 2015*, and *Transformative Avant-Garde and Other Writings*, among many academic journals and books. Most importantly, a collection of his writings titled *Critical Vehicles* was published by the MIT Press (1999), a comprehensive monograph of his work titled *Krzysztof Wodiczko* was published by Black Dog Press, London (2012). *Abolition of War* (2013) and *Transformative Avant-Garde and Other Writings* (2016) and its expanded edition (2022) were also published by Black Dog. An expanded edition of *Abolition of War* in Polish, *Obalenie Wojen*, was published by MOCAK in 2013.

The book of his collected writings in Polish titled *Rozmowy i Teksty Krytyczne* (Critical Texts and Conversations), edited by Marek Wasilewski, was published by Arsenał, Poznań, in 2022.

Wodiczko's work is presented as part of the internationally distributed PBS television series *Art 21* and in a DVD as a part of the book *Art in the Twenty-First Century*.

The film *Krzysztof Wodiczko: the Art of Un-War*, directed by Maria Niro, has been in distribution since 2023.

Wodiczko received a master's degree in fine arts in industrial design from the Academy of Fine Arts, Warsaw (1968). He has a doctoral degree in the arts from the Academy of Fine Arts in Warsaw (2023) and a doctorate *honoris causa* from the University of the Arts in Poznań (2008) and from the Maine School of Art (2007).

He lives and works in New York City, Boston, and Warsaw.

Ian Wojtowicz

Wojtowicz creates systems for augmenting human creativity. He works as an artist, engineer, writer, cartographer, designer, or educator depending on the nature of the project. His cultural work uses design tactics to provoke public discourse on "wicked" problems, often employing the techniques of editing and repair.

He holds a degree in Art, Culture, and Technology from MIT where he studied with Krzysztof Wodiczko and has taught, shown projects, and lectured internationally.

Ben Wood

Since 1999 Ben Wood has established himself by offering a reawakening of history, exposing vital realities of our current time and place. Wood has positioned himself as a groundbreaker in the merging of art, history, and technology. He is especially devoted to using contemporary media to animate public spaces with images of their lost histories and exposing how histories of marginalized and forgotten communities may be visually introduced into the physical landscape of the present. Based in San Francisco, his work has been shown in San Francisco, Mexico City, Honolulu, and London.

Illustration Credits

1 Introduction

1.1 Photograph courtesy of Krzysztof Wodiczko.

1.2 Photograph courtesy of Krzysztof Wodiczko.

1.3 Photograph courtesy of Krzysztof Wodiczko.

1.4 Photograph courtesy of Krzysztof Wodiczko.

1.5 Photograph courtesy of Krzysztof Wodiczko.

1.6 Drawing © Krzysztof Wodiczko. Courtesy Galerie Lelong & Co., New York.

1.7 Stephen Salisbury, "Depicting the Destitute," The Philadelphia Enquirer (November 2, 1989), 1-C, 4-C. Used by permission.

1.8 Julie Salamon. "A 'Mobile Home' for the Homeless," Wall Street Journal (April 4, 1989), A20. Used by permission.

1.9 Derek May dir., Krzysztof Wodiczko: Projections (National Film Board of Canada: 1991). Used by permission.

1.10 Derek May dir., Krzysztof Wodiczko: Projections (National Film Board of Canada: 1991). Used by permission.

1.11 Drawing © Krzysztof Wodiczko. Courtesy Galerie Lelong & Co., New York.

1.12 Text by Krzysztof Wodiczko, from his essay "Art, Trauma and Parrhesia," Art and the Public Sphere, vol. 1, no. 3 (2011).

1.13 Screenshot from Interrogative Design Workshop, http://web.mit.edu/idw/ (December 9, 2002).

1.14 Screenshot from course outline of Warren Sack and Krzysztof Wodiczko's course on "Ethical Media Art," https://web.archive.org/web/20100722120830/http://xenia.media.mit.edu/~wsack/ethical-media-art.html (Fall 1995).

2 When Is Design a Question?

2.1 Photograph courtesy Jaekyung Jung.

2.2 Photograph courtesy Jaekyung Jung.

2.3 Illustration courtesy Jaekyung Jung.

2.4 Video stills courtesy of Richard Streitmatter-Tran.

2.5 Letter reproduction courtesy of Richard Streitmatter-Tran.

2.6 Photograph courtesy of Sara Hendren.

2.7 Photograph courtesy of Sara Hendren.

2.8 Photograph courtesy of Sara Hendren.

2.9 Photograph courtesy of Sara Hendren.

2.10 Photograph courtesy of Sara Hendren.

2.11 Photograph courtesy of Orkan Telhan.

2.12 Photograph courtesy of Pete Ho Ching Fung.

2.13 Illustration courtesy of Ian Wojtowicz.

2.14 Illustration courtesy of Ian Wojtowicz.

2.15 Photograph courtesy of Ian Wojtowicz.

2.16 Photograph courtesy of Krzysztof Wodiczko.

2.17 Drawing courtesy of Krzysztof Wodiczko.

2.18 Photograph courtesy of Krzysztof Wodiczko.

3 Participation

3.1 Photograph courtesy of Samson Wong.

3.2 Photograph courtesy of Orkan Telhan.

3.3 Photograph courtesy of Orkan Telhan.

3.4 Illustration courtesy of Ian Wojtowicz.

3.5 Drawing courtesy of Krzysztof Wodiczko. Altered for visibility.

3.6 Drawing courtesy of Krzysztof Wodiczko. Altered for visibility.

3.7 Illustration courtesy of Ian Wojtowicz.

3.8 Photograph courtesy of PS1 MOMA and Pia Lindman. Photo credit: Grady Gerbracht.

3.9 Photograph courtesy of LMCC and Pia Lindman. Photo credit: Amanda Matles.

3.10 Painting courtesy of Sao Paulo Biennale and Pia Lindman.

3.11 Photograph courtesy of James Shen.

3.12 Photograph courtesy of James Shen.

3.13 Photograph courtesy of Krzysztof Wodiczko.

3.14 Photograph courtesy of James Shen.

3.15 Photograph courtesy of James Shen.

3.16 Photograph courtesy of James Shen.

3.17 Photograph courtesy of James Shen.

3.18 Photograph courtesy of Matthew Mazzotta.

3.19 Photograph courtesy of Matthew Mazzotta.

3.20 Photograph courtesy of Matthew Mazzotta.

3.21 Photograph courtesy of Matthew Mazzotta.

3.22 Photograph courtesy of Matthew Mazzotta.

3.23 Photograph courtesy of Matthew Mazzotta.

3.24 Photograph courtesy of Matthew Mazzotta.

3.25 Photograph by UnpetitproleX, "Palace of Assembly Chandigar," (2021), https://upload.wikimedia.org/wikipedia/commons/6/6d/Palace_of_Assembly_Chandigarh.jpg.

3.26 Photograph courtesy of Gauri Nagpal.

3.27 Photograph courtesy of Gauri Nagpal.

3.28 Photograph courtesy of Gauri Nagpal.

3.29 Excerpt from "The Street Vendors Protection of Livelihood and Regulation of Street Vending Act," *Gazette of India*, vol. 2014, no. 7 (March 4, 2014).

3.30 Photograph courtesy of Gauri Nagpal.

3.31 Illustration courtesy of Gauri Nagpal.

3.32 Illustration courtesy of Gauri Nagpal.

3.33 Photograph courtesy of Gauri Nagpal.

3.34 Photograph courtesy of Gauri Nagpal.

3.35 Article excerpt from "Major flags off street vending e-carts," *Hindustan Times* (January 23, 2023).

3.36 Illustration courtesy of Ben Wood.

3.37 Reproduction of Victor Amautoff's mural *Life of George Washington*, courtesy of Ben Wood.

3.38 Photograph courtesy of Marisa Morán Jahn.

3.39 Photograph courtesy of Marisa Morán Jahn.

4 Public Space

4.1 Screenshot of Google Images search for "fearless girl bull tweets." All images creative commons license.

4.2 Photograph courtesy of Gerald Auten and Zenovia Toloudi, *"Speak! Listen! Act!,"* exhibition, Strauss Gallery (2016).

4.3 Photograph courtesy of Dimitris Papanikolaou, *Techno-utopias,* exhibition, Jaffe Friede Gallery (2019).

4.4 Photographs courtesy of Antoni Muntadas.

4.5 Photograph courtesy of Antoni Muntadas.

4.6 Photograph courtesy of Frida Escobedo.

4.7 Photograph courtesy of Frida Escobedo.

4.8 Photograph courtesy of Azra Akšamija.

4.9 Drawing courtesy of Azra Akšamija.

4.10 Photograph courtesy of Michael Rakowitz.

4.11 Photograph courtesy of Michael Rakowitz.

4.12 Photograph courtesy of Michael Rakowitz.

4.13 Drawing courtesy of Michael Rakowitz.

4.14 Photograph courtesy of James Shen.

4.15 Photograph courtesy of James Shen.

4.16 Photograph courtesy of Lucy Orta.

4.17 Photograph courtesy of Lucy Orta.

5 Theater

5.1 Photograph courtesy of Krzysztof Wodiczko.

5.2 Photograph courtesy of Dread Scott.

5.3 Photograph courtesy of Dread Scott.

5.4 Photograph courtesy of Mark Von Holden.

5.5 Photograph courtesy of Marisa Morán Jahn.

5.6 Photograph courtesy of Kelly Dobson.

5.7 Drawing courtesy of Kelly Dobson.

5.8 Excerpt from Kelly Dobson's PhD dissertation "Machine Therapy," page 33.

5.9 Photograph courtesy of Sohin Hwang.

5.10 Photograph courtesy of Sohin Hwang.

5.11 Photograph courtesy of Sohin Hwang.

5.12 Drawing courtesy of Krzysztof Wodiczko.

5.13 Photograph courtesy of Krzysztof Wodiczko.

5.14 Excerpt from Kelly Dobson, "Machine Therapy," (doctoral dissertation, MIT, 2007), 29, https://dspace.mit.edu/handle/1721.1/44329.

5.15 Excerpt from Kelly Dobson, "Machine Therapy," (doctoral dissertation, MIT, 2007), 30, https://dspace.mit.edu/handle/1721.1/44329.

5.16 Excerpt from Kelly Dobson, "Machine Therapy," (doctoral dissertation, MIT, 2007), 29, https://dspace.mit.edu/handle/1721.1/44329.

5.17 Photograph courtesy of Michael Rakowitz.

5.18 Photograph courtesy of Michael Rakowitz.

6 Realism

6.1 Gustave Courbert, "The Stonebreakers," Wikipedia, https://en.m.wikipedia.org/wiki/File:Gustave_Courbet_-_The_Stonebreakers_-_WGA05457.jpg, accessed April 24, 2024.

6.2 Illustration courtesy of Ian Wojtowicz.

6.3 Photograph by Mobilus in Mobili, 2020. https://flic.kr/p/2jeYxZW.

6.4 "Robert E. Lee Statue Projection at Night," courtesy of Alex Criqui and Dustin Klein.

6.5 Drawing courtesy of Krzysztof Wodiczko.

6.6 Drawing courtesy of Max Mollon.

6.7 Photograph courtesy of James King.

6.8 Photograph courtesy of Design Friction.

6.9 Photograph courtesy of Krzysztof Wodiczko.

6.10 Drawing courtesy of Krzysztof Wodiczko.

6.11 Drawing courtesy of Krzysztof Wodiczko.

6.12 Screenshot of article excerpt by Karen Cheung, "Video: Artists programme huge '2047 countdown' on ICC building during China official's visit," Hong Kong Free Press (May 18, 2016). Photograph courtesy of Samson Wong.

6.13 Screenshot of article excerpt by Ellen Pearlman, "1,588-Foot-Tall Artwork Lights Up a Political Inferno in Hong Kong," Hyperallergic. (June 1, 2016).

6.14 Photograph courtesy of Chris Csíkszentmihályi.

6.15 Article excerpt by Brad Weiners, "Do androids dream of First Amendment rights?" Salon.com (February 25, 2002).

6.16 Illustration courtesy of Chris Csíkszentmihályi.

7 Memory

7.1 "A Monument Man Gives Memorials New Stories To Tell," New York Times (January 23, 2020). Used by permission.

7.2 Photograph by Mobilus in Mobili, 2020. https://flic.kr/p/2jeYxZW.

7.3 Photograph courtesy of Michael Rakowitz.

7.4 Illustration courtesy of Ekene Ijeoma.

7.5 Illustration courtesy of Benjamin Jancewicz.

7.6 Photograph courtesy of Natalia Romik.

7.7 Illustration courtesy of Ian Wojtowicz.

7.8 Illustration courtesy of Ian Wojtowicz.

7.9 Illustration courtesy of Krzysztof Wodiczko.

7.10 Illustration courtesy of Krzysztof Wodiczko.

7.11 Illustration courtesy of Krzysztof Wodiczko.

7.12 Illustration courtesy of Krzysztof Wodiczko.

7.13 "La Marseillaise" relief by François Rude on the Arc de Triomphe, Paris, France. Photograph courtesy of Alvesgarpar, Wikimedia commons, https://en.m.wikipedia.org/wiki/File:Paris_July_2011-16a.jpg.

7.14 Excerpt of "El triumfo de la imaginación," trans. "Triumph of the imagination," El Pais (October 1, 2021).

7.15 Christo and Jeanne-Claude, "Arc de Triomphe, Wrapped," Paris, France. Photograph by Ssirdeck, Wikimedia Commons (October 2, 2021), https://commons.m.wikimedia.org/wiki/File:L%27Arc_de_Triomphe,_Wrapped.jpg.

7.16 Photograph courtesy of Yang Jiechang, Centre Georges Pompidou / Bibliothèque Kandinsky.

7.17 Photograph courtesy of Sofia Ponte.

8 Prosthetics

8.1 Photograph courtesy of Krzysztof Wodiczko.

8.2 Photograph courtesy of Krzysztof Wodiczko.

8.3 Photograph courtesy of Krzysztof Wodiczko.

8.4 Photograph courtesy of Krzysztof Wodiczko.

8.5 Photograph courtesy of Krzysztof Wodiczko.

8.6 Drawing courtesy of Krzysztof Wodiczko.

8.7 Photographs courtesy of Krzysztof Wodiczko.

8.8 Photograph courtesy of Gustavo Romeiro.

8.9 Photograph courtesy of Gustavo Romeiro.

8.10 Drawing courtesy of Gustavo Romeiro.

8.11 Photograph courtesy of Gustavo Romeiro.

8.12 Photograph courtesy of Gustavo Romeiro.

8.13 Photograph courtesy of Ginger Nolan and Carl Solander.

8.14 Photograph courtesy of Krzysztof Wodiczko.

8.15 Photograph courtesy of Krzysztof Wodiczko.

8.16 Photograph courtesy of Toshiro Tomatsu and Kelly Dobson.

8.17 Illustration courtesy of Kelly Dobson.

8.18 Photograph courtesy of Ani Liu.

8.19 Press coverage, Fox News.

8.20 Photograph courtesy of Ani Liu.

8.21 Photograph courtesy of Ani Liu.

8.22 Photograph courtesy of Ani Liu.

9 Ethical Alertness

9.1 Photograph courtesy of Dan Borelli.

9.2 Beth Daley, "Cancer Alert Sounded: State study ties Ashland waste site to an elevated risk," Boston Globe (April 26, 2006). Article used by permission.

9.3 Photograph courtesy of Dan Borelli.

9.4 Photograph courtesy of Dana Gordon.

9.5 Photograph courtesy of Jae Rhim Lee.

9.6 Photograph courtesy of Orkan Telhan.

9.7 Illustration courtesy of Mariana Morais.

9.8 Photograph courtesy of Mariana Morais.

9.9 Illustration courtesy of Mariana Morais.

9.10 Illustration courtesy of Mariana Morais.

9.11 Illustration courtesy of Mariana Morais.

9.12 Photograph courtesy of Mariana Morais.

9.13 Photograph courtesy of Sputniko!

9.14 Photograph courtesy of Sputniko!

9.15 President Dwight D. Eisenhower, "Farewell address," *Papers of Dwight D. Eisenhower as President, 1953-61*, (Eisenhower Library: National Archives and Records Administration), January 17, 1961; Final TV Talk 1/17/61 (1), Box 38, Speech Series.

9.16 President Dwight D. Eisenhower, "Farewell address," *Papers of Dwight D. Eisenhower as President, 1953-61*, (Eisenhower Library: National Archives and Records Administration), January 17, 1961; Final TV Talk 1/17/61 (1), Box 38, Speech Series.

Index

T